Paul Cézanne

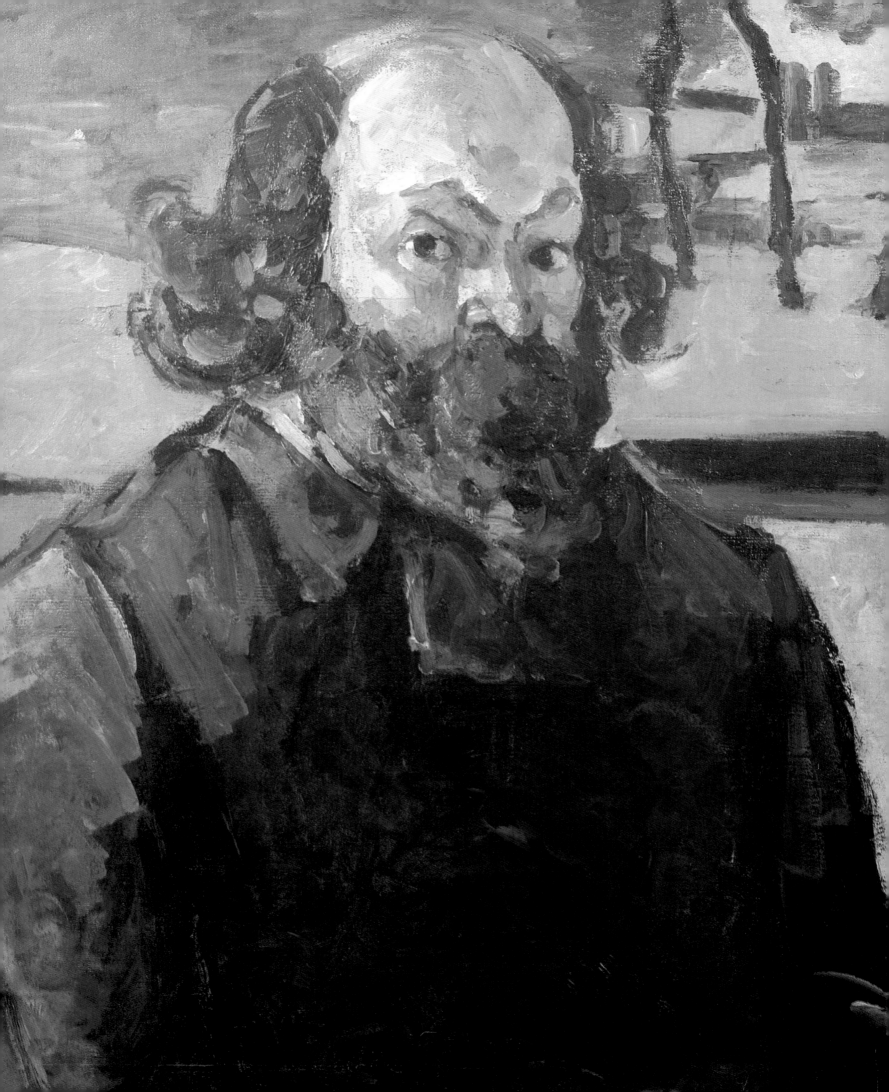

Hajo Düchting

PAUL CÉZANNE

1839 – 1906

Nature into Art

TASCHEN

HONG KONG KÖLN LONDON LOS ANGELES MADRID PARIS TOKYO

ILLUSTRATION PAGE 2:
Self-Portrait, ca. 1873/76
Portrait de l'artiste
Oil on canvas, 64 x 53 cm
Venturi 288
Musée d'Orsay, Paris

The editors and publishers would like to thank the museums, collectors, archives and
photographers who assisted us in the making of this book, in particular Ursula and
André Held and Ernst Reinhard Piper. The paintings of Cézanne are here arranged
according to the subjects covered by the chapters of the book, and only loosely in chrono-
logical order. Dates are given in accordance with Lionello Venturi's catalogue of
Cézanne's works (*Cézanne, son art, son œuvre*, Paris 1936) and the research findings of
John Rewald, whose thesis *Cézanne, sa vie, son œuvre, son amitié pour Zola*, originally
published in Paris in 1939, was revised and republished in a German version (Cologne,
1986) together with his new catalogue of Cézanne's works. Dates given in this book may
at times be inexact, or range over a span of several years, for reasons connected with the
complexity of the field.
I.F.W.

The publisher and author would like to thank the following museums and collections
for their support in providing photographs and picture material (with page number of
illustration):
Boston, Museum of Fine Arts: 74; Chicago, the Art Institute of Chicago: 66, 109, 136;
Hamburg, Elke Walford: 82; London, The National Gallery: 145, 163; Paris, Réunion des
Musées Nationaux: 10, 41, 48, 69, 78/79, 101, 102, 143, 147, 161, 164, 170, 178, 187, 193;
Weilheim, Artothek: 60/61, 124.

To stay informed about upcoming TASCHEN titles, please request our magazine at
www.taschen.com/magazine or write to TASCHEN America, 6671 Sunset Boulevard,
Suite 1508, Los Angeles, CA 90028, USA; contact-us@taschen.com; Fax: +1-323-463-
4442. We will be happy to send you a free copy of our magazine, which is filled with
information about all of our books.

© 2009 TASCHEN GmbH
Hohenzollernring 53, D–50672 Köln
www.taschen.com

Original edition: © 1989 Benedikt Taschen Verlag GmbH
Edited and produced by Ingo F. Walther, Alling
English translation: Michael Hulse, Cologne
Biographical and bibliographical material: Ingo F. Walther, Alling
Cover design: Sense/Net, Andy Disl & Birgit Eichwede, Cologne

Printed in China
ISBN 978-3-8365-1012-7

Contents

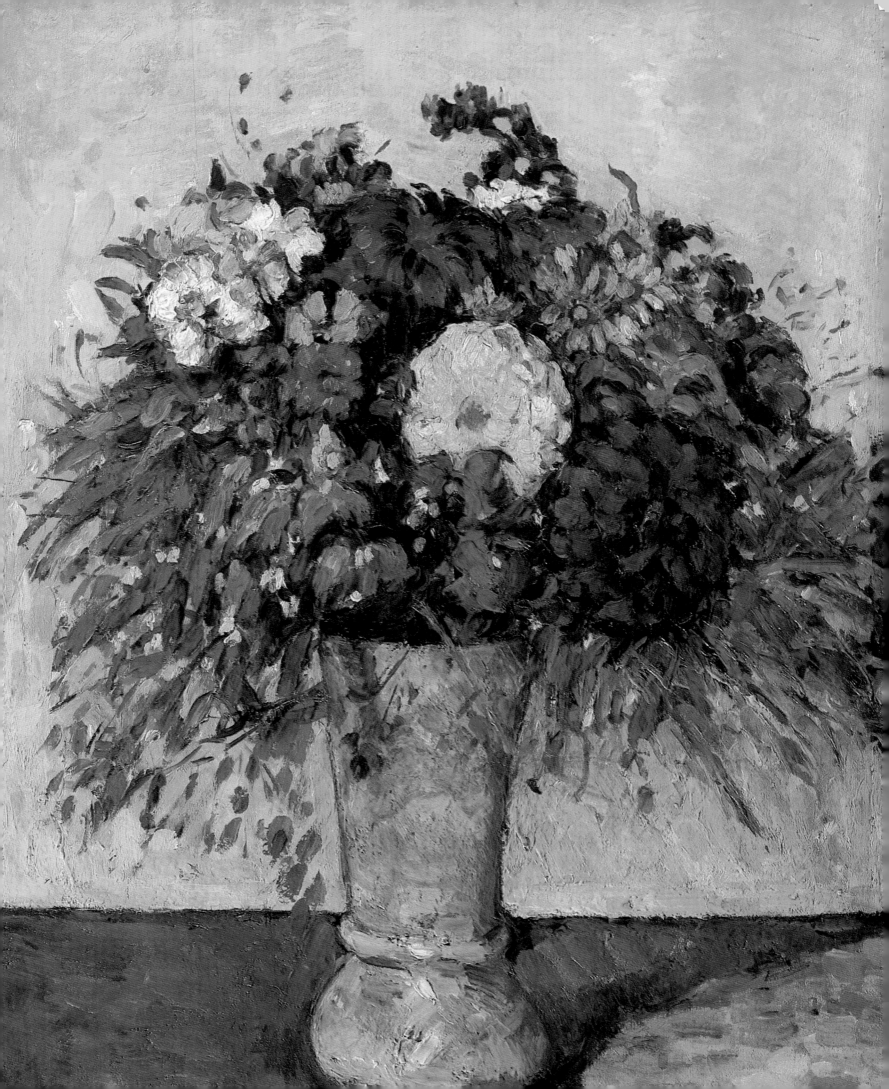

Foreword

There is no longer any question that Paul Cézanne was one of the great artists of our age. Since his death his fame has grown apace. The torn and controversial recluse from Aix-en-Provence has found his place in the history of art. When we now look at his work we may well sense little or nothing of the struggles and suffering that produced it; few artists have created an oeuvre so filled with peace and harmony. He painted still-lifes, landscapes, portraits, and a few large figural compositions, motifs which seem entirely usual components of the classical repertoire Cézanne was so attached to. The critics have been busy on Cézanne; countless studies have dwelt on particular aspects of his art; the art historians have diligently classified and pigeonholed. Yet we know little about the man himself. And an overall approach to the man and his times, his art and his traditions, all taken together, is conspicuous by its absence. The work of his early years has always been an obstacle, those dark and daunting pictures full of violence and unbridled longing. People have preferred Cézanne the great landscape artist, Cézanne the sensitive portrait painter, Cézanne the genius with colour. Of course that is Cézanne too; but the early works are equally a part of his life and the great art it produced.

Like Kurt Badt's 1956 study, which remains one of the best and most thorough works on Cézanne, the present book proposes to treat the man and the artist as one, and to take the earlier and later work together rather than in isolation. "What makes Cézanne's art unique," wrote Badt, "is that beneath an appearance of considerable objectivity he is presenting his own inner being, either from specific angles or in terms of his fundamental sensibility in his world, in his age." This sentence might have served as epigraph to this book, which aims to give as serious consideration to statements by Cézanne and his contemporaries, to the story of his life, and to his evolution as an artist, as to the vast numbers of outstanding pictures he painted. Cézanne was no solitary genius scattering pearls in the path of art historians, and rather than treat him in splendid isolation the present book will examine him in the context of his life and times. This involves his relations with Emile Zola and Camille Pissarro as much as his attitude to Impressionism or the new currents in art in the 1880s. It also involves his personal conflicts and problems: his continuing attempts to solve them

Man Bathing, 1879–1882
Pencil with watercolour, 21.5 x 15.3 cm
Wadsworth Atheneum, Hartford
(Conn.)

Light Blue Vase, 1873–1875
Bouquet de fleurs dans un vase bleu
Oil on canvas, 56 x 46 cm
Venturi 182
Hermitage, St. Petersburg

7

provided palpable motivation for his art, as we clearly see not only in the early but also in some of the late works.

The temperament that is so apparent in his early works, and which Cézanne toiled so hard to curb, was one of his great natural advantages and a source of his imaginative power. Cézanne made originality one of the key criteria in assessing artistic achievement. After Cézanne, originality became indispensable in the modern artist. But there was more to it than that. In the 1870s, Cézanne's approach underwent a fundamental change, albeit a change unaccompanied by any shift in his emotional energy. Artistic truth lay in the profundity of Nature. That truth was Cézanne's goal, and his pursuit of it distinguished him from the Impressionists and their records of visual perceptions. From now on he was out to paint what was lasting, permanent, indestructible. To that end he devised entirely new visual and compositional means and methods, and in his late period they culminated in his most beautiful works, works which are of vital importance in modern art.

Cézanne had a spiritual view of Nature as a cosmos in which all things were interrelated and removed beyond mere chance, a cosmos that embraced and nurtured all the phenomena of Life. In the course of this book we shall enquire to what extent his own wishes and dreams influenced that lofty artistic vision. We shall also examine that use of symbolism which marks off his method from that of the Impressionists and leaves him closer to the Symbolists. In Cézanne's time, a profound socio-cultural crisis was reflected in a vast variety of artistic approaches; and Cézanne's own diversity developed from the intersections of those approaches. Cool, objective scrutiny of available reality was replaced in his age by the quest for a more expressive style that would grasp what was essential and profound in the subject; the quest can be followed in various forms, such as the theories of the Neo-Impressionists, the mythical ideas of the Symbolists, and the pared-down arabesques of the Synthetists and the Nabis.

Cézanne lived and worked in Provence, yet remained fully involved with the processes of upheaval and regrouping which were characteristic of his time. His subjects were drawn from his home parts. The life in his work comes from his own emotional dynamism and his imagination. His technical approach developed out of his view of the styles available in his time. And all of it together added up to a symbolism of the real.

Cézanne's pictures attest longing for perfect beauty, for peace and harmony, for a happy and fulfilled life, for a paradise on earth — which was destined to remain a dearly-bought utopian vision, a beautiful dream. Cézanne's truth was unique and unrepeatable. Nevertheless, in the words of Henri Matisse, "there is something of all of us in Cézanne".

Cézanne's painting documents a remarkable case history in the perpetual tale of Man's relations with Nature, and the reconciliation

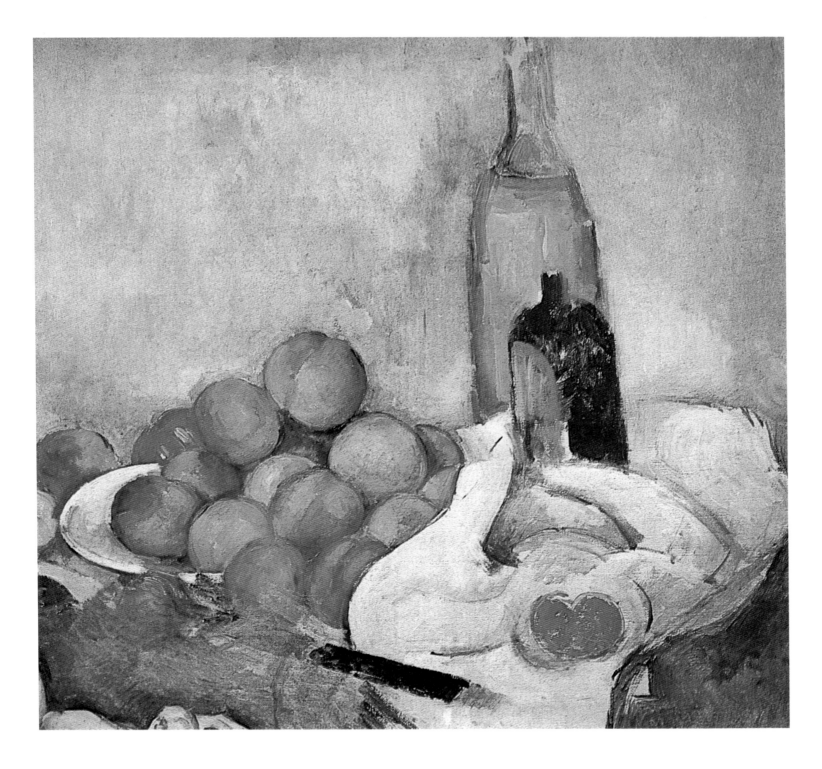

of those polarities that were at war within men in the artist's time and wrested an entire epoch out of true. The turmoil has remained. The problems are as great as they ever were. And perhaps it is for that reason that Cézanne's pictures have come to be seen as moments of tranquillity, moments in whose beauty we sidestep the inner struggles that went into their creation.

I am especially grateful to Benedikt Taschen Verlag and their general editor, Ingo F. Walther (who also supervised the lay-out of the book), for making it possible to present so broad a view of Cézanne in this monograph, with all his periods and important works represented in generous format.

Plate of Fruit and Bottles, 1890–1894
Nature morte: bouteilles et pommes
Oil on canvas, 50.5 x 52.5 cm
Venturi 604
Stedelijk Museum, Amsterdam

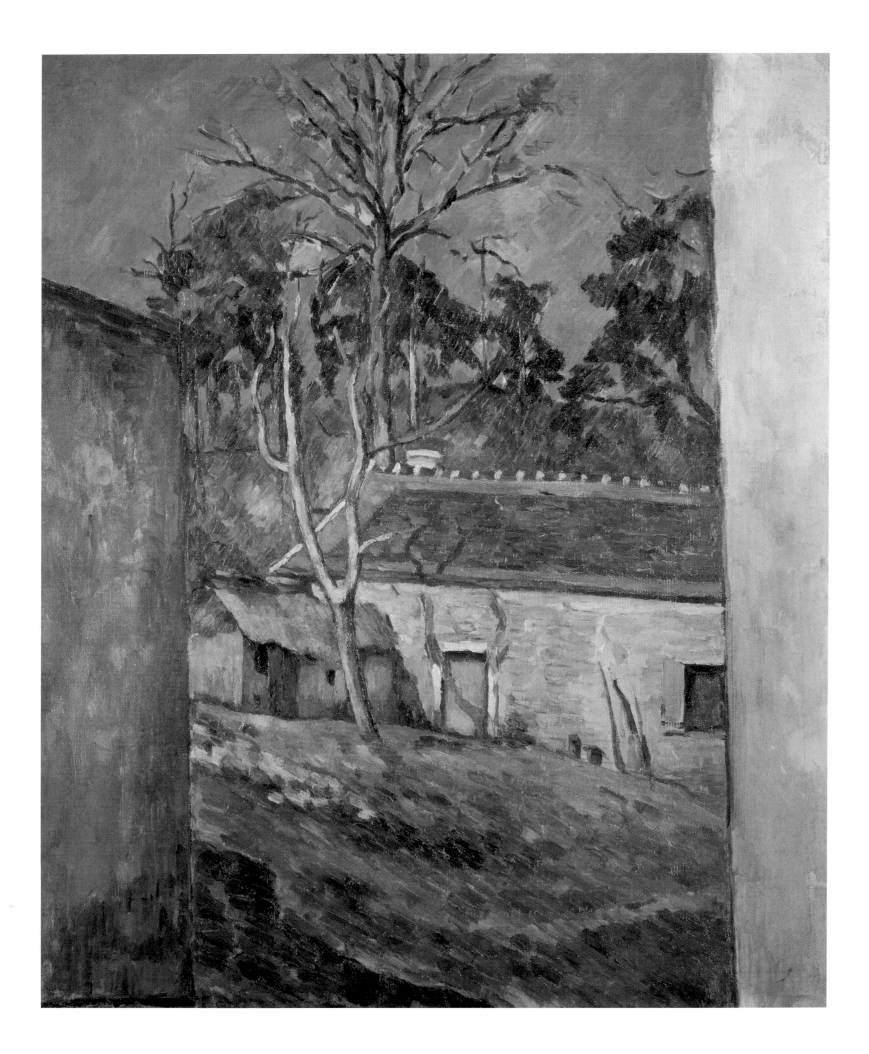

Cézanne and Provence

Paul Cézanne's art is linked in various and special ways to his home region, Provence, and with the places and formative experiences of his youth, which he spent near Aix-en-Provence. There can have been few other painters who have dealt so fully with the landscape and also the people of Provence. This fact appears all the more astounding if we bear in mind that in Cézanne's day the art world was entirely centred on Paris. True, Cézanne did spend eight years in the art capital, from 1862 to 1870, and subsequently returned for short visits; but he never felt at ease amongst the boulevard flaneurs or the artistic circles in the cafés, or in the demi-monde of the salons. He painted a few early works on city subjects, but all in all he preferred his familiar Provence, which afforded him the tranquillity and solitude he needed for his work and provided him with ample subjects to last him his whole life long.

Cézanne's landscapes draw upon a circumscribed repertoire of landscape elements: the hills and mountains of Provence, fields shimmering in the heat of the sun, pine forests windswept by the mistral, villages clinging to craggy slopes, and the rivers, lakes, and picturesque Mediterranean coast. Since early youth he had loved the hot, bare landscape of Provence, as he liked to stress in letters: "This region is full of undiscovered treasures. There has been no one to date who proved worthy (in his pictures) of the riches that lie slumbering here." (To Victor Choquet, 11 May 1886.) Nevertheless, Cézanne's numerous paintings, drawings and water-colours of Provence tell us little about the specific features of that landscape. The artist's attention was fixed on the unchanging fundamental structures of Nature; and so we learn nothing of the moods of different times of the day or year, of particular beauty spots, or of idyllic, atmospheric moments.

Human culture has left its mark on Provence since time immemorial. Throughout the region, evidence of prehistoric settlements and their religious cults can still be found. Then came the Roman imperial masters, making the profoundest impact of all. From townships and temple complexes such as Glanum we can infer the process by which the Roman way (and conception) of life was gradually but totally adopted in Provence. The Ostrogoths and Visigoths, the Franks and the Arabs, all invaded at some time;

"To paint a picture means making a composition... The aptest qualification for fine artistic conception is greatness of character." PAUL CEZANNE

Farmyard at Auvers, 1879/80
Cour d'une ferme à Auvers
Oil on canvas, 65 x 54 cm
Venturi 326
Musée d'Orsay, Paris

11

Provence remained a bone of contention throughout its chequered history, until in 1486 – following the rule of the Counts of Provence, particularly the last Anjou ruler, "good King René" – it became part of France For the next three centuries, the spartan region remained what its name etymologically implies: a province. The people of Provence viewed the state with rebellious disaffection, saw to the continuation of their own customs, language and literature – and welcomed the Revolution in 1789, believing that the new values it promised would provide them with the autonomy they wanted. Originally, the song that now serves France as a national anthem was sung by revolutionary troops as they left Marseille.

But that was several decades before Cézanne's time. Aix-en-Provence, once the capital of the region and the seat of the Counts of Provence, was a remote Rip van Winkle of a town, sleepy and provincial. The aristocracy had retreated to their town residences in the Cours Mirabeau, and now, divested of an active political role, observed middle-class life in Aix with a distrust that was all the greater. They were principally on the northern side of the Cours, and the south side, together with the adjoining blocks, was thought of as the *ville aristocratique*. In his 187 novel *La Fortune des Rougon*, veiling his description under the name Plassans, Emile Zola (who had gone to school in Aix) gave his account of the ancient seclusion of Aix behind its thick, fortified walls: "As if it were out to seal itself off in isolation, the town is girdled by an old wall that no longer serves any purpose but to make the town darker and more cramped." The walls in question were not demolished until 1880. And at the end of the 19th century, the writer Edmond Jaloux could still see Aix as "a town petrified in the sleep of ages, indifferent to everything".

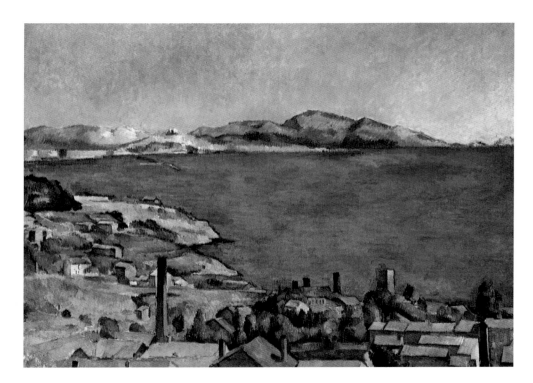

The Bay of Marseilles, seen from L'Estaque, ca. 1885
Le golfe de Marseille, vu de L'Estaque
Oil on canvas, 73 x 100.4 cm
Venturi 429
The Metropolitan Museum of Art, New York, Mrs. H. O. Havemeyer Foundation, The H. O. Havemeyer Collection

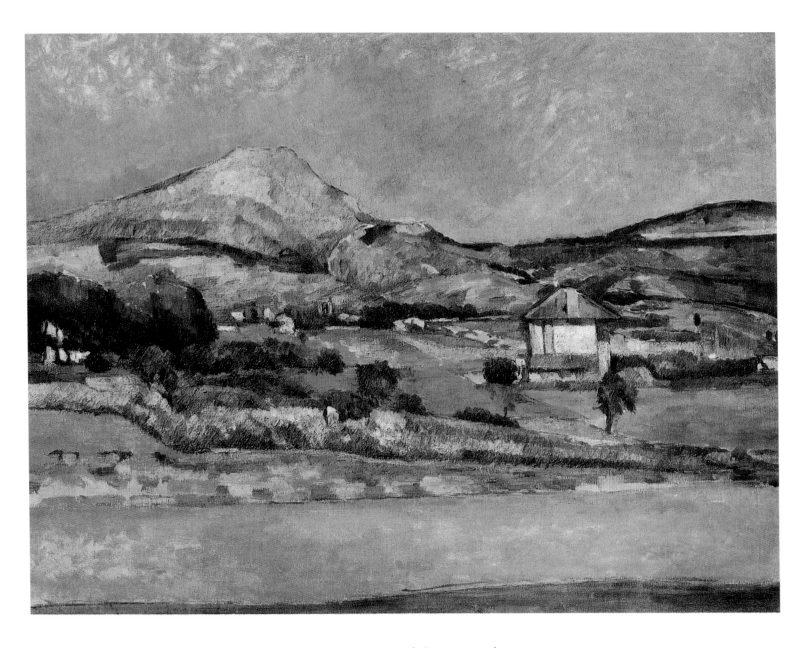

Aix's self-imposed isolation was exacerbated by failure to adapt to the industrial age. The late construction of railway lines illustrates this strikingly: the Aix-Rognac line was opened in 1846, the Aix-Pertuis line in 1868, and the Aix-Marseille line not until as late as 1877. The last of these spanned the Arc valley by means of a high viaduct which Cézanne occasionally included in his views of Mont Sainte-Victoire. Aix had a light textiles industry and dyeing works; several distilleries and food producers (among them a maker of delicious jams); and, outside the town, the Tholonet quarries, the Célony plaster works, and brickworks. The 19th century saw the addition of a new industry — manufacturing rabbit-fur hats.

One successful hatter was a man by the name of Louis Auguste Cézanne. His forefathers had immigrated from Italy; the family name had been taken from a village near Briançon when they moved there. The family had not yet produced anyone of outstanding calibre, but Louis-Auguste himself was a shrewd businessman

Upland with Houses and Trees,
1882–1885
Plateau de la montagne Sainte-Victoire
Oil on canvas, 58 x 72 cm
Venturi 423
Pushkin Museum, Moscow

and had done well. Together with two partners he had opened a domestic and export millinery – Martin, Coupin & Cézanne – in the heart of the Cours, in the Rue des Grands-Carmes. Soon Cézanne *père* was running the business on his own, and it was flourishing so nicely that he began looking for ways of expanding. After Aix's Bank Bargès collapsed in 1848, Louis-Auguste Cézanne and its head teller, Cabassol, joined forces, combining the hatter's capital and the banker's expertise to establish a new Banque Cézanne et Cabassol. The bank was a goldmine. Cézanne's success made him a rich, much-envied and philistine Croesus. And in 1859 he bought an 18th century estate, the Jas de Bouffan, which had once been the residence of the governor of Provence, and converted it for his own purposes.

It was into this middle-class milieu that Paul Cézanne was born on 19 January, 1839. His mother, Anne-Elisabeth Honorine Aubert, was a chair-maker's daughter. Her brother worked in Cézanne's millinery. Two years later, Marie – who was to play an important part in Paul's life – was born. It was not until 1844 that Cézanne *père* troubled to marry the mother of his children, thus legitimizing them. The couple had another daughter, Rose, in 1854; Paul was never to be especially close to his younger sister.

Old Cézanne was the undisputed head of his household. He was strict and authoritarian, would brook no contradiction, and thus gave his children an upbringing that was typical of the time. Little Paul preferred to go to his warm-hearted and imaginative mother if he was in need of the tenderness and security he did not find in his father. The father cared only for business and making money.

Young Paul would also turn to his sister Marie. Marie was the apple of her father's eye, and would defy her father on occasion or tease a smile from his grimly sealed lips. Paul admired her grasp, understanding and skill. Though it was up to him, as elder brother, to act the part of protector, it was often the other way round. As for Paul, he felt paralyzed in the presence of his father. He would retreat into isolated seclusion and make clumsy drawings and paintings, which his loving mother would praise; and she would defend her son's artistic efforts, supporting Paul when his father grew more and more worried, and arguing: "What do you expect? His name is Paul – like Veronese or Rubens!"

In 1849, Paul started at the Jesuit Ecole de Saint-Joseph as a day pupil. The school did not inspire confidence, and Paul's years there (until 1852) were marked by stoical patience. Only the Collège Bourbon, a boarding school where the children of the wealthy, upper ranks of Aix society went, was right for a banker's son, though; and at the age of thirteen Paul moved there. He was given a thorough classical education, and proved particularly good at the natural sciences, Greek and Latin. For a few sous he would translate Latin verse in his spare time. He enjoyed reading Horace and Vergil, a taste he retained until old age. But what mattered more to

Louis-Auguste Cézanne, the Artist's Father, Reading "L'Evénement", 1866
Louis-Auguste Cézanne, père de l'artiste, lisant «L'Evénement»
Oil on canvas, 200 x 120 cm
Venturi 91
National Gallery of Art, Washington, D. C.

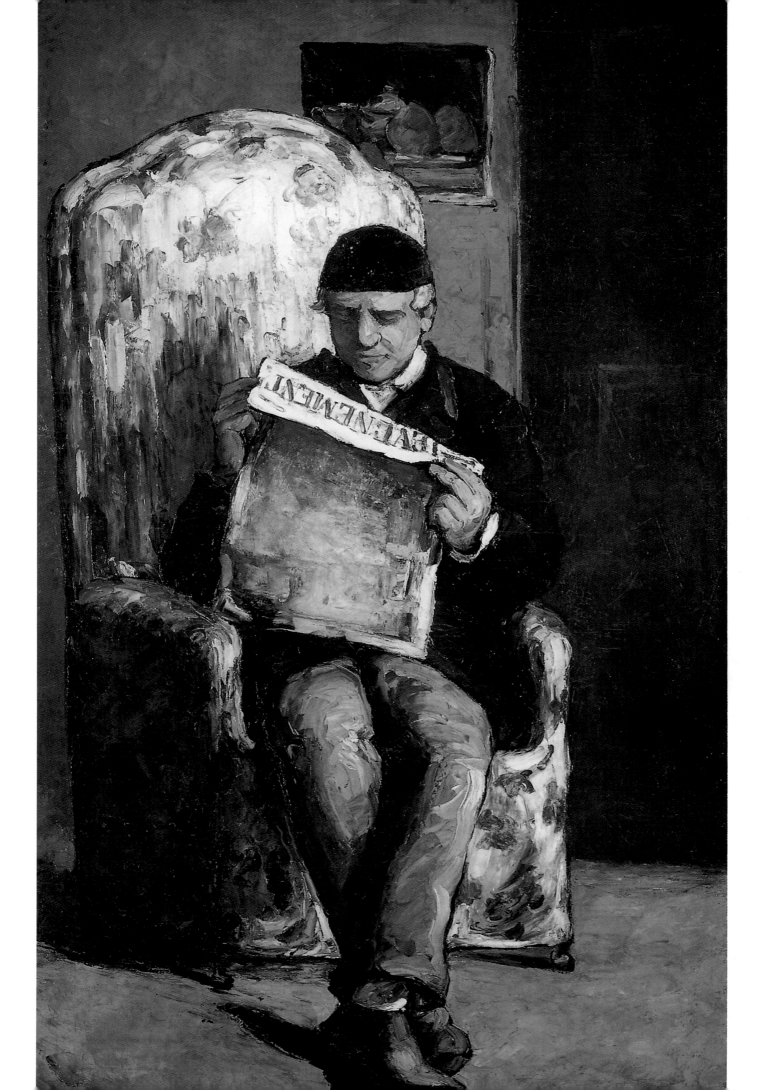

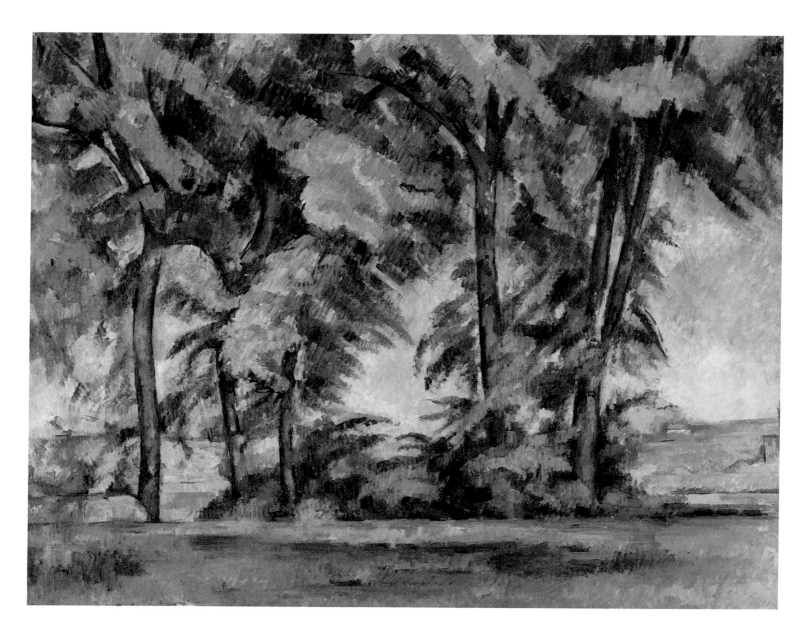

Big Trees at Jas de Bouffan,
1885–1887
Grands arbres au Jas de Bouffan
Oil on canvas, 64.7 x 79.5 cm
Venturi 475
Courtauld Institute Galleries, London

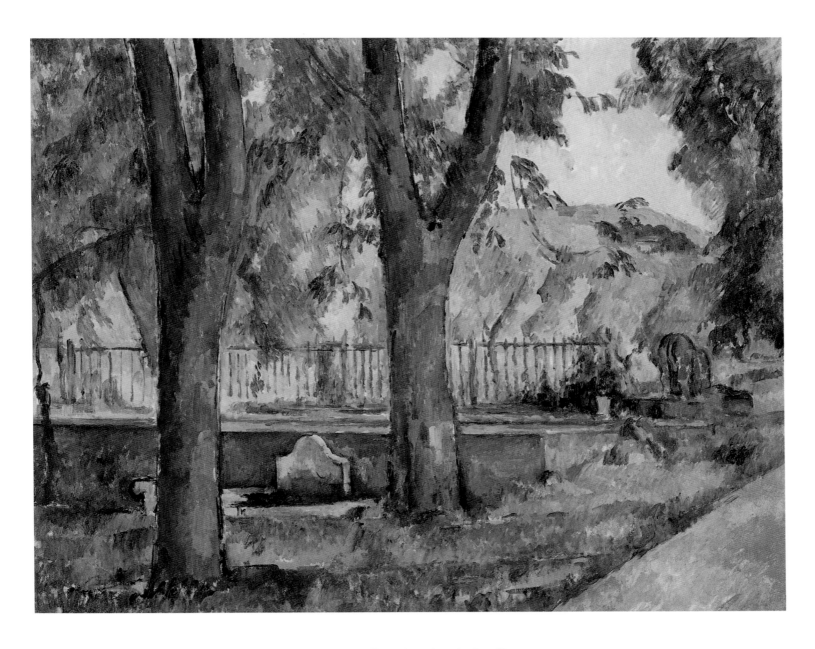

Pool and Trough at Jas de Bouffan,
1880–1890
Bassin et lavoir du Jas de Bouffan
Oil on canvas, 64.8 x 80.9 cm
Venturi 648
The Metropolitan Museum of Art, New
York
Bequest of Stephen C. Clark

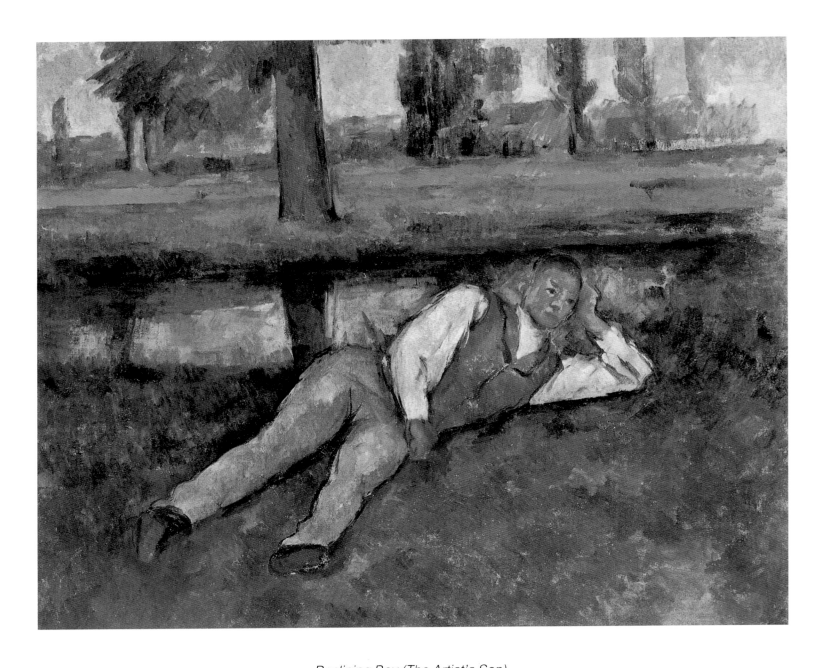

Reclining Boy (The Artist's Son),
1882–1887
Garçon couché (Le fils du peintre)
Oil on canvas, 54.4 x 65.5 cm
Venturi 391
Armand Hammer Collection, Los
Angeles

young Paul than his studies was his friendship with a weakly boy from Paris called Emile Zola. Emile's father had come to Aix to build a dam for a reservoir but had died during the construction work, and now the boy was living in a poor part of town with his mother and grandmother, forever in need of money, the butt of his fellow-pupils' mockery. Cézanne took young Zola's part against the Aix boys. They were joined by Baptistin Baille, thus making the "inseparable trio". For Paul, it was the beginning of the most beautiful time of his life, a period of harmony, friendship and happiness, of shared interests in art and literature, of ambitious artistic plans for the future. Walking near Aix, on visits to Mont Sainte-Victoire, or on the banks of the Torse and Arc, the three youths would talk about everything that was in their hearts and minds. They would recite poems they had written, and read out favourites by Victor Hugo or Alfred de Musset. Cézanne was especially fond of Baudelaire's *Les Fleurs du mal*, and in later years could still quote it from memory. They also discussed art, and took Stendhal's *Italian Art* as their text. But Cézanne was more attracted by the poets, and – dissatisfied by his occasional attempts to paint, in the attic of Baille's home – saw himself becoming one himself. It was certainly true that he had no great talent for drawing. Only once (in 1854) did he receive a prize for drawing – doubtless because he had been taking extra tuition from Joseph Gibert at the Municipal Art School.

In 1858 Zola moved to Paris, which put an end to the boys' nature rambles and happy hours of shared enthusiasms. Court cases had drained Zola's mother's financial resources, and in the end she had no alternative but to leave Aix, in the hope of finding life in Paris cheaper. Zola had high hopes of the change; but he left a depressed Cézanne behind, a Cézanne who wrote sorrowful, self-pitying letters to the lost friend of his youth: "My dear friend, ever since you left Aix I have been a prey to heavy-hearted grief; I swear to God this is no lie. I hardly know myself. I am ponderous, stupid and slow." (To Zola, 9 April 1858.)

Cézanne's letters included drawings, poems, Latin verses, and puzzles. Zola was taken with his friend's poetic efforts and encouraged him: "That is exactly it, my dear fellow. You have a writer in you, just as I have. My verses are probably purer than yours, but yours are definitely more poetic and true. You write with your heart. I write with my head." (Zola to Cézanne, 1 August 1860.)

Cézanne, however, was indifferent to Zola's advice. He lacked the will to be a poet or writer. He wrote purely for pleasure, to please Zola, and to have an outlet for his irony. One poem of a more serious nature, 'Hercules at the Parting of the Ways', prompted Zola to speculate on Cézanne's innate artistic nature. But Cézanne himself was irresolute, and drifted; and in any case he was in love, though it was a love that remained unfulfilled. In order to maintain contact with art, he resumed studies at the Aix Art School. In 1858 he spent the summer holidays with Zola, but remained as unde-

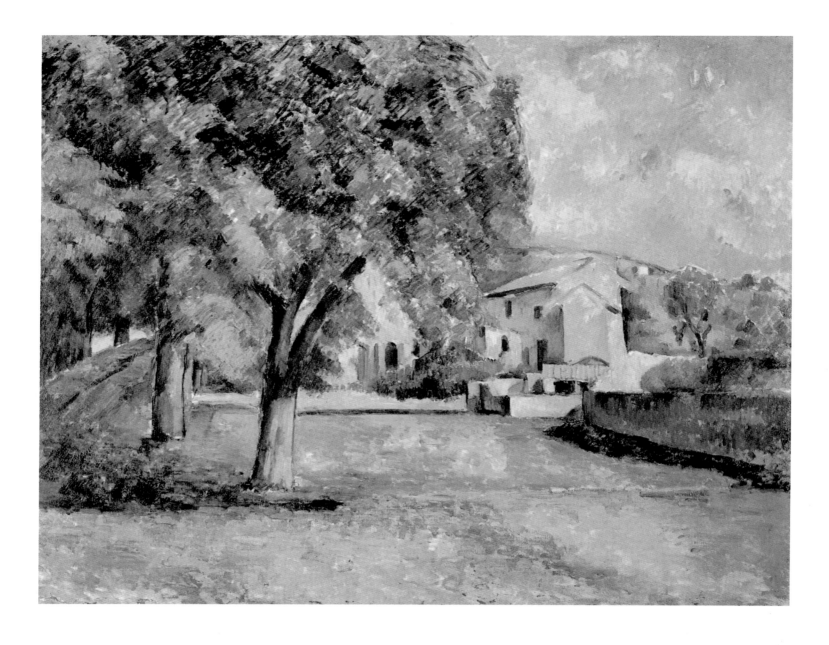

*Chestnut Trees and Farm
at Jas de Bouffan,* 1885–1887
Marroniers et ferme du Jas de Bouffan
Oil on canvas, 72 x 91 cm
Venturi 462
Pushkin Museum, Moscow

cided as before. And so, after passing his school-leaving exams, he bowed to his father's wishes and took up law studies at Aix University. These studies too left him dissatisfied, particularly since he was supposed to be joining his father's bank after his finals, a grim prospect. At least his father did not object to his continuing to attend Gibert's drawing classes in the evenings, and there he saw old schoolfriends once again: Philippe Solari (who wanted to be a sculptor), Numa Coste and Achille Emperaire, whom Cézanne and Zola declared to have great artistic gifts. Life classes were held from six till eight in the morning in the summer, and in winter from seven till nine, on Mondays, Tuesdays and Fridays. Gibert's students were also expected to paint portraits in oil, draw friezes and ornaments, and make copies of lithographs in the Aix museum, faithful to the very last detail. None of this academic programme succeeded in scaring Cézanne off.

The Art School was housed in the Musée Granet, the Fine Art Museum in Aix, where Cézanne could admire second-rate works

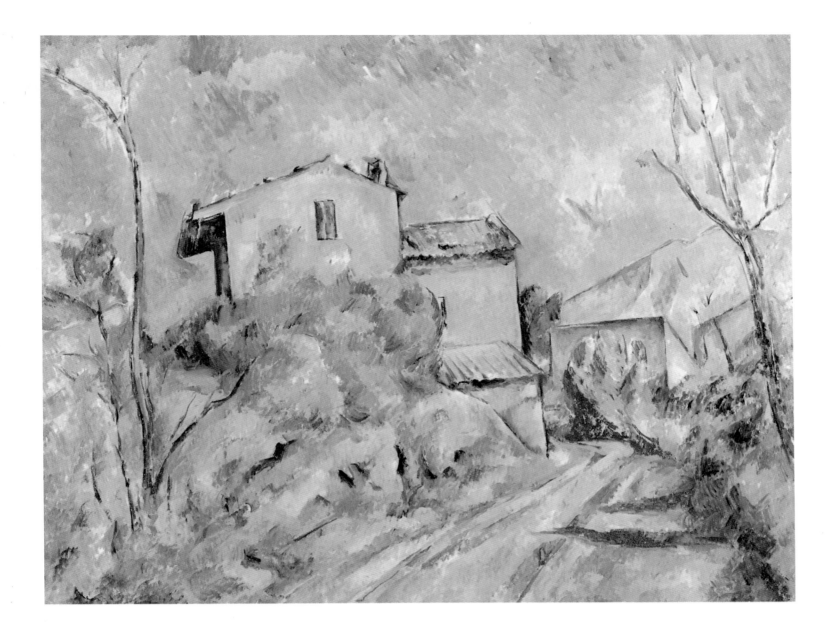

of art. The museum held pictures by the *tenebrosi* – lesser French and Italian masters – but was notable for the collection of works by François-Marius Granet (1775-1849), a friend of Ingres who had painted Italian motifs using relaxed brush-strokes and a bright palette. Cézanne was particularly interested in Granet's oils and water-colours showing Mont Sainte-Victoire done in the style of the English landscape artists. Of the other works in the museum, Cézanne was especially taken with *Jupiter and Thetis* by Ingres, which he rejected on stylistic grounds but nevertheless found charismatically fascinating. The works he chose to copy, though, were two mediocre pieces: *The Prisoner of Chillon* by Edouard-Louis Dubufe, and *The Kiss of the Muse* by Félix-Nicolas Frillié. The latter appealed to Cézanne's mother so immensely that till the day she died she had it hanging in the room where she spent most of her time, and she would also take it with her whenever she travelled, no doubt as a kind of devotional picture to bear all her love and hopes for her son.

Maison Maria on the Road to Château Noir, ca. 1895
Maison Maria, sur la route du Château Noir
Oil on canvas, 65 x 81 cm
Venturi 761
Kimbell Art Museum, Fort Worth

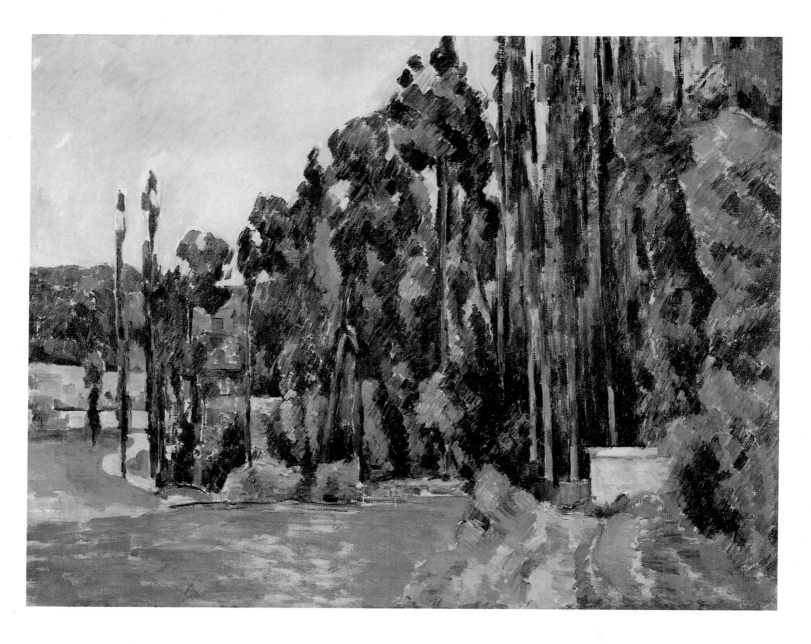

Poplars, 1879–1882
Les peupliers
Oil on canvas, 65 x 81 cm
Venturi 335
Musée d'Orsay, Paris

In 1859 Zola was again in Aix, recovering from the exertions of his school-leaving exams, and encouraged Cézanne to be a painter. Still Cézanne was hesitant. His father's disapproval, and his ties to his parental home and the familiar and dearly-loved Provence, seemed an insuperable obstacle. Zola implored him to take a decision at last and match his artistic inclinations with dedicated work: "My dear fellow, what it takes is a little effort, a little persistence. The devil take it, where is our courage? After every night there must be a dawn; so let us try to get through the night as well as possible, so that when day breaks you can say: 'Father, I slept well, I feel strong and ready to start. Take pity, do not lock me up in an office! Let me out, otherwise I shall suffocate – be gracious, Father!'" (Zola to Cézanne, 5 May 1860.)

Zola knew what he was talking about. After failing his school-leaving exams a second time, he plunged into the deep end, surviving on a pittance earned by writing, dreaming of fame. At any rate, whatever differences there were between the two friends were forgotten once they were out in Nature again. They went on rambles to the dam, and to Les Infernets, a gorge in an untamed setting of parched hills and fissured earth, where plants and bushes grew and footpaths led. They climbed to Château Noir, an abandoned mansion where at one time an alchemist reputedly dabbled in his wicked arts, and then continued to the Bibémus quarry, which had been supplying the orange stone used for houses in Aix since the time of the Romans. From there the two friends had a magnificent view across the red soil of vineyards, the meadows along the banks of the Arc, the dam, and then the Sainte-Baume and Etoile hills and right in front of them the mountain of light, Mont Sainte-Victoire. And once again they tackled its slopes, up to the Pilon du Roi near the mountain village of Gardanne. Cézanne painted the two friends as *The Robbers* – a picture which would have afforded us a fine impression of those formative experiences as well as a first self-portrait, but which is unfortunately lost.

Paul Cézanne soon had the chance to test his skills as a painter. In 1859 his father bought Jas de Bouffan, a fine old estate near Aix; and in 1860 Paul was permitted to paint an *Allegory of the Four Seasons* (Musée du Petit Palais, Paris) on the four wall panels (previously covered by tapestries) in the salon. Casting modesty to the winds, he signed himself "Ingres" and dated the painting "1811". The work is remarkably stiff, and borrowed from classical models. Later a portrait of Cézanne's father (p. 15) was hung there too. The portrait shows Cézanne *père* reading a newspaper; and it is difficult to say whether the artist was bowing to the authority of his father or making a gesture of defiance.

Things grew more troubled than ever between father and son. Cézanne was a listless student, and pestered his father for permission to go to Paris, where Zola and a life as a painter awaited him.

But his father was unbending. "My child," he told his twenty-year-old son, "think of your future! Genius keeps no man alive. But money does." The tense situation Cézanne then found himself in, torn between his father's demands and Zola's importuning, was expressed in poems stylistically reminiscent of Baudelaire. In one of them, *A Terrible Story*, the artist is in the depths of a pitch-black forest at midnight, in the embraces of a dead woman, pursued by Satan. In another, which was accompanied by a sketch drawing, a family is seated at table, eating the skull of "the inhuman mortal who kept us in want so long". Badt interprets the father as Cézanne himself, the children as the pictures he was yet to paint, and the "inhuman mortal" as Louis-Auguste Cézanne, the tyrant who forced Cézanne to continue with his uncongenial studies and from whom the young man could expect nothing but to inherit the wealth his father's business sense had amassed. The day would come when the painter (to be) would be able to assure the existence of his children (paintings) by means of the money (sense) of his father; but at present the youth was still humiliatingly dependent on his father.

Cézanne's departure was put off time after time. First his sister Rose was ill. Then Cézanne *père* consulted Gibert, who was of the opinion that Cézanne could study art just as well in Aix. Cézanne became increasingly apathetic, neglected his studies, and tried to put up with things as they stood. When he was not drawing chez Gibert he was painting out in the open or at Jas de Bouffan, where he was allowed to set up a studio in one of the rooms. His self-confidence was suffering, and he was subject to doubts concerning his artistic abilities. He passed through alternating periods of wild enthusiasm and deep dejection. "I have been suckled on illusions," he observed, assessing his situation accurately.

Zola tried to help his friend out of his emotional doldrums, and even drew up a precise work schedule for Cézanne's Paris studies. Receiving no reply for some time, Zola adopted a peremptory tone: "Is painting no more to you than a mood that seized hold of you one day when you were bored? Is it just a pastime, something to talk about, or a pretext for neglecting your law studies? If that really is the case, I understand your attitude: you are right not to put things to the test or go too far in your collisions with your family. On the other hand, if (as I have always believed) you have a calling to be a painter, and if you think yourself capable of producing something worthwhile once you have done some hard work at it, then you are an enigma to me, a sphinx, quite indescribably impossible and obscure." (Zola to Cézanne, July 1860.)

Zola's anger shook Cézanne. He became more restive than ever; and at last his father yielded. He gave Paul his consent to go to Paris – initially with his father and Marie, who were to help the stubborn young painter find suitable accommodation. And so, in April 1861, Cézanne travelled to Paris for the first time.

The Smoker, ca. 1895
Le fumeur
Oil on canvas, 91 x 72 cm
Venturi 686
Hermitage, St. Petersburg

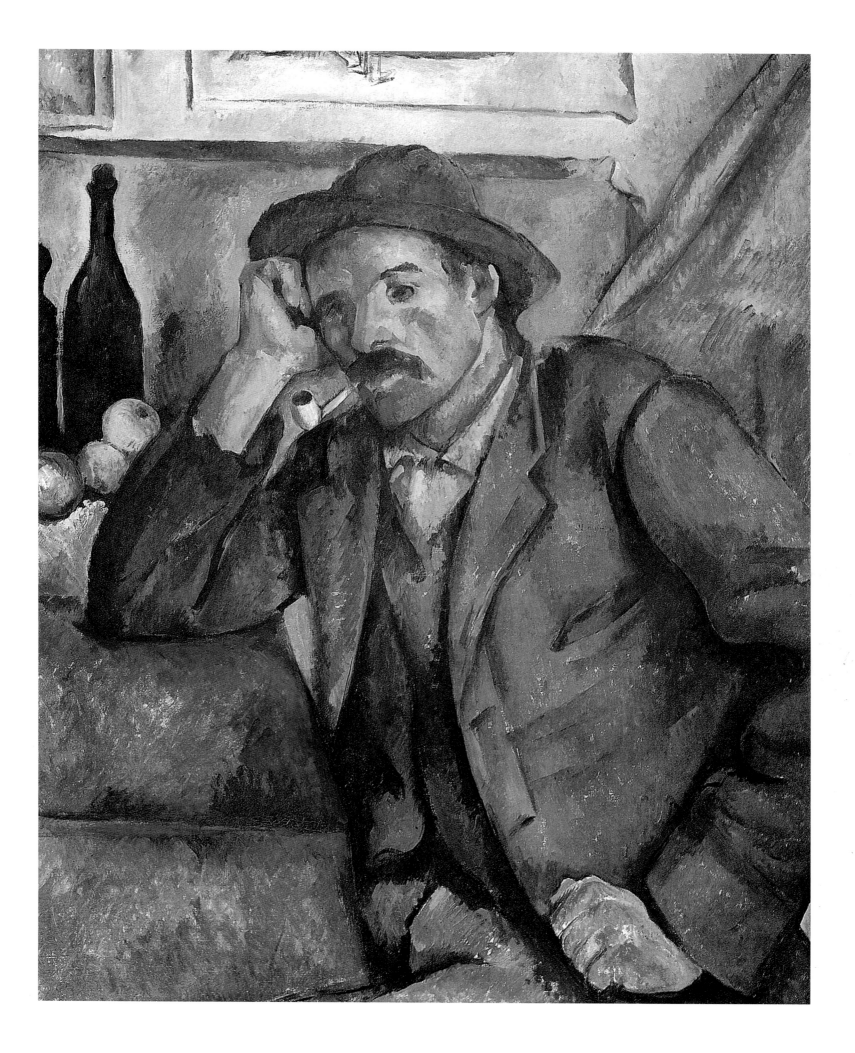

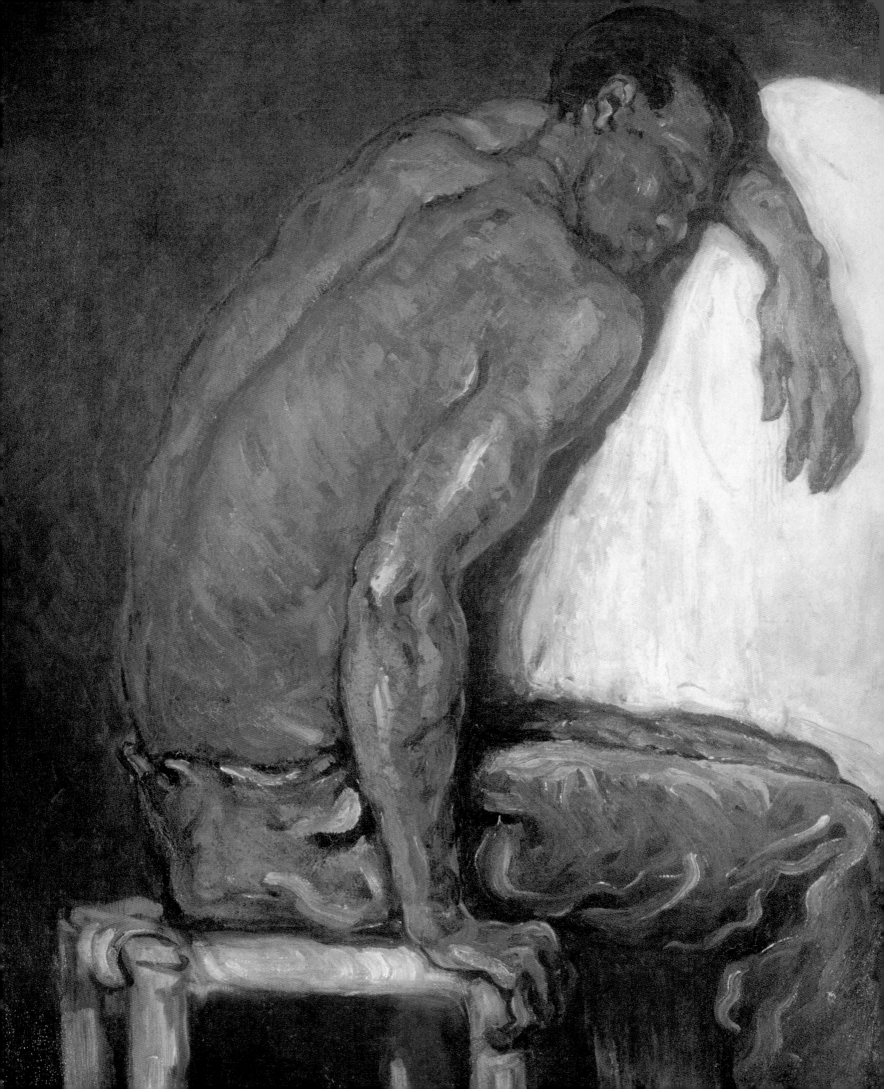

The Struggle of Love:
Cézanne's Early Work

At last Cézanne was in Paris! He rented rooms in the Rue des Feuillantines, near the Pantheon quarter where Zola lived. He had an allowance of 125 francs a month – and high hopes of Paris, the pulsing life of the city where all the important artists met, the changes and inspiration it would afford. But in the event the move from provincial life with his familiar friends and family to the vast anonymity of the city left Cézanne floundering. The Paris of Georges-Eugène Haussmann and Jacques Offenbach was alien to him, and so it remained.

Zola knew what Baron Haussmann's building projects meant from his own experience. He was living in a run-down pension frequented by prostitutes and thieves and regularly raided by the police. Beside it was one of the countless building sites that scarred Paris during the reconstruction period: entire quarters where cholera had raged in 1832 were being demolished, and the mature charm of old Paris was being destroyed by the pickaxe. Where once there had been narrow lanes and twisted alleys, intimate and picturesque, the great boulevards were now being laid out, offering vast and straight perspectives (and easier policing). *Le Boulevard*, the heart of Paris, from the Rue Faubourg Montmartre to the Opera House, attracted houses of finance, luxury shops and elegant cafés, and became the focus of the Parisian life of pleasure. The Second Empire's glittering demi-monde could see and be seen along the new boulevards. The world of luxury was increasingly concentrated in the glassed-over passages between two streets which were being built from 1852 onwards, and the shadowy hedonism of the era could be found there in its purest form: "Creations of glass and cast-iron gilded with bronze, with their dainty candelabra of frosted glass and their half-lit galleries, they afforded refuges to lovers and to those who traded in love. And often they sold the accessories of the trade: there were little chemist's shops selling rubber goods for the most intimate of purposes, booksellers specializing in erotica and shops selling 'artistic' nude photos, seedy little theatres and dismal cafés for a clientèle who wanted to remain undisturbed for one reason or another." (From Siegfried Kracauer: *Jacques Offenbach und das Paris seiner Zeit*, 1976.)

Paris was the grand new cosmopolitan metropolis, the new

"Courage, then, once again! Take up your brush once more and give your imagination free rein. I believe in you."
EMILE ZOLA

The Negro Scipio, ca. 1867
Le nègre Scipion
Oil on canvas, 107 x 83 cm
Venturi 100
Museu de Arte, São Paulo

Male Nude, 1863–1866
Charcoal, 50.2 x 30 cm
Private collection

Interior with Two Ladies and a Girl,
1860–1862
Scène d'intérieur
Oil on canvas, 91 x 72 cm
Venturi 24
Pushkin Museum, Moscow

Babylon, the city of *savoir vivre*, the setting of Offenbach's operettas, in which *la vie Parisienne* was celebrated as one long neverending festival. The Paris of that time was Europe's boulevard, Europe's broker – and Europe's brothel. The new boulevards were bright with the light of gas-lamps. The cafés, clubs and boulevard theatres glittered with exotic magic. In the passages and stores, reality seemed as mysteriously multi-facetted as in Ali Baba's cave. Paris danced to the tune of gold, fast money, speculation, and spendthrift consumer lavishness. The city was a man-made paradise, a glorious scenario where men and women of the world could enjoy playing the parts of flaneur and dandy, banker and speculator, coquette and cocotte.

Confronted with this flashy display of flaunted glitz, Cézanne was out of his depth. His manner and accent seemed gauche and uncouth, even to fellow-artists at the Académie Suisse. The Académie Suisse was on the second floor of an old building on the Ile de la Cité, at the corner of the Boulevard du Palais and the Quai des Orfèvres. Père Suisse, formerly a model for life classes, had founded the academy to give young art students the opportunity to draw models. For 10 francs a month, they had three weeks of drawing a male model and a fourth drawing a female. A number of famous artists had climbed those narrow stairs at one time or another, among them Eugène Delacroix, Gustave Courbet and Richard Parkes Bonington. What Père Suisse offered was not instruction by some pedantic professor forever splitting academic hairs and digging an early grave for dreams of artistic achievement, but instead the bracing atmosphere of youthful, bohemian contention amongst many and various kinds of would-be artists, none of them with a good word to say for the École des Beaux-Arts or the Salon artists, all of them anxious for recognition by the very Establishment they affected to despise. And indeed, a picture by Edouard Manet – *The Spanish Singer*, 1860 (Metropolitan Museum of Art, New York) – had just been accepted for the Salon (and was even praised by Théophile Gautier). Manet had attended sessions at the Académie Suisse and was highly thought of by the young artists there.

At the academy Cézanne also met Claude Monet, Pierre Auguste Renoir and Camille Pissarro. Pissarro, a kindhearted elderly man who had been living in Paris since 1855, took Cézanne's part against the taunts of the other youths. Cézanne was a tempestuous, short-tempered man, whose thin-skinned irascibility earned him the nickname *L'écorché* (The Man Without Skin) after the plaster models the academy used for the study of human muscles. Cézanne bought one of these "flayed" figures himself, and included it in a still-life (p. 196) in memory of those hours of torment at the Académie Suisse, or perhaps simply as an expression of general discontent. He struck up an instant friendship with only one of his fellow-students, the cripple Achille Emperaire (cf. p. 48),

28

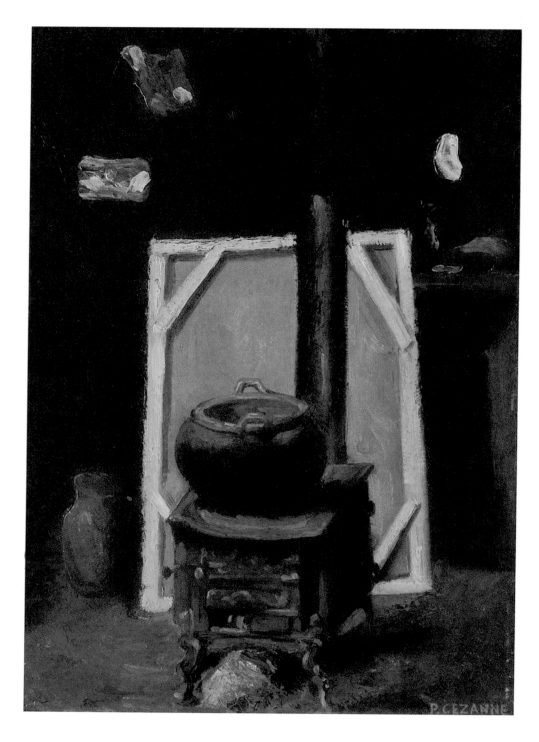

The Stove in the Studio, 1865–1868
Le poêle dans l'atelier
Oil on canvas, 42 x 30 cm
Venturi 64
Private collection, London

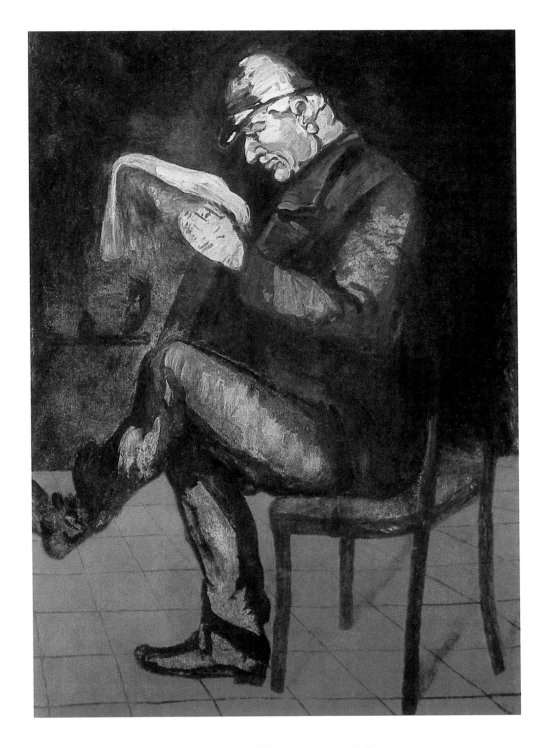

*Louis-Auguste Cézanne, the Artist's
Father*, ca. 1862
Portrait de Louis-Auguste Cézanne,
père de l'artiste
Oil on canvas (with plaster grounding),
168 x 114 cm
Venturi 25
The National Gallery, London

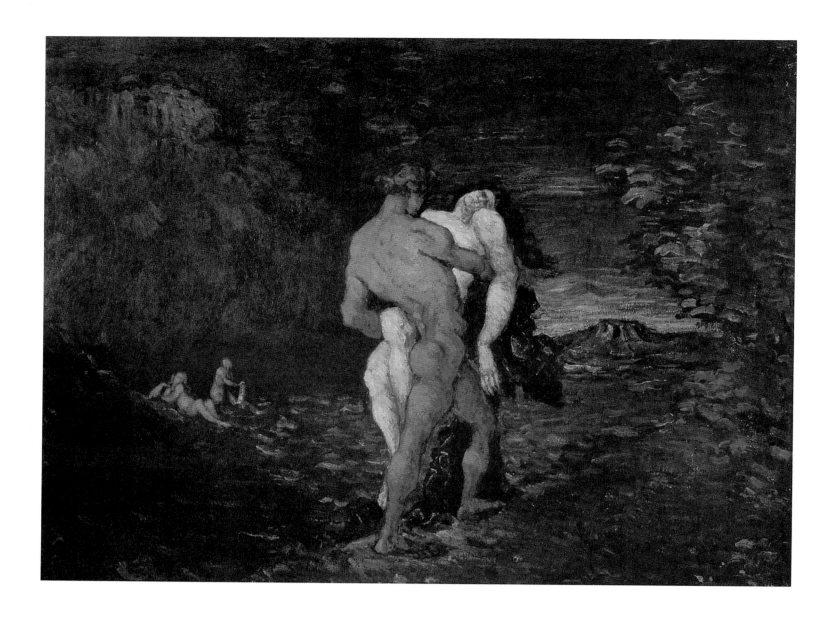

The Abduction, ca. 1867
L'enlèvement
Oil on canvas, 90.5 x 117 cm
Venturi 101
Fitzwilliam Museum, Cambridge

who had already been with him at Gibert's Art School in Aix. Like Cézanne, Emperaire was an outsider, an unhappy man spurred on by an urge to create immortal masterpieces. Unceasingly he tried to compensate in his paintings for what he had been denied by Nature: physical beauty.

Cézanne was unsettled by the emphatic femininity of Emperaire's pictures, which were reminiscent of ancient fertility idols. He himself was inhibited by the female models; he would produce colour studies and sketches and do the rest in the quiet of his studio, for preference. Cézanne was insuperably shy when confronted with women, and this, together with his general reticence towards others, made him seem distant. The restlessness and bewilderment in him were expressed in letters he wrote at the time: "I had expected that the boredom that was overwhelming me would relax its grip once I left Aix. But in fact I have merely changed my domicile, and the boredom has moved with me. I have left my parents, my friends and my routines behind, but that is all. And yet I am out and about almost all day long. I have seen (I know this

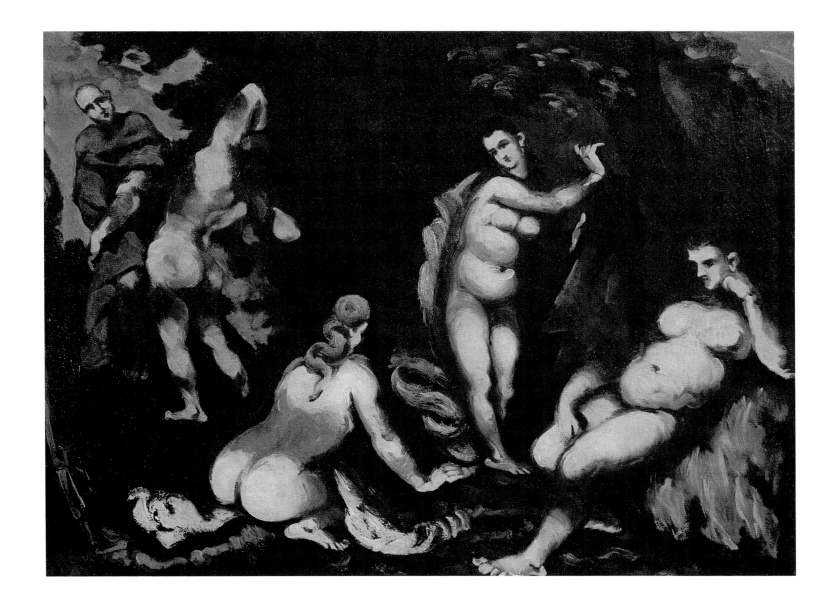

sounds naïve) the Louvre, the Luxembourg and Versailles. Of course you are aware what tedious stuff is in those wonderful buildings. It is staggering, extraordinary, overpowering [...] Just don't go imagining that I shall become a Parisian..." (To Joseph Huot, 4 June 1861.)

Zola too noticed the emotional turmoil and apathy that had seized hold of Cézanne and were preventing him from working: "I rarely see Cézanne [...] In the mornings he goes to the Atelier Suisse while I stay at home writing. He spends the rest of the day drawing chez Villevielle. Then he has his dinner and goes to bed early, and I do not see him. Was that what I was hoping for? Paul is still the fine, strange youth I knew in our schooldays. To prove he has lost none of his eccentricity, I need only tell you that the moment he arrived here he was talking of returning to Aix. He fought for three years to come here, and now he doesn't give a fig for it all. I must confess that when I am confronted with a character such as his, by changes in behaviour so irrational, I keep my mouth shut and pack away my logic. Trying to persuade Cézanne of

The Temptation of St. Anthony,
ca. 1870
La tentation de Saint Antoine
Oil on canvas, 54 x 73 cm
Venturi 103
E. G. Bührle Foundation, Zurich

something is like trying to get the towers of Notre-Dame to dance a quadrille." (Zola to Baptistin Baille, 10 June 1861.)

As Zola and Cézanne saw less of each other, the friendship cooled palpably. Zola was disappointed by Cézanne's growing lack of courage; he himself, after all, had to contend against far greater difficulties. He had given up his job in order to concentrate on his writing; he was scraping by on the proceeds of poorly-paid proof-reading work he did for an economist; and his health had deteriorated. And now Cézanne's mulishness on top of it all! Zola tried in vain to set Cézanne to work. Cézanne simply dodged his friend's reproaches, and repeatedly changed his lodging – only to return to Zola out of the blue. He began a portrait of the writer, but left it unfinished. Disappointed in him, Zola inclined increasingly to turn away from him: "Paul may have the genius of a great painter," he wrote, "but he will never have the genius needed to *become* one. The slightest obstacle throws him into despair. So I repeat that he must leave if he wants to spare himself a great deal of misery." (Zola to Baille, 1861.)

However, Cézanne's wretchedness only began *after* his head-long departure from Paris. Unable to make his own decision, he was persuaded by his father to take a job as a clerk in the bank. Cézanne did not stay long. He resumed painting, fitted out a spacious studio at Jas de Bouffan, and thought of his time in Paris. Defiantly he wrote in the bank ledger: "Alarmed and dismayed, old Banker Cézanne / Finds his place taken by a painter man." Old Banker Cézanne discharged his obstinate son once and for all from his banking duties; but he required him to study art seriously at the École des Beaux-Arts, and to show that he had been doing so conscientiously.

So Cézanne returned to Paris, determined to mend his ways. Influenced by Zola's mania for work (the author was writing his first novel – *La Confession de Claude*, 1865), he took rooms in the Rue de l'Est, a quiet street by the Parc du Luxembourg's tree nursery, and went regularly to the Académie Suisse. The new Realism was spreading, and its theories were discussed at the academy, as well as Courbet and Corot, and the art of Manet, who was just making a stir at the Salon. Every would-be artist wanted to storm the Salon, and Cézanne was no exception. True, he had failed the École des Beaux-Arts entrance exam; but he was undeterred. The real target was Adolphe William Bouguereau's Salon. That was the eye of the needle through which any artist who wanted official recognition, major commissions, and his laurels had to pass. What the annual Salon wanted, though, was anodyne pictures with titles like *Robbing the Nest*, *The First Embrace* or *A Christening Present of Bonbons*, or alternatively immense historical scenes accompanied by long and complicated glosses. It was the narrative content that counted, be it of a historical or anecdotal nature. Attempts at natural or realistic presentation met with severe criticism.

*Man in a Cotton Cap
(L'Oncle Dominique),* 1865
L'homme au bonnet de coton
(L'oncle Dominique)
Oil on canvas, 79.7 x 64.1 cm
Venturi 73
The Museum of Modern Art, New York,
on loan from the Metropolitan Museum
of Art, New York

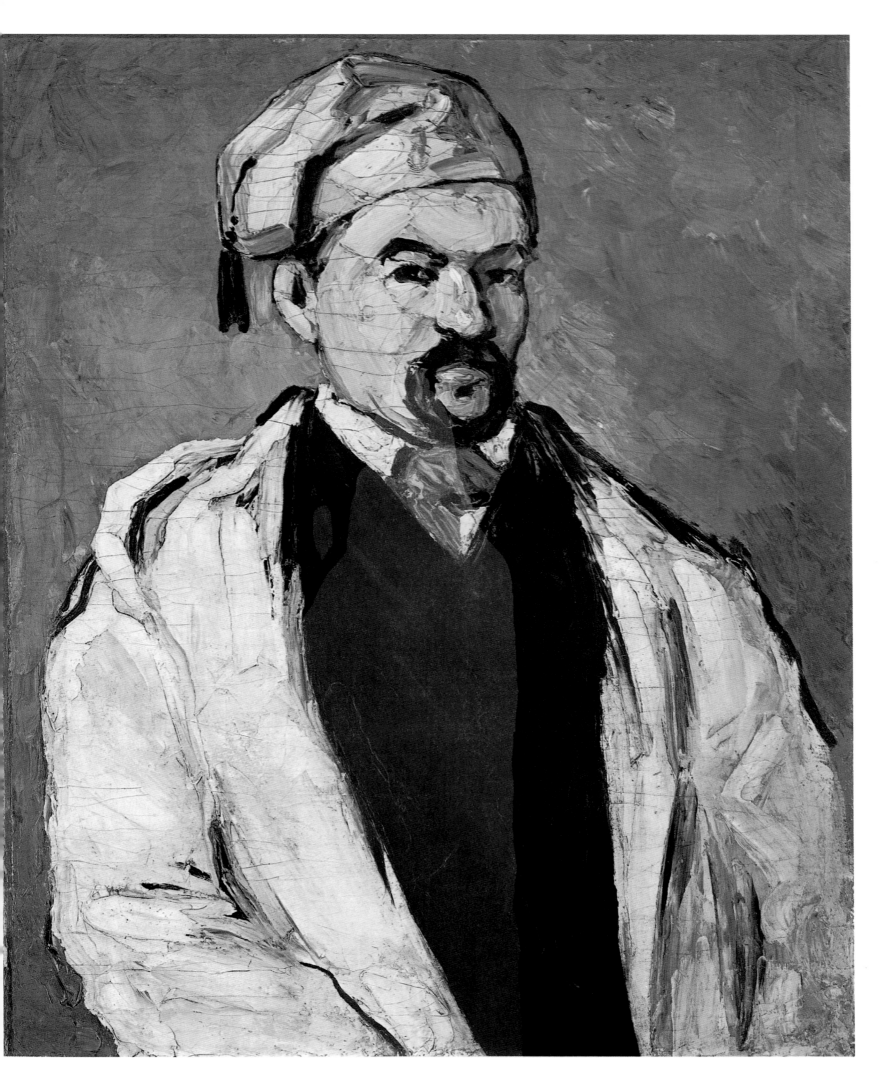

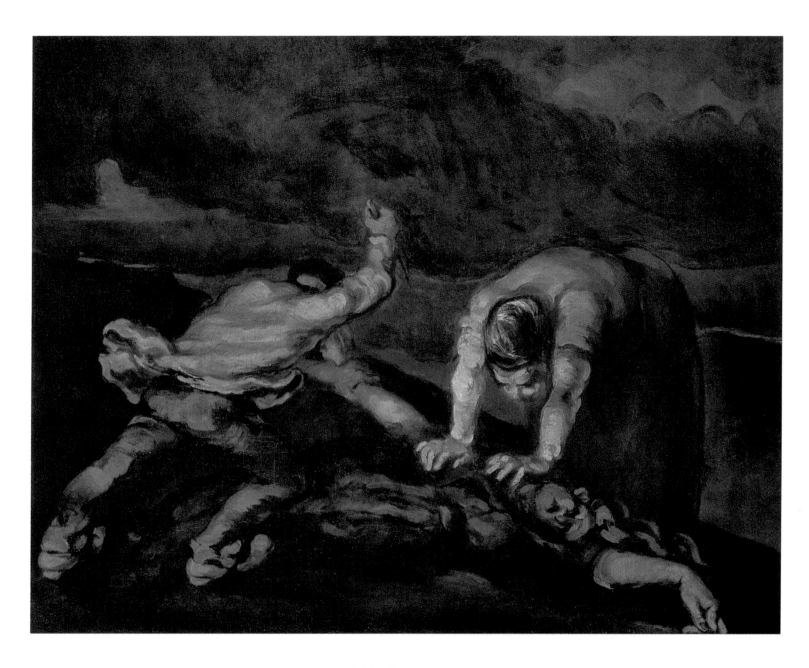

A Murder, ca. 1870
Le meurtre
Oil on canvas, 65 x 80 cm
Venturi 121
Walker Art Gallery, Liverpool

Nevertheless, the Salon remained the target. After all, it afforded young artists their only chance of exhibition space. In 1863 an unusually strict jury had rejected some four thousand works, prompting the refused artists to petition Emperor Napoleon III jointly. The emperor responded to the controversy by inaugurating a second, parallel exhibition, known as the Salon des Réfusés, where paintings that departed from the Second Empire's ideal of beauty could be seen.

Manet's *Déjeuner sur l'Herbe* was the much-derided talking point of the exhibition, along with *The Woman in White* (National Gallery of Art, Washington) by the American painter James Abbot McNeill Whistler. Manet's painting shows a naked woman sitting in the open with two clothed men – a common *bréda* (a cheap whore from the Bréda quarter near Les Batignolles, where Manet lived) picnicking with two wastrels. Middle-class propriety was outraged. No offence was taken at Paul Baudry's *The Pearl and the Wave* (Museo del Prado, Madrid) or Alexandre Cabanel's florid *Birth of Venus* (Musée d'Orsay, Paris), which the emperor subsequently acquired for his own collection. But Manet's nude was a scandal. No one cared about its classical models, among them Titian's *Concert in the Country* (Musée du Louvre, Paris) or Marcantonio's engraving after Raphael's *Judgement of Paris*. Manet had transposed the classical *fête champêtre* to modern industrial society, aided by his favourite model, Victorien Meurent, and her brothers.

Manet was partly thinking of Courbet, whose *Baigneuses* of 1853 (Musée Fabre, Montpellier) had inaugurated a new kind of realism which the young generation of painters were diligently copying. Courbet too had been availing himself of that engraving by Marcontonio Raimondi; it was a favourite in Parisian studios. Manet seems to have been particularly influenced by Courbet's *Demoiselles au bord de la Seine* of 1857 (Musée du Petit Palais, Paris), which he transformed into a genuinely "realistic" scene. At all events, *Déjeuner sur l'Herbe* was entered in the annals of scandal opened by Courbet's new realism. And both Manet and Courbet appealed strongly to Cézanne, who borrowed a spatula technique and a few motifs (loosely paraphrased) from Courbet.

Cézanne had two (unidentified) pictures in the Salon des Réfusés, but they attracted little attention. At that time he was painting in a restless and uncertain style which borrowed not only from the realists but also from Delacroix. Cézanne admired Ingres's contemporary, the much-maligned advocate of glowing colours, for his brushwork and colours and for his monumental subject matter: literary scenes taken from Dante, Shakespeare, Byron or Walter Scott, scenes that tended to juxtapose violence and sensuality.

Cézanne copied Delacroix's *Barque of Dante* (private collection, Cambridge, Mass.) and *Medea* (Musée des Beaux-Arts, Lille). He added glowing shades to his palette, and let his imagination loose.

Time and again he returned to the seclusion of Jas de Bouffan, painting still-lifes, landscapes and portraits in hasty abandon. The model he found most rewarding to work with was his Uncle Dominique, and he painted him in various guises – as a monk, for instance (p. 44), or in a cotton cap (p. 35).

Cézanne's mental conflicts, the tension of the family situation, his problems with his art, and the upheavals his experience of Paris had involved him in, all met in large figural compositions such as *The Orgy*. There was a respectable tradition behind this painting of an orgiastic banquet, from Veronese's *Wedding at Cana* (Musée du Louvre, Paris) to Delacroix's *Death of Sardanapal* (Musée du Louvre, Paris); but it also reflects Cézanne's personal need to work crises in his own life (with his father, for instance) out of his system.

Cézanne's imagination was doubtless further spurred by his reading of Gustave Flaubert's *Temptation of Saint Anthony* (1874), and particularly by the description of Nebuchadnezzar's banquet given in that book. The second version of the novel appeared in instalments in 1856/7 in *L'Artiste*, and Cézanne also drew inspiration from the illustrations in the magazine.

Cézanne's attraction to Romantic themes reflected his deep wish for emancipation from ties to his parental home, and in particular for release from a despotic father who humiliated his son in ways that ranged from monitoring his mail to cutting up his canvases in his absence. In *The Orgy*, that longing for freedom was linked with an erotic libertinism which could appear distinctly disturbing in other works he painted at the time. We register the note in *The Abduction* (p. 32), for instance; Cézanne gave the picture to Zola, who hid it in the attic on account of the risqué content. The ominous combination of sexuality and violence in that painting reappeared with a vengeance in *A Murder* (p. 36). Women feature either as passive victims or as seductive *bêtes humaines* (as in *The Temptation of St. Anthony*, p. 33). The conflict of flesh and spirit in these pictures mirrored the struggles going on within Cézanne, his sexual obsessions, his inability to relax into life, and his quest for liberation through art.

He found the correlatives through which to express this conflict in Flaubert, in Baudelaire's *Fleurs du Mal* (which became a lifelong companion), and also in Zola's novels *Thérèse Raquin* (1867) and *Madeleine Férat* (1868), in which the young writer, penning a dark and unsubtle realism, lashed the hypocritical double standards of the age. Scenes and memories from the youth the two men had shared, a youth that seemed long ago but which still united them, appeared in fictional form in these early works of Zola's.

Zola took to realism; and the more Cézanne's gloomy scenes and exaggerated pessimism repelled him, the more he inclined towards the other painters he had got to know through his friend: Pissarro, Monet, Edgar Degas, Renoir, and Henri Fantin-Latour.

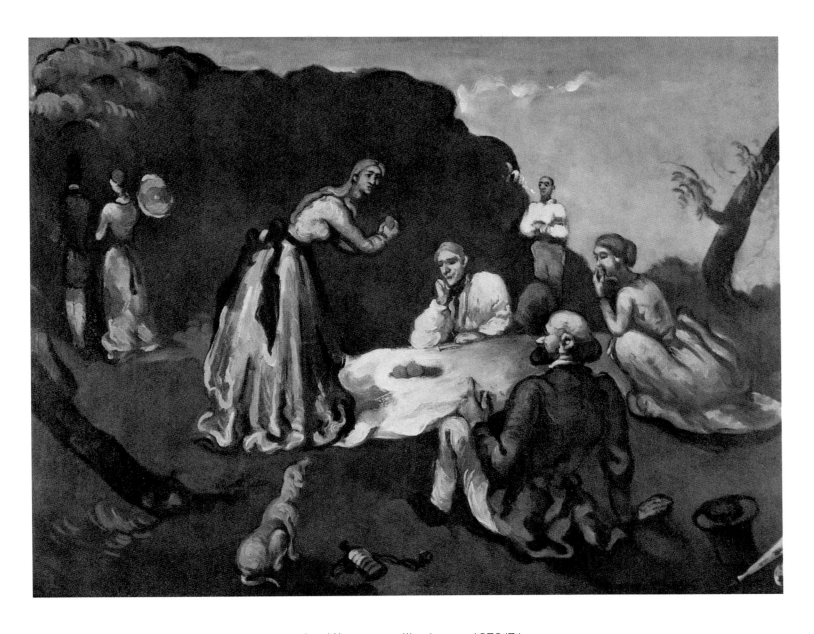

Le déjeuner sur l'herbe, ca. 1870/71
Oil on canvas, 60 x 80 cm
Venturi 107
Private collection, Paris

The Dance, 1869–1871
La danse
Pencil, 12.2 x 21.8 cm
Graphische Sammlung Albertina,
Vienna

He valued Manet above all of them. Manet was the presiding genius of the Batignolles circle that met in the Café Guerbois to thrash out artistic matters. Zola had developed an enthusiastic taste for art criticism, even though he had no special expertise beyond that enthusiasm, and in *L'Evénement* he had a platform for vitriolic attacks on the Salon jury and painters (which soon had to be discontinued because of the protests they attracted). On an impulse, Zola collected the articles he had already published and brought them out in book form, titled *Mon Salon* . Most of the new painters were included (Manet, Monet, Corot, Charles-François Daubigny and Pissarro, though not Cézanne) and their opposition to the dismal taste of the Salon was described. In a lengthy foreword, Zola once again recalled the youthful times he had shared with Cézanne (doing so for the last time) and encouraged his old friend to persevere.

It reads like a letter of farewell: "For ten years we have been debating questions of art and literature. We lived together, and – do you remember? – often daybreak found us still immersed in discussions, discussions in which we would examine the past, scrutinize the present, and try to locate the truth, since all our endeavours were aimed at fashioning an infallible, total belief. We moved awesome mountains of thought. We tested and discarded all the systems. And after all our efforts we realised that aside from energetic, individual life there is nothing but lies and stupidity. Happy are those who have memories! In my own existence, I see you like the pale young man Alfred de Musset speaks of. You represent my entire youth. You are connected with my every joy, my every sorrow. In that spirit of brotherhood we evolved side by side. And today, at the outset of our careers, we have confidence in each other because our hearts are full of each other."

We might consider one of Cézanne's most enigmatic early works in terms of this dissolution of an old friendship. The title *Le déjeuner sur l'herbe* (p. 39) is of course a nod towards Manet; but the composition and the idea behind the picture are distinctly different. The setting is a dark, cloudy landscape (such as often features in early Cézanne) where curious things are going on, and in the foreground is a group of four people seated around a laid table. The bald, bearded man closest to us clearly represents Cézanne himself. To his right is a young woman who bears a facial resemblance to the artist's sister Marie, raising her hand to her mouth in a gesture of astonishment or premonition. Opposite the bearded man sits a younger, pale man, his head propped thoughtfully on his hand. (This pose recurs in later Cézanne and is indicative of melancholy or sad recollection.) Completing the foursome is a young blonde woman, standing to the bearded man's left and apparently handing or showing him a fruit, presumably one of the apples that are on the table. This puzzling scene also includes various objects lying on the ground, a dog (watching attentively)

Sorrow (Mary Magdalen), ca. 1868/69
La Madeleine ou la douleur
Oil on canvas, 165 x 125.5 cm
Venturi 86
Musée d'Orsay, Paris

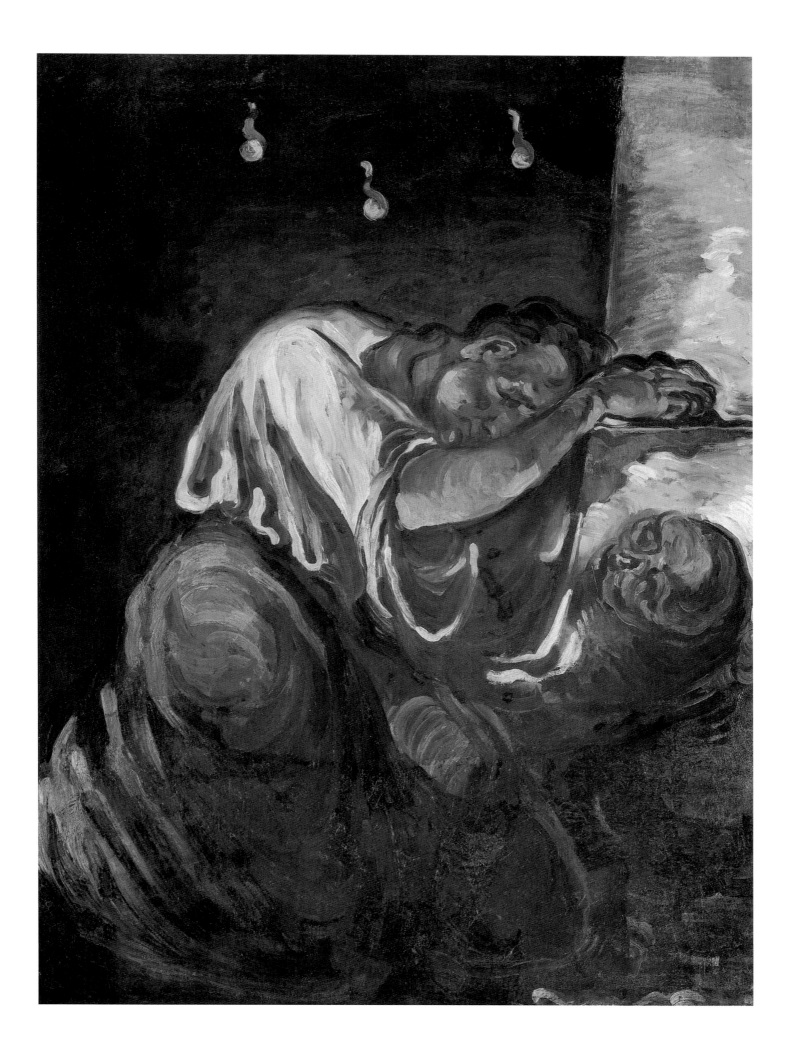

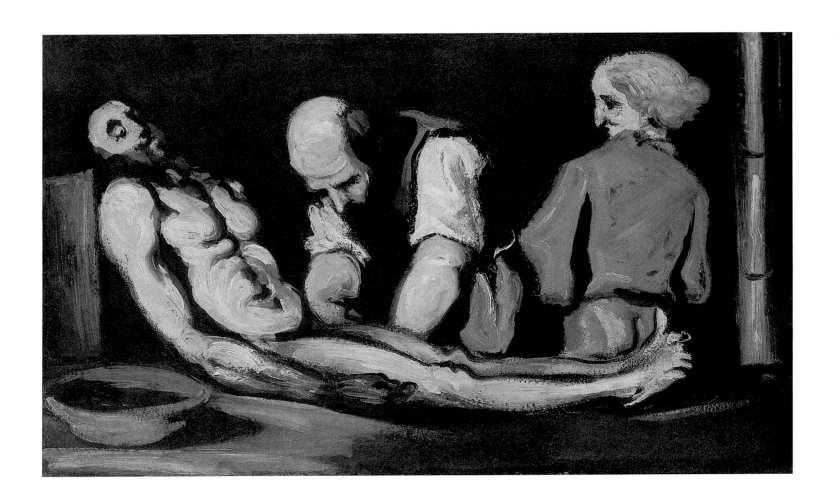

Autopsy, ca. 1869
L'autopsie
Oil on canvas, 49 x 80 cm
Venturi 105
Private collection

and in the background an onlooker, detached yet alert and demonstratively smoking a pipe. To the left, a couple are vanishing into the dark undergrowth – a kind of sub-plot. If we take the apples to be symbolic, as *The Judgement of Paris* (1862-1864, private collection) and Cézanne's later still-lifes suggest we should, the situation appears to involve an existential decision which Cézanne must (and will) take – as the disappearing couple implies. The artist is hoping for assistance from his pale vis-à-vis and alter ego; but all he gets is mournful memories.

The detached onlooker in the background may be Zola, who now occupied a peripheral position in Cézanne's life, in his recollections of their shared past. Badt has proposed that a similar figure in the New York *Card-Players* (p. 160) should also be interpreted as Zola. In other words, the picture was Cézanne's version of a longstanding conflict he repeatedly tackled on new levels in attempts to find a solution. In a sense it was the same conflict as informed the pictures that influenced him, such as Manet's *Déjeuner sur l'Herbe* – a conflict characteristic of the entire 19th century, of sensuous desire versus rational moderation, of instinctual drives versus reason.

Perhaps Cézanne was out to prove to Zola that he was prepared to travel the road of the artist, as his friend had advised. But there

were obstacles along his way; sexual desire was still prompting Cézanne to take the dark by-ways, and he still felt profoundly and humiliatingly dependent on his father, who observed his struggles with indifference. Cézanne painted his father seated comfortably, reading his newspaper, wearing the cap he wore about the house (p. 15, and cf. p. 31). But Cézanne *père* is reading not the Republican *Le Siècle* but the Liberal paper *L'Evénement*, where Zola fought his battles on behalf of modern painting. It is a two-edged portrait in which Cézanne mocks his father but also pleads for recognition and understanding; and it is interesting to note that he painted his unfortunate friend Emperaire in the same armchair (p. 48). But Emperaire is transformed into a true king: the dwarf achieves a solitary grandeur, the chair becomes his throne, and above him is inscribed in gold lettering: Achille Emperaire Peintre. The art of painting will triumph, will grant the unfortunate his victory. This picture too was rejected, though, like the many others Cézanne submitted to the Salon jury.

In 1867, the year of the World Fair, which saw the Empire's industrial and political power paraded for all the world to see, Cézanne was finally mentioned in the press, in a polemic written by one Alfred Mortier: "I have been told of two rejected pictures by M. Sésame (no relation to the Arabian Nights), the very same Sésame who occasioned general hilarity at the Salon des Réfusés (where

Girl at the Piano, 1868/69
(Tannhäuser Overture)
Jeune fille au piano
(L'Ouverture de Tannhäuser)
Oil on canvas, 57 x 92 cm
Venturi 90
Hermitage, St. Petersburg

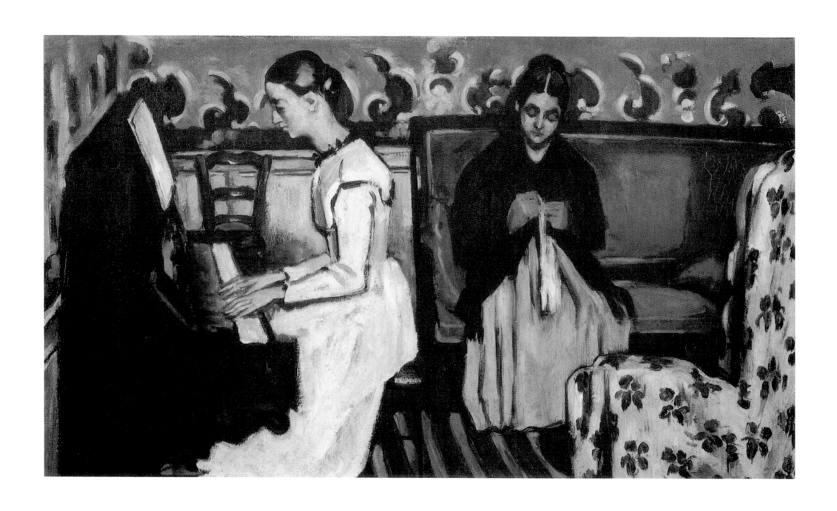

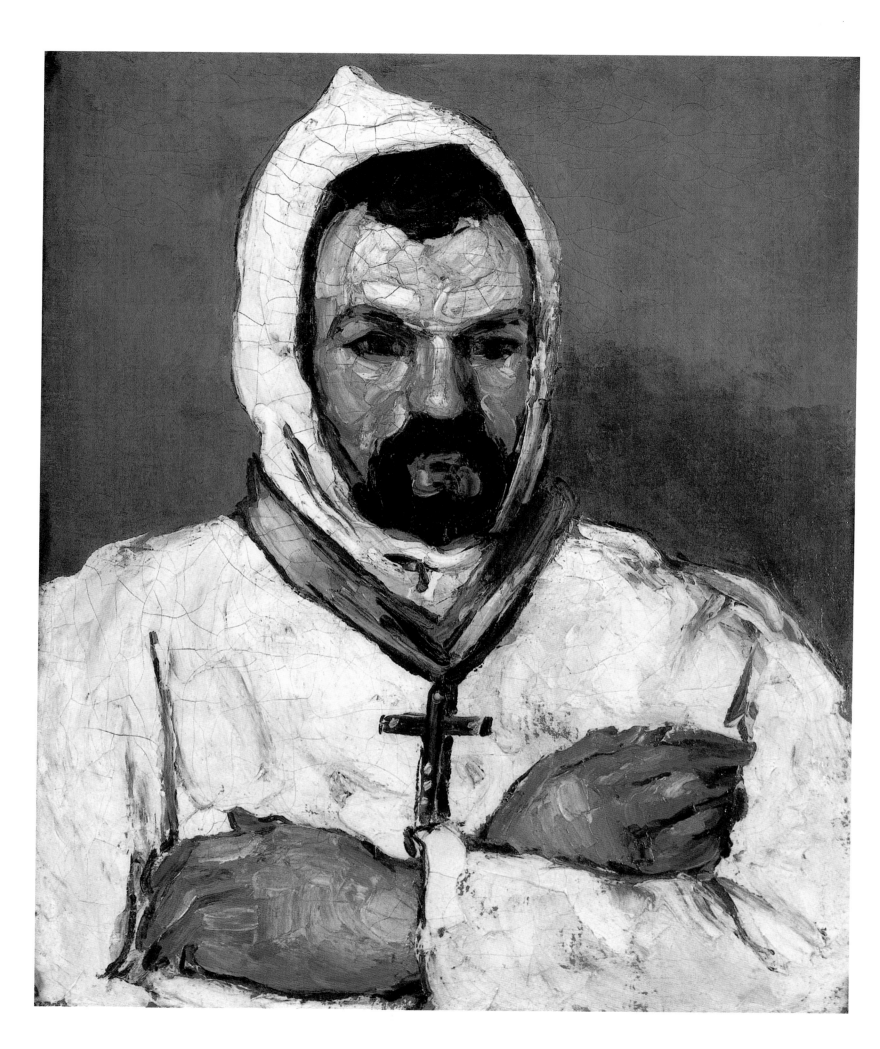

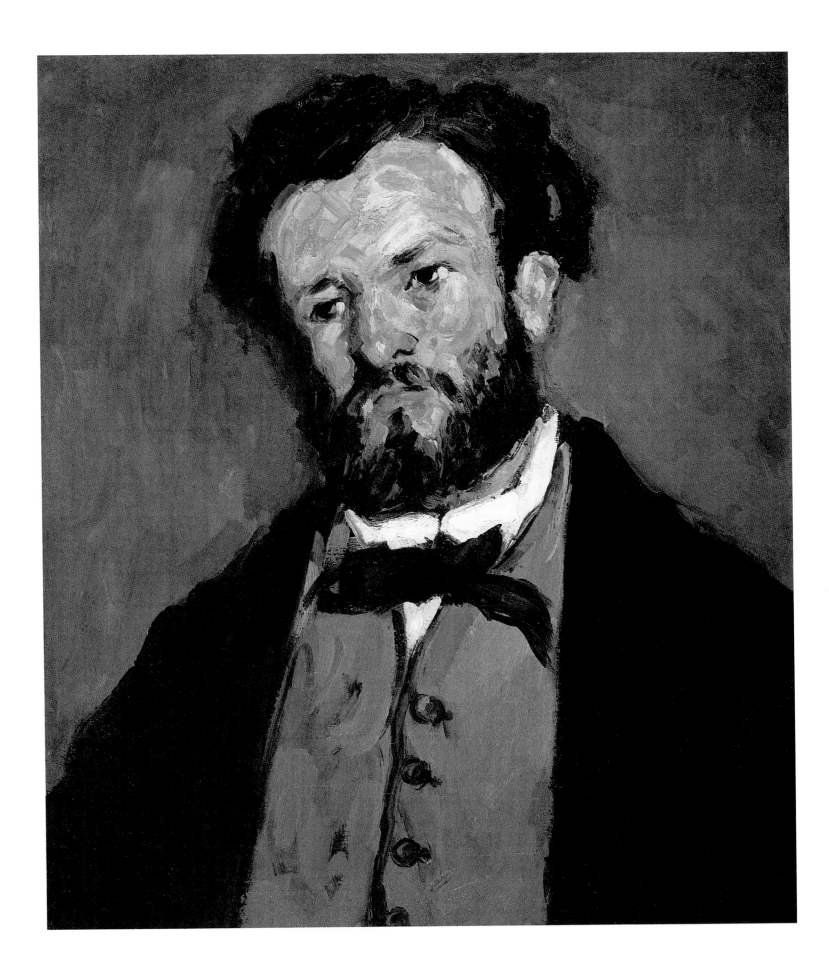

else?) in 1863 when he exhibited a painting that showed two pig's trotters in the form of a cross. This time M. Sésame submitted two compositions that were not so bizarre but still deserved their exclusion from the Salon. Both were titled *Rum Punch*. One showed a naked man who has just brought some rum punch to a woman dressed to kill, the other showed a naked woman and a man costumed as a *lazzarone* – over whom the grog has been spilt."

Zola immediately protested against this slanderous slur; but his protest was astonishingly mild, and in fact aimed mainly at correcting the name. He made no comment on Cézanne's painting. He already felt remote from Cézanne, and was more interested in Manet, to whom he dedicated an autobiographical study which was distributed outside Manet's pavilion at the World Fair. Possibly Zola still believed in Cézanne's genius – but not in his powers of persistence and achievement. He brusquely refused to give Cézanne's address to Théodore Duret, an influential critic, on the grounds that Cézanne was still feeling his way and it would be best to wait till he had found himself.

Though the "rum punch" pictures are lost, drawings also feature the subject, a subject which Cézanne used elsewhere in *Afternoon in Naples* (p. 47). Cézanne was plainly taking a hint from another of Manet's works, *Olympia* (Musée d'Orsay, Paris), which had caused an outcry. Essentially there is no obscenity in Cézanne's picture, any more than in Manet's *Olympia*; the artists' gaze is frank, requiring a revised view of sexuality and assaulting the hypocritical double standards of the middle classes in the process. The couple in Cézanne's painting, relaxed in their pleasure, untroubled by societal constraints, merely highlight the dream of an untrammelled loving relationship such as Cézanne was not to enjoy. They also point up the social notion of a "free love" such as the salons and boudoirs could not provide. The French preferred subjects of this kind dressed up in the frivolity of an Offenbach operetta or camouflaged by the ornate décor of Salon paintings. Cézanne's picture, like Manet's, was plainly probing a painful social wound. Yet the picture (with its anti-academic technique) also represents an attempt at cure.

A drawing called *The Dance* (p. 40) reflects Cézanne's times even better, with its twofold vision of the nature of temptation: resisting and giving in. The flaneurs and dandies are seen in top hats and tails, coolly and cynically watching the fiery performance of the dancer. Apart from Toulouse-Lautrec, there can have been few artists who have recorded the reality of the city so brutally and nakedly: cynicism, voyeurism, the coupling of undisguised lust with consumerism. The Goncourt brothers recorded a dance scene of this kind in their diaries (1865): "It was not shamelessness any longer, it was blasphemy. All the nastiness of the street argot, the gutter ironies, the words spat out and spewed, the dirty

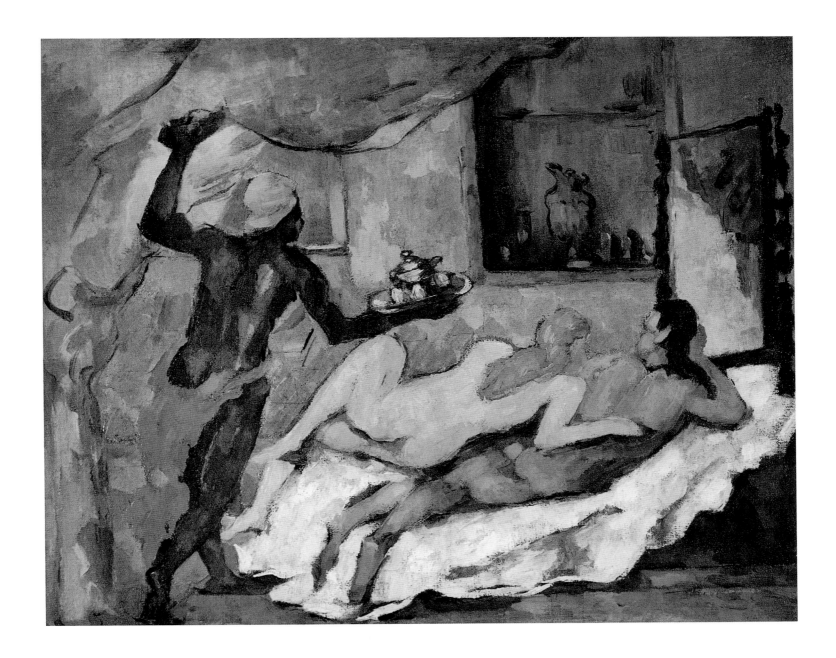

cynicism — it all seemed to be brought out and expressed in the dance by those legs, that body, that woman, that dress." The most important figure in the drawing, though, is remote from the cold, greedy pleasure of the other men: one in a comfortable frock coat, wearing a peaked cap and smoking a pipe, is reclining at the lower left. This man has often been interpreted as a self-portrait, but details familiar from the three portraits of Cézanne *père* and other drawings (the comfortable coat, the banker's peaked cap) make it seem likelier that this is a phantom image of the artist's father.

In Cézanne's early work, thwarted wishes, suppressed drives and the conflicts that resulted, together with the existential problems of an artist's life, were linked with social criticism. It is not difficult to understand Cézanne's aggressive stance towards the glitz market if we bear his circumstances in mind. It is true that (unlike many fellow-artists) he was relatively free of financial worry; but the humiliation of having to account to his despotic father for his

Afternoon in Naples (Rum Punch),
1876/77
L'après-midi à Naples (Le punch au rhum)
Oil on canvas, 37 x 45 cm
Venturi 224
Australian National Gallery, Canberra

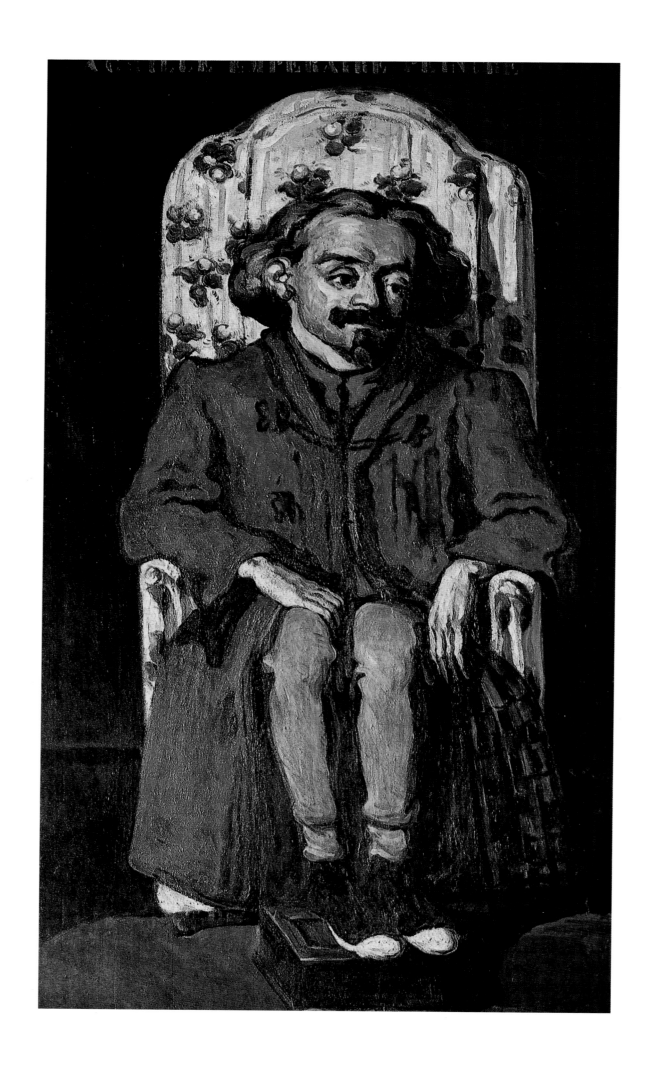

every move must have been trying. And when, in 1869, he entered upon a relationship with Hortense Fiquet, he kept the fact secret, even after their child gave the couple a kind of family status.

The pictures Cézanne painted at that time constitute a veritable collection of human fears and horrors. Scenes of murder and rape alternate with gloomy visions such as *Autopsy* (p. 42). Temptations that offer no escape are followed by collective or private orgies. Cézanne seems to have been mounting a deliberate onslaught on all the tenets of contemporary taste and morality. He once told Pissarro that he would like to make the Bouguereau Salon blush. But the intransigent rejection masked a yearning for love and recognition, both as an artist and as a man. The widening gap between himself and Zola left the first move up to Cézanne. Zola's growing success as a writer confirmed this situation; *Thérèse Raquin* (1867) made the novelist both popular and controversial on account of the "monstrous immorality" of the subject, an adulterous affair that begins with murder and ends in suicide. Zola was to become the merciless chronicler of his age, with cool and analytic powers of observation. As of 1869 he was preparing *Les Rougon-Macquart*, his vast novel sequence (running to twenty volumes) in which he took a panoramic look at contemporary morality.

Cézanne, too deeply involved with his own instincts and drives, at the mercy (as it were) of the nightmarish happenings in his pictures, was not yet able to rid himself of the fears within him. But in some portraits painted at the end of the 1860s, Cézanne achieved something else. They are works such as *Antony Valabrègue* (p. 45) or the so-called "penitential pictures" done somewhat earlier such as *Sorrow (Mary Magdalen)* (p. 41) and *The Negro Scipio* (p. 26) – "a powerful piece of painting", in Pissarro's opinion. In these pictures we see a new will, a wish to observe reality patiently and objectively, as a means of subduing his own violent resistance to his fate. We see that new will most clearly in *Skull, Candlestick and Book*. Painted with broad generosity, using the palette knife, the picture juxtaposes symbols of inner enlightenment with those of the memento mori tradition. It was intended as a gift for the musician Heinrich Morstatt, who "set Cézanne's acoustic nerves vibrating with Wagner's music".

Cézanne's own struggle of love was rounded off with a painting and water-colour of that title (pp. 50/51). Various couples are seen fighting in a pastoral setting, with a barking dog excitedly following the action. Autobiographical memories of bathing with friends and a dog called Black merge with Cézanne's own problems; but here an end to the struggle can be foreseen, with a reconciliation of the warring parties. These couples united in the struggle of love are an apotheosis of happiness and fulfilled love. It is Cézanne's version of Cythera, the island of love, a utopia of togetherness, an earthly paradise that he was soon to take as the subject for his *Bathers* series.

Achille Emperaire, 1868–1870
Charcoal and pencil, 48.4 x 31.8 cm
Musée d'Orsay, Paris

Achille Emperaire, ca. 1868
Portrait Achille Emperaire
Oil on canvas, 200 x 122 cm
Venturi 88
Musée d'Orsay, Paris

The Struggle of Love, 1875/76
La lutte d'amour
Oil on canvas, 38 x 46 cm
Venturi 380
National Gallery of Art, Washington,
D.C., Gift of the W. Averell Harriman
Foundation

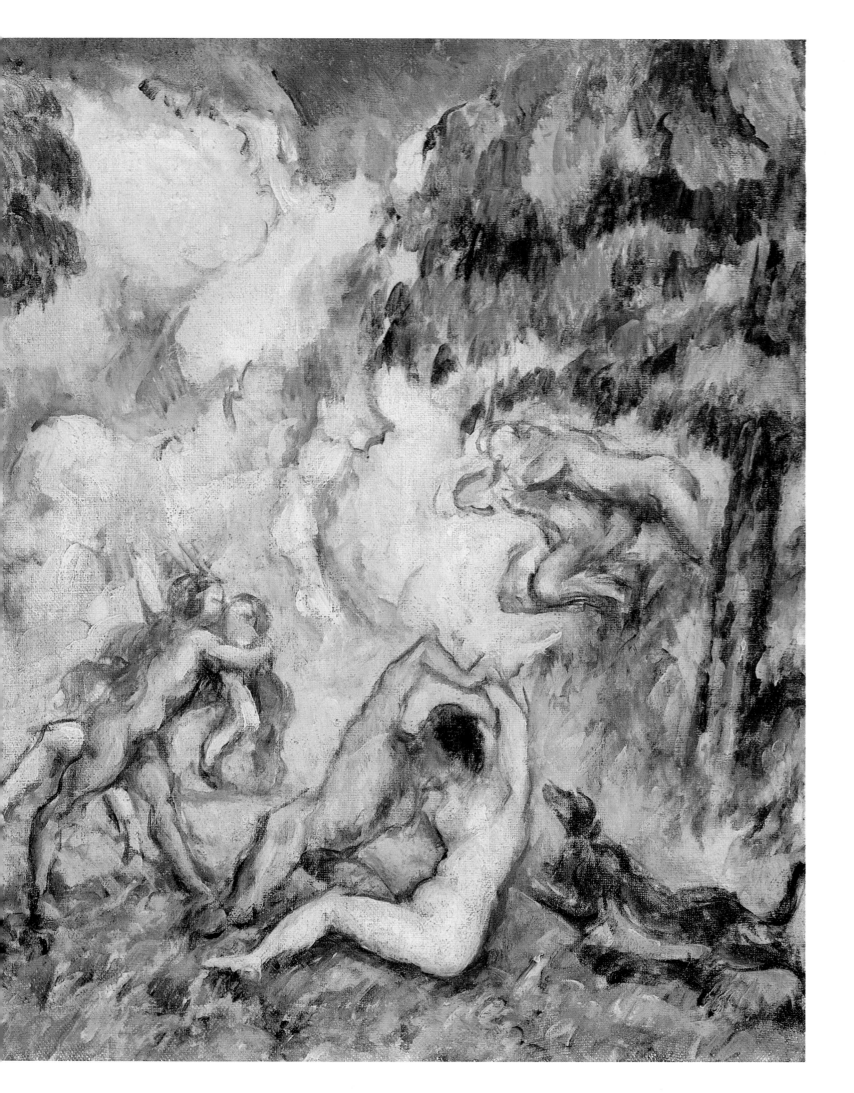

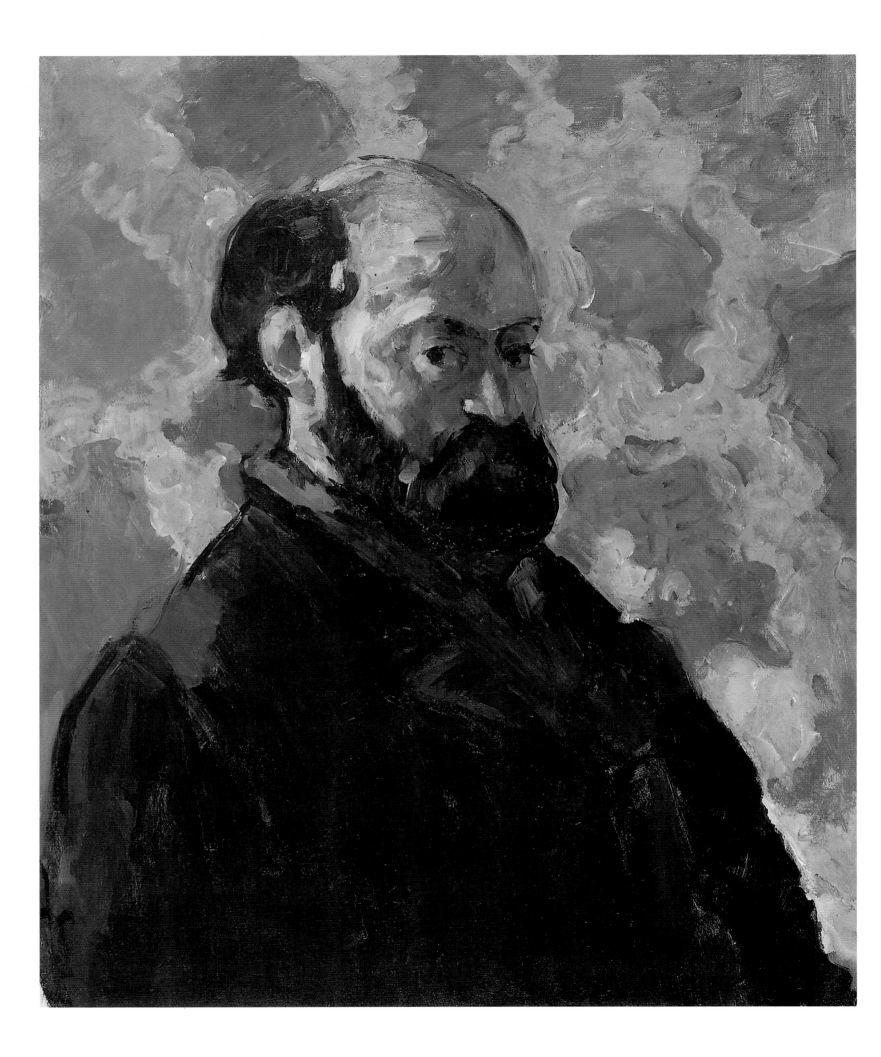

The Cutting:
Cézanne's Breakthrough

Zola was moving towards that form of hyper-realism known as Naturalism, but he failed to detect any similar tendency in his old friend Cézanne. Indeed, in Cézanne's years of early turmoil there were very few who had an eye for that potential for a masterly combination of gripping realism and submerged symbolism which was visible in his work again and again. Cézanne was dividing his time between Paris and Aix, and schoolfriends regularly informed Zola of his progress. One of them, Fortuné Marion, a scholar and amateur painter who would go in quest of subjects with Cézanne, wrote to Zola describing the new discipline Cézanne was proposing to submit to: "My dear friend, there is less official recognition of realistic painting now than there has ever been. It is quite likely that in the foreseeable future Cézanne will be unable to exhibit at official shows. He is already too well known; too many revolutionary artistic ideas are associated with his name. The painters on the jury will not weaken for a single moment. I admire the cold-blooded resolution with which Paul writes: 'So be it! I shall go on hurling paintings of this kind at them for all eternity.' Taking all of this into consideration, though, he ought to ponder other, better ways of reaching the public. The technical skill he now has is astounding. His exaggerated wildness is under control. I feel it is high time circumstances made it possible for him to create the wealth of work it is in his power to create." When he referred to Cézanne's astounding technical skill, Marion may have been thinking of the still-lifes of the 1860s, paintings such as *Jug, Bread, Eggs and Glass* (p. 54) or *Jar, Coffee-Pot and Fruit* (p. 55). In these works we most readily see the skills in painterly technique which Cézanne had acquired from his study of Spanish and Dutch masters (such as Hals, Zurbarán and Ribera).

Another still-life, the 1870 *Black Clock* (p. 56), can be discussed in this context too. Done with extreme care, indeed in rather *voulu* fashion, the composition includes objects that Cézanne's contemporaries would generally have thought out of place in a still-life. They are on a big white cloth with deep folds; this cloth covers a sideboard in front of a mirror which is only partly visible. The objects include a cup, a glass vase and the black clock itself — but also a lemon and a large conch, which not only add subtle colour to the harmonic balance of the picture but also contribute a curious note of symbol-

Self-Portrait, 1878–1885
Pencil, 30 x 25 cm
Szépmüvészeti Múzeum, Budapest

Self-Portrait on Rose Background,
ca. 1875
Autoportrait au fond rose
Oil on canvas, 65 x 54 cm
Venturi 286
Private collection, Basle

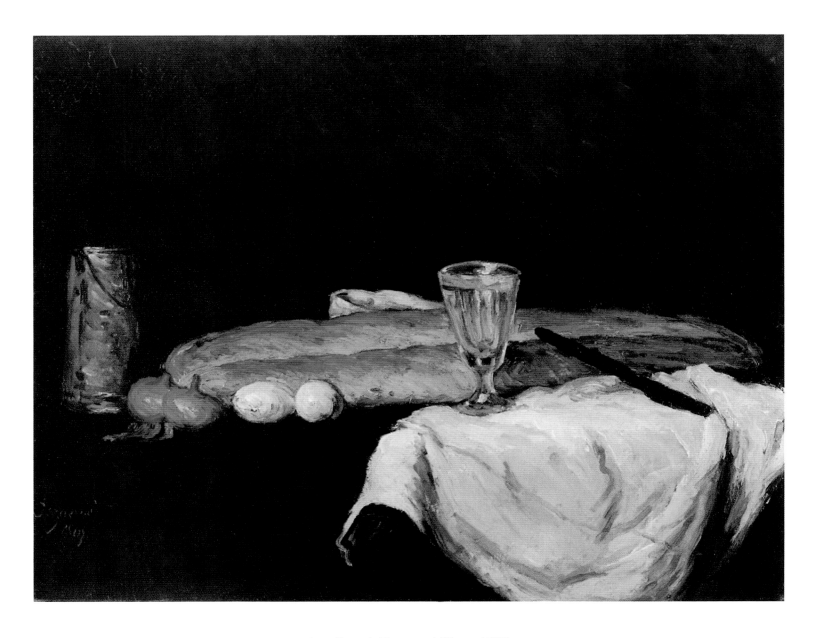

Jug, Bread, Eggs and Glass, 1865
Nature morte: le pain et les œufs
Oil on canvas, 59 x 76 cm
Venturi 59
Cincinnati Art Museum, Cincinnati

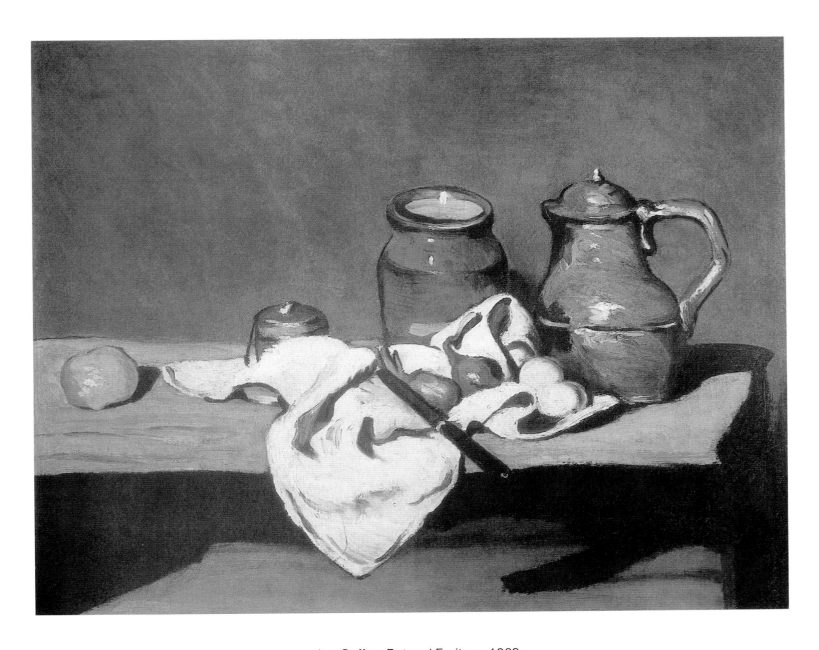

Jar, Coffee-Pot and Fruit, ca. 1869
Nature morte: pot vert et bouilloire d'étain
Oil on canvas, 64.5 x 81 cm
Venturi 70
Musée d'Orsay, Paris

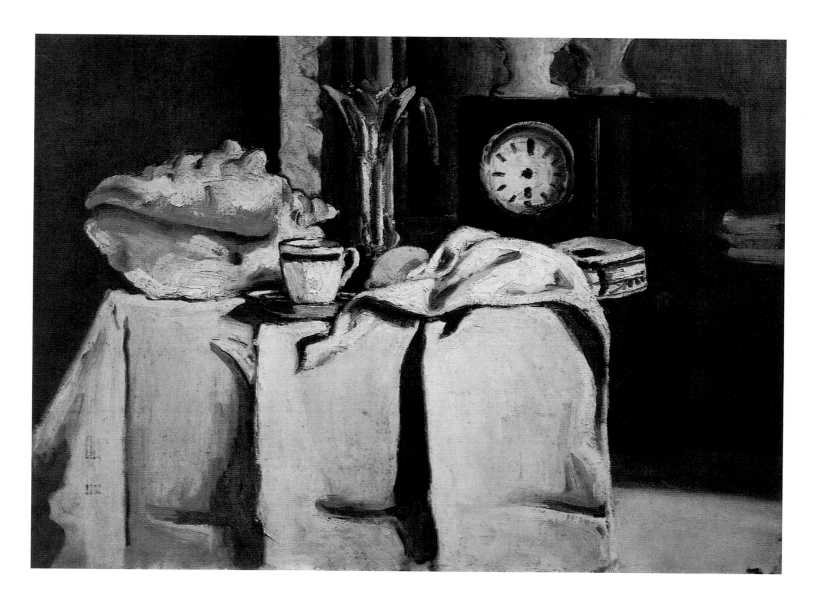

The Black Clock, ca. 1870
La pendule noire
Oil on canvas, 55.2 x 74.3 cm
Venturi 69
Private collection, Paris

ism. The colour scheme and the formal treatment are of course reminiscent of 17th century Dutch still-lifes, and also of Manet's, and his predilection for glittering, shimmering surfaces. Nevertheless, the details of this picture speak a language that touches upon different levels of consciousness. The face of the blue-black marble clock has no hands: Time has stood still and is suspended in this symbolic arrangement so disquietingly dominated by the gaping red cleft of the shell. The subtle delicacy of the colours complements the symbolic values traditionally associated with shells, water and women, a cluster of values seen (though not for the first time) in 19th century work such as Courbet's women in or by the water.

Throughout the 19th century we find the myth of womanhood projected onto the endless variety of Nature, with a particular emphasis on the "dark, motherly waters" Novalis wrote of. Water can symbolize birth and protection, but springs, pools, streams or seas can also stand for those devouring forces in Nature that emphasize transience. This still-life, then, shows Cézanne's own dilemmas coinciding once again with conflicts that were characteristic of the age.

As Kracauer puts it: "Since depth was frowned upon, the surface of existence had to be reflected, as if in facetted mirrors." Cézanne's brand of realism was already aiming deeper than were the Batignolles painters, later the Impressionists, who were in pursuit of the beautiful illusions created by things. We can sense his desire to rein in his emotions and achieve a certain stability amidst the turbulence of instinctive drives. Time and again he sought refuge in observing Nature and tried to record his observations in evenly balanced compositions. Amid the flux and change, Cézanne was after a fixed point.

His interest in landscape developed relatively late. We know he painted and drew in the open as early as 1862, but we cannot vouch for work prior to landscapes done around 1865 while walking near Aix-en-Provence with friends. Then in 1866, staying in Bennecourt, he ceased to see landscape as a backdrop for scenes of violence and began to approach it in its own right. In 1870 he again painted a number of landscapes at L'Estaque, such as *Snow Thaw in L'Estaque* (p. 59). But pictures such as these lack the serene charm of Impressionist paintings by Sisley, Renoir or Pissarro. The colours are muted, light and dark are strongly contrasted, and the unsophisticated impasto application is highlighted with bold colour at certain points; tranquil as such scenes may seem, they are nevertheless turbulent and dramatic. There are no people in them, yet a certain tension implies that something terrible is about to happen. Cézanne superimposed his passionate temperament on the landscape, imprinting his own questing, distraught individualism upon it. This would have suited Zola's conception of realism, which the novelist outlined in the foreword to *Mon Salon* and later pithily summed up in the words: "A work of art is a corner of creation seen through a temperament."

About the same time as the L'Estaque landscapes, Cézanne painted *The Cutting* (pp. 60/61). This painting was a further milestone in Cézanne's progress from the violent early style to contemplation of Nature. Its palette of earthy tones (lighter, though still governed by contrasts of light and dark), the use of light, and the expressive, impasto brushwork, are by no means discontinuous with the early work, though. Cézanne largely dispenses with perspectival depth, transferring his compositional emphasis to parallels and horizontals that seem to meet in the middle of the painting. The spatial flatness and the highlighting of the middle distance have the effect of stressing what we see there. There is something of a stage set in the positioning of the solitary house to the left, on the hill which the railway cutting passes through, and (for the first time in Cézanne's oeuvre) Mont Sainte-Victoire to the right. Not a soul is in sight; the only sign of life is the handful of bushes and trees.

It is a composition marked by balance and unconstraint. By directing our gaze across the estate wall, and matching the foreground

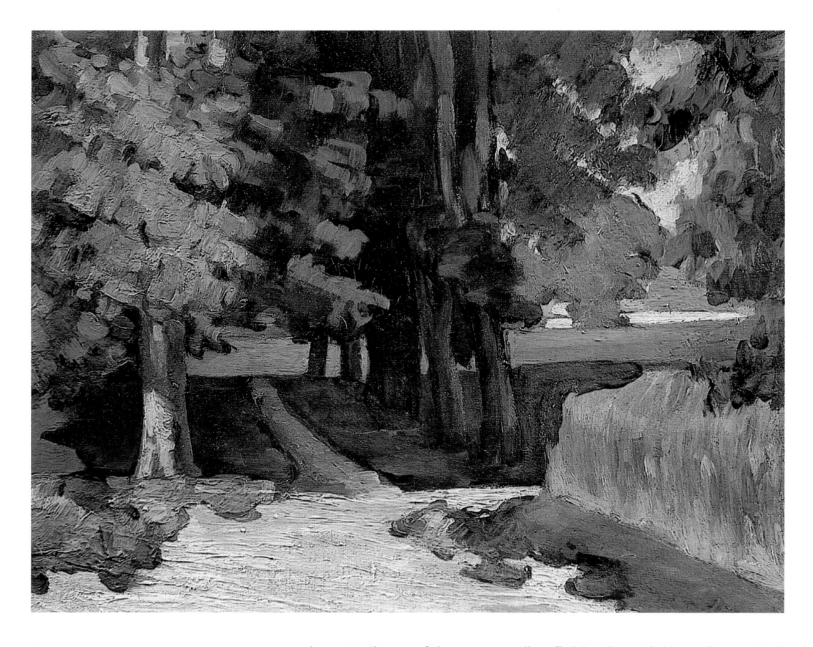

Avenue at Jas de Bouffan, ca.1869
L'allée du Jas de Bouffan
Oil on canvas, 36 x 44 cm
Venturi 47
Tate Gallery, London

colours to those of the surrounding fields, the artist has dismantled any tensions there might have been in our sense of the view. The cutting, a wound in the natural landscape, is counterpointed by the mountain, steep and monumental, dominantly rising to vast skies above a blue horizon suggestive of the sea. The mountain looks like a crystallized shape emerging from the viscous mass of colour, from the textural uniformity below: something firm and enduring amongst the wounds of shifting Time. We can just make out the spire of the venerable old Church of Saint Sauveur in Aix-en-Provence beyond the hill, and this has the effect of confirming a quality in Cézanne's vision. Normally the house, the cutting, the mountain and the church would not all be visible simultaneously. Presenting them in this way, Cézanne endows them with a deeper meaning which we might think of as a kind of heroic isolation, though also as the expression of a quest for a fixed point of reference, for permanence amid the changes that afflict the landscape and Man as well.

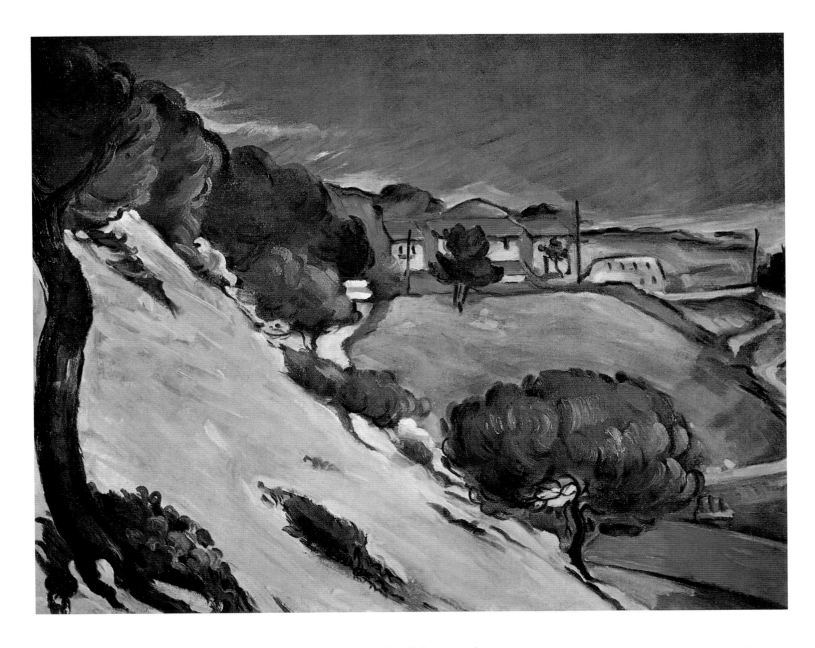

The idea of progress prompted enthusiasm in Cézanne's contemporaries; but the painter himself was often sceptical, whether he was speaking of urban development in Aix or of the demolition of old buildings in L'Estaque. "We must hurry – it's all disappearing," he is said to have remarked to Emile Bernard. He was thinking of changes that were being made everywhere around 1870. Railway lines not only scarred the landscape but altered traditional ways of life and habits of perception. Points of view had been static; now the new modes of transport gave ways of seeing an accelerated, panoramic quality which affected people profoundly.

Statements by early rail travellers show that they felt the old space-time continuum to have been destroyed. For many train passengers, the new speeds were quite simply a shock to the cognitive system, one which they needed to acquire immunity to. Cézanne responded to the changes modern times brought with them by appealing to the forces of Nature and that mysterious harmony deep within. For Cézanne the measureless profundities

Snow Thaw in L'Estaque, ca. 1870
La neige fondue à L'Estaque
Oil on canvas, 73 x 92 cm
Venturi 51
Private Collection, Zurich

PAGES 60/61:
The Cutting, ca. 1870
La tranchée
Oil on canvas, 80 x 129 cm
Venturi 50
Bayerische Staatsgemälde-
sammlungen, Neue Pinakothek,
Munich

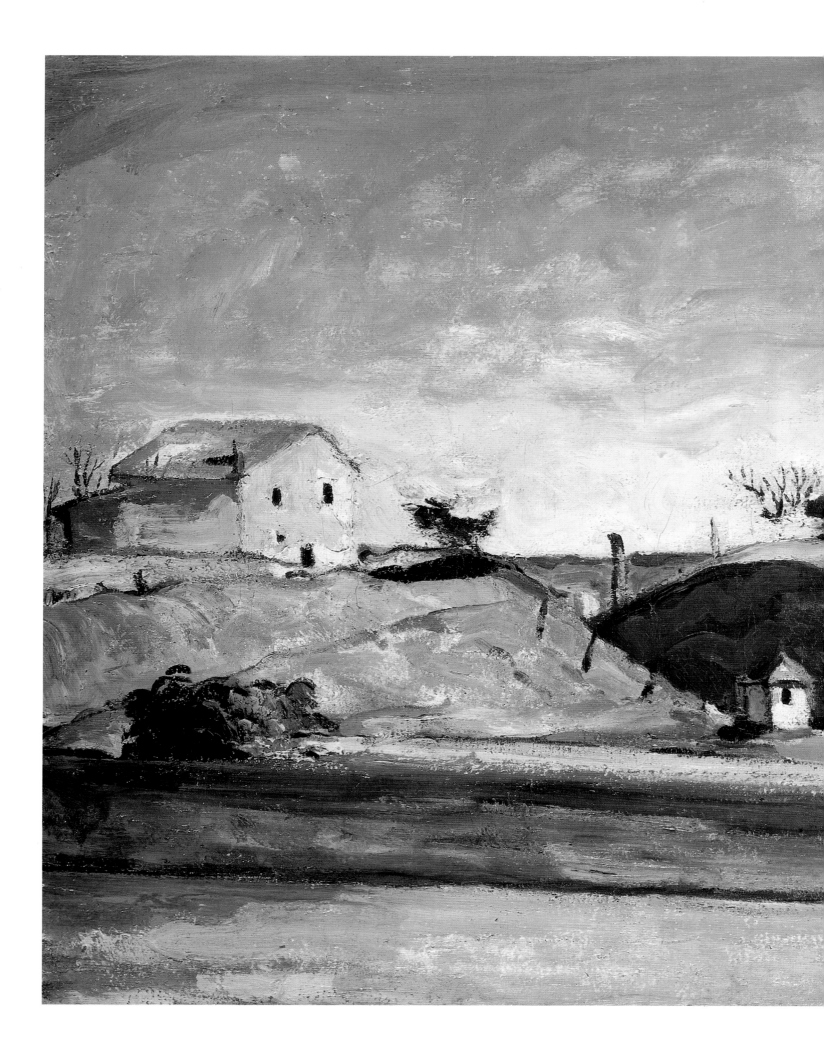

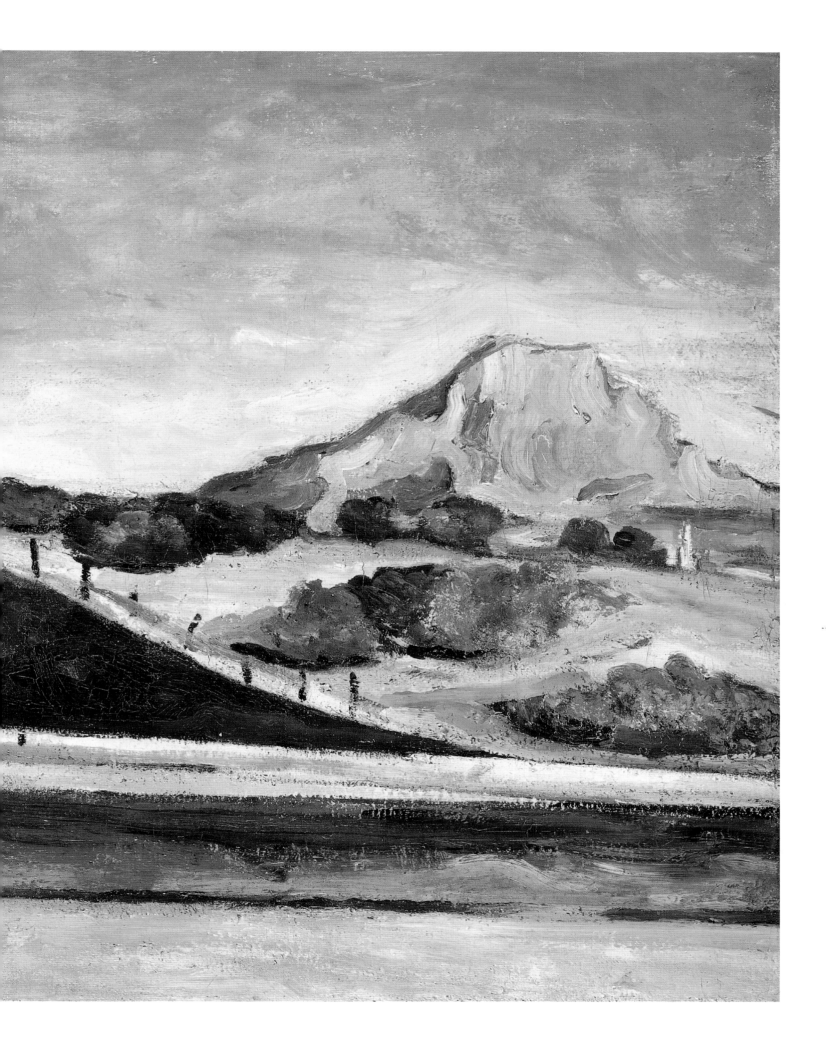

of Nature, inaccessible to Man and indestructible by Man's violence, had the power to heal all the wounds of Time.

In *The Cutting* we see two new aspects of Cézanne's work: on the one hand a quest for the permanent and enduring, expressed in the compositional approach, brushwork producing an impression of uniformity, and the symbolism of the mountain, and on the other hand an appeal to Nature as the force which can reconcile opposites, heal breaches, and mend the split between Man and Nature, a split which is found within Man too in the tension of instinct and mind. The exploitation of the natural environment was of course accompanied by increasing alienation from Nature, and people sought various kinds of recompense for that alienation: the man-made Edens of the cities, landscape idylls, the soothing emotional resources of the salons and passages, and the esoteric cults that counter-acted the 19th century's excessive rationality.

The Cutting revealed the new vision of an artist able to discipline his inner conflicts in a fresh approach to Nature. That fresh approach did not involve the idylls many of the Impressionists had recourse to. Nor did Cézanne yearn for far-off mythic strands such as the Symbolists and Neo-Classicists longed for. The cast of Cézanne's seriousness was different. His image of Nature derived from a quest for the truth that lay beneath appearances. He was presently to submit to the teachings of Impressionism, in order to "bridle his temperament", acquire technical expertise, and develop his visual means; but he soon moved on from the movement, faithful to his quest for the heart of his unrest. In Nature he was looking for the roots of human existence, a coherent and indestructible core where harmony prevailed between Man and the universe.

The Cutting also shows Cézanne applying his brush to society's open wound. In a meditative manner he was looking for ways of coping with the shock of the modern. Time after time, he tried to cope in his own life by fleeing Paris for the remoter reaches of Provence, where memories of a happy childhood remained fresh. When we consider the period of Cézanne's breakthrough, the laboured criticism by a certain Stock, who had seen Cézanne's paintings in the 1870 Salon des Réfusés, acquires an unsuspected dimension of truth: "Courbet, Manet, Monet, and all you painters of the spatula, the scrubbing-brush, the broom, and other utensils, you have been upstaged! Allow me to present your new master, M. Cézannes. Cézannes? Who? What?? Who on earth...??? Cézannes comes from Aix-en-Provence. He is a realistic, and not least ... convincing painter. These are his very words, spoken in a decidedly southern accent: 'Absolutely, my dear M. Stock, I paint what I see and how I feel. My feelings are very powerful. The others – Courbet, Manet, Monet and the rest – feel and see the way I do too, but they don't have the courage. They paint pictures for the Salon. But I do have the courage, M. Stock – the courage of my conviction. And he who laughs last, laughs longest!'"

Small Delft Vase, 1873–1875
Vase de fleurs (Bouquet au petit Delft)
Oil on canvas, 41 x 27 cm
Venturi 183
Musée d'Orsay, Paris

Nature, Escapism, and the Eternal Feminine:
Cézanne and Impressionism

The formative experiences of Cézanne's youth were very closely connected with responses to the aesthetic pleasures of landscape, particularly with the idyllic Arc valley. Even after his friends Zola and Baille had departed, Cézanne still liked to go walking in the countryside, either alone or with fellow-students at the Aix Art School. In his letters to Zola he would recall the idyllic times they had spent together. Those early impressions of Nature, with their associations of happiness, left Cézanne with a lasting image within, a spur, a goal to pursue. The earliest record we have of his desire to re-enter the magic realm occurs in a letter to Zola after they had spent a summer holiday in Bennecourt together: "I am seeing splendid things here, and will have to decide only to paint in the open." (Letter to Zola, 19 October 1866.)

Sojourn in "wonderful countryside" with writer and painter friends, and heated debates on art which always ended in amicable reconciliation, provided Cézanne with the relaxation he needed after the shock of Paris. In the landscape painter Antoine Guillemet (1841–1918), a friend of Pissarro and Courbet and disciple of Corot and Daubigny, he met a man who was able to provide vital encouragement. Guillemet described Cézanne's art as an "incredible development" and said he was painting "brightly" again – an indication of the influence of Corot. Once he had returned to Aix, Cézanne even proposed devoting himself exclusively to landscapes, though initially he kept to sketches and studies. At this period it was the expressive portraits and the foreboding scenes of violence and sexual aggression that remained most revealing of his inner turmoil.

It was not until after *The Cutting* (1870) that Cézanne began consistently to concentrate on landscape. He particularly liked painting views of L'Estaque, a small and charming township near Marseille. One reason he moved there was that he and Hortense wanted a quiet place to live. Cézanne had been living with Hortense Fiquet (who had modelled for him in Paris) since 1869, and although the initial release from sexual repression had presently given way to a more detached view of the partnership, it was clearly his changed private circumstances that gave him his new inner peace. (Zola, incidentally, married about the same time.) Another reason for the move was that during the Franco-Prussian War

Camille Pissarro:
Paul Cézanne, 1874
Etching, 27 x 21 cm
Bibliothèque Nationale, Paris

House of Père Lacroix at Auvers, 1873
La maison du père Lacroix à Auvers
Oil on canvas, 61 x 51 cm
Venturi 138
National Gallery of Art, Washington,
D.C., Chester Dale Collection

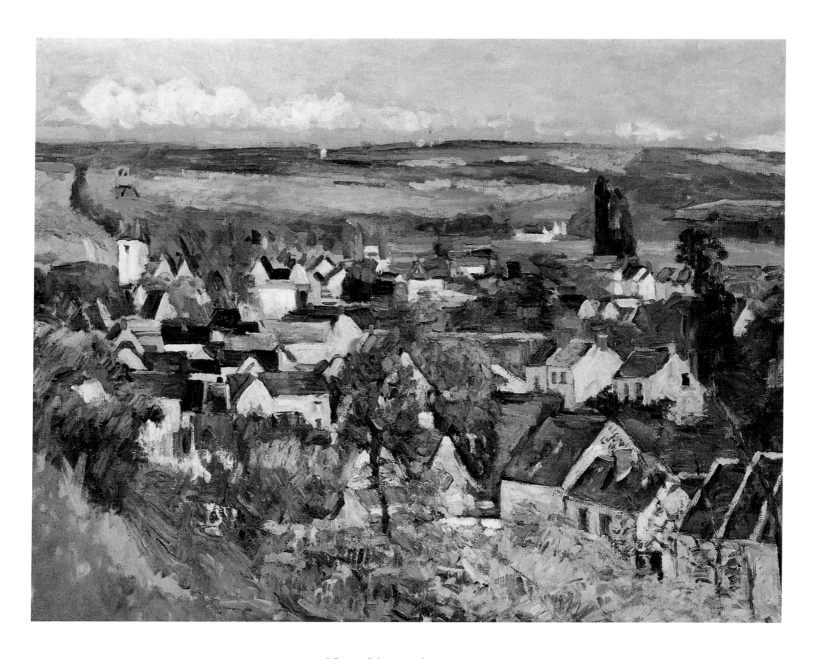

View of Auvers from above,
ca. 1874
Auvers, vue panoramique
Oil on canvas, 65.2 x 81.3 cm
Venturi 150
The Art Institute of Chicago, Chicago,
Mr. and Mrs. Lewis Larned Coburn
Memorial Collection

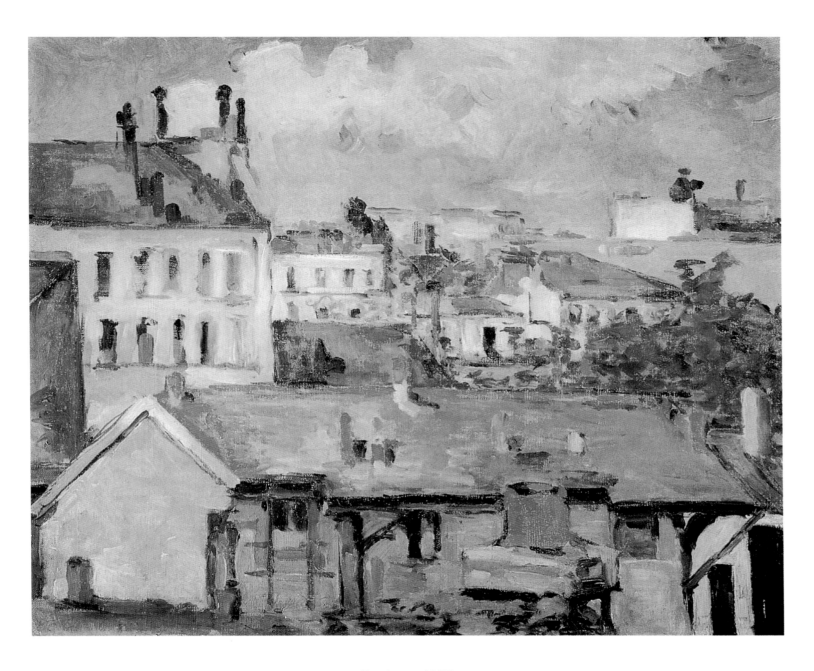

Roofs, ca. 1877
Les toits
Oil on canvas, 47 x 59 cm
Venturi 1515
Hahnloser Collection, Berne

Cézanne wanted to avoid the risk of being called up. Moving to L'Estaque, he avoided both conscription and the struggle for a new society (a struggle which many of his friends were involved in). The landscapes he painted at L'Estaque were a far cry from prevailing notions of landscape art. Cézanne's farmsteads, tracks and fields, impasto or applied with the spatula, used powerful contrasts of light and dark which made them seem more suitable as backdrops for his violent scenes. They did not fit contemporary taste in landscape painting, a taste which the Académie Française felt had gone quite far enough in any case.

Zola described the landscape approach of the Naturalist avant-garde in his 1867 critique of the Salon: "Traditional landscape is dead, killed by Life and Truth. No one nowadays would dare say that sky and water are vulgar, or that a horizon has to be painted evenly and precisely if work of any beauty is to be created . . . There are some contemporary landscape painters who have evolved a way of painting Nature to suit the taste of the public. It has a certain truth to it, yet at the same time it has all the flashy charm of a lie . . . What I find fault with in their work is the lack of a personal touch. They have taken the way things really are in Nature and produced a typical image of Nature, and that image can be discovered without any great variation in every one of their pictures. Talented Naturalists, by contrast, interpret according to a personal view of things. They translate truths into a language of their own. Nature is still their yardstick, but they retain their individuality too. First and foremost they are human, and that humanity is involved in everything they paint. That is why their works will last."

In his critique, Zola contrasted the Salon landscape artists with the Impressionist Batignolles circle, the early landscape work of Monet, Pissarro, Sisley, Jean-Baptiste Armand Guillaumin and Guillemet. Cézanne's L'Estaque landscapes might readily have been ranked alongside that work on the principle Zola himself laid down: "A work of art is a corner of creation seen through a temperament." Indeed, there is *temmperramente* (as Cézanne pronounced the word) in every single brush-stroke he made at that time. He could take the most tedious of motifs and transform them into something dramatic. Even his father's house, Jas de Bouffan, which makes so insipid an impression in contemporary photographs, seems vibrant with invisible force in the pictures he later painted (cf. p. 20).

Landscape as a genre had won recognition relatively late in France. The Académie still considered it an inferior branch of art because it was too "subjective", involving moods, ideas and valuation. Ironically enough, though, it was from within the ranks of the Académie that Pierre Henri de Valenciennes and his pupil Jean Baptiste Deperthes had established the *style champêtre* as a landscape genre in its own right, at the beginning of the 19th century. Yet notwithstanding the fact that the change from land-

House of Dr. Gachet at Auvers, ca. 1873
La maison du docteur Gachet à Auvers
Oil on canvas, 46 x 38 cm
Venturi 145
Musée d'Orsay, Paris

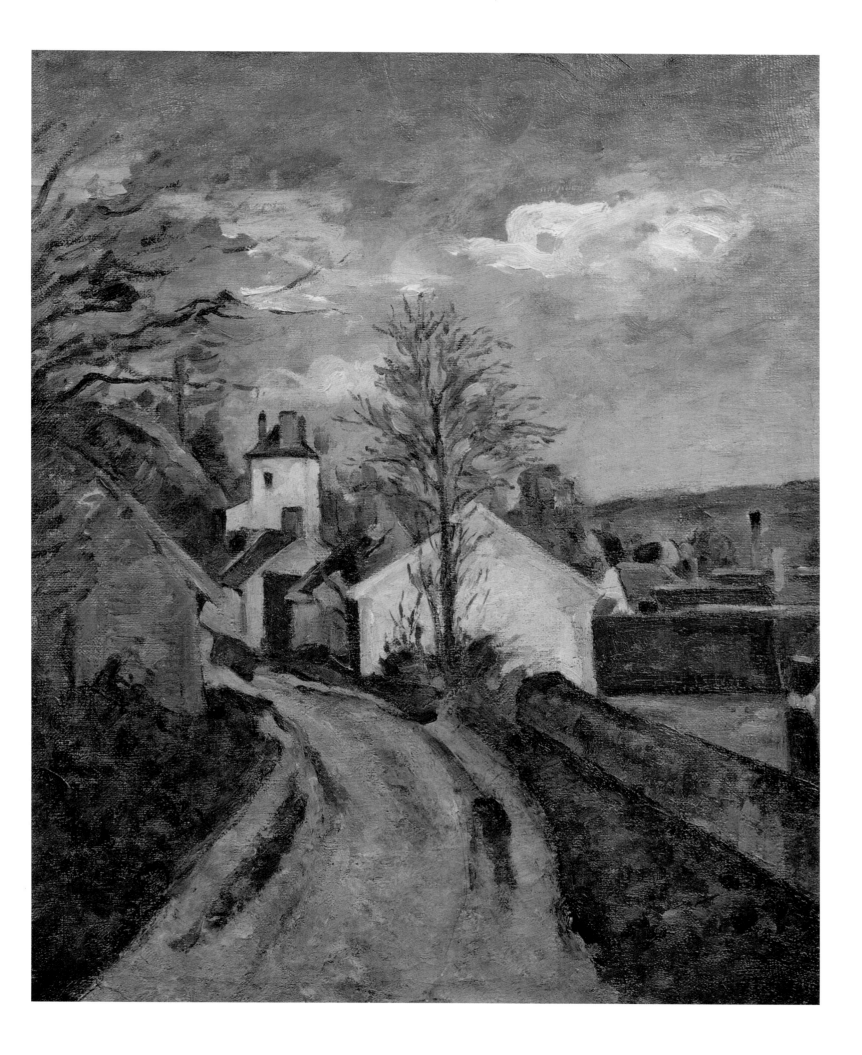

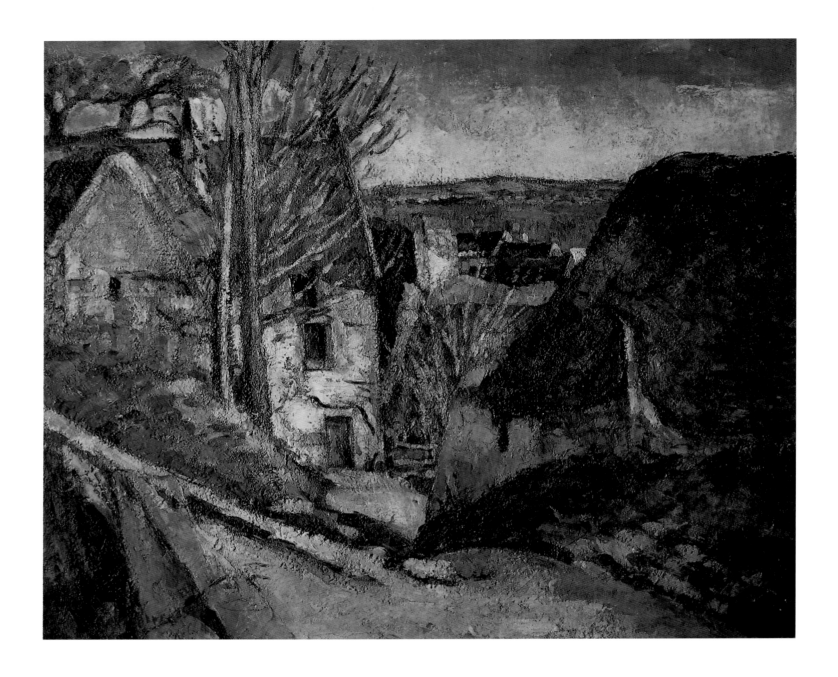

The House of the Hanged Man at Auvers, ca. 1873
La maison du pendu à Auvers
Oil on canvas, 55 x 66 cm
Venturi 133
Musée d'Orsay, Paris

scapes composed in a historical spirit to spontaneous, atmospheric sketches occurred within the institutional context, the academic school put up stubborn initial resistance to the "independent" painters, the Romantics and the Barbizon School, who preferred the *paysage intime*. This approach, derived from English art, called for close and affectionate scrutiny of the landscape of a particular region. The Barbizon painters had taken important steps on the way to a realistic view of landscape, and the Impressionists owed a good deal to their strategy. Still, it was an approach that also implied the retreat of Art from the critical concerns of Society, and the new mid-century interest in landscape painting can be seen as a flight from political reality. This was apparent to contemporaries such as the critic Jules-Antoine Castagnary, who referred to "Nature as escapism" at the 1857 Salon. And if the art of the Barbizon painters made possible that subjectivism which the Académie

viewed with such suspicion, the forest of Fontainebleau was quite literally a place of escape, since Théodore Rousseau (one of the Barbizon School) had persuaded Napoleon III to set aside six hundred hectares as a nature reserve. Metaphorically, we might see it as a reserve for anti-bourgeois artists at odds with the reality of the Second Empire. And certainly the Batignolles group, in dispensing with academic rules and subject matter, were also asserting their own freedom from the Empire's social norms and conventions.

Cézanne's idyllic conception of a peaceable life in the lap of Nature, a notion that had great inspirational force for him, was not merely utopian nostalgia for an imaginary island of bliss. Doubtless there were regressive elements in it; but it also continued that vein of social criticism which was apparent in his early work as a concomitant of his own inner state of emergency. After 1870, the oppressive visual terms of the early work were replaced by calm, by a new humility before the possibilities open to painting and art's "natural motifs". The substance of Cézanne's art was by no means altogether changed; he merely garbed it afresh, and it remained apparent in figural scenes, too. Cézanne now learned a good deal from the "school of Nature" (and from Pissarro), but his core (albeit subconscious) motivation, his fundamental sense of the harmony and security offered by Mother Nature, was never lost, and later he notably took it as his subject in the *Bathers* series.

In L'Estaque, Cézanne recalled Pissarro, his first advocate in Paris, his paternal friend and adviser. When Pissarro proposed that Cézanne join him in Pontoise so that they could paint from Nature together, the younger artist gladly acceded, and at the end of 1872 he and Hortense moved to Pontoise with their son Paul, staying first in a hotel near Pissarro's flat and then moving to a house in Auvers early in 1873. One of their neighbours was Dr. Paul Gachet. Dr. Gachet was a man whose unconventional appearance (he was known as Dr. Saffron because he dyed his hair yellow) was matched by equally unusual ideas. He familiarized himself with homeopathic methods at a time when they were widely pooh-poohed. A socialist of conviction, he would charge his poorer patients nothing. His practice proper was in Paris, in the working-class suburb of Saint-Denis. Gachet often accepted pictures as payment for the advice and treatment he gave his artist friends. An amateur painter himself, he loved art dearly, and supported his friends by buying their work or providing monthly allowances. Cézanne received a warm welcome at Dr. Gachet's home, and the moral support he so desperately needed. Possibly it was there that he was inspired to paint *A Modern Olympia* (pp. 78/79) which Gachet subsequently bought.

It has been usual to interpret Cézanne's stay in Pontoise and Auvers as a turning-point, his conversion to an Impressionist palette and technique. At the time, Pissarro had two main princi-

ples in his method of work. His palette was bright, consisting predominantly of primary and secondary colours lightened with white, and his brushwork emphasized brief strokes and dabs that conveyed an atmosphere of light reflected colourfully. He also made frequent use of a compositional approach borrowed from Corot, and especially from photography, selecting detail sections of a particular view and linking foreground and distance by means of perspective lines that were radically separated in the foreground. In addition, Pissarro adopted the Barbizon School's motif of the peasant seen in his everyday surroundings, a subject which Jean-François Millet had made his own.

The beauty of landscape always depends on Man; Man and Nature are inseparably linked in an essential symbiosis. It follows that a landscape without people cannot mean as much to Man as a landscape might (if it provided a natural *vita rustica*, offering hard work yet also essential rewards, as a counter to the *vita urbana* of the soulless city). When Cézanne opted for the country, and landscapes, his decision was fundamentally the result of an inner development connected with the frustrations of Paris and his sense of rejection both as artist and as human being. Sooner or later his restless to-and-fro between Aix and Paris had to be resolved: for Aix and Provence, for Pontoise and Auvers. Though Cézanne was a highly educated man, and could quote both modern literature and Latin verse from memory, he tended to be awkward and unrefined in his behaviour, speech and dress. Doubtless we should see his demonstrative failure to conform as a protest against all things conventional, which Cézanne, the misunderstood and as yet imperfectly mature genius, was out to resist. Whatever was middle-class in character aroused his rage and ridicule. Even Manet the presiding spirit of the Batignolles circle, Manet whom Cézanne honestly respected, was not exempt. On one occasion a childishly malicious Cézanne refused to shake the dandyish Manet's hand on the mocking grounds that he had not washed his hands that day.

The emotiveness of Cézanne's revolt, both within and without, now encountered the revolutionary mind of Pissarro, who was able to express emotion (in human and in artistic terms) with a greater maturity. Cézanne submitted to his counsel with the patience of a pupil. Louis Le Bail, a painter who went to see Pissarro in the 1890s, left a brief, slogan-style summary of his doctrine: "Look for a variety of Nature that suits your temperament – one should pay more attention to the subject's shape and colours than to the drawing – the brush-stroke, the right shade of colour, and the correct degree of brightness, should create the drawing's impact – make short brush-strokes and aim to record your perceptions directly – the eye should not be caught by one point but should take in everything and observe the reflections as it does so – paint energetically and do not hesitate, because it is best of all not to

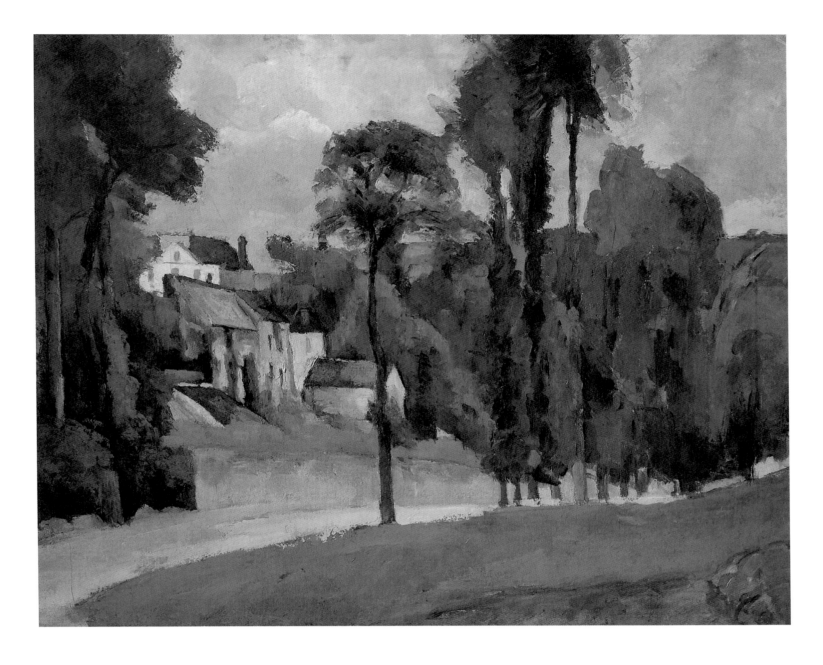

forfeit one's first impression – one should have one master alone, Nature, and to that master one should always turn for advice." When they studied subjects together, Cézanne learned how to observe and reproduce the diverse ways in which light was reflected. He used an aerial perspective that created unity of overall impact; created an atmospheric whole from the use of colour values in the subject and in the light; and would dab on the light colours (as in *View of Auvers from above*, p. 66).

Some of his pictures could have been taken for Pissarro's, in fact, and ungenerous critics accused the two painters of copying each other. As late as the 1890s, replying to an article by Camille Mauclair on the occasion of Ambroise Vollard's first Cézanne exhibition, Pissarro felt obliged to explain the mutual influence: "Undoubtedly Cézanne first came under the influence of Delacroix, Courbet, Manet, and even Legros, as all of us did; in Pontoise he was under my influence, and I was under his... In Cézan-

Trinitarian Monastery at Pontoise (The Retreat), 1875–1877
Paysage à Pontoise (Clos de Mathurins)
Oil on canvas, 58 x 71 cm
Venturi 172
Pushkin Museum, Moscow

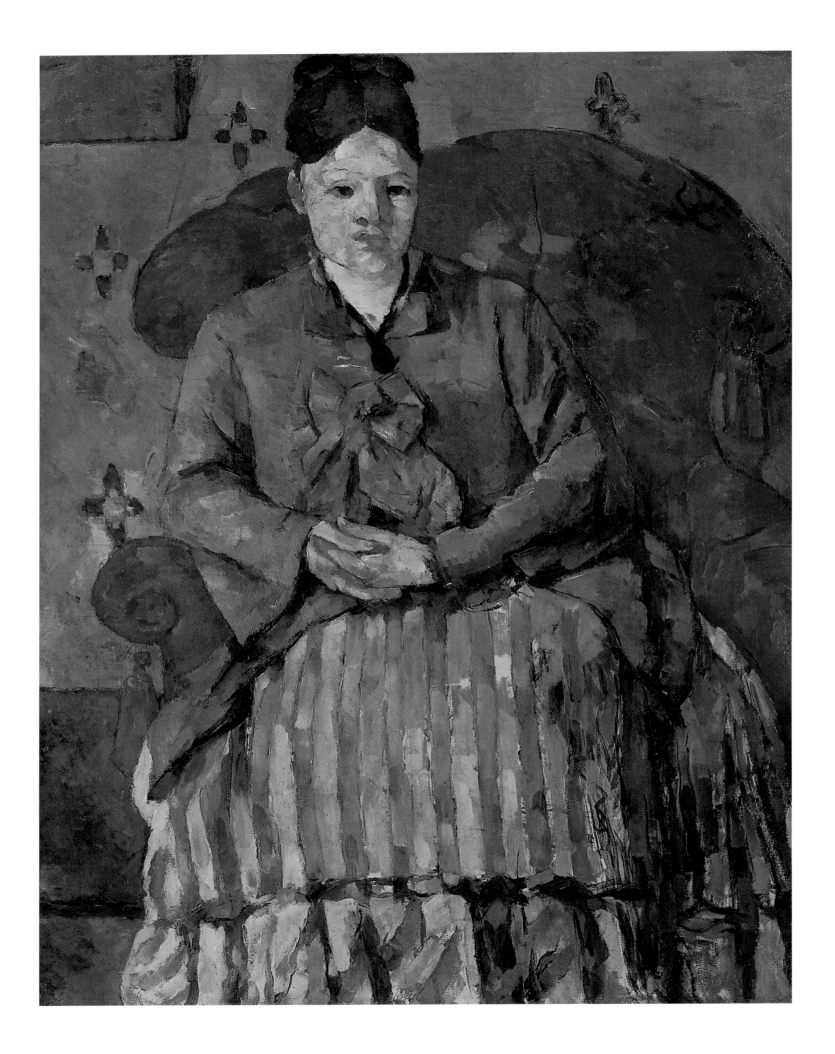

ne's exhibition at Vollard's, the closeness of some of his Auvers and Pontoise landscapes to mine is striking. Of course it is true that we were always together; but it is certain that each of us had his own response, which is the one thing that matters."

In *The House of the Hanged Man at Auvers* (p. 70), one of the best-known pictures Cézanne painted in those years, we can see him approaching Impressionism but at the same time keeping his distance. The freshness in Cézanne's treatment derives from the view between the houses and trees to the distance, the plain of Auvers, with hills beyond. But what is striking is the unusual layout of the foreground. In Pissarro's paintings, our gaze is generally drawn into the scene by perspectival means; in Cézanne's, a hummocky, grassy foreground area drops away into the middle and drags our gaze with it, between the buildings and down into the village. At left there is another wall arresting our gaze. Thus our line of vision is curiously crossed and broken in this composition; and its disconcerting air is made even more unsettling by the lack of a fixed point of view. In its bright and subtle use of colour, this picture is the closest Cézanne comes to Pissarro's technique; yet he departs from the practice of Impressionist works in employing a carefully calculated internal structure. Three parallel levels mark the foreground, middleground and background, and are unified into one structural whole by the uniformity of colour values; this was subsequently to become one of Cézanne's major compositional principles. Pissarro's choice of motif, viewpoint and detail has a more random flavour, a flavour of first impressions. Cézanne, though, even when he is closest to Impressionism (as in this painting), is notable for the calculation in his approach to his subject, and for his structural density.

In the 1870s, Cézanne was already evolving the way of applying paint which was to be characteristic of what is known as his "constructive" period (after 1878). A farmer who watched Pissarro and Cézanne at work remarked laconically that Pissarro was "stabbing the canvas" whereas Cézanne "slapped the paint onto it". Lucien Pissarro, the painter's eldest son, recalled that at that time Cézanne began to mark out a structure of subtle diagonals by means of precise brushwork, while Pissarro would paint in small strokes like commas, a method which was to enrich the Impressionists' technical repertoire under the name *virgulisme*. Cézanne's method of applying paint in short, parallel strokes had the effect of weaving a sense of textural unity that included all of the things in a painting in a colourful overall impact. The visual substance acquired the coherent solidity of a crystalline structure.

Given these differences, it seems pointless to debate whether Cézanne was ever an Impressionist. Once the heyday of Impressionism dawned, Cézanne had already put both Paris and Impressionism far behind him. He had work on show in the first and third Impressionist exhibitions, and the great differences in choice of

Madame Cézanne in a Red Armchair,
1877
(also known as: Madame Cézanne in a Striped Skirt)
Madame Cézanne dans un fauteuil rouge
(Madame Cézanne à la jupe rayée)
Oil on canvas, 72.5 x 56 cm
Venturi 292
Museum of Fine Arts, Boston, Robert Treat Paine II Foundation
By kind permission of the museum

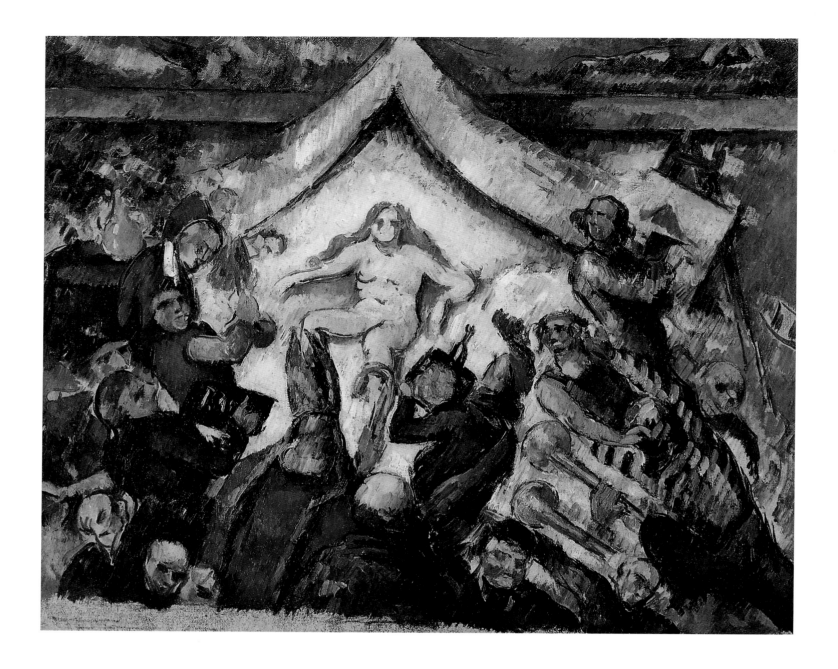

The Eternal Feminine, 1875–1877
L'eternel féminin
Oil on canvas, 43 x 53 cm
Venturi 247
Private collection, New York

subject and technical treatment were plain to him. He had learnt what Pissarro could teach him – a light palette, emphatic colour highlighting, a new brushwork technique, and above all devotion to landscape – and he would never forget any of it. But in terms of their responses to the things they saw, the two painters were worlds apart, and of course it showed in their art. In Cézanne's perceptions there was greater complexity – quite simply, there was *more* – than could ever be seen by the Impressionist eye. His way of seeing was alive with that passion within which he had but recently disciplined, and with that longing for harmony and permanence which he was trying to express in new means. Impressionist technique provided him with a point of departure in his exploration of other avenues of artistic expression.

The welcome he had received in Pissarro's and Dr. Gachet's households restored Cézanne's courage and confidence. His pri-

vate situation was still difficult, though, and without the support of his friends he would have found it hard to get by. He even paid for his groceries with paintings. Pissarro put Cézanne in touch with Paul Durand-Ruel, the first dealer to specialize in Impressionist art (a decision which nearly ruined him). Pissarro also took him to Père Tanguy, a Parisian paint dealer, who had escaped death by a hair's breadth during the Commune and was already making provocative speeches again. Tanguy was a dedicated supporter of the "bright" art of the Batignolles painters. The freshness and originality of Cézanne's works appealed to him, and so he provided the artist with paint and canvas, in return for pictures to sell to clients. In due course his stockroom filled with Cézannes of every period attracted young painters such as Emile Bernard, Maurice Denis, Paul Gauguin and Vincent van Gogh on pilgrimages, to revere their new master, Cézanne.

Nude Study, 1885–1895
Pencil and wash, 63.5 x 49.4 cm
Fogg Art Museum, Harvard University,
Cambridge (Mass.)

For Pissarro and the others at the Café Guerbois, things were little better. The 1873 economic crisis did nothing to improve Durand-Ruel's trade; and the Salon was as closed to these paint-ers as it had ever been – the criteria of selection had not been relaxed in the new Republic. Courbet was debarred from exhibiting because of the part he played in the Commune. Monet, Pissarro and Sisley submitted nothing, in protest. Renoir was turned down. Only Manet's *Le Bon Bock*, not one of his best, won the jury's approval. And so it was that – rather than exhibit at a second Salon des Réfusés – they turned to the plan of a joint exhibition which had been in their minds since 1867.

On 5 May 1873, the day the Salon opened its doors, Paul Alexis (a friend of Zola and Cézanne) made public the proposal for an independent exhibition in *L'Avenir National.* Evidently his article drew upon talk amongst the Batignolles circle in the Café Guer-bois. Briefly he summarized the reasons for spurning exhibitions controlled by selection panels. Republicans (he wrote) were ac-cusing the Academie of betraying the Republic; but in point of fact the jury was not guilty, since *any* jury was invariably blind and ignorant as far as art was concerned. "We must get rid of the jury!" What mattered now (he wrote) was to organize an independent exhibition. Monet, replying on behalf of the circle, promised that one was in preparation. Alexis published Monet's letter on 12 May, adding the information that a number of important artists, including Pissarro, Johan Barthold Jongkind, Sisley and Guillaumin, were already behind Monet.

On 15 April 1874 the exhibition by the *Société anonyme des artistes, peintres, sculpteurs, graveurs, etc.* opened in the studio of Nadar, the photographer in the Boulevard des Capucines. Along with the Batignolles group (Manet excepted) more conventional, non-revolutionary artists who simply wanted to avoid the jury selection procedure exhibited too. The Café Guerbois circle were in fact a minority. Nonetheless, it was they who bore the brunt of

A Modern Olympia, 1873/74
Une moderne Olympia
Oil on canvas, 46 x 55.5 cm
Venturi 225
Musée d'Orsay, Paris

the derisive criticism. Their work was damned as "unfinished", "slovenly", "anarchist", and "subversive". They were rebels, departing from the norm. It was the Commune all over again. The press and the public were agreed in their dismissal of the exhibition: it was a national disgrace! The unanimous outrage of the bourgeoisie (predominantly Bonapartist or Royalist in temper) suggests that they were deeply unsettled. To be on the safe side, they assumed that a "painters' co-operative" and "slovenly" art must hail from the rebellious Communard camp. "They were accused of being Communards, and if the situation had been only a little more sensitive their paintings would have been burnt," wrote Gustave Geoffroy, a friend of the "rebels".

The public had grown accustomed to the "pure" landscapes of Corot and Daubigny – but whatever were these pictures that broke every rule of composition, pictures with no recognisable perspective, uniformly bright, and with emphatic colour highlights, pictures that trampled on the traditional sense of near and far! Approval would have been tantamount to opening wide the door to anarchism (and not only in art)! And how sloppily the paint was applied! True, the academic style in landscape permitted emphasis of light and colour and overall tonal effects. But a painting ought to give the impression of being finished. It should be carefully composed, and the brushwork ought not to draw attention to itself. These Impressionist pictures failed altogether to satisfy normal criteria. Indeed, the very word *impression* was taken by the art critic Louis Leroy to imply sketchiness and haste – the label summed up all the derision and abuse that were heaped on the paintings.

And then the subjects they chose to paint! Even the well-disposed Castagnary observed: "M. Pissarro paints simply and vigorously. His all-seeing eye grasps a total scene at once ... Otherwise, though, he does have a lamentable love of fruit and vegetable gardens, and will not allow even the humblest cabbage or other vegetable to deter him." Though painting cabbages, the vegetable of ordinary people, was doubtless a natural gesture in the direction of simplicity, wasn't it still a shade too banal?

But it was Cézanne's paintings that represented the triumph of "ugliness" and were the universal target of ridicule. With Monet's and Pissarro's recommendation he had submitted three Pontoise works: an Auvers landscape, *The House of the Hanged Man at Auvers*, and *A Modern Olympia* (pp. 78/79). Castagnary was generally a thoughtful and open-minded critic, and welcomed Impressionist art as "lively, captivating, full of vitality"; but Cézanne's work gave him (and many others) pause. The "School of Naturalism" had scarcely ventured before the public (he wrote) but it was already showing regrettable signs of decay. "After their idealistic beginning they will succumb to unrestrained Romanticism where Nature is merely a pretext for reveries. Their powers of imagination are no longer capable of expressing anything other than personal,

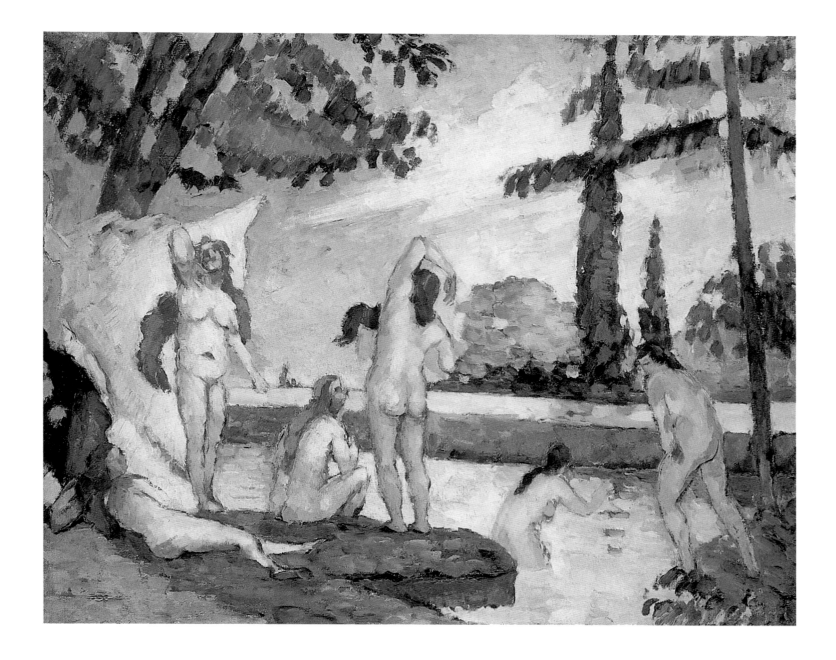

subjective fantasies which are unanswerable to reality and thus have no universal validity whatsoever."

Conservative critics were more forthright in their mockery of Cézanne: "On Sunday the public had occasion to scoff at a fantastic figure being presented to a dope addict beneath opium heavens. This apparition of naked, delicate pink flesh, a sensual vision offered up on an empyrean cloud by some kind of demon or incubus – this little hideaway in some fabricated paradise astounded even the most daring. M. Cézanne gives the impression of being a species of lunatic, painting with delirium tremens."

A Modern Olympia takes a twofold risk. With even greater directness than the work it is modelled on, Manet's *Olympia*, it shows a compromising situation such as every good citizen was aware of but repressed. It also tackles a societal issue that Zola later took as his subject in his novel *Nana*: prostitution, and the transformation of human relations into an exchange of com-

Six Women Bathing, 1874/75
Baigneuses
Oil on canvas, 38 x 46 cm
Venturi 265
The Metropolitan Museum of Art, New York

Beside the Seine at Bercy,
1876–1878
La Seine à Bercy (d'après Guillaumin)
Oil on canvas, 56 x 72 cm
Venturi 242
Hamburger Kunsthalle, Hamburg

modities. "Nana becomes an elemental force, a destructive ferment, but without ever intending to. It is her sex, the scent of woman, that destroys everything that comes near her... The full power of the arse. The arse on an altar where all go to worship. An entire society pounces on her arse. The poem of male desire, that great lever that sets the world moving. There is only arses and religion. So I must show Nana at the centre of it all, like an idol before which men (of different temperaments, for various reasons) prostrate themselves."

The "fabricated paradise" expressed fantasies that were not only Cézanne's. Within this provocatively succinct treatment of the time-honoured subject of bought love, an anti-middle-class attitude lay concealed, that attitude which prized the visionary imagination of the artist. Baudelaire had turned to the visionary in answer to the processes of disintegration he beheld all around him: "Genius is childhood rediscovered!" What Baudelaire meant was a deliberate return of the artistic imagination to primary processes,

a return which the use of drugs (for instance) made possible. The totality of human experience thus aimed at, the sensuous unity of the inner and outer life, was dealt with in Baudelaire's poems (which Cézanne could quote by heart) – and in *A Modern Olympia*. This taxed the understanding of a bourgeois public rather too much; but naturally gallery-goers understood an assault on "public morality" only too well. The dramatic technique and powerful colours served to emphasize the "indecency" of Cézanne's scene, and guaranteed that the Bouguereau Salon public would blush ...

It was now three years since Cézanne had last been in Aix. The need to placate his father or put off his mother recurred with mounting frequency. And the malicious reception the Impressionist exhibition was given only made things worse. So Cézanne decided to return to Aix. Pissarro painted a portrait of his friend to mark Cézanne's departure from Pontoise (right). Cézanne – wearing a thick jacket and a fur cap – makes a stocky impression, and looks paralyzed by the blows of Fate. His gaze seems reticent and evasive, but has a touch of childlike defiance and helpless protest too. "Life is terrible" for an artist who wants to believe in his vocation but whom no one seems prepared to take seriously. In the background Pissarro summarizes their Pontoise programme. At the lower right there is one of his own landscapes, *The Gisors Road* (1873), glancing at his "doctrine". Above it there is a caricature portrait of Courbet as a martyr (Courbet had been wrongly accused of destroying the Vendôme column, and had been found guilty); he appears to be gazing down at Cézanne and raising his glass to drink his health. To the left is a further caricature, of Adolphe Thiers, first president of the Republic. With the new France, the Master of Realism, and the teachings of Impressionism, Pissarro's painting seems to be wishing Cézanne well on the way ahead.

Impressionism itself seemed to bode only ill at that time, though. With critical malice added to the ridicule of the man in the street, sales of pictures remained far below what the artists had been hoping for. When the *Société anonyme* drew up its accounts, every exhibitor turned out to owe 184.50 francs. By general consent, Renoir dissolved the society. Pissarro's situation grew so precarious that he and his family moved in with another painter friend at his farm at Montfoucault. To raise funds, Renoir, Monet and Sisley decided on an auction of Impressionist paintings at the Hôtel Drouot. Well-disposed critics tried in vain to create an air of solid respectability by making bids; they were shouted down in the uproar. Hardly surprising, maybe, after the critic Albert Wolff had heralded the event in *Le Figaro* in this fashion: "The impression the Impressionists convey is of a cat trampling on the keys of a piano, or an ape that has got hold of a box of paints."

One serious collector at the Hôtel Drouot was Victor Choquet, an obscure customs inspector. Friends had deterred him from view-

Camille Pissarro:
Portrait of Paul Cézanne, ca. 1874
Oil on canvas, 73 x 59.7 cm
Private collection, Basle

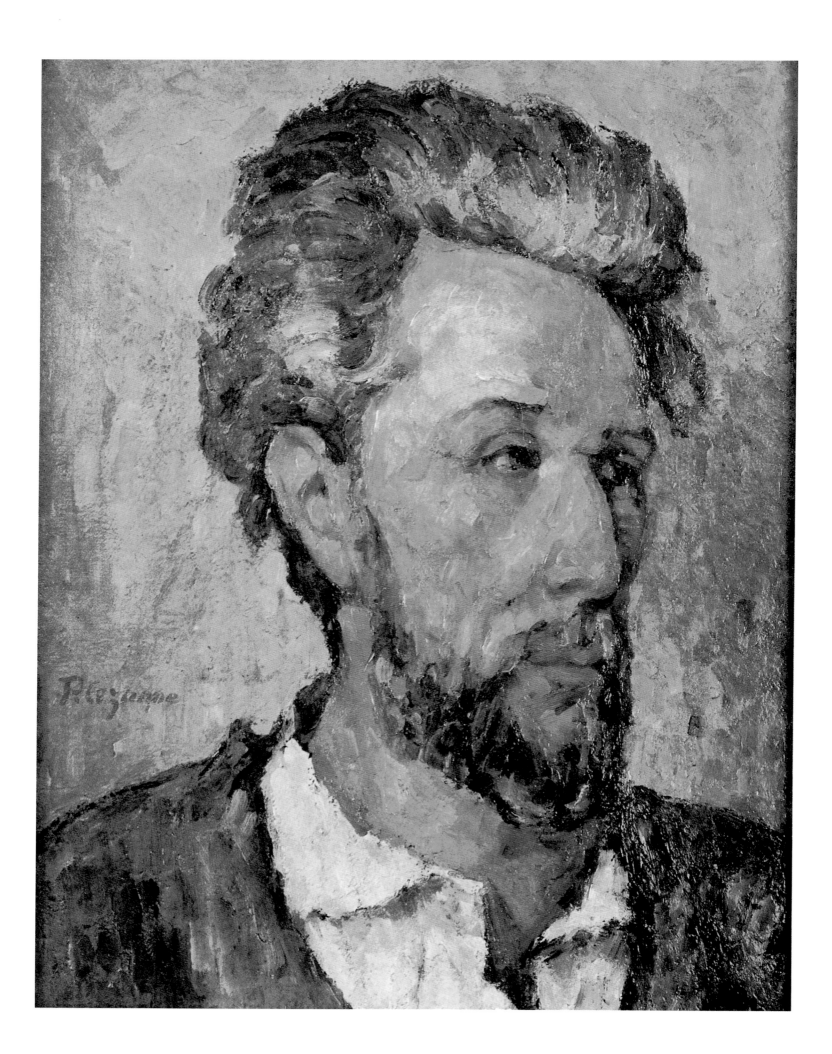

ing the exhibition at Nadar's. Now he finally saw Impressionist work for himself, and instantly became an ardent admirer. Renoir (whom Choquet commissioned to paint his wife in 1876) took him along to Tanguy's to show him Cézanne's pictures. Choquet was overwhelmed, and eager to make the acquaintance of this marvellous talent. It turned out to be a meeting of kindred spirits, and Cézanne, looking at Delacroix's water-colours with Choquet in the latter's Paris apartment, quite forgot his habitual wariness and fear of being made to look a fool. And then he withdrew to Aix once again, and concentrated on figure paintings of men and women bathing in the open. Cézanne referred to these works as studies.

His work of the 1870s differed from the earlier period in being the product of new discipline: sophisticated composition and a lighter palette showed that a maturer Cézanne had learned the lessons of Pontoise well. His statements were fundamentally the same, though. However various Cézanne's subjects and stylistic phases, there was a psychodynamic constant that made its presence felt throughout, objective though he might aim to be. That constant was the reconciliation of opposites, the mythic union, the longed-for purification of a besmirched existence full of conflict into a new, crystal-clear unity which would enfold what was once divided and discrete in an all-embracing higher order.

It was a time of struggle, renunciation, and apparent failure. And Cézanne was still far from attaining that vital contemplative peace which would have enabled him to express his experience in art and evolve an altogether new quality of artistic communication. Impressionist technique helped him approach his subjects in a disciplined manner, and he was now able to tap the resources of colour. But his core content still derived from deeper, darker levels of the human condition. His pictures were not cheerful idylls, scenes of easy-going conviviality, or experiments in precise recording of colour and light. "Monet is nothing but an eye – though, God knows, what an eye!" commented Cézanne, mixing deprecation with his obvious admiration. Cézanne still had some way to go before he had the calm command that was needed to work *sur le motif*, to make the profoundest depths of Nature his own.

Some time in the period 1875-1877, using the light colours of Impressionism and the short brush-strokes he had taken to in Pontoise, he painted *The Eternal Feminine* (p. 76), a picture which constitutes a highly original recapitulation of the thematic concerns of his early work. There she is, the "unchaste whore", the demonic woman, enthroned on a billowy kind of bed canopied with a baldachin – and, in attendance on her, hosts of men from every walk of life, painters, writers, musicians, bankers, even clergymen, all come to worship at the altar of sin. The entire scene has a curiously disjointed, unclear quality, like some fleeting mirage or an image from a dream. Is this homage to the eternal feminine set in an interior, as the vase on the table to the left would suggest? Or is it in

Trees in the Park, 1874
Pencil, 23.6 x 17.7 cm
Graphische Sammlung Albertina,
Vienna

the open, as seems to be implied by the wall behind the woman, towards the top of the picture, beyond which we can see the green shoreline of a sea? Interior and exterior seem to have entered into a symbiotic union. Rational distinctions have been supplanted by the symbolic logic of an artistic vision. Was Cézanne inspired by Zola? Or had he perhaps seen Manet's *Nana* (Kunsthalle, Hamburg), which was turned down by the 1877 Salon jury and could subsequently be seen in the window of a fashionable store in the Boulevard des Capucines? Among the Romantics, and in Baudelaire too, Woman was often seen as a demonic creature of ill omen, and possibly this influenced Cézanne's approach; though he may equally well have been making an ironic comment on his own ambivalent attitudes to women. The ideal of the eternal feminine with which Johann Wolfgang von Goethe chose to end the second part of *Faust*, an ideal of universal exaltation and sublimity, has been rendered a faceless monster of the flesh in Cézanne's painting, with no meaning other than the sexual.

To the painter on the right, this woman represents the temptations of Eros incarnate. But she is also a goddess of Time, the grand Babylonian whore, enthroned by lucre. Flesh and money are the two sides of a single coin in a consumer society which has denatured human relations. Seen like this, the painting proves to combine Cézanne's private obsessions and thwarted desires with a critique of society. The men thronging about the female idol epitomize the folly of the middle classes who scorned Cézanne's paintings, preferring their consumer pleasures and purchasable caresses. Writing to Zola from Marseille on 24 September 1878, the painter put his contempt for the "bastards in society" in forthright terms: "You have no idea how presumptuous these wretched people are. They have just one single instinct: money-making. People say they earn a lot. But they are excessively ugly — when you look at them from outside, social habits blur whatever traits of originality these fellows might have had. In a few hundred years there will be no point in living any more; everything will have been levelled out." Viewed in these terms, the painting settles Cézanne's old score with the "irresolute philistines" who put their money in the bank or spent it in the brothel rather than supporting lofty artistic ideals. That said, though, we should note that the painter (and other creative artists) is included in the worship of this Golden Calf. The painter is tempted too (as we can see in so much of Cézanne's early work). He too is held in thrall by unsatisfied desires. But he fought the dangers in his work at the easel; and in his later work, far from joining in the chorus of the damned, Cézanne put a mountain at the centre of his visual world, Mont Sainte-Victoire.

That mountain functioned as a counterbalance against the tendency to dissolution, against a flood of negatives. The demonic woman was also the all-devouring Terrible Mother, more a menace than a seduction, an archetype that was not so much a sign of

Aqueduct, 1885–1887
L'aqueduc
Oil on canvas, 91 x 72 cm
Venturi 477
Pushkin Museum, Moscow

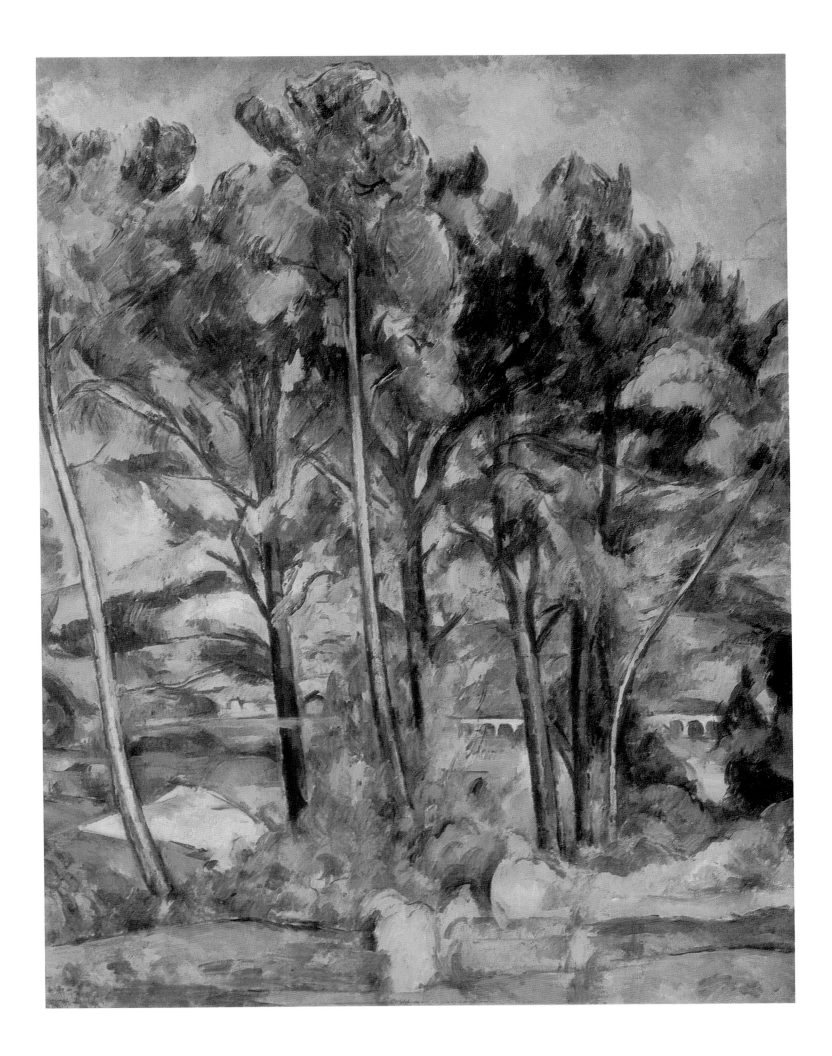

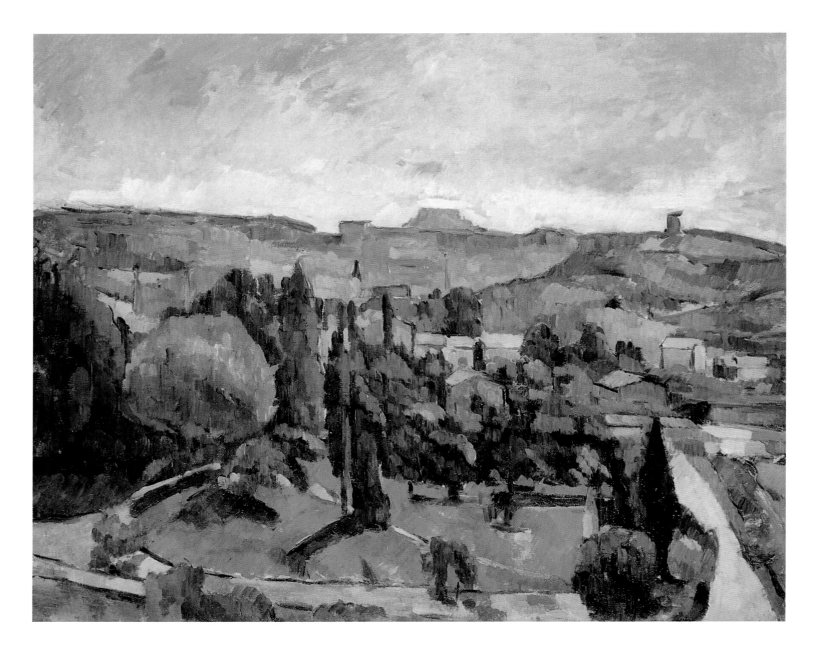

Pilon du Roi from Bellevue,
1884/85
Le Pilon du Roi, vue de Bellevue
Oil on canvas
Venturi 416
Private collection

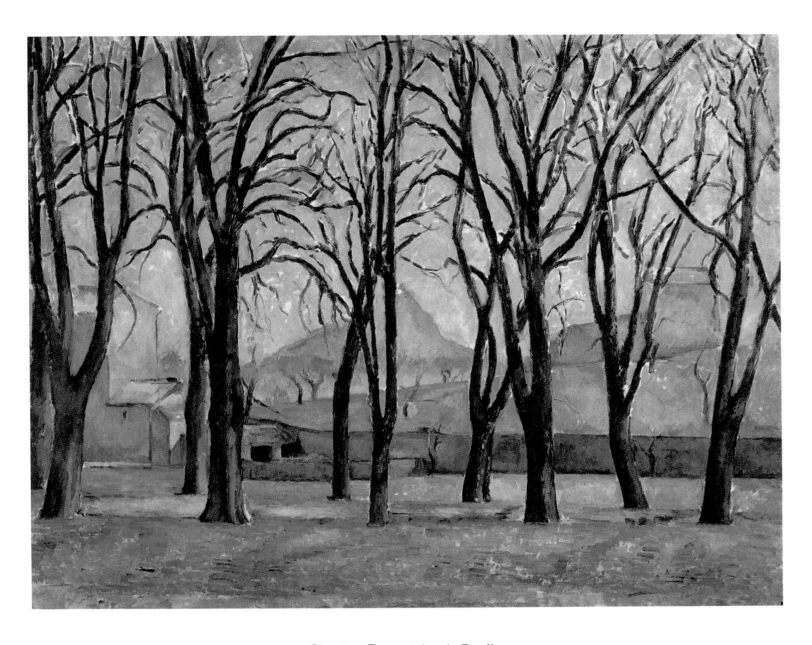

*Chestnut Trees at Jas de Bouffan
in Winter,* 1885/86
Marroniers du Jas de Bouffan en hiver
Oil on canvas, 73.8 x 93 cm
Venturi 476
Minneapolis Institute of Art,
Minneapolis

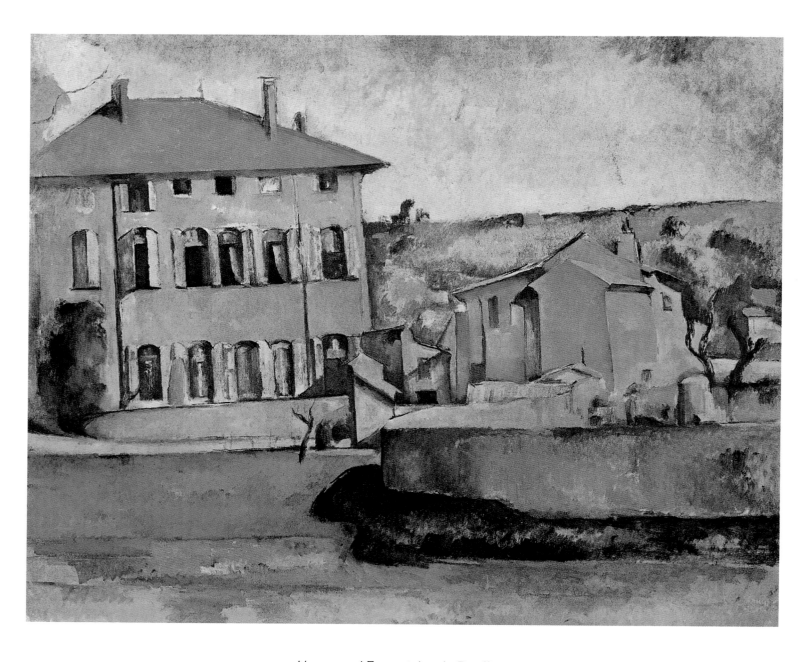

House and Farm at Jas de Bouffan,
1885–1887
Maison et ferme du Jas de Bouffan
Oil on canvas, 60.5 x 73.5 cm
Venturi 460
Národní Gallery, Prague

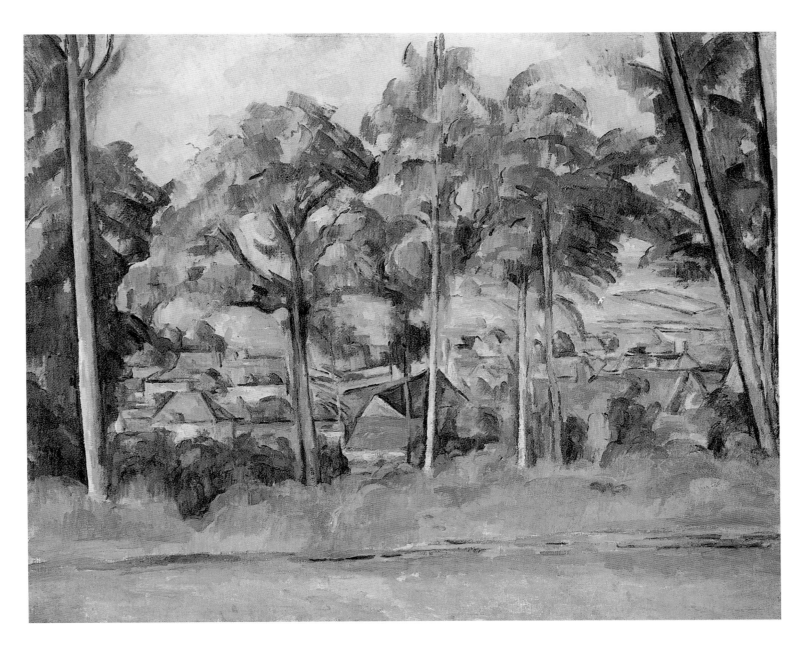

Village in Provence, ca. 1885
Village en Provence (Campagne
méridional)
Oil on canvas, 65 x 81 cm
Venturi 438
Kunsthalle Bremen, Bremen

sexual neurosis (though that might also play a part) as a depth-psychological constant in the quest for human identity. Throughout his life, Cézanne remained unsure of himself and ill-suited to normal contact. He left everyday reality to two women who had great power over him, his mother and his sister Marie. He himself continued in his attachment to illusions – illusions that were not to become artistic ideals until late in his life, when they defined his achievement and laid the foundations of lasting fame.

We have few pictures of these two women who had so profound an influence on Cézanne. Of his mother there is only an early portrait on the reverse of a portrait of his sister Marie (1866/67). That delicate and gentle image of his sister is matched by another which is quite different (1865/67), showing her melancholy and mysterious, a dark and negative alter ego. This split of the feminine into the good and the bad was characteristic of the times, and can be found throughout the art and literature of the age (not only in Cézanne). *Girl at the Piano (Tannhäuser Overture)* (p. 43) is one of his most interesting works in this context. It was painted in the late 1860s, when a German musician called Morstatt introduced Cézanne to the music of Wagner. At left is the artist's sister, playing the overture of the title on the piano; behind her, slightly off-centre, sits his mother, knitting. To the right is a comfortable armchair where the father would normally be sitting and where in fact he *was* sitting in an earlier version of the picture, before Cézanne painted him out. It is difficult to imagine Cézanne's oedipal conflict being more vividly illustrated. The threesome will only be complete if Cézanne takes the armchair and joins the atmosphere of warmth and security established by his mother and sister.

The allusion to Wagner's *Tannhäuser* confirms this interpretation. There had been violent protests when the so-called Paris version of the opera was premièred in 1861; on the other hand, others were wildly enthusiastic, and the Wagner cult was founded. The opera made a deep impression on Baudelaire, and in his essay *Richard Wagner and Tannhäuser in Paris* he defended Wagner in terms of his position in the art of modernity. That essay was no ordinary hymn of praise. What gave it its distinctive flavour was Baudelaire's attempt to translate the impressions made on him by Wagner's music into lyrical prose, a synaesthetic procedure that was to have tremendous influence on Symbolism. One of Baudelaire's poetic passages of paraphrase dealt with the overture to *Tannhäuser*, a bacchanalian orgy in which Baudelaire saw the divine and the diabolic locked in combat. And Venus was in league with the Devil. Venus stands for the destructive *femme fatale* who offers the satanic cult of sexuality in place of the middle-class, Christian code (marriage, chastity, discipline) which Elisabeth represents and dies for. The "psychic duality" Baudelaire saw in Tannhäuser, that inner conflict between artistic sublimation and instinctive drives (enacted with impassioned fury in the Venusberg

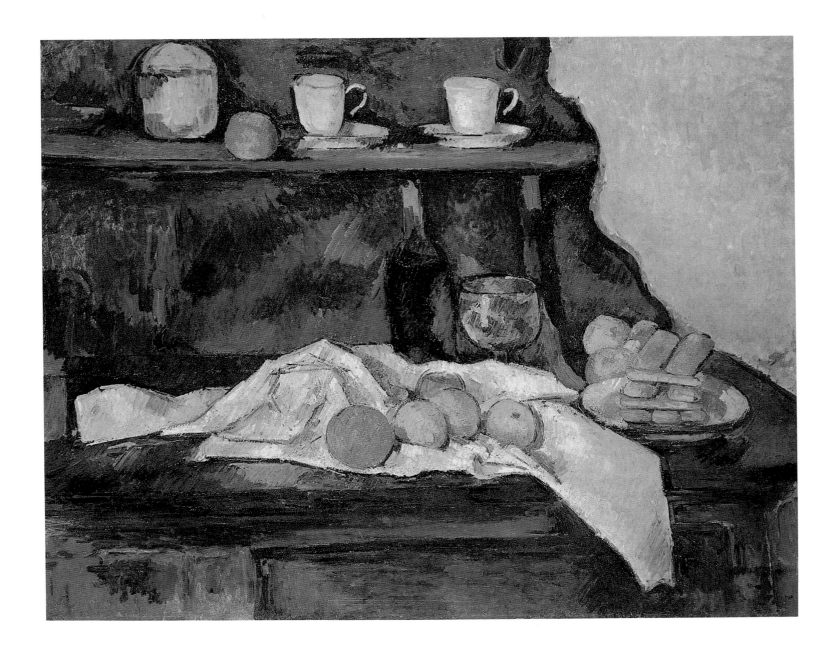

bacchanal), inevitably struck a chord with Cézanne (and with many other artists). The problems of Tannhäuser were his own.

The eternal feminine was the temptation of Eros that the painter had to resist in order to locate the "divine genius" within himself. In the struggle of love, the conflict of divine and profane love was expressed in bacchanalian, orgiastic terms before attaining another artistic level. Cézanne's longing for union with Nature (which he revealingly put as working "sur le motif") issued in his Provence landscapes, particularly those showing Mont Sainte-Victoire, and the figure paintings of bathers. Nature (in the widest sense), and the yearnings for fulfilment and security that Nature could satisfy, were no longer symbolized in the myth of Woman but in a totality of structure that transferred Cézanne's wishes and fantasies to a higher level, both technically and thematically.

Receptacles, Fruit and Biscuits on a Sideboard, 1873–1877
Le Buffet
Oil on canvas, 65 x 81 cm
Venturi 208
Szépmüvészeti Múzeum, Budapest

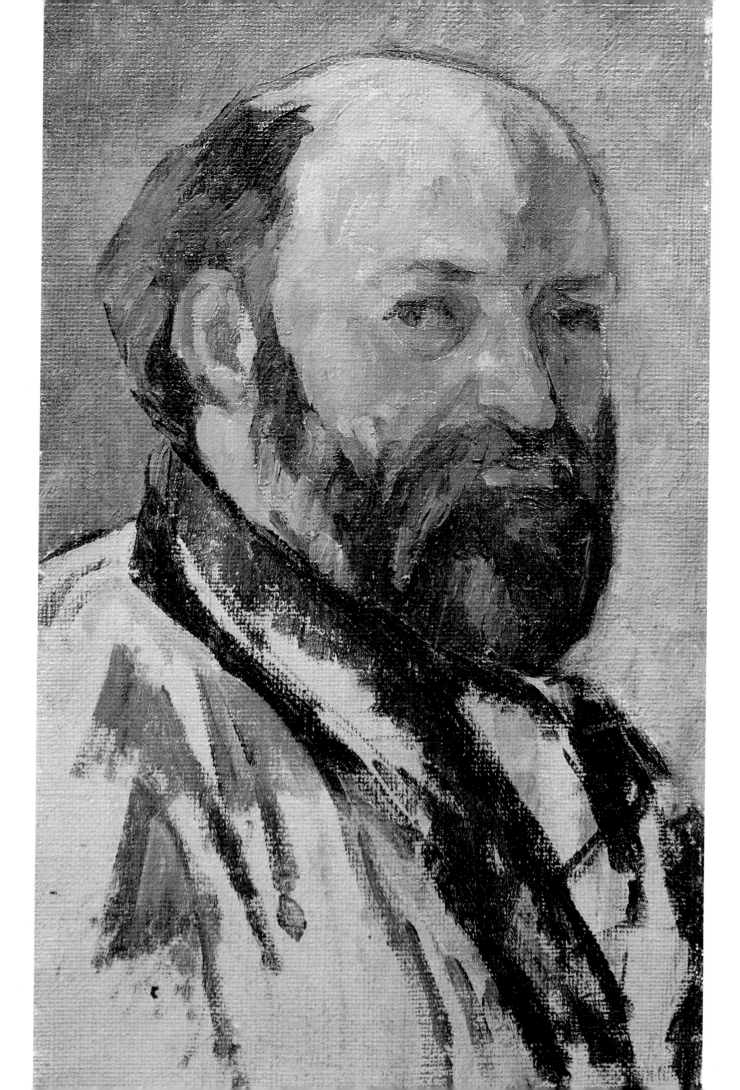

When Cézanne turned to Nature after 1872, in his landscapes, still-lifes, and figure paintings, he did so partly in a spirit of nostalgia, questing for an earthly paradise or at least for the arms of Mother Nature (however ambivalently she might be conceived), but partly too with his gaze fixed ahead, drawing imaginative power from his (subconscious) conflicts, establishing new techniques, new motifs, a new style of communication, a new approach to harmony. For Cézanne, Impressionist painting technique was a means of reconciling opposites. Colour had the power to link near and far, hard and soft, coarse and tender. The Impressionist way of handling the brush transformed the world of infinitely various things into a homogeneous fabric of paint, of chromatic associations. Cézanne both adopted and adapted Impressionist technique. Vibrant atmospherics were not enough for him, nor was he content with the subtle interplay of highly sophisticated innuendoes of colour and light. He did not want to draw a veil of colour over the world of real objects. He wanted contact amongst things, that community in Nature which Cézanne the man never attained and which he indeed flinched from. Cézanne's landscapes, even those painted under the supervision of Pissarro, were firm and thoroughly structured; compared with the work of Pissarro himself (or of other Impressionist artists) they seem as palpably solid as masonry. It is as if Cézanne had laboriously built protective walls against a tidal wave of the negative anima. They are islands in an ocean of Impressionist paint. His brush-strokes record a conception of Nature based on permanence and depth, association rather than dissociation, making of the diversity of Nature (which so inspired the Impressionists) something altogether distinct, enduring and profound and thoroughly integrated.

Probably the first Impressionist exhibition brought home to Cézanne how little he had in common with them, and he did not exhibit at the second show. Instead, he (and Pissarro) joined Alfred Meyer's Union Artistique. The second Impressionist exhibition in 1875 once again met with violent criticism, but sales were better, and proposals for a third show were made not only by the painters but also by leading collectors and critics. Not wishing to jeopardize the chances of the third Impressionist exhibition, Cézanne and Pissarro quit Meyer's co-operative and took part. Cézanne had seventeen pictures on show; and, as before, they attracted the most vituperative attacks. His paintings met with laughter and abuse from press and public alike. One of the works he exhibited was Victor Choquet (p. 84); it was promptly dubbed "Billoir en chocolat" (Billoir being a notorious murderer of the time). Choquet himself tried to bring gallery-goers round to Cézanne's art, but he was only ridiculed. Cézanne was truly "intransigent, stubborn, pigheaded, fantastic", according to Le Petit Parisien: "We must confess – on looking at his Bathers, his head of a man (Choquet), his Female Figure – that the impressions we get from Nature have

nothing in common with those the creator of these pictures gets." And Leroy, the cynical critic who wrote for *Charivari* and had coined the term "Impressionism", offered "a word of good advice" to pregnant women, whom he urged to hurry past the portrait of Choquet: "This strange, leathery head might make too powerful an impression on you, and cast a spell on the fruit of your wombs, infecting it with jaundice before it sees the light of day."

Georges Rivière's response in *L'Impressioniste* was the sole riposte to the scathing assault on Cézanne: "Of all these painters, M. Cézanne has suffered the most attacks and abuse over the past fifteen years. He has been the butt of every conceivable kind of defamation. His work is laughed at and will continue to be laughed at . . . For my own part I know of no painter's work that makes me laugh less. His work might prompt one to compare M. Cézanne with an Ancient Greek. His paintings emanate the same peaceful, heroic serenity as the pictures and terracottas of antiquity. The ignorant people who laugh at a picture like his *Bathers* remind me of barbarians criticizing the Parthenon."

The pendulum had swung to the opposite extreme: Cézanne was being exalted by a comparison with the art of antiquity. Borrowing from classical art was considered proper in the 19th century, as dozens of Salon pictures demonstrated. Even a serious artist such as Pierre Puvis de Chavannes quite unmistakably took what he wanted from "classical" painters such as Poussin. The subject of bathers (which had a tradition going back to the Renaissance) had been re-used by contemporary painters and interpreted in a modern style. Cézanne would doubtless have admired works on the subject by Titian, Rubens or Poussin in the Louvre. He had been far more impressed, though, by contemporary treatments by Courbet, Delacroix or Manet. Cézanne was not at all interested in a classicist revival. If bathers now became one of his regular subjects, it was not because he was prompted by classical sources. The studies he drew for these works were often crude, the very opposite of a neo-classical ideal of beauty. The coarse realism of Courbet and Honoré Daumier still informs these works, and in terms of composition they can seem stiff and unconvincing. Still, this was the subject Cézanne chose as his very own. And in it he was to evolve a symbolism that translated the latent conflicts of his early work into a new, even visual idiom.

This latest public rebuff disappointed Cézanne profoundly, and he withdrew from his circle of friends. At times he would re-appear at their new meeting-place, the Café Nouvelles-Athènes, only to vanish once more, equally abruptly. Cézanne put Impressionism behind him, and separated from the Impressionists. He had to go his own way, far from the controversies and mockery of the Parisian avant-garde. It was the solitude of Provence, his home parts, unsullied by the mud-slinging of painters and critics, that gave him peace and enabled him to find a way ahead as a painter.

Self-Portrait in a Beret, 1873–1875
Autoportrait à la casquette
Oil on canvas, 53 x 38 cm
Venturi 289
Hermitage, St. Petersburg

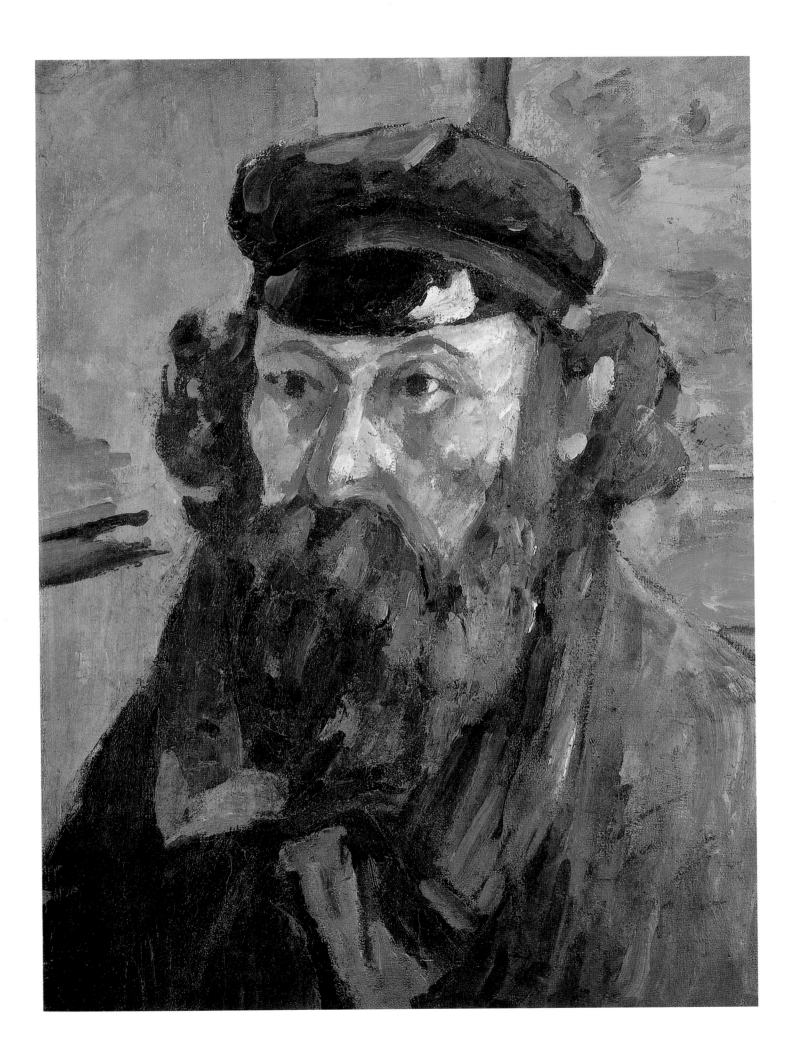

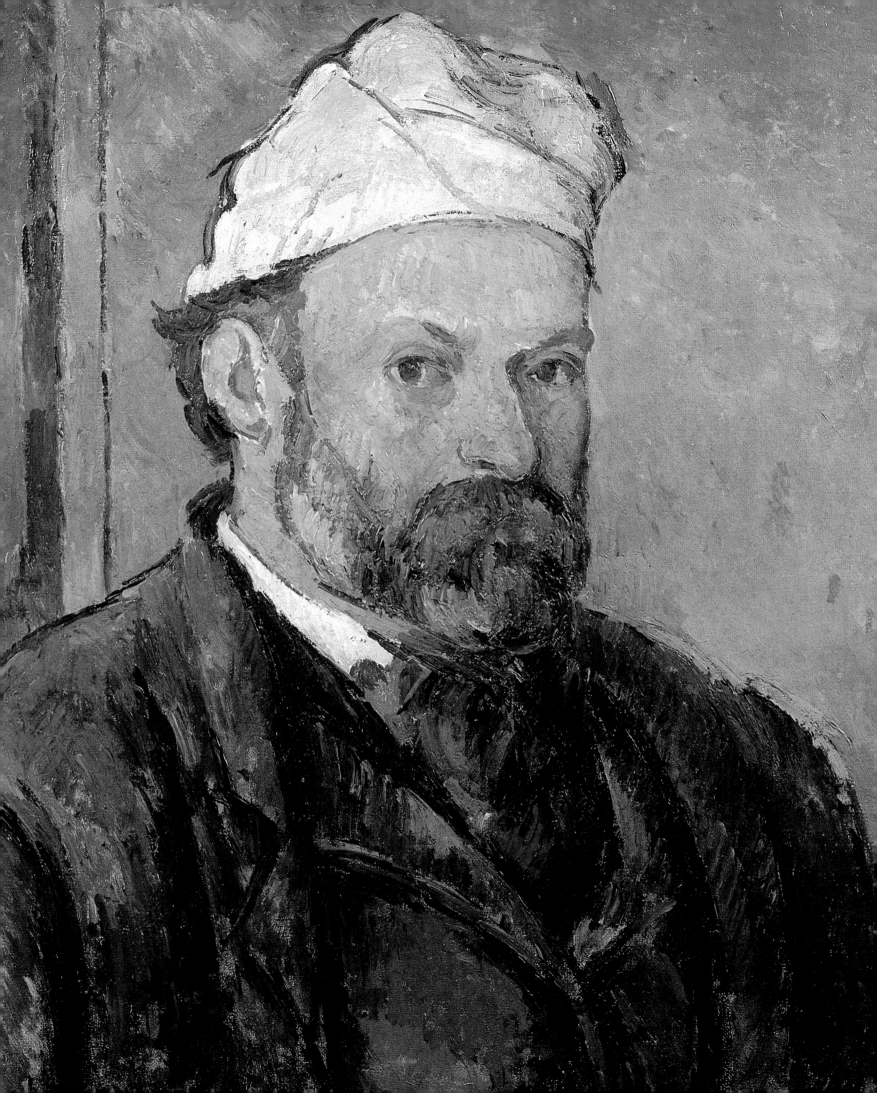

Cézanne opts out:
The Crisis of Impressionism

At the same time as Cézanne was leaving Paris after the humiliation of the third Impressionist exhibition, in quest of peace and quiet at Jas de Bouffan, his old friend Zola was celebrating his first major triumph, the novel *L'Assomoir* (1877). The novel was set amongst the Parisian working classes and described a family destroyed by alcohol and poverty with unremitting frankness and exactness of observation. The middle-class press attacked Zola's "repulsive" Naturalistic presentation of milieux. But in spite of the opposition, the novel and a stage adaptation made Zola famous and filled his pockets. At last he had achieved his ambitions for recognition and a life of ease. He bought a house in the little village of Médan, in the Ile de France, and had it gradually converted into a summer residence, where he took to playing host to writer friends of the Naturalist school, publishers, illustrators and critics. And of course he did not forget his old friend Cézanne. Zola wanted to show off his success and wealth, to Cézanne above all others. Cézanne for his part welcomed any change. He took the opportunity of his stays in Médan to paint in the surrounding country: in Bennecourt, Melun, Auvers, Pontoise, and La Roche-Guyon (where Renoir lived).

Chez Zola he was not altogether at his ease; his novelist friend had changed considerably, and now resided like some grand old Magus of Letters in an immense room crammed with exotic props. Zola wrote his novels at a vast desk heaped with knick-knacks in front of a huge open fireplace with a motto inscribed over it: *Nulla dies sine linea* (not a day without writing). In Cézanne's eyes, Zola had become "a proper dirty bourgeois"; the painter would answer the novelist's refined manners with uncouth behaviour and an ill-groomed appearance.

When he had had enough of the authors' talk of print-runs and fees, Cézanne would go painting. He took Zola's boat ('Nana'), rowed across to a little island, and painted the Château Médan with Zola's house on its right (p. 100). The line of trees and their reflection in the water give the picture an inner coherence which is reinforced by the parallel brush-strokes. The diagonal hatching of the brushwork and the cross-barred effect of the trees and houses provide the painting with a stable structure. Gauguin was struck by the picture when he visited Tanguy (who was his paint supplier too)

"Our Cézanne is giving us all hope. I have seen, and have in my possession, a painting of remarkable power and energy. If (as I hope) he stays in Auvers for some time, and settles as he plans, he is going to astonish an artist or two who have been over-eager to condemn him." CAMILLE PISSARRO

Self-Portrait with Head Covered,
1881/82
Portrait de l'artiste au bonnet blanc
Oil on canvas, 55.5 x 46 cm
Venturi 284
Bayerische Staatsgemälde-
sammlungen, Neue Pinakothek,
Munich

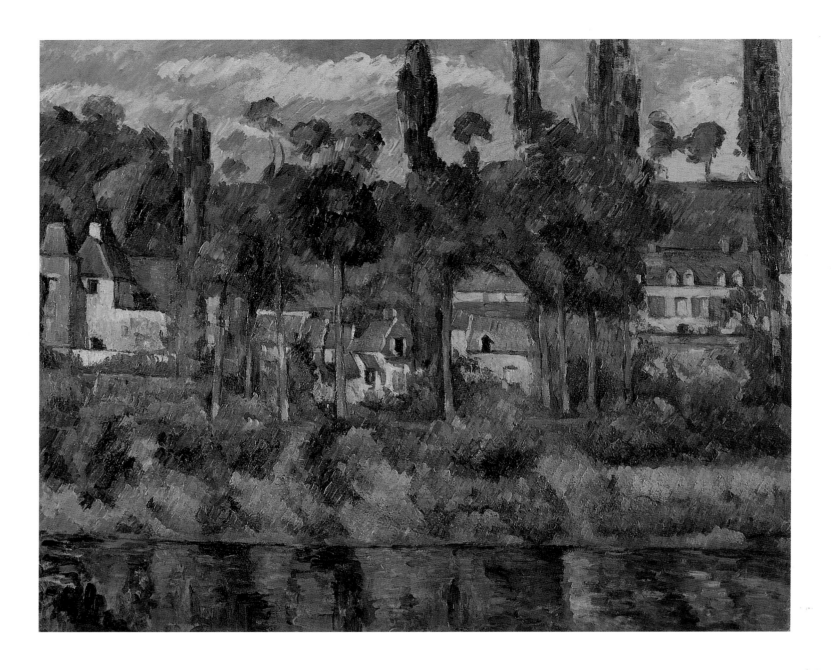

The Château at Médan, 1879–1881
Château de Médan
Oil on canvas, 59 x 72 cm
Venturi 325
Glasgow Art Gallery and Museum,
Glasgow

and bought it, and left this account of the impact its colours make —
and incidentally a delightful vignette of Cézanne's way with people
who interrupted him when he was working:

"Cézanne is painting a shimmering landscape against an ul-
tramarine background, with intense shades of green and ochre
gleaming like silk. The trees are stood in a row like tin soldiers, and
through the tangle of branches you can make out his friend Zola's
house. Thanks to the yellow reflections on the whitewashed walls,
the vermilion window shutters take on an orange tone. A crisp
Veronese green conveys the sumptuous leafage in the garden,
and the sobre, contrasting shade of the bluish nettles in the fore-
ground renders the simple poem even more sonorous.

"A presumptuous passer-by takes a shocked glance at what
seems, in his eyes, to be a dilettante's wretched daubing, and asks
Cézanne in a professorial voice, with a smile,

"'Trying your hand at painting?'

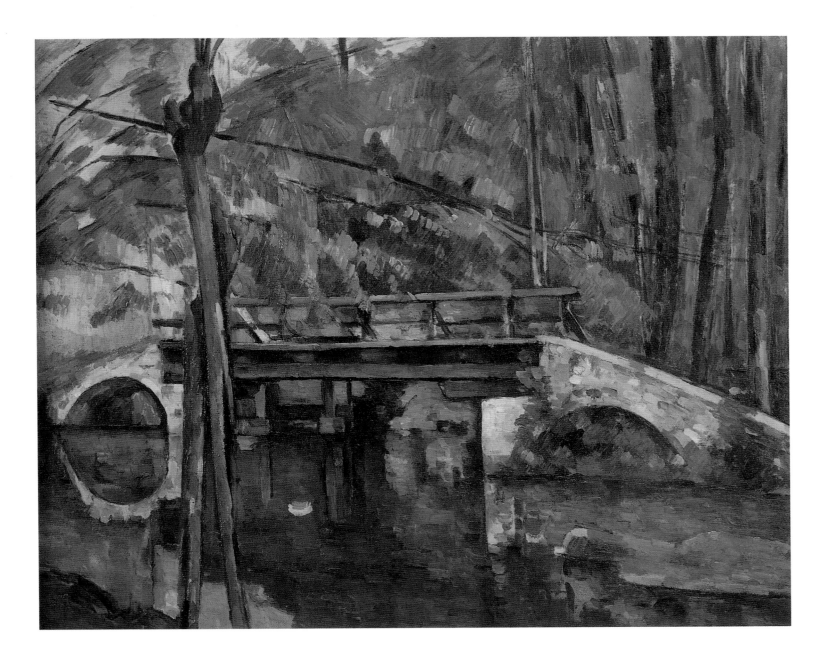

"'Yes — but I'm no expert!'

"'I can see that. Look here, I was once a pupil of Corot. If you don't mind, I'll just add a few well-placed strokes and set the whole thing right. What count are the valeurs, and the valeurs alone.'

"And sure enough, the vandal adds a few strokes of paint to the shimmering picture, utterly unabashed. The oriental silk of this symphony of colour is smothered in dirty greys. Cézanne exclaims: 'Monsieur, you have an enviable talent. No doubt when you paint a portrait you put shiny highlights on the tip of the nose just as you would on the bars of a chair.'

"Cézanne picks up his palette once more and scratches off the mess the man has made. Silence reigns for a moment. Then Cézanne lets fly a tremendous fart, and, gazing evenly at the man, declares: 'That's better.'"

This story, probably passed on by Guillemet, may have been elaborated but nonetheless rings true as a portrait of Cézanne at

The Bridge at Maincy near Melun, 1879
Pont de Maincy, près de Melun dit
autrefois Pont de Mennecy
Oil on canvas, 58.5 x 72.5 cm
Venturi 396
Musée d'Orsay, Paris

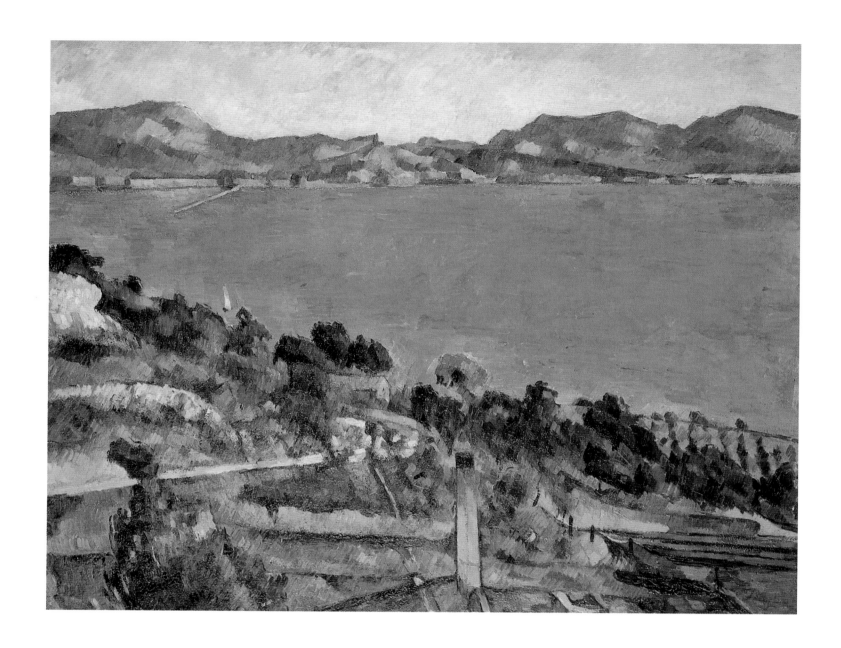

L'Estaque, ca. 1882/85
Oil on canvas, 59.5 x 73 cm
Venturi 428
Musée d'Orsay, Paris

Médan. The contrast between the host, bourgeois and comfortable, and his guest, fighting to establish his artistic style, could scarcely have been greater. Cézanne was perfectly happy to do without the "wide world" Zola was trying (in vain) to introduce him to. Zola took him to a soirée given by Henri Désiré Charpentier, the publisher. Celebrities of the artistic scene were there, from Henri Rochefort to Sarah Bernhardt, and house authors such as Edmond de Goncourt, Octave Mirbeau and Alphonse Daudet. The painter felt out of it, worlds apart from sophisticated society, and, fearing no one was taking him seriously, he remained silent rather than look a fool.

Nor did Cézanne feel any closer to Impressionism. True, he occasionally visited the ageing Pissarro at Pontoise and painted with him "sur le motif"; but the differences in their approaches

were increasingly apparent to him. For Cézanne, Impressionism was a transitional phase. He felt the movement had been all too easily satisfied with idyllic natural scenes awash with light and colour, immersed in atmospherics that flattered subjects and smoothed their hard edges. He started criticizing Impressionism in public: the paintings of Renoir and Monet struck him as too much "like cotton-wool", too inexact in composition. For his own part, he wanted "to make Impressionism permanent, like the art in the museums" which he still went to study in Paris. It ought to be possible to restore stable structure to the dissolution of colour and precise observation of light – to be a "Poussin of Nature".

The Bridge at Maincy (p. 101), one of Cézanne's finest and most famous landscapes, went far beyond what was dreamt of in the Impressionist philosophy of composition. The crossing and dovetailing lines of the trees, the arches of their crowns, the simple but effective shape of the bridge, all have the manifest presence of something organic. Cézanne was no longer using Pissarro's tiny patches of paint; instead he painted larger, contained units of colour that notched into a whole. The structure of the composition was not to fall apart at any point; quite the contrary, every dab of paint was meant to correspond with another, so that a tight, unified whole would evolve, like the symmetry of a pure crystal.

What Cézanne and the Impressionists still had in common, of course, was the struggle for recognition. All the painters (irrespective of their individual development) had initially seen the new art as anti-academic, anti-Salon. Now, however, Renoir and Monet also withdrew from the next exhibition. Many of the founder members of the Impressionist movement were becoming disillusioned and detached; academic painters who really had nothing to do with Impressionism were jumping on the bandwagon, and failure and in-fighting took their toll.

Renoir and Monet wanted to try the Salon again. They did in fact succeed in by-passing the usual competitive selection procedure and exhibiting at the 1880 Salon, but their works were so poorly hung that they attracted little attention. Enraged, they approached Zola (through Cézanne's good offices) with the request that he throw down the gauntlet one more time and take up the old fight for Naturalism and Impressionism. Zola did so, contributing four articles to *Le Voltaire* under the title 'Naturalism in the Salon'. But he was not as devoted to their cause as the painters had supposed. He criticized the last Impressionist exhibition, which he had felt did no good at all; the public had now acquired a taste for Impressionism, he conceded, and painting in general had benefitted, but a tide of "modern painting" was rising, art that was merely a feeble copy of what the Impressionists initially aimed at. The exhibitions had proved too easy a way of winning the public's favour; he claimed it would have shown greater courage "to hold out in the breach, come what may". More problematic still, according to Zola, was the

fact that the Impressionist movement had not yet produced either a masterpiece or a homogeneous style: "The true misfortune is that not one of the group has yet succeeded in putting the new formula which is adumbrated in their works into practice with any power or conviction. The formula exists, in an infinite number of scraps; but nowhere is a master among them using it. All of them are fore-runners. Their artist of genius has not yet been born. We can see their aims and pronounce them good, but the quest for a master-piece based on the formula, a masterpiece that would make us bow our heads in recognition, is fruitless. That is why the Impressionist struggle has not achieved its aims yet. They are falling short of what they want. They are stuttering, unable to find the right word."

Interestingly enough, the only one to agree with Zola's view was Cézanne. Perhaps he saw himself as the pioneer seeking a new formula, a revolutionary visual strategy. Zola had referred to Cézanne too, but with his familiar cool detachment: "M. Paul Cézanne, who has the temperament of a great painter, is still struggling with problems of technique. All in all he is closest to Courbet and Delacroix." Apparently Zola had failed to register that Cézanne had already put the Impressionist phase behind him, and had most emphatically moved on from that early period in which the influence of Courbet and Delacroix is indeed visible. But the two old friends were agreed concerning Impressionism. Cézanne had long since stopped visiting the Café Nouvelles-Athènes; and stories and legends were gradually attaching to him, making his work seem more obscure than ever.

Cézanne went back to Aix again. From there he went to L'Esta-que and Gardanne, and painted a number of new pictures. His visual structure grew tighter and tighter, his colours tautened into firm material, with no atmospheric gaps or anecdotal extras. Cézanne repeatedly painted the Bay of Marseille seen from L'Es-taque (cf. pp. 12, 102, 105 and above) and these paintings demon-strate the ways in which Cézanne's approach diverged from that of the Impressionists. The composition on page 105, for instance, divides into three planes layered on top of each other: a hilly landscape with trees in the foreground, the sea in the centre, and in the background a coastline, mountains, and the overarching sky. To indicate spatial depth, perspectives of air and colour, the Impr-essionists added shades of blue and faded the colours towards the background. Cézanne used a different method. All three visual planes in the Chicago picture (p. 109) have equally strong con-trasts and the same tonal values. An impression of depth is con-veyed nonetheless by a reduction in the amount of detail on the far coastline and by superimposing houses in the foreground. On the other hand, Cézanne emphasizes the flat surface of the painting by using firm brush-strokes and strong colours for the background too. The addition of shades of blue-green to the overall ochre and orange of the foreground links that zone of the canvas with the

View of L'Estaque and the Château d'If,
1883–1885
Vue sur L'Estaque et le Château d'If
Oil on canvas, 71 x 57.7 cm
Venturi 406
On loan to the Fitzwilliam Museum, Cambridge

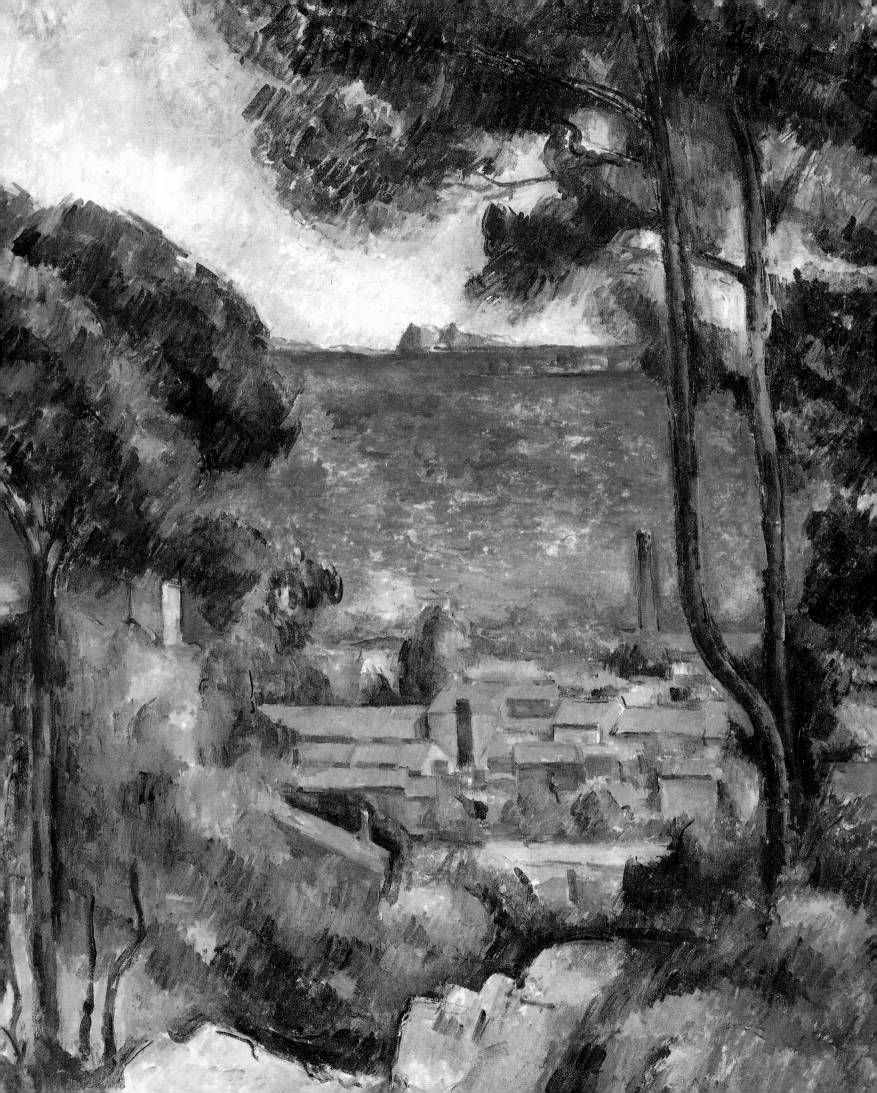

impenetrable blue of the water and in turn links that blue to the mountains in the distance, where greens and ochres found in the foreground are recapitulated, thus incorporating all three pictorial planes into a single unity.

In a letter to Pissarro, Cézanne lends weight to our sense of a curiously flat depth in the picture: "It is like a playing-card here. The sun is so frightful that it seems to me as if objects were all silhouetted, not in black and white but in blue, red, brown and violet. I may be mistaken but this strikes me as the absolute opposite of modelled depth." (Letter to Pissarro, 2 July 1876.) The crisp light of the south rendered objects flat and two-dimensional in Cézanne's eyes, but it also endowed them with a manifest surface structure. Cézanne tried using strong colour contrasts (blue, orange, green, ochre) not only to reproduce this effect of the light but also to bridge spatial colour values and the picture surface.

This new aim for an integrated solidity of form in his work can be demonstrated in many of the paintings Cézanne did at L'Estaque in the 1880s, such as *Houses at L'Estaque*. It shows a steep slope and some buildings whose shapes match the craggy hillside nicely. The slope occupies nearly all of the canvas, with only a small strip of sky left at the top. The blue of the sky can be seen palely reflected on the rocks, though, and shades of blue have even been added to the ochre of the houses. It is not drawn across the subject like a veil of atmospherics suggesting air and haze, however; the brush-strokes are clearly defined. The world of the actual is fashioned in colour, as it were. The individual rocks have a chiselled distinctness and lend the composition a crystalline hard-ness that consorts well with the bright, cutting light of the south. In spite of this distinctness, though, Cézanne's use of a uniformly parallel brush-stroke and his patterning of colour values create unity: the world of the actual does not fall apart into isolated fragments, but is made whole by the constructional function of paint.

There is no longer anything ephemeral in Cézanne's paintings. They do not merely record the moment. Neither Time nor Man nor flux is their centre. These landscapes seem to be beyond Time. Time is a component, included in them, woven into the pictorial structure to create a tight visual fabric which incorporates the various, changing phenomena of Nature into a new unity: near and far, land and water, stones, air and vegetation. Things seem frozen, crystallized in obedience to new laws which transform even organic matter into structures that strike us as geological in character. Cézanne dispenses with atmospherics. He sets the anecdotal charm and the accessories of the Impressionists aside, those qualities that leave their work standing amidst the historical documents of a bygone age. Cézanne provides no access to an emotional response. What we see, directly and with great intensity, is a clear, carefully structured composition which does not conceal its

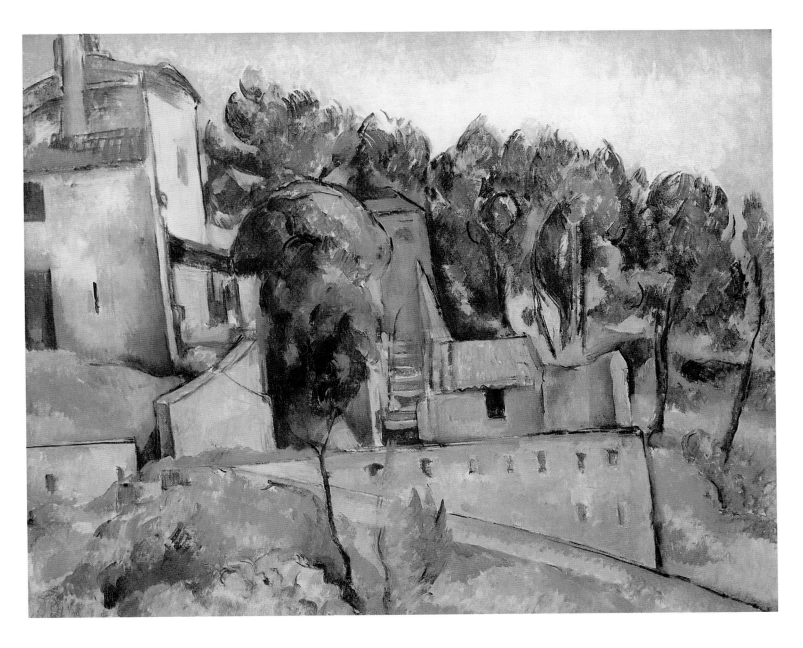

Bellevue House, 1890–1894
La maison de bellevue
Oil on canvas, 60 x 73 cm
Venturi 655
Private collection, Geneva

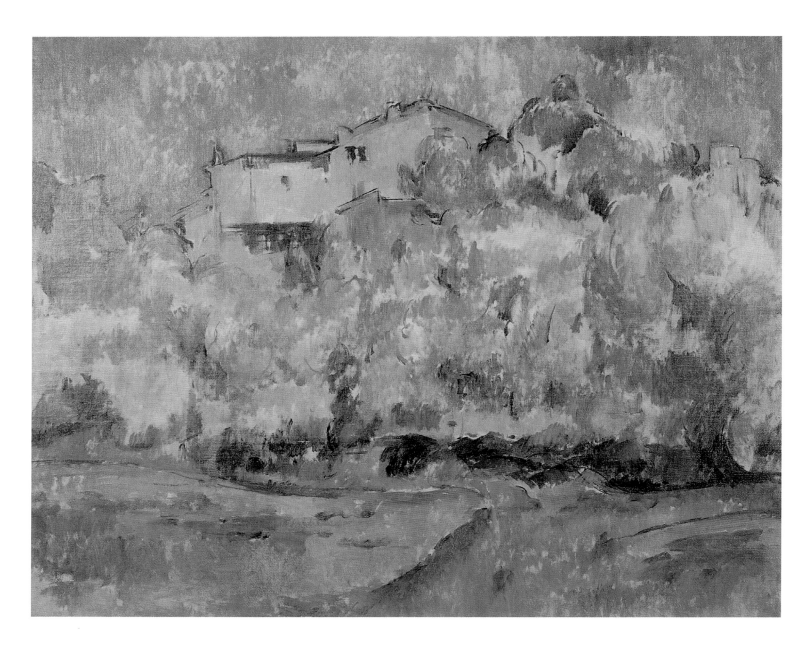

Bellevue House and Dove-Cote,
1888–1892
Maison de bellevue et pigeonnier
Oil on canvas, 65 x 81.2 cm
Venturi 651
Folkwang Museum, Essen

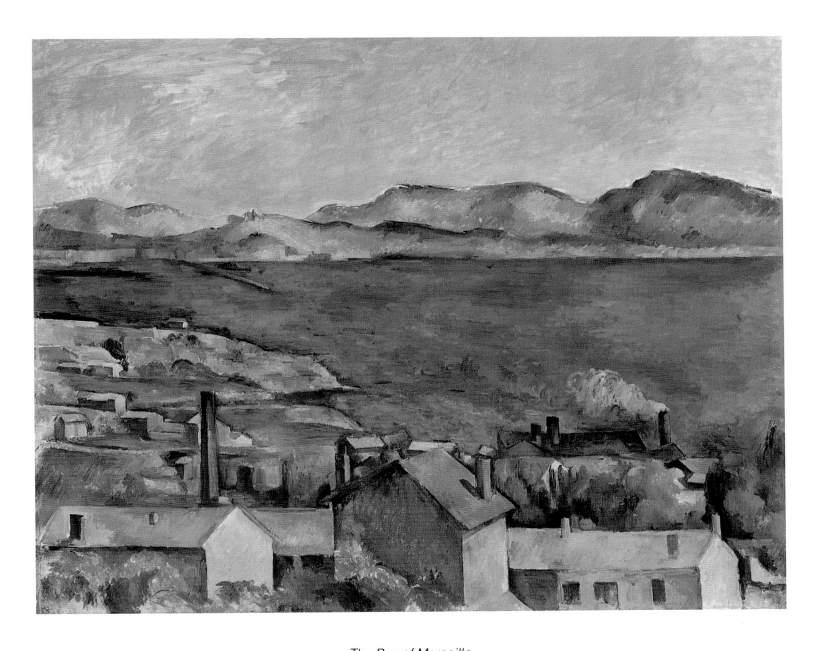

The Bay of Marseille,
seen from L'Estaque, 1886–1890
Le golfe de Marseille, vue de L'Estaque
Oil on canvas, 80 x 99.6 cm
Venturi 493
The Art Institute of Chicago, Chicago,
Mr. and Mrs. A. Ryerson Collection

principles and processes of construction from us but indeed makes a point of revealing them – like the iron-and-glass buildings that were being celebrated in the Paris of that time, or like the Eiffel Tower, the technical marvel of the age, the great augur of the modern era.

It was that modernity which Cézanne was escaping, though. He did not need the inspiration of life in Paris, as Renoir, Degas and Toulouse-Lautrec did. Cézanne was satisfied with the familiar motifs of his home parts: near Jas de Bouffan (cf. pp. 108 and 109), on walks near his brother-in-law's, or in the woods of Château Noir, up to the Bibémus quarry. Cézanne found his subjects on his doorstep; and they were saturated with the memory of a time that was gone forever, a time that Cézanne wanted to record and preserve. He was not interested in the Impressionist sense of flux which rendered everything a whirlpool of colour in analogy to societal change. He wanted to preserve permanence in change. He was after the timeless, not the contemporary. He valued that contemplative escape from Time which modern men so rarely achieved in their fast societies. For the Impressionists, a brief moment needed capturing as the greatest good in a happy life. Renoir's group scenes presented the sensuous warmth of human society, men and women relaxing in a timeless zone freed of social constraint. Monet's series of the 1890s dealt with the passage of Time, taking any objects (haystacks, poplars, cathedrals) to illustrate changing conditions of light and colour at different times of day and thus the laws which govern Nature – and Man. Pissarro's view of Nature was essentially utopian, envisaging a post- (or pre-) industrial agrarian society in which Man lived and worked in harmony with Nature.

Cézanne saw Nature differently. Let us recall his biographical position. Cézanne was not valued highly either as an artist or as a human being. In the parental home he was spied on and kept tied to the apron strings. His despotic father treated him with condescension and suspicion. His elder sister Marie looked after him to the point of smothering him in care, but did not understand his art or approve of it. His mother and sister urged him to order his affairs (particularly as far as his relationship with Hortense was concerned). Good society, which Zola valued so highly, was not open to Cézanne. It was a vicious circle: the more he was excluded, the more he opted out of society. So what Cézanne was looking for in contact with Nature, and in tracing the structures of Nature, was some fixed stability. Uncertain of his identity in a period of social acceleration, he used his painting to ward off the danger. Cézanne interpreted natural phenomena as fundamentally unchanging, beyond Time, beyond the fates of mankind. That was his sole hope and consolation. Cézanne's art dealt with the basic structure of the world. Rather than mirroring shifts in fashion, he wanted to take hold of what was enduring. That permanence is visible in the

110

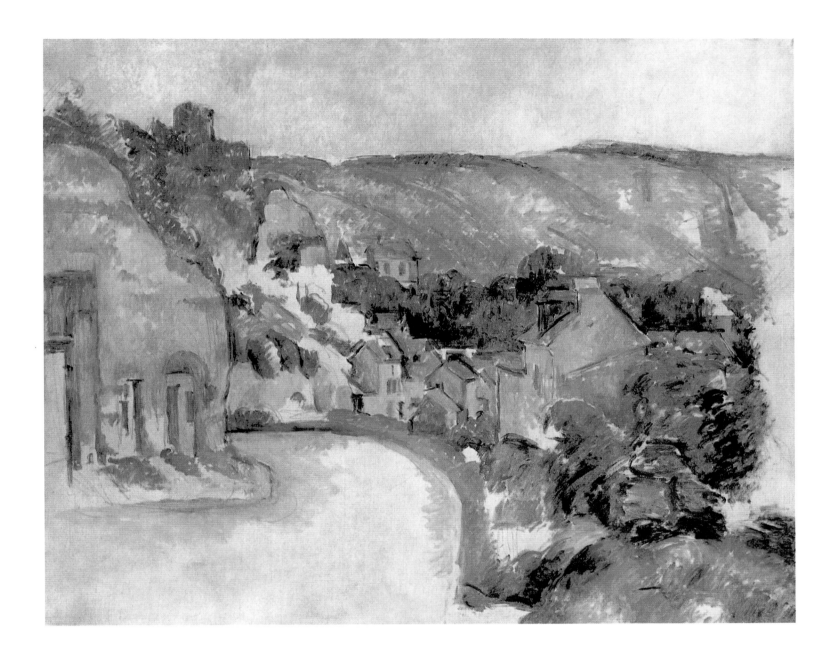

colourful visual structure of his work: constructive brush-strokes and distinct blocks of colour establish a new unity whose name, if we will but perceive it, is Truth.

Cézanne was interrupted in his quest for a while. In 1885 he had a passionate love affair. Describing it in a letter to Zola, he concluded with the words: "Trahit sua quemque voluptas." Rather than being done for by his passion, though, Cézanne fled to Renoir's at La Roche-Guyon, his longing for love unappeased. After four weeks spent with his fellow-painter he moved on via Villennes (near Médan) to Vernon. "I cannot find anything here that I can use in my present state," he wrote to Zola. "I have decided to return to Aix as soon as possible. Before I do so I shall visit Médan, to shake your hand. For myself there is only absolute isolation, the town brothel or something of the kind, nothing else. I'll pay. It's an ugly word, but I need peace, and I can get it, at that price. If only my

At La Roche-Guyon, 1885
Le tournant à La Roche-Guyon
Oil on canvas, 62 x 75.5 cm
Venturi 441
Smith College Museum of Art,
Northampton (Mass.)

family were not so meddlesome, everything would have been fine." (To Zola, 25 August 1885.)

At La Roche-Guyon (p. 111) clearly illustrates Cézanne's state of mind at that time. Only half finished, it has nothing of the constructive approach of those years. The colours and brushwork are nervy and sketchy. Only the houses show his endeavour to get a grip on himself by working on a subject.

Jas de Bouffan had become intolerable too. Cézanne's father had spied on his son, discovered that he had a family, and had grown more tight-fisted and intolerant than ever. And the painter had little in common with Hortense any more. The portraits of Madame Cézanne done around that time (cf. p. 131) tell a tale of alienation and rejection. The only true affection Cézanne enjoyed was that of his thirteen-year-old son Paul, whom he liked to draw and paint (cf. p. 134).

Cézanne always saw himself in the same pose: in semi-profile, turned slightly away, reticent, bitter, misanthropic (p. 120). The *Self-Portrait with a Palette* (p. 130) shows him as Don Quixote, with a palette and brush in place of a sword and shield, going to tilt not at windmills but at the easel: that is the victory he must win. He has to win everything on that one card. He has to seize hold of everything Life is denying him.

He painted the parental home, Jas de Bouffan, in gloomy colours that bring to mind Poe's story *The Fall of the House of Usher*. Under pressure from his parents and sister, nagged by Hortense, Cézanne would leave Jas every morning and go to Gardanne, a little mountain village in the Haute Provence, to work. The landscapes he painted there (p. 113) expressed a new self-confidence – among other things, in their very construction. "I am beginning to paint again," he wrote to Zola at the end of August, "now that I have so little to worry about. Every day I go to Gardanne, and do not return to Aix before evening."

After a while, Cézanne and his family rented lodgings in Gardanne, so that he did not have to travel the twenty kilometres every day. He described his new sense of motivation in a letter to Choquet: "This area is full of hidden treasures. There has not yet been anyone whose paintings were worthy of the riches that lie dormant here." (11 May 1886.)

Above all, Cézanne could see Mont Sainte-Victoire from Gardanne, a subject "full of hidden treasures" that he was to concentrate on in increasing measure. The mountain looms like a mighty bastion in the background of these pictures, an indestructible work of Nature that will survive all the slings and arrows of Life, all the shifts in culture and fashion. Working on the motif of the mountain gave Cézanne new hope and strength. In *The Cutting* the mountain had already played an important part in the composition. Now, in the 1880s, it occupied Cézanne regularly and took a central position in his work. Seen from Jas de Bouffan, the mountain was

Gardanne, 1885/86
Oil on canvas, 92 x 73 cm
Venturi 431
Brooklyn Museum, Brooklyn (N.Y.)

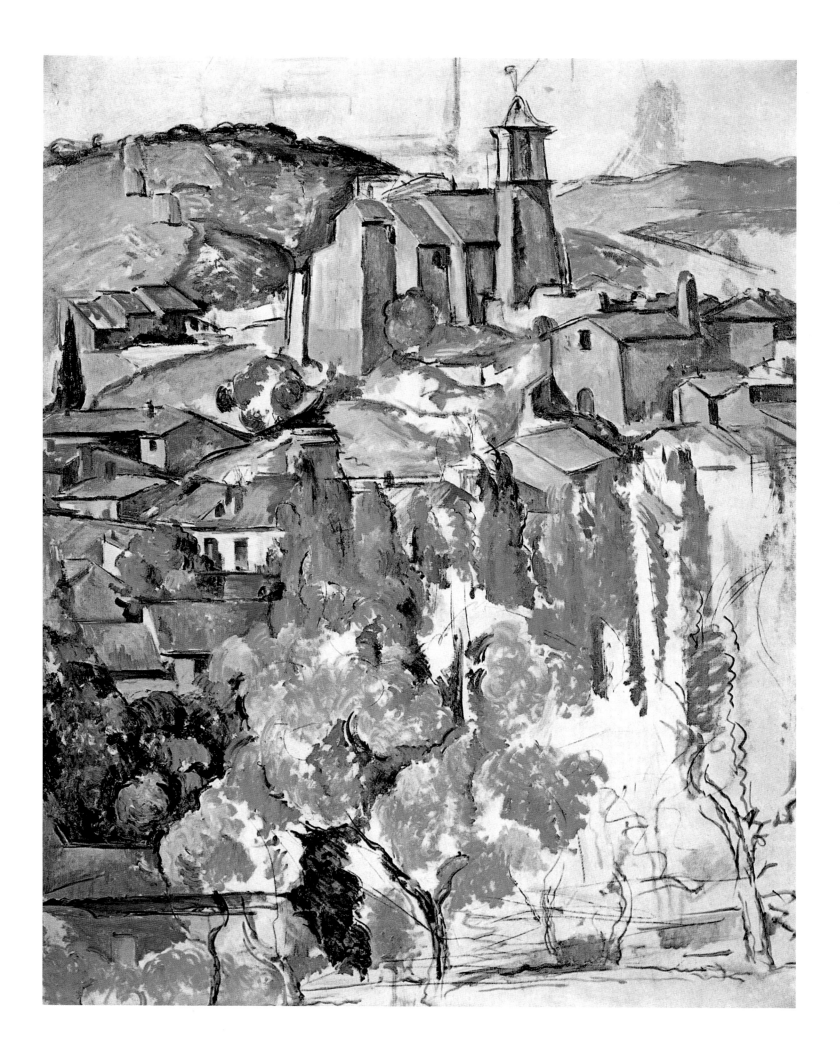

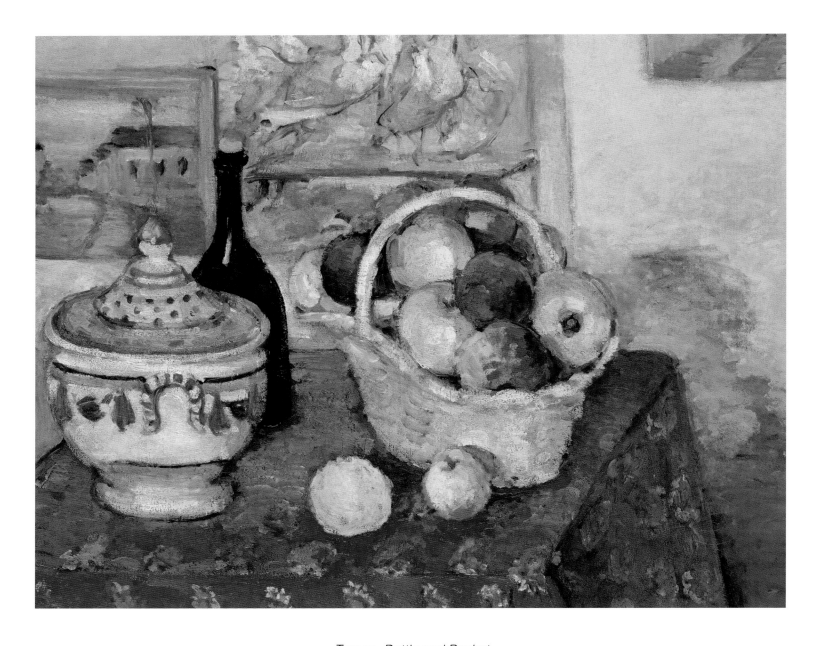

*Tureen, Bottle and Basket
of Apples,* ca. 1877
Nature morte à la soupière
(Pommes, bouteille et soupière)
Oil on canvas, 65 x 81.5 cm
Venturi 494
Musée d'Orsay, Paris

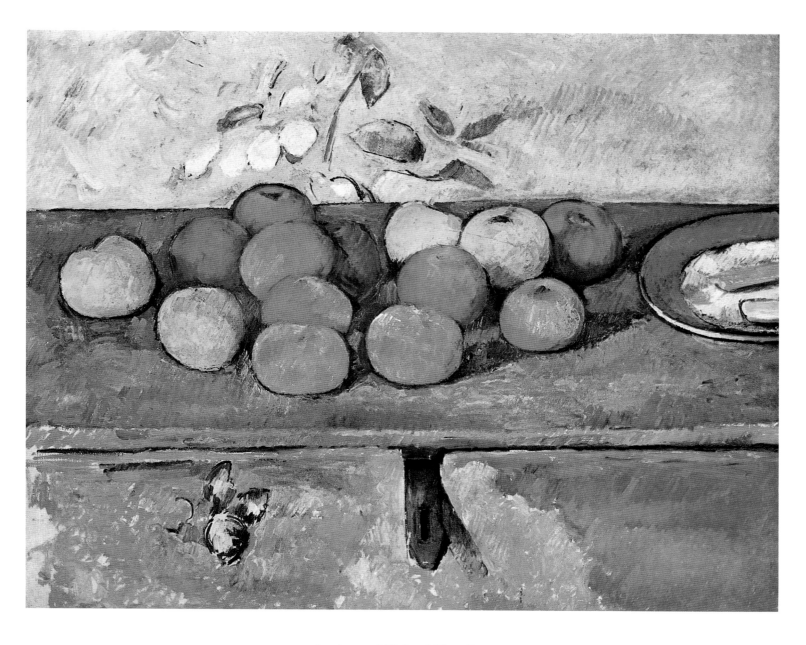

Apples and Plate of Biscuits,
1879–1882
Nature morte: pommes et biscuits
Oil on canvas, 46 x 55 cm
Venturi 343
Musée de l'Orangerie, Paris

only a vague outline beyond the chestnut trees (p. 89); but from Gardanne Cézanne saw the south side with the flat-topped escarpment, a few hills, and scattered houses – and that was how he painted it in *Mont Sainte-Victoire, seen from near Gardanne* (p. 113).

His favourite spot was Bellevue, his brother-in-law Maxime Conil's farmstead. (Conil had married Cézanne's younger sister Rose.) The property was on a hillside with a fine view of the Arc valley across to Mont Sainte-Victoire. Cézanne painted the buildings and dove-cote (p. 107) and a view of the valley (p. 119). Another of his favourite spots was a hill between Bellevue and the neighbouring farm, Montbriant. From there Cézanne commanded a panoramic view of the landscape, complete with the railway viaduct. In *The Great Pine (Mont Sainte-Victoire)* (p. 118), the mountain in the background provides the dominant theme while a large pine frames the composition, its branches following the outline of the mountain-top. There is great poetic vitality in this composition, and we are reminded of Hokusai's *Hundred Views of Mount Fuji* (1883). The Japanese master was revered and collected by French artists of the time. In that cycle of wood-cuts Hokusai expressed his reverence for the sacred mountain, Fuji, and a wish for artistic perfection and immortality. Cézanne's approach to *his* mountain seems to draw upon similar sources in the imagination.

These Sainte-Victoire landscapes were more than a homage to Cézanne's home parts. The new panoramic approach showed Cézanne moving ahead, higher, to the very pinnacles of his art, the peaks he climbed in his late work. In contrast to the industrial panoramas of his time, Cézanne's landscapes attested a deep love of Nature. His gaze is an embrace – an embrace of all Nature, and the mountain as Nature's representative. In his later years of life, Cézanne was to seek artistic perfection through work on Mont Sainte-Victoire above all, questing for Nature's depth and permanence, which he sensed behind the bright façade of a world he could not relate to.

At the same time, Impressionism was undergoing a crisis. The problems within the group were doubtless the main cause. They no longer pulled together as they once had. Many of the artists were going their own ways. A new generation was moving centre-stage, with new ideals and new objectives that were no longer content with Impressionism's recording of the moment. In 1884 the Salon des Artistes Indépendants was established, and over four hundred artists thronged to a wooden hut in the Tuileries. The centre of attention was Georges Seurat's *Bathing at Asnières* (1883/84, National Gallery, London). Seurat's was a new name on the art scene. And the first picture he exhibited caused a sensation.

Apart from the in-fighting, the Impressionists were beset with doubts. Pissarro thought his own work too tame and insipid and

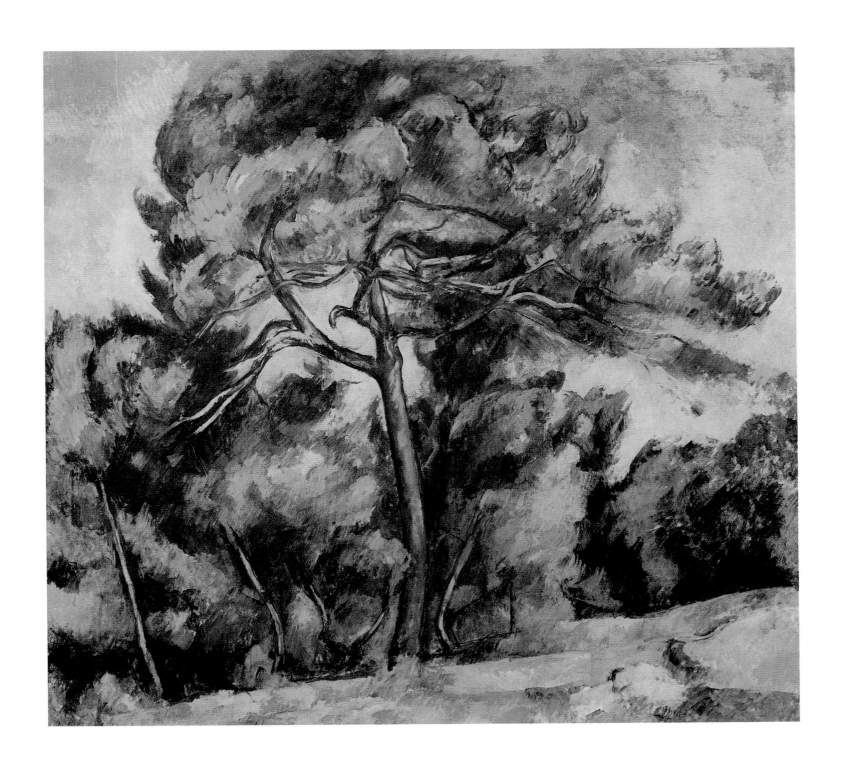

flat. Renoir was plunged into a profound crisis and destroyed his own paintings. He believed he had been neglecting the draughtsmanship side of artistic creation, and by way of reaction started work on *The Bathers* (1887, Philadelphia Museum of Art, Philadelphia), which he composed with immense care and attention to line. This inaugurated Renoir's period of austerity, in which he tried to conjoin the colourful brightness of Impressionism with the simple clarity of Raphael and Ingres. Monet too was dissatisfied with his

The Great Pine, ca. 1896
Le grand pin
Oil on canvas, 84 x 92 cm
Venturi 669
Museu de Arte, São Paulo

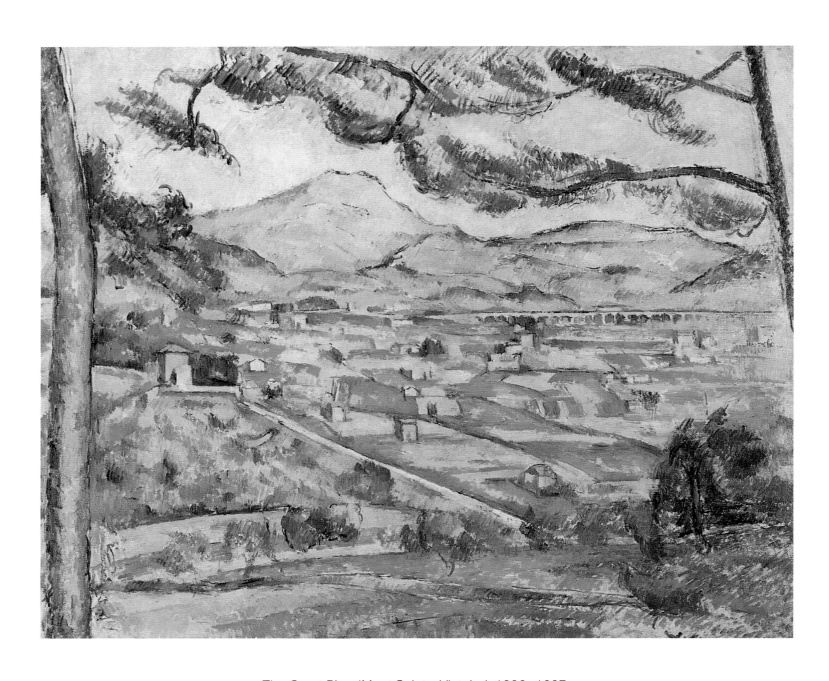

The Great Pine (Mont Sainte-Victoire), 1886–1887
Le grand pin (La montagne Sainte-Victoire)
Oil on canvas, 60 x 73 cm
Venturi 455
Phillips Collection, Washington, D.C.

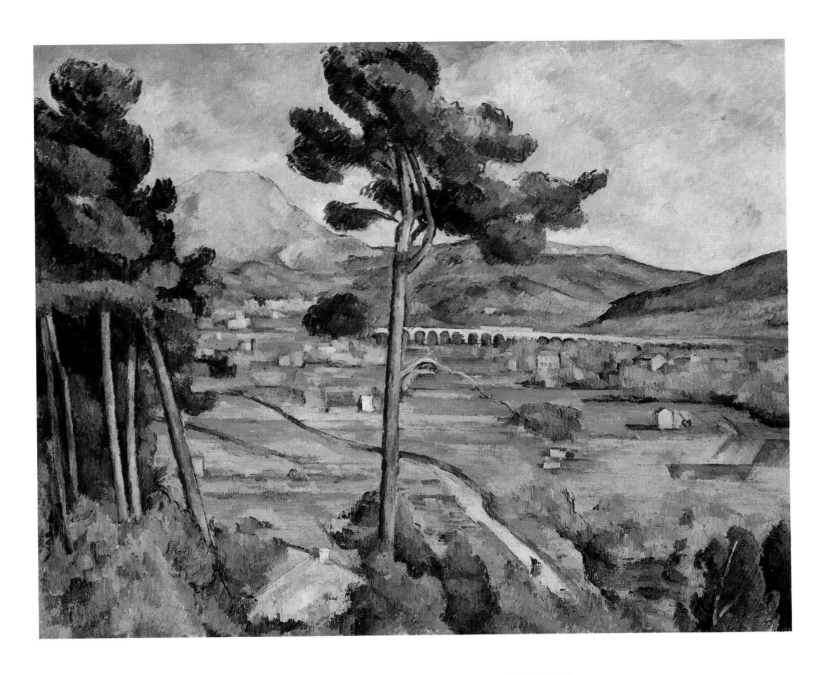

Mont Sainte-Victoire seen from Bellevue, 1882–1885
La montagne Sainte-Victoire, vue de Bellevue
Oil on canvas, 65.5 x 81 cm
Venturi 452
The Metropolitan Museum of Art, New York,
Mrs. H. O. Havemeyer Foundation,
The H. O. Havemeyer Collection

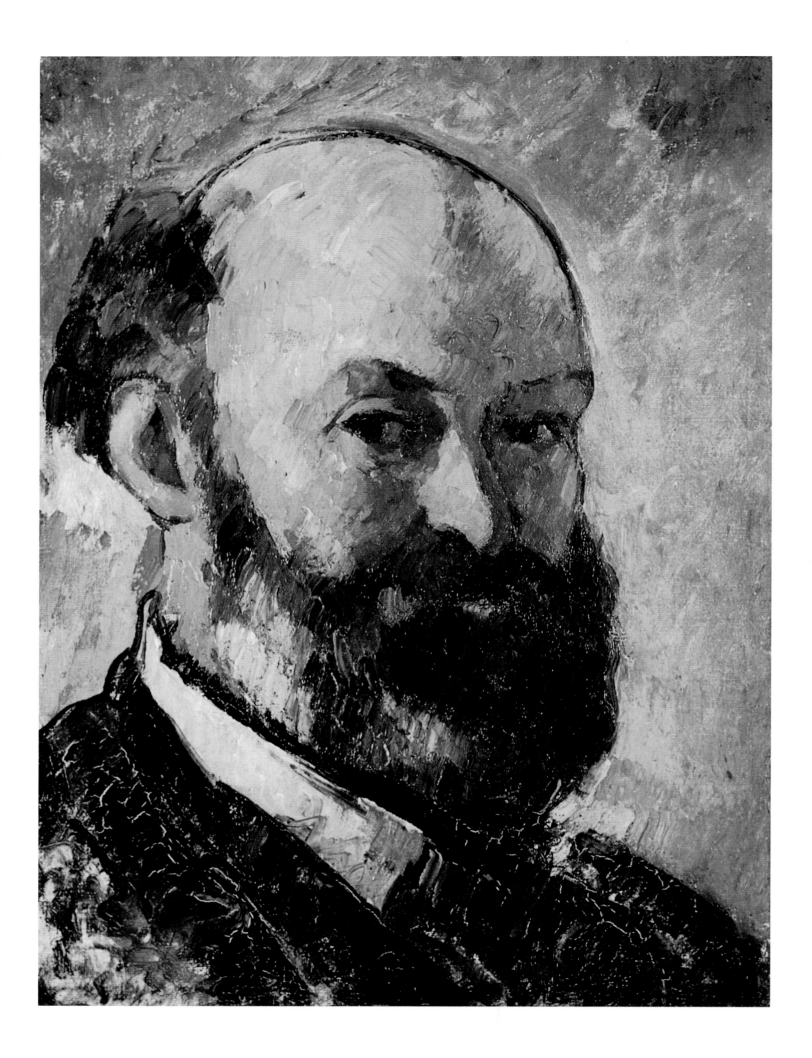

own work. He reworked many of his paintings and destroyed others. Monet and Renoir travelled to the Côte d'Azur in quest of new inspiration and met Cézanne in Marseille. Renoir contracted pneumonia and was nursed back to health at Jas de Bouffan by Cézanne's mother. Cézanne and Renoir went out painting "sur le motif" together, taking Mont Sainte-Victoire as their subject, and the joint venture served to highlight the differences in their approaches once again. As for Degas, he was going through a phase of thinking himself to have failed; he suspected he had been too careless in the way he used his talent. All of the old Impressionists were trying to rid themselves of the constrictions of the group, once and for all. They were after new subjects, new approaches, a new technique – in a word, a new style. And that new style had patently been evolved. It was already on show, in the Salon des Indépendants . . .

The paintings of Seurat and Paul Signac demonstrated the new constructive element which every painter had been looking for in those days. The Neo-Impressionists (as they came to be called) developed the technique of pointillism, which took its bearings from research in physiology and the theory of colour. Pointillism used a systematic grid of coloured dots which subsequently merged into a "visual blend" in the eye of the beholder, giving the picture a brighter, more brilliant impact. Pissarro found the style so persuasive that he completely changed his own. He told Durand-Ruel the art dealer of the importance of "a modern synthesis of the findings of science, that is to say, Chevreul's colour theory, the experiments of Maxwell, and the results of O. N. Rood." Pointillism promised greater precision, more emphasis on composition, and more powerful effects of light. When Durand-Ruel, having weathered the financial crisis of 1883, came to plan a major exhibition in America in 1885, it became clear that there was no longer any agreement amongst the Impressionists. Pissarro wanted to have the old group expanded to include Seurat and Signac, the painters of the new movement. Renoir, though, poked fun at the anarchic views of Pissarro and Gauguin.

Thus a new wave broke upon the artistic scene. The very name suggested that it would be looking for new subjects and vesting its ideas in attractive symbolic terms. From this mood of change and excitement in Paris, though, Cézanne kept his distance, as ever. He did not even go to the monthly Impressionist soirées. The quest for a new style made little impact on him. He had perceived his own way and meant to follow it to the very end. In the seclusion of his Provence isolation he established his own working rhythm, governed by daily work "sur le motif". And in his treatment of Nature Cézanne was to reveal a far profounder symbolism of the real than anything dreamt of in the hazy philosophy of the Symbolist movement that was about to begin.

Self-Portrait, 1879–1882
Autoportrait
Oil on canvas, 39.5 x 24.5 cm
Venturi 367
Oskar Reinhart Collection, Winterthur

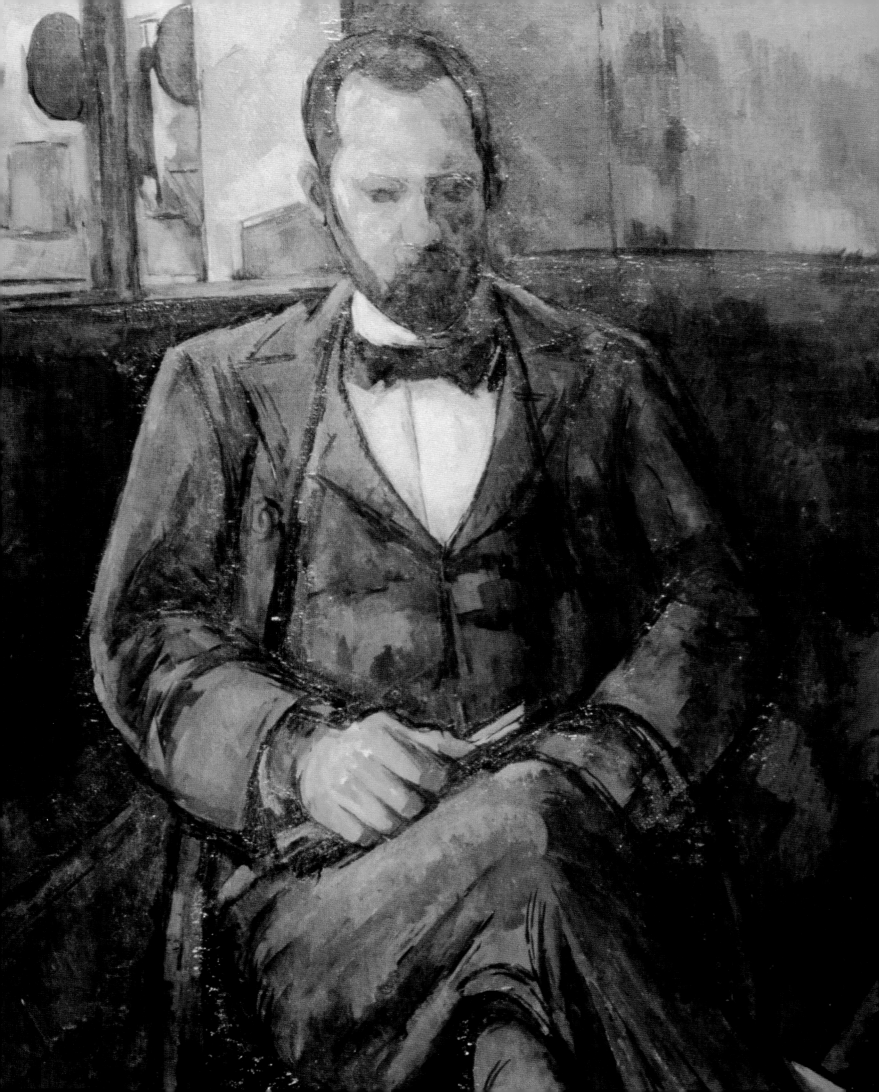

Cézanne and Literature:
Zola, Balzac, Huysmans

In March 1884 Charpentier (Zola's publisher) brought out a novel entitled *A Rebours*. It proved a sensational success. The author was Joris-Karl Huysmans, a close friend of Zola's who until then had been a devotee of Naturalism. But this new novel concerned a decadent wealthy man, Jean Floressas des Esseintes, who went into a kind of retreat, in isolation from the world, indulging in the pleasures of an extreme, cultic aestheticism. In his splendid and notably eclectic residence he revelled in a new life-style based on the pessimistic philosophy of Schopenhauer (widely read in the 1880s), preferring the aesthetic fastidiousness and indeed preciosity of an artificial paradise to the "shallow banality" of reality. Huysmans integrated influences and theories of considerable diversity into his novel. When he refers to poets, des Esseintes mentions not only Baudelaire and Paul Verlaine but also, above all, Stéphane Mallarmé, whose mysterious verse had not yet made him famous but was familiar to the avant-garde. *A Rebours* highlighted a new artistic movement that was already in the making in literary circles, it is true, but which had not yet located a focus or slogan. The latter was now supplied by des Esseintes: "The most important thing is to achieve a great enough ease to experience hallucinations and to substitute the dream of reality for reality itself." The Symbolist poets who succeeded the Naturalist school emphasized a higher, unknown reality which could be given artistic form by means of dream images, visions, allusions and the creative potential of the imagination.

"Symbolist poetry aims to vest the Idea in a sensitive form which is not an end in itself but is subordinate to the Idea it expresses," announced the Symbolist poet Jean Moréas in his manifesto of 18 September 1886, published in the widely-read *Le Figaro*. Felix Fénéon founded a magazine called *La Revue Indépendante* which acted as a forum for those writers (Zola, Huysmans, Goncourt, Mallarmé, Moréas) who welcomed the decline of Naturalism and the advent of Symbolism as a way of overcoming the aesthetic crisis of the 1880s.

Zola and doctrinal Naturalism had of course been affected by the radical transformation of literary and artistic values. While Huysmans was writing his novel, Zola was at work on *La joie de vivre* (1884), a further instalment in his massive cycle *Les Rougon-*

Ambroise Vollard, ca. 1899
Pencil, 51.1 x 45.9 cm
Fogg Art Museum, Harvard University, Cambridge (Mass.)

Ambroise Vollard, 1899
Portrait d'Ambroise Vollard
Oil on canvas, 100 x 81 cm
Venturi 696
Musée du Petit Palais, Paris

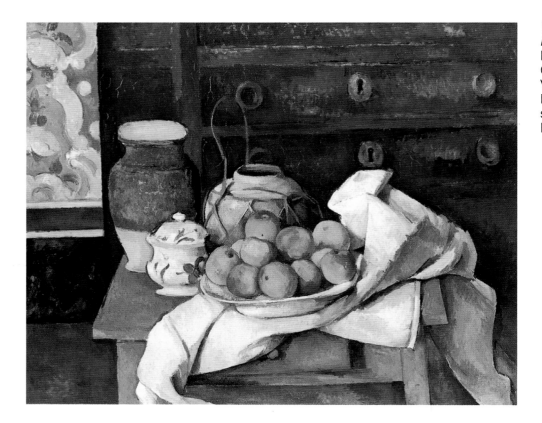

*Vessels, Fruit and Cloth
in Front of a Chest,* 1883–1887
Nature morte à la Commode
Oil on canvas, 73.3 x 90.2 cm
Venturi 496
Bayerische Staatsgemälde-
sammlungen, Neue Pinakothek,
Munich

Macquart. In this novel, one of his most personal, Zola tried to come to terms with the death of his dearly-loved mother. The book's principal theme is fear of death, a neurotic *angst* that afflicts the central character, Lazare Chanteau. Into that character Zola put all his own fears concerning the cultural and social crisis of the 1880s. It is true that Zola's fundamentally positive attitude to life gains the upper hand in the course of the novel; but it had been clear since his critique of the 1880 Salon that Zola was well aware of the crisis and was engaged in the quest for a way out of it.

The artistic development of Impressionism left Zola particularly dissatisfied, and he planned a new novel that would show the doubts and disappointments of an entire generation of painters. Paul Alexis, an old schoolfriend, published a memoir titled *Emile Zola, notes d'un ami* (1882) in which he outlined Zola's plans for the book: "I know that in the character of Claude Lantier he means to study the terrible psychology of artistic impotence. This central man of genius is a sublime dreamer, though in his work he is paralyzed by a profound crisis. In his ambit are other painters, sculptors, musicians, and writers, a whole group of ambitious young people who have set out to take Paris by storm. Some of them fail, and others succeed to a greater or lesser extent, but all of them suffer from the selfsame disease of art: variations on the great contemporary neurosis."

At the end of December 1885, *Gil Blas* began the serialization of Zola's new novel, *L'Oeuvre.* The Impressionists were outraged. All of them discovered themselves in the book. And all of them

resented Zola's attacks on Impressionism — at a moment such as that, when they were all racked by doubts and financial difficulties!

Cézanne was hardest hit of them all. He was moved when he read the earlier parts of the book, reliving shared memories of the days of their youth, pranks played at the College Bourbon in Aix, bathing parties along the Arc and the Torse, their dreams of fame, their exalted artistic ideals. But as he read on a feeling of unease grew upon him. This artist reaching for the stars, squandering his genius — wasn't it he himself, Cézanne? They were his own paintings that were being described. And then this terrible ending, Lantier's suicide in front of his last, unfinished painting. So that was how Zola saw him: as a failure incapable of producing art of lasting expressive power, a man vanquished by his own neuroses and inhibitions. In a final letter to Zola, Cézanne thanked the novelist for his gift of the book and signed off on a formal and sad note: "in memory of the days that are gone". (4 April 1886.) They were never to meet again. Zola accepted the painter's wish to live and

Vessels, Cloth and Pot-Plant in Flower, 1882–1887
Pot de Fleurs sur une Table
Oil on canvas, 60 x 73 cm
Venturi 357
Private collection, Paris

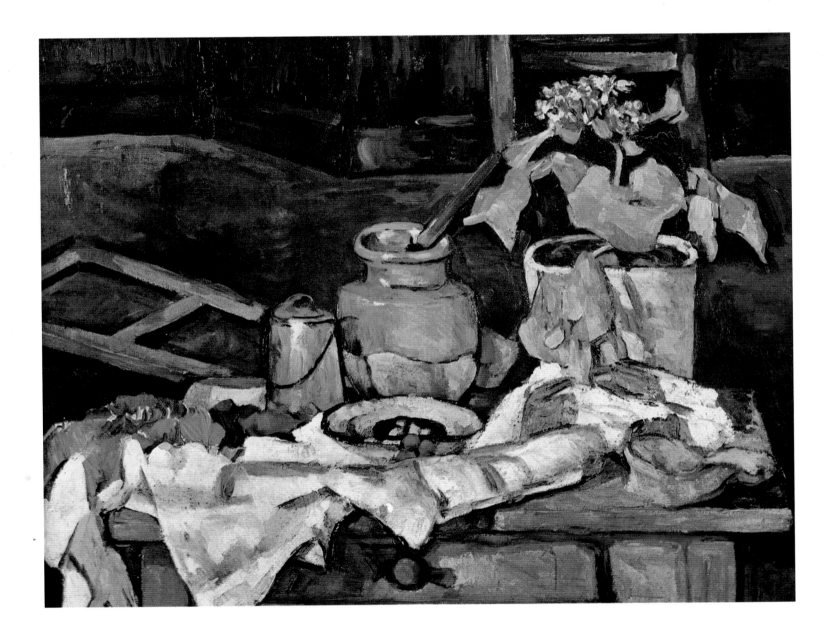

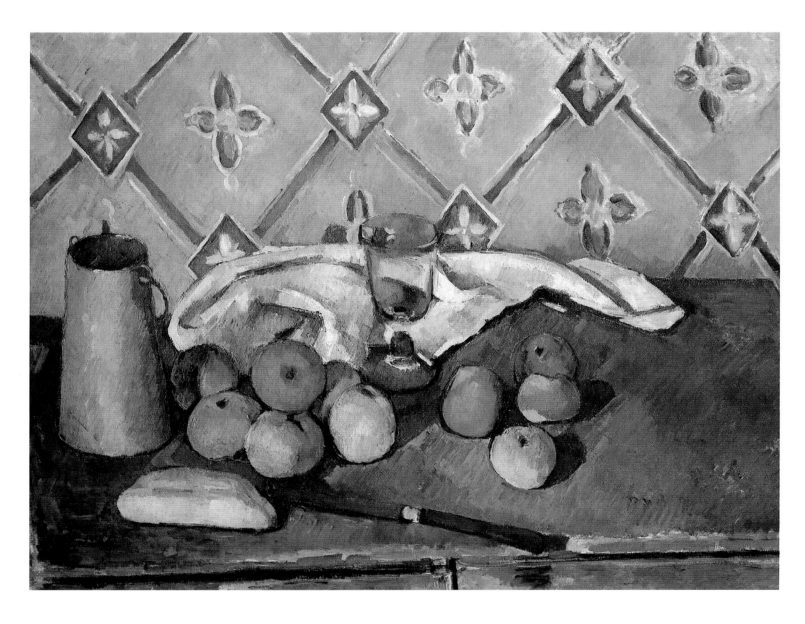

Jug, Fruit, Cloth and Glass,
1879–1882
Nature morte: fruits, serviette et boite à lait
Oil on canvas, 60 x 73 cm
Venturi 356
Musée de l'Orangerie, Paris

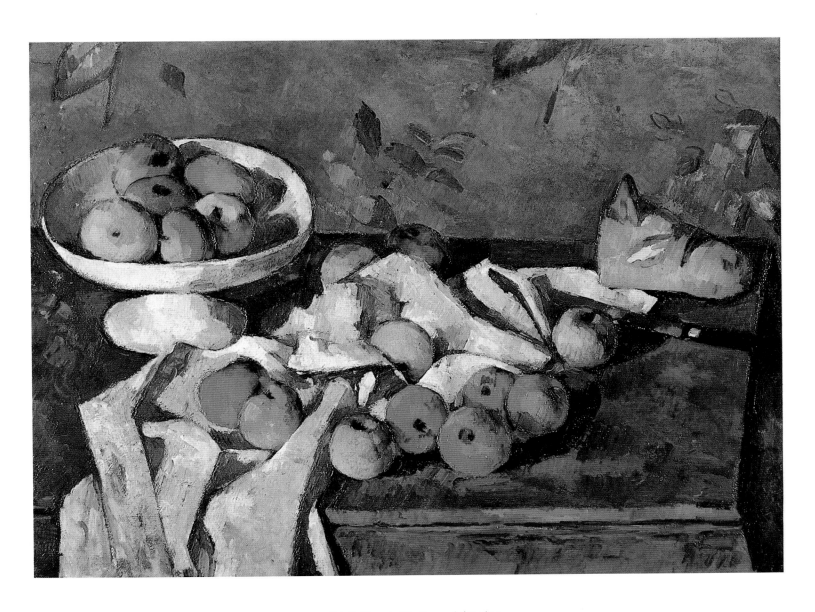

Fruit-Bowl, Cloth and Apples,
1879–1882
Nature morte: compotier et pommes
Oil on canvas, 55 x 74.5 cm
Venturi 344
Oskar Reinhart Collection, Winterthur

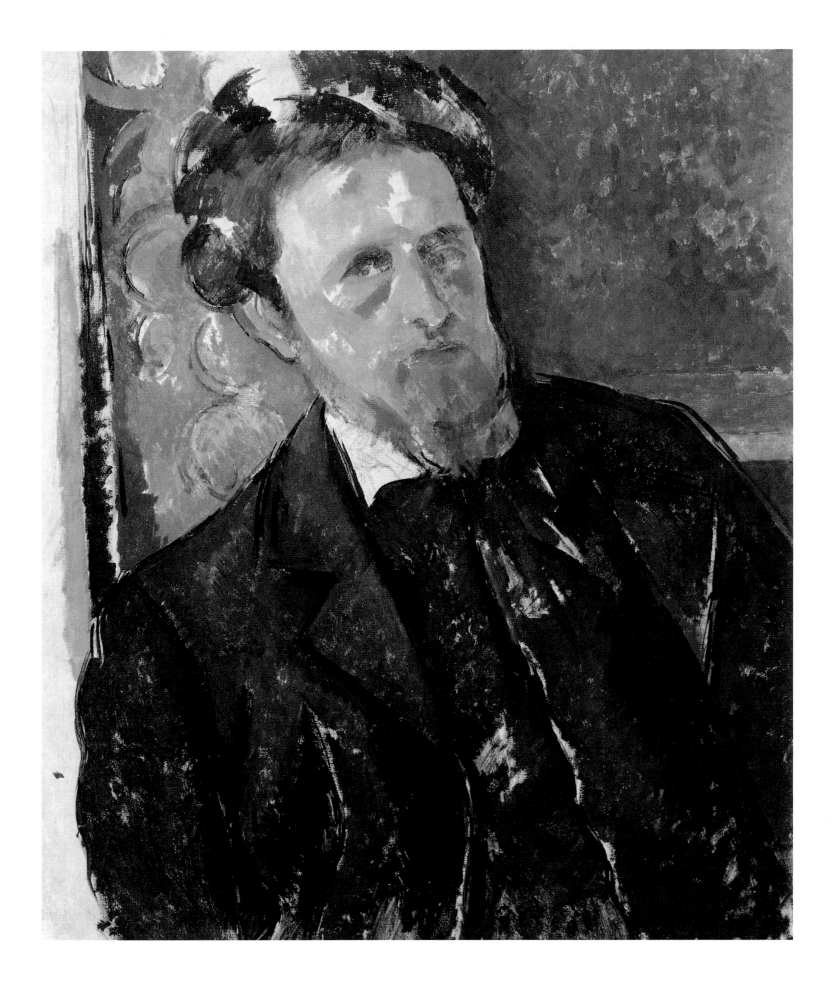

work alone. All that remained between them were their memories of youthful days; as artists their contact had become impossible.

But who was Claude Lantier in reality? The character in the novel was a composite of memories and anecdotes relating to various Impressionist painters; perhaps Cézanne had identified with him too much? Or was Zola indeed lamenting Cézanne's inability to mature the powers within him, which he had previously regretted in letters to his friend? Their reactions suggest that almost all the Impressionists thought Claude Lantier a portrait of themselves. Zola, however, repeatedly insisted that his character was a composite of his own creation, drawn just a little from talks at the Café Guerbois or at Bennecourt. And we should not overlook the fact that Zola gave Lantier certain traits of his own, such as his irrational, Mallarmé-like side.

Lantier was an invention, created by Zola from observation for his own ends. The character expresses the breach between Romanticism and Naturalism, and the shift from a non-evaluative, analytic account of reality to fantastic ideas and hypotheses. But the novel's plot does move along the lines of the contemporary debate in aesthetics, which Zola followed very closely. In the description of Lantier's masterpiece (which does not fit Cézanne's work at all) there are references to "mysterious colour practices", mathematical combinations and scientific principles which unambiguously point to the new style in painting – which Zola had made sure to study at the 1884 Salon des Indépendants. Evidently the references must be to Seurat's artistic programme, his optical blending of tiny dots of colour in accordance with the theories of Rood and Maxwell, the influence of Eugène Chevreul's colour theory, and the principle of the emotional expressiveness of rising and falling lines as laid down by Charles Henry (in his *Introduction à une esthétique scientifique*, 1885). The Neo-Impressionists were not using their scientific ideas to reinforce an Impressionist view of Nature, though. They were out to establish a new artistic style, one that was rendered impregnable by its theoretical foundations.

Zola's references to the psychological and physiological investigation of colour may therefore be considered a kind of contribution to the debate on aesthetics, on an art of ideas and fantasy, which the pupils of the Académie Cormon (Louis Anquetin, Bernard and Toulouse-Lautrec) were soon to help initiate. That would make Lantier a pioneer of the new Symbolism in art, which was to deliver painting from the cul-de-sac of Naturalism and Impressionism. Zola was in the process of modifying his old theory: the objective of art was still the presentation of reality, but it ought to be an intensified reality, and that intensification was possible through a pantheist conception of Nature, in which all things were seen as mysteriously interrelated. To Zola's way of thinking, Impressionism had failed to achieve that goal. Now it was up to a new generation of painters to pursue that course. Zola was following the progress of

"I wanted to make Impressionism into something as solid and permanent as the art in museums." PAUL CEZANNE

Joachim Gasquet, 1896/97
Portrait de Joachim Gasquet
Oil on canvas, 65 x 54 cm
Venturi 694
Národni Gallery, Prague

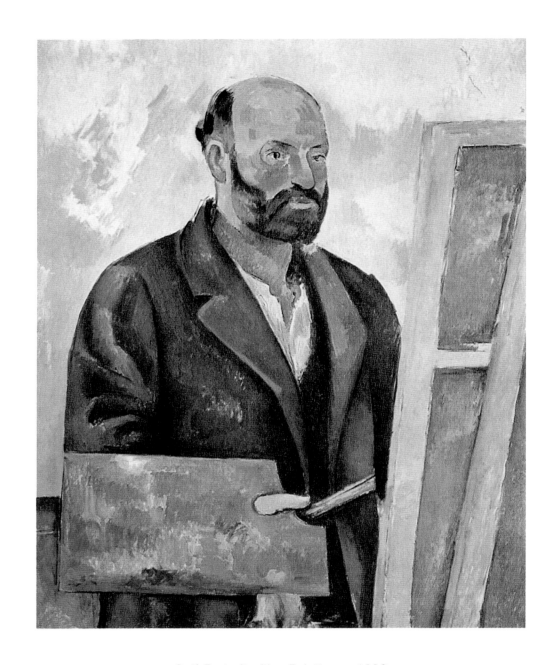

Self-Portrait with a Palette, ca. 1890
Autoportrait à la palette
Oil on canvas, 92 x 73 cm
Venturi 516
E. G. Bührle Collection, Zurich

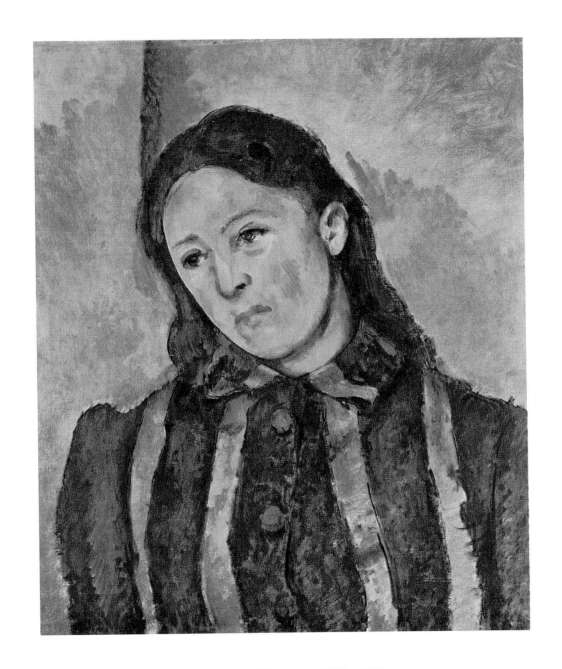

Madame Cézanne, 1883–1885
Portrait de Madame Cézanne
Oil on canvas, 62 x 51 cm
Venturi 527
Private collection, Philadelphia

things with great interest – but he totally overlooked the fact that the artist who came closest to the lofty ideal of art he proclaimed was Cézanne.

Of the original Impressionists, only Degas, Morisot and Pissarro participated in the eighth and last Impressionist exhibition in 1886; but they were joined by Gauguin, Guillaumin, Odilon Redon(!), Seurat, Signac, Claude-Emile Schuffenecker and others. This time the customary adverse reception was aimed at a curious aspect of the show's title. A critic called Hamel expressed surprise at finding "Impressionists, Intentionists, Illuminists and Independents" all sailing together under the Impressionist flag. The orthodox Impressionists, among them Monet, Renoir and Max Liebermann, exhibited at the Galerie Georges Petit. These painters were gradually acquiring a middle-class audience, while the independents were still questing for new goals. Some of them considered Seurat's *Un Dimanche à La Grande Jatte* (1884-1886, Art Institute of Chicago, Chicago) to be the artistic turning-point that introduced a new and stable order, meditating upon the essentials.

Two painters in particular were increasingly being identified as the precursors of Symbolist art. One was Puvis de Chavannes, whose *Sacred Grove* (The Art Institute of Chicago, Chicago) attracted considerable praise at the 1884 Salon. His calm and even compositions gave rise to talk of a classicist revival and a "new, sensitive art of harmony". According to the critic Albert Aurier, Puvis was out to "grasp the mysterious meanings of lines, light and shadow and use these elements as one might use an alphabet, to write down the wonderful poems of thoughts and dreams."

Alongside Puvis, the name of Cézanne was also mentioned. When in 1883 Huysmans published *L'Art moderne*, a collection of art reviews, Pissarro asked him why Cézanne went unmentioned, to which Huysmans unflatteringly replied that though he liked Cézanne's temperament he found his art unfinished and indicative of defective vision rather than originality. Now, three years later, Huysmans published a series of articles in *La Cravache*, and one of them was devoted to Cézanne. "Suddenly one becomes aware of altogether new truths, truths one had never paid attention to before: unfamiliar yet real shades, patches of colour with a character all their own, shadows falling from the far side of fruits across a white cloth, with a hint of blue that makes them quite magical... All in all a forerunner of colour, one who contributed more to the Impressionist movement than the late Manet [who had died in 1883], an artist with a diseased retina, whose overwrought powers of perception discovered the preliminary stages of a new art."

Through Gauguin's good offices above all, a new generation of painters were aware of Cézanne's work. The best place to see his pictures in Paris was Tanguy's paint shop; since 1877, Cézanne had not exhibited at any further Impressionist shows. After the economic crisis of 1883 Gauguin had given up a career at the stock

exchange and (with Pissarro's guidance) was devoting himself to painting. He was enthusiastic about Cézanne's pictures, but his warmth was hardly reciprocated, and Cézanne was even to accuse Gauguin of having stolen "his little secret". Gauguin did indeed write to Pissarro enquiring after a mysterious formula he believed Cézanne to be in possession of: "Has Cézanne hit upon an exact, universally valid formula, then? If he does discover a procedure for summing up all his exaggerated sensations in one manner, I implore you to slip him one of those mysterious homeopathic draughts and interrogate him while he is asleep. And then you must come to Paris with all speed and let us know!"

Aside from the humorous tone of the letter, we again see the new artistic generation's aim to find a new style for translating an overriding idea into terms of sense perception. In Gauguin's eyes Cézanne remained an "oriental mystic" who was working on a conclusive synthesis, like himself. For other painters too, Cézanne's work increasingly took on the character of a revelation. The young painters of the Académie Julian – Bernard, Maurice Denis, Pierre Bonnard and Edouard Vuillard – admired the even sense of balance in his pictures, his austerity and simplicity, and a quality of the sublime (which they related to their own aims). His work was seen as the solution to the problem of "keeping the power of perception in a central perception, but replacing experience with reflection."

In Cézanne's theories of art (in other words, conversation and opinions) they identified a synthetic, symbolic tendency which they discussed in a number of articles on him. To the new painters, Cézanne's association of structuring and feeling, and the harmony of Nature and pictorial form, seemed to offer a way out of their dilemma, a Hobson's choice of prettifying Impressionism or mystifying Symbolism. According to Denis, Cézanne was "the fulfilment of the classical tradition and the fruit of the great struggle for freedom and light which has put new life into modern art – the Poussin of Impressionism".

Apparently Cézanne himself claimed he wanted to "redo Poussin after Nature". What linked Puvis and Cézanne in the eyes of these painters was their attempt at an "ideal synthesis of Nature and Art", an attempt that was circumscribed neither by too great a fidelity to Nature (as in the case of the Impressionists) nor by academic rules. The landscapes of Puvis were at once stylized and realistic. He claimed that his aim was to create an art parallel to Nature.

Cézanne expressed himself in similar terms. Art (he told Joachim Gasquet) is a harmony that runs parallel to Nature. But what distinguished Puvis from Cézanne in the last analysis (and indeed still confirms Cézanne's superiority) was the former's lack of technical spontaneity and the stiffness of his compositions. Even the Symbolists found the erudition of Puvis's allegories

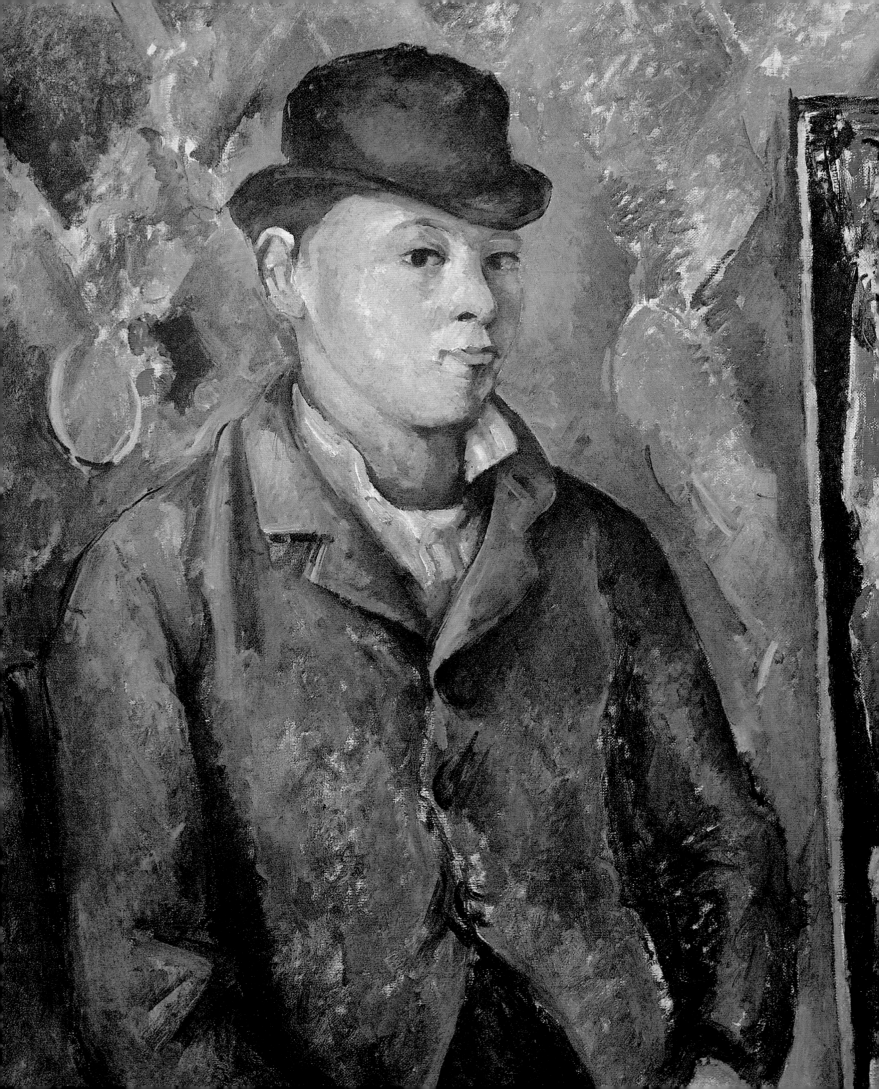

lacking in emotional depth. His quest for a style was still too much under the influence of academic views of Nature. That was where Cézanne came into his own. His enigmatic paintings, his virtuoso yet simple technique, the balance of his compositions, and the legendary character of his life and work in remote isolation, made Cézanne the hero the new generation chose to identify with.

The painter himself had a low opinion of the fuss that was being made about him, and thought little of the excited awareness of a new departure in art. He thought the new styles risky experiments, Symbolist painting "stuff and nonsense", and even the work of the Gauguin circle (which Bernard and Denis belonged to for a while) unimportant "little Chinese pictures". After the breach with Zola he completely avoided contact with the old Impressionists, who still met once a month. Cézanne left Aix and its environs less and less, even though he was now in a position to afford lengthy travels, if he had so desired.

The death of his father at the end of 1886 had suddenly improved his financial situation. His share in the inheritance ran to 400,000 francs a year, and a further 25,000 for Hortense and Paul. Cézanne and Hortense had now married, under pressure from his family, but they were no closer – quite the contrary, in fact. While Cézanne withdrew entirely into his art at Aix, Hortense spent most of her time in Paris with their son, fascinated by the sophisticated luxury of the capital. Cézanne kept to his former life-style. He lived at Jas de Bouffan, where his mother and sister Marie ran the household, and felt lonelier and more misunderstood than ever. What good was the babble of beginners to him in his heroic struggle for artistic truth? And as for Gauguin! A savage stirring up a *petite sensation* in the South Seas!

He felt deserted by everyone, Zola included. There was just one literary character Cézanne could identify with completely: Frenhofer, the painter who fails in the grand style in Honoré de Balzac's story 'The Unknown Masterpiece'. In the tale, Frenhofer has been working for years on a picture that is to sum up the entirety of experience and will be the summit of his artistic achievement – but no one has ever seen it. One day he decides to show the picture to some fellow-painters, since he now considers it finished. But there are only muddled lines and colours on the canvas, and a finely-painted female foot. Frenhofer has painted his picture out of existence, deluded by his belief in definitive perfection. "Frenhofer, c'est moi," Cézanne told his youthful admirer Bernard. (Bernard responded by quoting a passage from Balzac's story as the epigraph to his essay on Cézanne: "Frenhofer is passionately devoted to art, and sees farther and higher than other painters.") Indeed, Cézanne identified with Frenhofer to such an extent that when one evening conversation turned to Balzac's tale as he sat talking with guests he leapt to his feet and tapped his breast in silent accusation: *Frenhofer, c'est moi.*

Paul Cézanne, the Artist's Son, 1885
Pencil and black ink, 21.5 x 12.4 cm
Musée d'Orsay, Paris

*Paul Cézanne, the Artist's Son,
in a Hat,* 1888–1890
Portrait de Paul Cézanne,
fils de l'artiste, au chapeau
Oil on canvas, 64.5 x 54 cm
Venturi 519
National Gallery of Art, Washington, D.C.

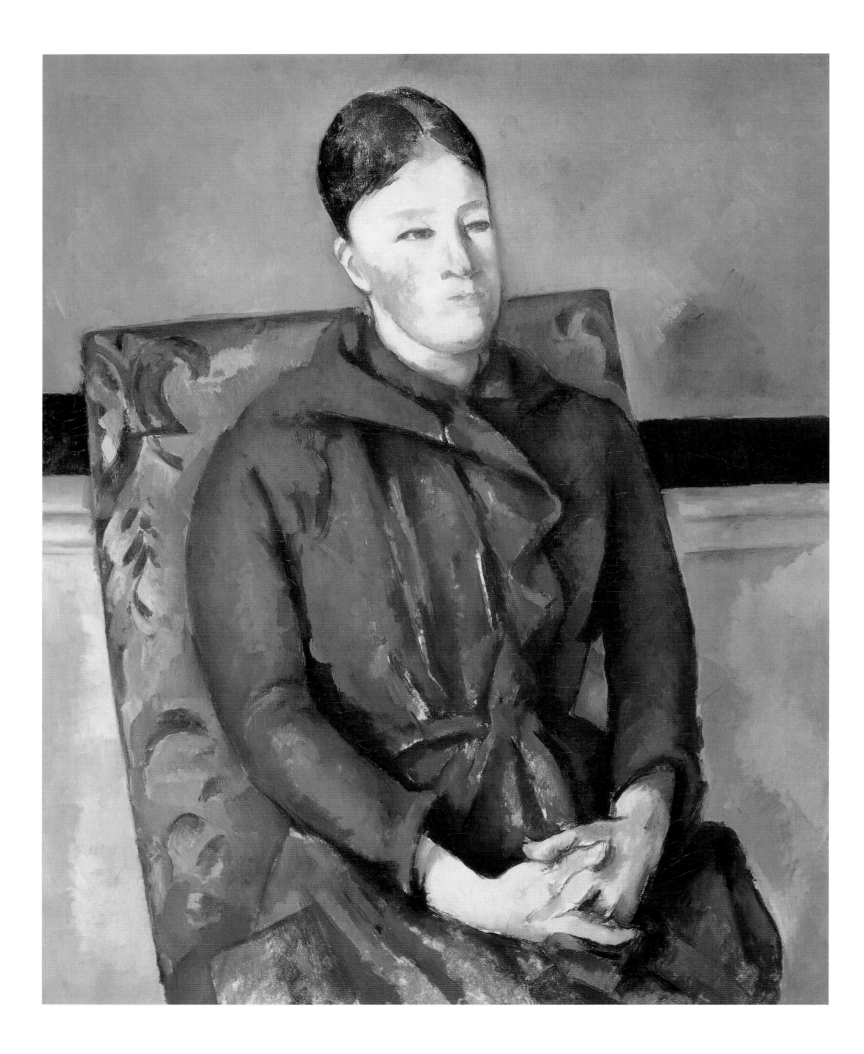

Whatever his doubts about achieving his goals, Cézanne still sought the public arena. Only once did he manage to trick his way into the Salon Bouguereau: a new rule permitted Guillemet to declare one of Cézanne's canvases as the work of a pupil and exhibit it without submission to the jury. (This loophole was closed a year later.) Cézanne's old friend and admirer Choquet managed to have *The House of the Hanged Man at Auvers* (p. 70) shown at the 1889 Paris World Fair, but it was so poorly hung that neither critics nor public took much notice. The Eiffel Tower, that symbol of modern technology and progress, exerted a magnetic fascination, though. The Symbolists had protested in vain against its construction. Very soon the Tower was to initiate a new myth, which a new generation of artists would seize upon in their turn.

In 1894 the gift of the Caillebotte Collection put the old Impressionists back at the centre of attention. Consisting of some sixty works by Degas, Monet, Renoir, Manet, Sisley, Pissarro and Cézanne, this formidable collection was refused by the state, under pressure from a massive lobby of protesting politicians, academics and critics who claimed that accepting the bequest as it stood would mean "the ruin of the French nation". And so Renoir, as executor of the estate, was obliged to make concessions, if the Collection and the pledge that it would be housed in the Musée du Luxembourg were not to be lost. Which meant that only two "harmless" works by Cézanne were accepted.

Hard upon the heels of the Caillebotte Gift came the sale of the Duret and Tanguy Collections. In March 1894, Théodore Duret, an art critic and a friend of Zola, sold off his collection, which included three Cézannes. A few weeks later the contents of Père Tanguy's store of paintings were auctioned off. An art dealer by the name of Vollard bought six Cézannes. Gustave Geoffroy was prompted to write a lengthy appraisal of Cézanne: "Cézanne has come to be seen as the precursor the Symbolists invoke, and if we keep to the facts it is absolutely certain that there is a direct link, a verifiable evolutionary connection, between the art of Cézanne and that of Gauguin, Bernard and the rest, indeed that of van Gogh. From this point of view alone, Cézanne's name deserves to be ranked as high as it merits. But whether Cézanne and his successors are cognate souls in any essential sense, and whether Cézanne advocates the same synthetist theories as the Symbolist artists – these are quite different matters. It is not difficult today, if we are thus inclined, to assess the overall development of Cézanne's work. And if we do so, our resulting impression that Cézanne by no means approaches Nature with artistic preconceptions, that he by no means has the despotic aim of subjugating Nature to some law or adapting it to some formula, will inevitably be strong. This does not mean that he has no programme or laws or ideals. But it does mean that he takes them not from art itself but from a profound curiosity, a desire to make the things he sees and loves his very own."

Madame Cézanne, 1887–1890
Pencil, 48.5 x 32.2 cm
Museum Boymans-van Beuningen, Rotterdam

Madame Cézanne in a Yellow Chair, 1893–1895
Madame Cézanne au fauteuil jaune
Oil on canvas, 81 x 65 cm
Venturi 572
The Art Institute of Chicago, Chicago, Wilson C. Mead Foundation Chicago

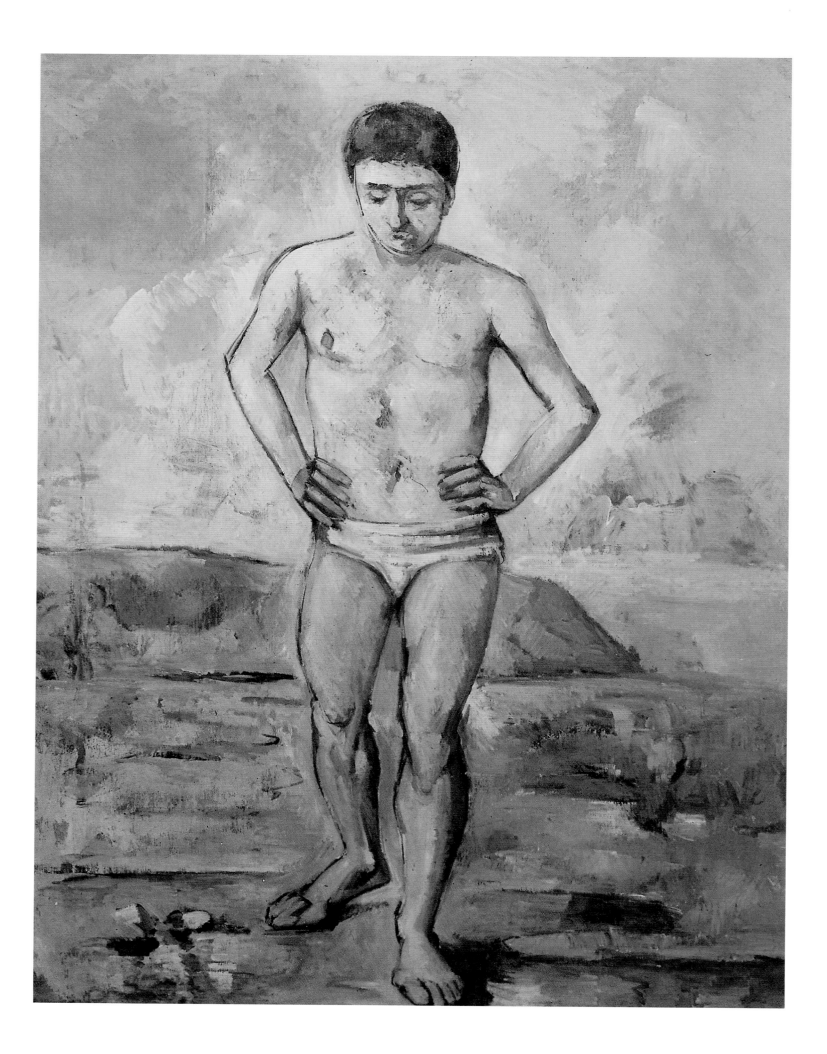

Redoing Poussin after Nature: Cézanne's Bathers

The quest for a new style and a new intensity of expression in the 1880s produced an astonishing diversity of literary and artistic groupings. The Symbolist label covered a multitude of aesthetic approaches, some of them linked by a shared appreciation of German philosophy and the music of Wagner, which was seen as a model for mysteriously meaningful art. In the *Revue Wagnérienne*, founded by Edouard Dujardin and Théodore de Wyzewa, Wagner was rated as far more than a mere composer: he was *the* symbolist artist. Wagner's operas and passages in the writings of E. T. A. Hoffmann prompted Baudelaire to formulate his theory of correspondences in which the barriers that separated word, sound and image were broken down by a synaesthetic system of universal analogy. Symbolist poets and thinkers profited greatly from Baudelaire's ideas. Mallarmé experimented with his *audition coloré* in his prose poem 'L'Après-midi d'un faune' (published in 1876, illustrated by Manet). And there was not only music of the word but also "Wagnerian painting" (visual analogies to Wagner's music); de Wyzewa detected it in artists as different as Redon, Puvis de Chavannes, Degas and Cézanne. The rather anaemic grace of Puvis's compositions was in fact generally viewed as "sensitive, harmonious art" by the Symbolists. In his monograph on Puvis de Chavannes, published in 1894, de Wyzewa described the significance of Puvis for the Symbolists in these terms: "We were thirsting for dreams, sensations, and poesy. Dazzled by a light that was far too bright, we were longing for the mist. And we turned with enthusiasm to the veiled, poetic art of Puvis de Chavannes."

In many respects, though, the Symbolists really had quite a different artist in mind when they referred to Puvis. Ever since Cézanne's last (i.e. the third) Impressionist exhibition, his bathers had been seen by some as "gauche and barbaric" but by others as a classicist revival (classical antiquity being taken to mean not only Greek but also Egyptian art). Cézanne's pictures of bathers were lauded for their combination of naturalness, spontaneity, and balanced ("classical") composition. And the very clumsiness of Cézanne's rendering of figures was taken as evidence of his unfeigned, genuine response.

The origins of Cézanne's preoccupation with bathers – a preoc-

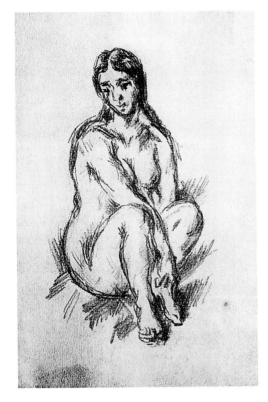

Seated Female Nude, 1879–1882
Pencil, 20.6 x 13 cm
Museum Boymans-van Beuningen, Rotterdam

Man Standing, Hands on Hips, 1885–1887
Le Grand Baigneur
Oil on canvas, 127 x 96,8 cm
Venturi 548
The Museum of Modern Art, Lillie P. Bliss Collection, New York

cupation that ran to over 140 oils, water-colours and drawings – lay partly in his earlier work. The tense sexual situation of his early days was expressed in eruptive, violent scenes that could be both strange and enigmatic. The titles Cézanne gave those scenes tended to render the content harmless, but nevertheless his inner conflict – a conflict intimately linked to his choice of an artist's life – was manifest. *The Struggle of Love* (pp. 50/51) enacts the contest of instinct and mind unambiguously; the theme was subsequently veiled and transformed in the series of *Bathers*, transposed to a higher level.

The origins of Cézanne's bathers were also biographical, and lay in the bathing trips along the Arc and the Torse which Cézanne and Zola had liked to recall in later life. In a letter to Zola of 20 June 1859, Cézanne recorded a scene featuring three men bathing. That basic fantasy can be traced throughout his work: Cézanne's sad nostalgia for something irretrievably lost, and his image of harmony between Man and Nature, produced pastoral scenes featuring bathers even in his early phase.

Courbet's image of Woman had met with severe criticism and had been widely burlesqued. What gave offence was the direct confrontation of natural nudity, with none of the erotic frisson of contemporary Salon art. Courbet's mythic prototype of Woman was Demeter, and from that vision of a natural cycle ruled by the goddess of earth there was every chance that Man would be excluded.

Cézanne's female bathers seem to share that Demeter-like quality; and it is striking that as we progress through the series the women in the paintings seem to be doing less and less actual bathing. In the earlier paintings the water is plainly visible, but subsequently the emphasis is primarily on the compositional placing of nudes in a natural setting. It is not clear what the individual bathers are doing, and later they are simply standing or lying, squatting or sitting, as the basic repertoire of positions might prompt.

In the 1870s Cézanne put the war of the sexes behind him in his work, and separated his bathers into male and female groups. The figures are often strikingly clumsy in these pictures. Cézanne had problems overcoming his shyness towards naked models, and was thus compelled to use early nude studies from the Académie Suisse, and photographs. At times he made do with his wife Hortense. Above all, though, Cézanne used drawings of classical originals for these compositions, in order to place his emphases without needing to trouble about individual details of movement and expression. The basic scheme of standing figures alternating with seated figures is somewhat expanded in his later work, where more active postures are introduced, but it is not fundamentally changed in any way.

Two figures are exceptions to this rule. The *Man Standing,*

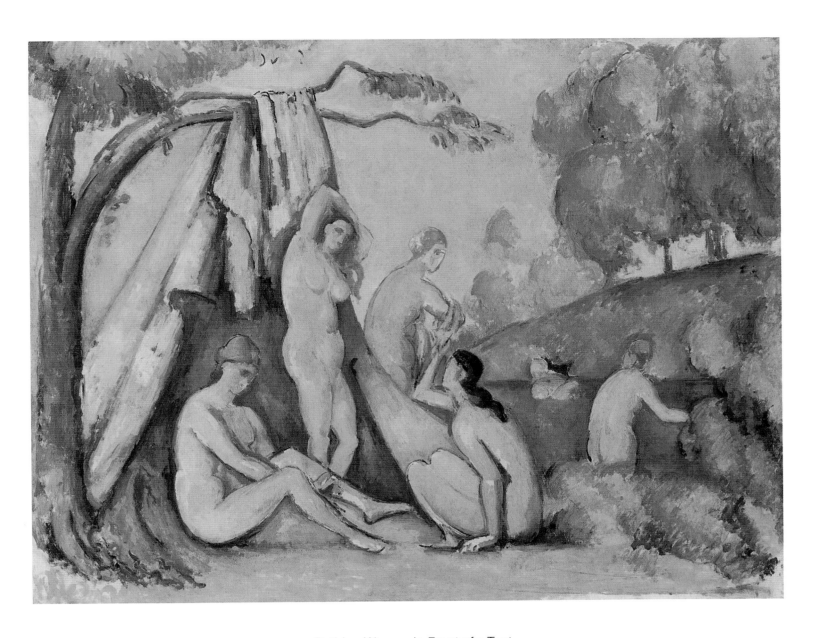

Bathing Women in Front of a Tent,
1883–1885
Baigneuses devant la tente
Oil on canvas, 63.5 x 81 cm
Venturi 543
Staatsgalerie Stuttgart, Stuttgart

Hands on Hips (p. 138) was originally intended as a central figure in another painting, but took on a life of his own. Elsewhere, a youth with arms outstretched appears in five paintings and sixteen drawings between 1875 and 1885. The way attention is focussed on him is intriguingly ambiguous; perhaps he symbolizes an elemental bond linking Heaven and Earth.

Cézanne himself often referred to this central subject matter by enigmatically saying that he wanted to "redo Poussin after Nature". Many painters of the 1880s took their bearings from classical art, and it is surely right to interpret the fact as an expression of cultural crisis. Unlike younger painters such as Bernard and Denis, though, Cézanne did not want a neo-classical revival. For him, the old masters in general were a source of instruction and pleasure. In the Louvre he would admire 15th century artists, Renaissance painters such as Titian, Jacopo Tintoretto and Giorgione, Baroque artists such as Rubens and Veronese, and Courbet and Delacroix among 19th century painters. To Poussin he allotted no special place. Cézanne was anti-doctrinaire in his attitude to the past, and valued masters of draughtsmanship or composition as highly as masters of colour. Line and paint were not at odds in Cézanne's

Five Men Bathing, 1892–1894
Cinq baigneurs
Oil on canvas, 22 x 33 cm
Venturi 587
Musée d'Orsay, Paris

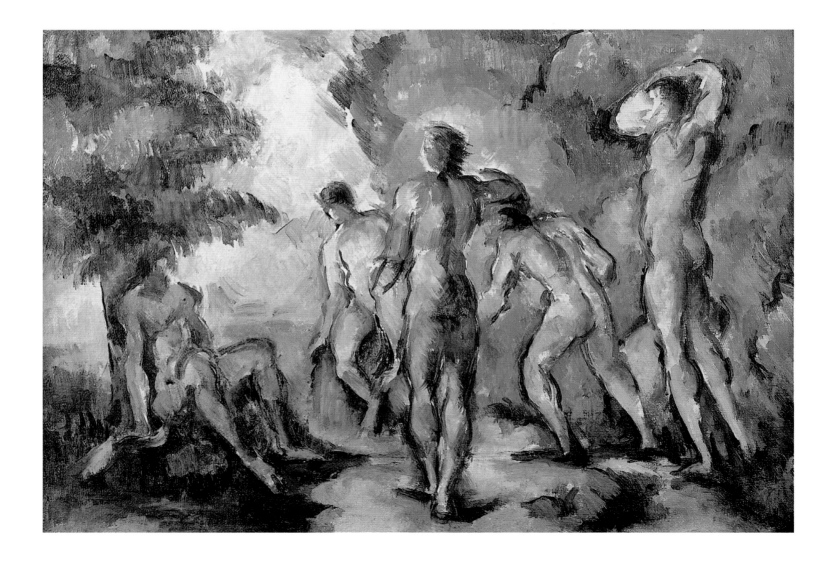

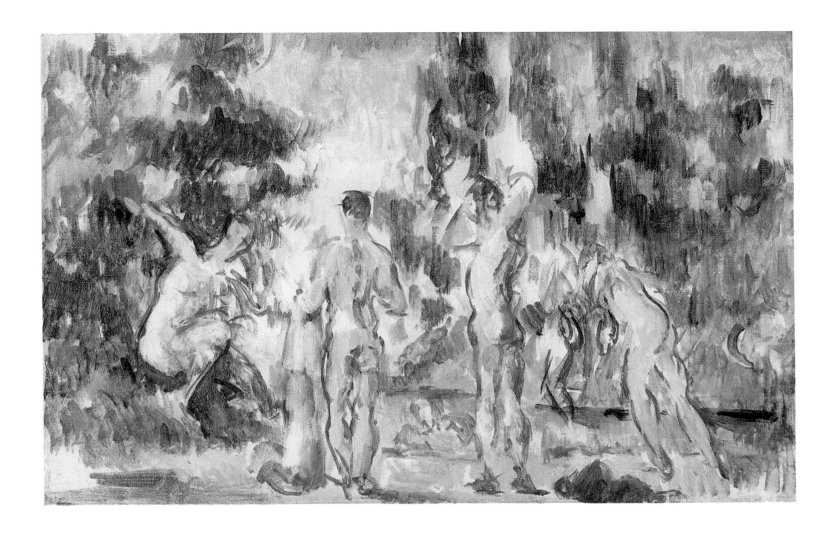

view; both were important components in a picture, and they had to be reconciled. Classicism exerted no compelling influence on him as it did on Bernard and Denis. Ingres he thought a "very minor painter". He admired Michelangelo as "a designer and thinker". An artistic intellect unschooled in Nature and lacking adequate "temperament" was abstract and valueless for Cézanne: "The Louvre is good for reference, but it should only be a go-between; the true and wonderful study that one must make is the study of the infinite variety of Nature." (Quoted from Emile Bernard: *Paul Cézanne*, 1900.)

In his sketch-books, Cézanne documented his predilection for Baroque art, for expressions of powerful, concentrated movement (in studies after Michelangelo, Rubens or Pierre Puget). There are only three drawings after Poussin, among them the shepherdess from the Louvre version of *Et in Arcadia Ego*, a reproduction of which Cézanne also had hanging in his studio. It has often been claimed, on the strength of a few spatial characteristics of a very general nature and the use of a structure limited to solid, clearly-defined forms (classical qualities), that there is a link between Poussin's pictorial structure and Cézanne's approach to composition; but this one painting of Poussin's which Cézanne demonstra-

Four Men Bathing, 1890–1900
Baigneurs
Oil on canvas, 22 x 35.5 cm
Venturi 585
Musée d'Orsay, Paris

PAGES 144/145:
Les Grandes Baigneuses,
1900–1905
Les grandes baigneuses
Oil on canvas, 126 x 196 cm
Venturi 721
The National Gallery, London

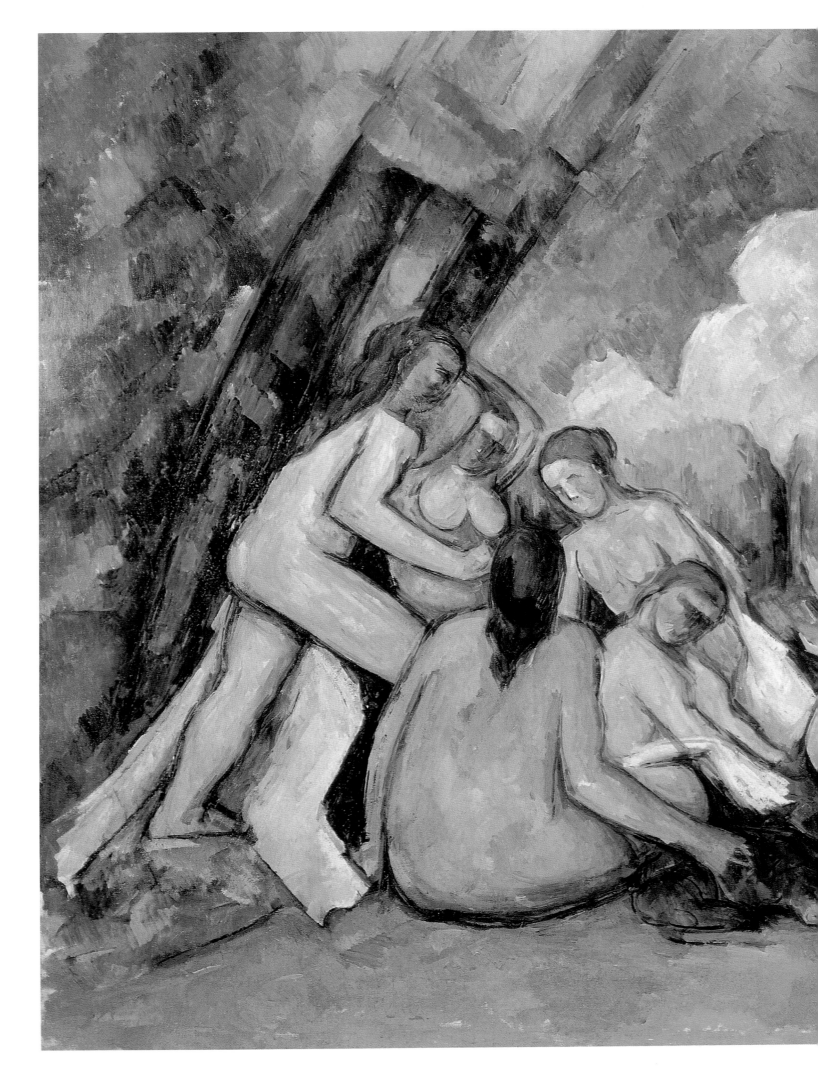

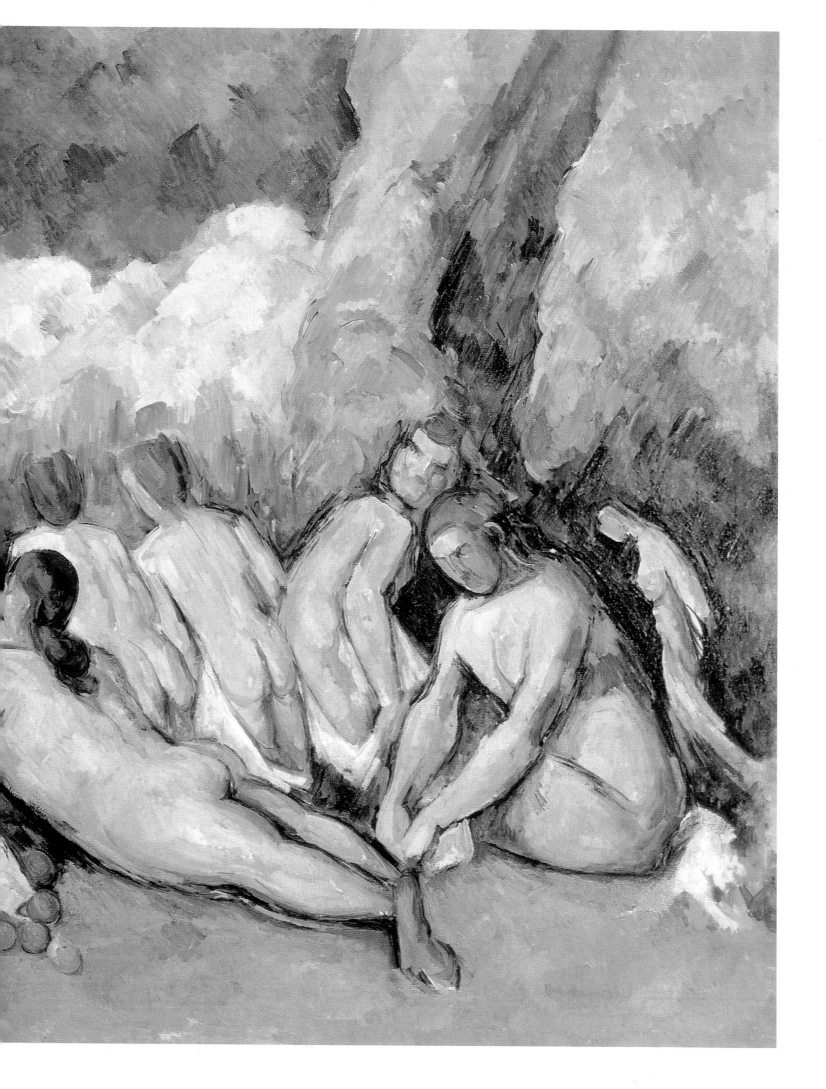

bly did admire tells us more about the character of the supposed connection. Poussin's theme of the universal presence of death, borrowed from antiquity, consorted well with Cézanne's fundamentally mournful sense of a lost harmony between Man and Nature – a sense of loss which (as we have seen) had biographical origins. It is possible to see Cézanne's bathers as a means of meditating – on the harmony of an idealized past, a Golden Age.

There is a specifically 19th century quality to the myth of the Golden Age. Harmony between Man and Nature had been lost; Man was alienated from Nature, and also exploited it. To supply the need this left, the 19th century evolved the myth of an earthly paradise. Socialist utopias opened up new realms of expectation through the hopes for societal change which they held out. In architecture and in painting the norm was again classical antiquity (cf. Karl Friedrich Schinkel's mural in the staircase of the Altes Museum in Berlin, *The Flowering of Greece*, begun in 1828). Ingres's *The Golden Age* (1862, Fogg Art Museum, Cambridge, Mass.) shows a harmonious life led in an idyllic natural setting under Nature's laws of growth and decay. The subject of the earthly paradise provided artists with an emblem of rediscovered creative power. Cézanne said: "The task of genius ought to be to show the amity of all things, striding forth into the open, all in step, their desires the same."

In other words, the bathers Cézanne painted were by no means as classicist in spirit as his contemporaries assumed. Equally, they have nothing to do with the Naturalist debate concerning the extent to which Man was a product of his time and social and cultural milieux (as in Zola's novels). Cézanne's pictures are a return to a fundamental myth of Nature. Initially dictated by his own emotional problems, his scenes were gradually stripped of biographical garb and came to represent a neutral zone in which no social comment was being made, no classical ideal or arcadian idyll pursued, but rather a utopia of freedom was being posited: a symbiotic co-existence of Man and Nature, a principle of hope. *Les Grandes Baigneuses I-III* engaged Cézanne from 1898 on and were left unfinished at his death. They are among the largest pictures he painted, which doubtless reflects their significance for the artist. The first of them, now in Philadelphia, is among his best-known works.

The composition of *Les Grandes Baigneuses I* is dominated by the triangular superstructure of the trees which overarch the bathing women like a cupola. We see a number of naked women by a river, in various positions, though it is unclear what exactly is happening. The strict composition marks off this painting from works by Cézanne's contemporaries (particularly the Impressionists). In the positioning of the bathers there is something hieratic, even processional, which is reminiscent of an Egyptian frieze. Nevertheless the painting seems unreal and alien. What is lacking

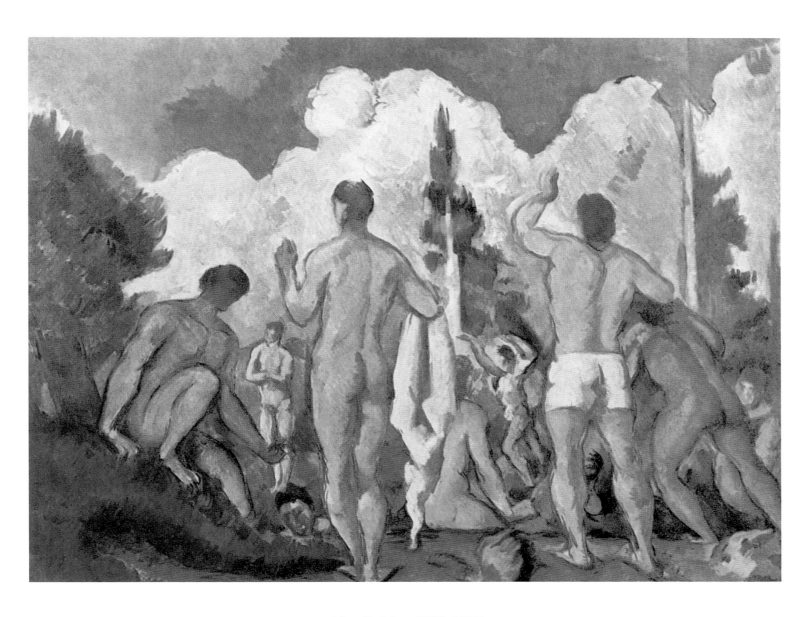

Men Bathing, 1890-1892
Baigneurs
Oil on canvas, 60 x 82 cm
Venturi 580
Musée d'Orsay, Paris

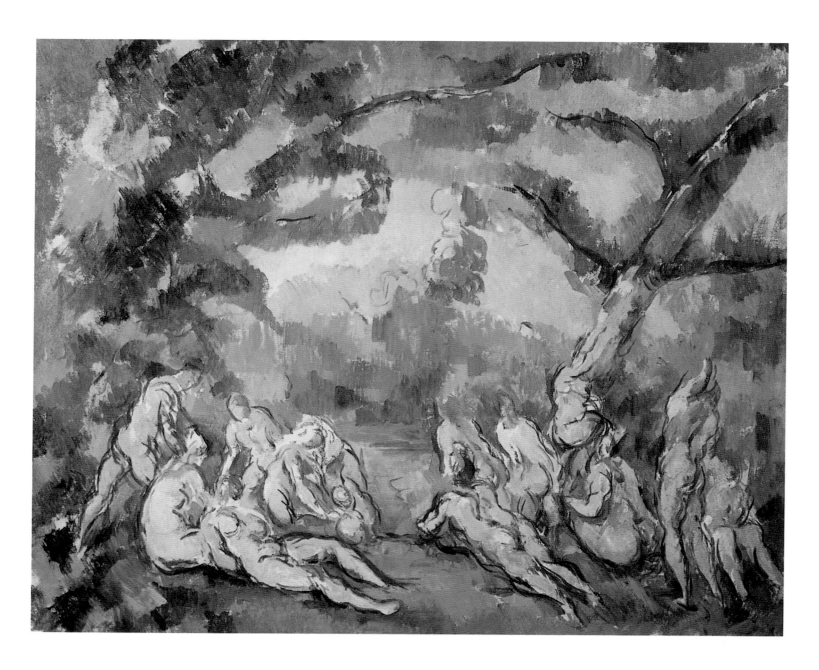

Women Bathing, 1900–1905
Baigneuses
Oil on canvas, 50 x 61 cm
Venturi 722
The Art Institute of Chicago, Chicago

is that natural freshness which Renoir was so well able to capture. The figures have a look of worshippers in some ancient, cultic religion. On the far bank we can make out a solitary male figure, and in the distance a church and wood mark the rearward limit. The dominant blues underline the ambivalent, dreamy mood. The austerely composed scene seems to pick up other scenes in early Cézanne where clothed men confronted naked women, in which case we might be right to see the church as a reference to the sustaining power of religion which Cézanne had discovered in old age – and as a useful defence against the overwhelming instinctual drives represented by the women.

In the other two versions of *Les Grandes Baigneuses* the arrangement of the figures is livelier and the landscape background more dramatic. Cézanne clearly adds an autobiographical note by introducing Black, the dog he and his friends had taken along on their bathing excursions (cf. pp. 144/145).

Four Women Bathing, 1879–1882
Pencil and black chalk, 20.3 x 22.3 cm
Museum Boymans-van Beuningen,
Rotterdam

The attempt to present the harmony of Man and Nature in an idealized image was widely undertaken by the artists of Cézanne's time. Seurat's depiction of the Grande Jatte, for instance, where Parisians (and especially lovers) liked to go on trips in the 1880s, was partly seen in this way. Of course the public and critics also saw that it was not merely a Sunday idyll, and that it showed a world of loose living and rendezvous, the monkey on the lead symbolizing (restrained) animality. Then there had been Courbet, transforming vulgar everyday life into images of natural existence. But Cézanne alone succeeded in bridging the gap between superannuated classical ideals and banal, unattractive realism by synthesizing the symbolic values of both. Thus the use of art figures, which often gives his compositions their awkwardness, was a solution to the problem of ideals versus contemporaneity. Cézanne's figures are detached from a contemporary context, yet they are not stylized along classical lines, as in Puvis, Denis, Bernard and other Neo-Classicists. They are timeless archetypes of non-historical harmony with all-powerful Nature.

Cézanne's women no longer personify the negative aspect of Woman but instead symbolize the creative power of the feminine principle, and thus also the creative unconscious from which the artist draws his imaginative energies. Monet's paintings of water-lilies also approached Nature, through a subject of some similarity (since water-lilies, in the literature of the time, were symbols of the feminine). But while Monet was interested in the blending and merging of colours, Cézanne's use of colour insisted on structural stability, that firmness he missed both in himself and in society. Cézanne's colours, like Monet's, operate on a unifying principle – but instead of dissolving they fashion everything into a transparent but stable structure. Monet's water-lilies show the whirlpool of Time which sucks down all things into ultimate oblivion. Cézanne's pictures are out of Time; they are timeless, mythic images of a torn

149

era that had no certain access to Nature as it negotiated a course between idealized longings and artificial worlds (such as Symbolism) towards the Modern.

The war of the sexes and the disharmony of Man and Nature seem to have achieved a condition of reconciliation in the last pictures of bathers, in the togetherness of figures and natural environment, the correspondence of all the component parts, the colourful vitality, and the cancellation of gender distinctions. Literary and artistic documents of the *fin de siècle* attest the powerful attraction of the ancient idea of the androgyne or hermaphrodite: both sexes united in a single being with all the good qualities of Man and Woman, in ideal perfection.

We know that Cézanne spoke of "the virginity of the world". His series of paintings showing bathers present one of the great dreams of mankind, the dream of union with Nature, the longing for an earthly paradise.

These pictures have always exerted a considerable fascination. When Vollard opened his Cézanne exhibition in 1896 he hung one of the pictures (p. 151) in the window. It excited a good deal of attention, and above all prompted great admiration amongst artists. Matisse bought the canvas, and in due course it inspired his own *Luxe, calme et volupté*. It was not until many years later that he gifted this key work to the Musée du Petit Palais in Paris: "I have had the picture for 37 years, and I hope I know it pretty well by now, albeit with some reservations; at critical moments in my own career as an artist it has restored my spirit; it has been the source of my belief and my endurance."

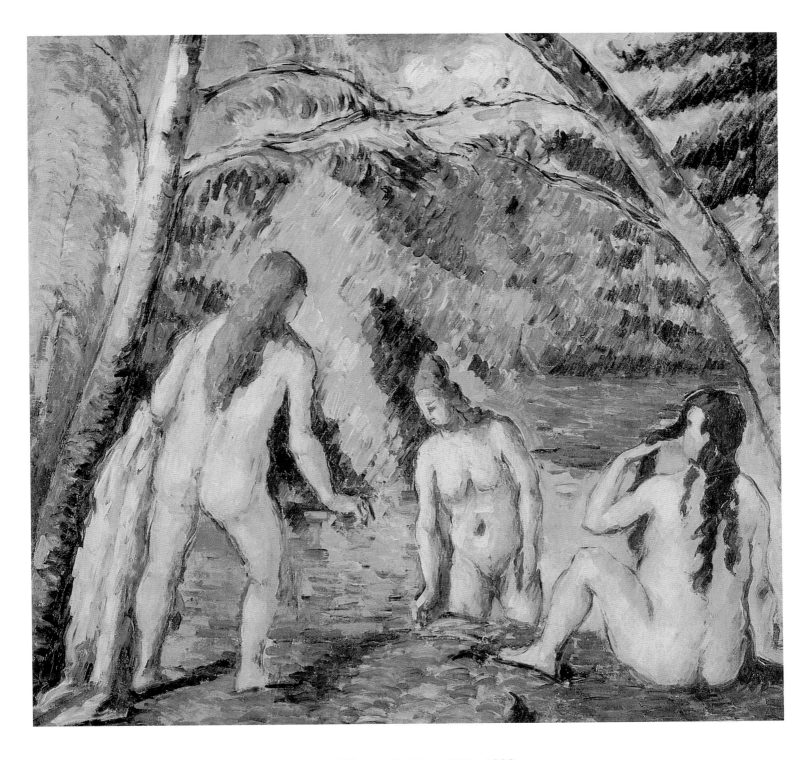

Three Women Bathing, 1879–1882
Trois baigneuses
Oil on canvas, 52 x 55 cm
Venturi 381
Musée du Petit Palais, Paris

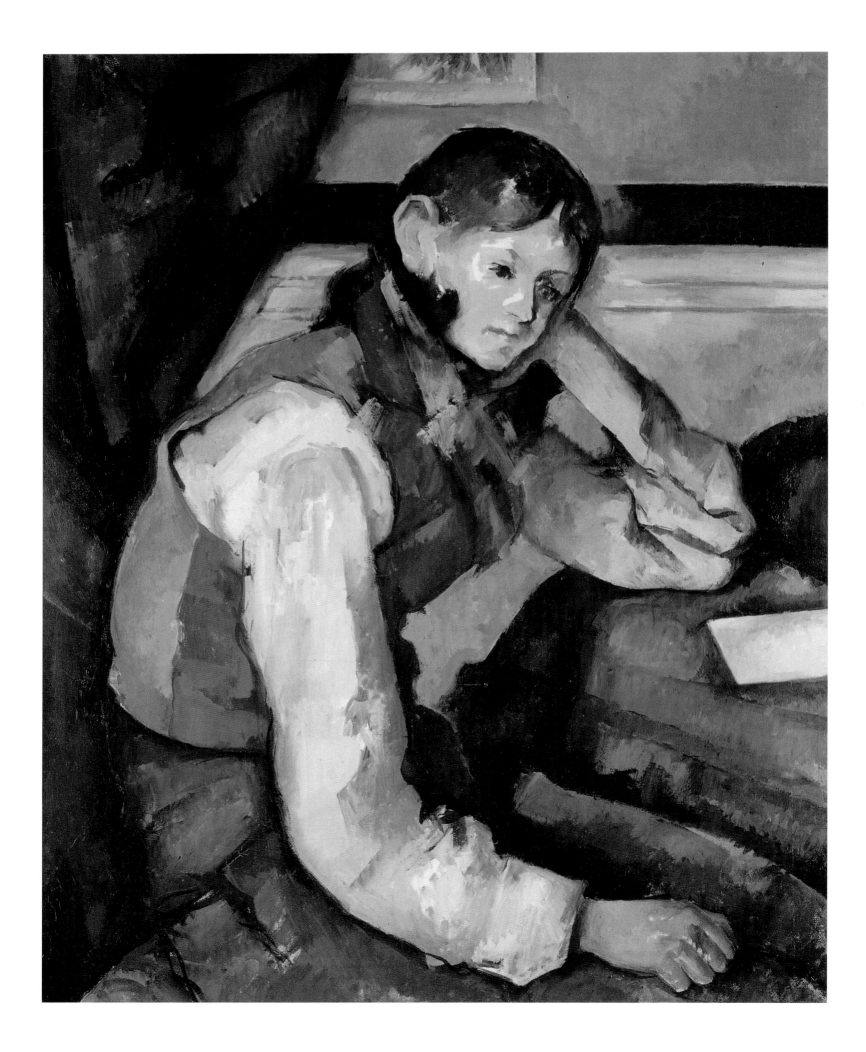

"The primitive of a new art": Portraits and Figures

At the end of the 1880s the insecure Third Republic was shaken by a number of crises. Talk in artistic bars such as the Brasserie Gambrinus and the Taverne Anglaise, or in the editorial offices of the *Revue Indépendante*, turned on matters other than new aesthetic departures. Changes in society were being debated — and the Symbolists and Neo-Impressionists joined the debate. In 1887 the French president was forced to resign following revelations of corruption involving his son-in-law. Jules Grévy's successor was Marie François Sadi Carnot, who was assassinated by an anarchist in 1894. The Boulanger crisis (occasioned by the dismissal of the revanchist General Georges Boulanger) prompted opposition on the extreme right which threatened to jeopardize Third Republic democracy seriously.

The Symbolists and their associates openly espoused the cause of anarchism. In 1889 Signac drew an imaginary scene of the death of Boulanger for a political pamphlet. The new artists had read very little of Kropotkin or Marx, but they came out on the side of extreme individualism, love of freedom, and humanity. Pissarro's cycle of drawings, *Social Injustices* (1889), was an unreserved plea for social justice. While the World Fair applauded technical novelties such as electric light, the anarchists drew attention to the reverse of the coin. Modern artists who had been spurned and rejected could identify with the dissatisfaction of the masses. They used their art for attacks on the petrifaction of capitalist society. They provoked. The paintings and drawings of Redon, a major new Symbolist artist, exemplified an unbound imagination that cared only for the wishes, hopes and dreams of an individual developing in his own free way.

In 1889 Huysmans published his art criticism in *Certain*. He drew attention to Redon, Gustave Moreau, Puvis de Chavannes, Whistler, Degas — and Cézanne, whom he presented as the precursor of the new approach to colour. Cézanne, with his overwrought powers of perception, had (he wrote) taken the preliminary steps in the discovery of a new art. 'Les Vingt', the group of progressive Belgian artists founded in 1884 by Octave Maus, like the Indépendants in Paris, shared this opinion. They invited Cézanne to exhibit in Brussels at the beginning of 1890, which he did, with Seurat, Signac, Pissarro, Redon, Toulouse-Lautrec and

"Two things matter in a painter: his eye and his mind. The two must give mutual support. Both need to be trained: the eye by studying Nature, the mind by an orderly, logical approach to impressions and experiences. They create the means of expression." PAUL CEZANNE

Boy in a Red Waistcoat, Leaning on his Elbow, 1888–1890
Garçon au gilet rouge
Oil on canvas, 79.5 x 64 cm
Venturi 681
E. G. Bührle Collection, Zurich

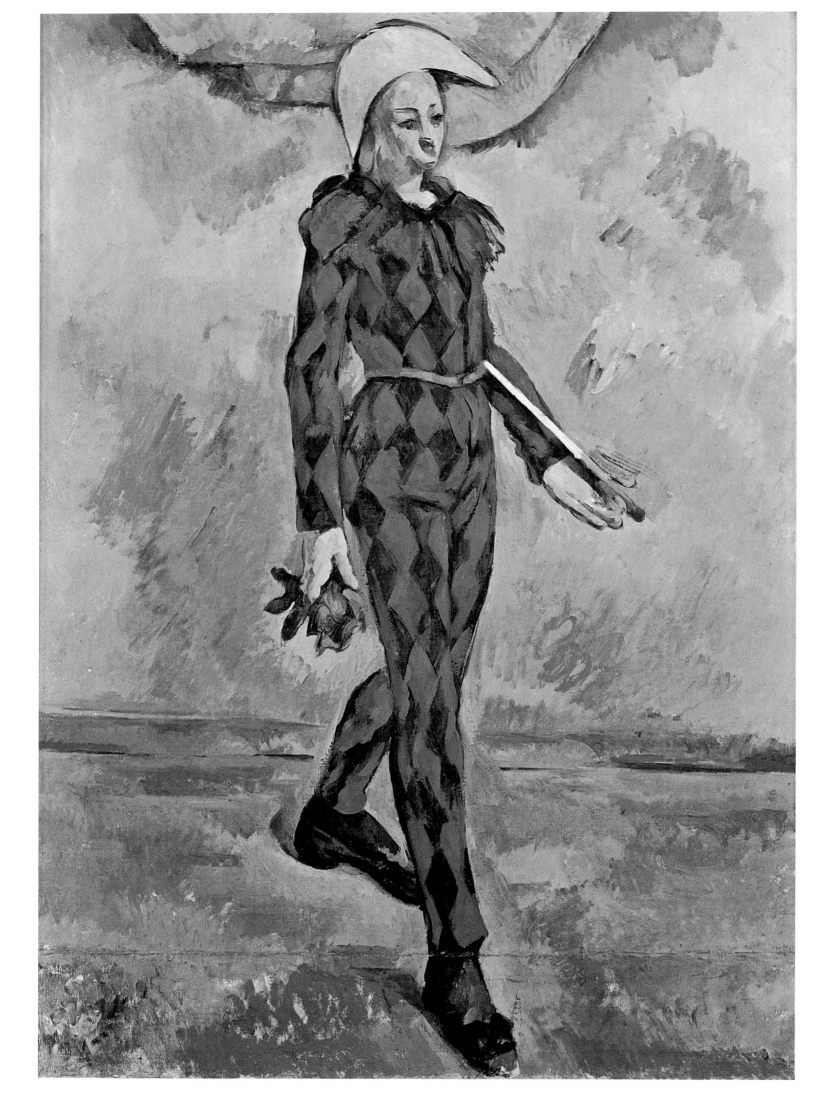

van Gogh. But the press ignored his work. Van Gogh was seen as the most important artist in the show.

In isolation at Jas de Bouffan, Cézanne registered little of the political tangles artists were involved in. His aged mother, his sister Marie (who ran the household) and Hortense were constantly at loggerheads over money. At last Hortense persuaded her husband to take the family to French Switzerland; there were questions of inheritance in her own family which needed seeing to. So for five months Cézanne travelled about Switzerland with his family – only to depart abruptly on his own when an anti-Catholic event vexed him. One wonderful landscape, *Lake Annecy* (p. 200), visibly expressed the painter's new isolation and loneliness. The lake and the mountain landscape look petrified or crystallized, as if they had been metamorphosed into some preternaturally hard substance.

Letters old friends wrote to Zola indicate that Cézanne became increasingly conservative towards the end of his life. We should see his return to the bosom of the church in terms of that conservatism rather than as sentimental old-age piety: he was seeking the same secure stability as he had been able to give to the structures of his paintings. Intolerant, mulish, fearful of contact, Cézanne grew ever more isolated from his old friends. The numerous portraits done in those years are eloquent of the distance Cézanne put between himself and the world. The pictures of Hortense, in particular, are marked by indifference towards the figure and her setting. Physiognomical detail is heavily played down so as not to disturb the visual equilibrium of the various parts of the picture (p. 157).

Cézanne even transformed his beloved son Paul into an alien creature. Inspired perhaps by the Aix carnival, Cézanne had Paul and his friend Louis Guillaume pose for a curious picture: *Mardi Gras*. We see two figures from the Commedia dell'arte, the Harlequin with a fool's wand under his arm and the Pierrot in white, on a "stage" somewhat inclined towards us. Part of the setting is curtained off with heavy, brightly-patterned drapes. The focal point is the Harlequin, striding out solemnly. He is emphasized by his flashy costume with its red-and-black diamond pattern; these reds are picked up everywhere, in the walls, curtains and floor, even in the Pierrot's white. Other versions show the Harlequin alone. The painting in the Rothschild Collection (p. 154), for example, gives us a Harlequin with an oddly distorted facial expression, standing in a space characterized purely by strong colour contrasts and expressive brushwork: the artist as fool, exposed to society's mockery, but also as a free man who can do or not do whatever he considers right. The Harlequin's distorted features may also point to the artist's alienation from society.

But what are we to make of the Pierrot trying to snatch away the Harlequin's wand? The figures have a monumental quality that

Harlequin, 1889/90
Arlequin
Oil on canvas, 92 x 65 cm
Venturi 553
Rothschild Collection, Cambridge

Madame Cézanne, ca. 1890
Pencil, 12.6 x 21.7 cm
Block Collection, Chicago

Madame Cézanne in the Conservatory,
1891/92
Madame Cézanne dans la serre
Oil on canvas, 92 x 73 cm
Venturi 569
The Metropolitan Museum of Art,
New York

goes beyond genre painting, so this is surely not a mere prank. If we take the Harlequin to represent the artist, we can see the white figure as a personification of that societal oafishness which was out to rob the artist of his dignity and standing (the wand/the brush).

Another famous series confirms our impression that Cézanne was aiming at a symbolic level beyond first impressions. Workers at Jas de Bouffan (pp. 25 and 158) whom Cézanne watched playing cards were probably his models for the five paintings and various studies showing card-players which he did between 1890 and 1892. We can readily study the evolution and concentration of the picture in the various individual canvases. Probably Cézanne painted the version showing five figures first (Barnes Foundation, Merion). It is a well-observed genre scene with all the props such a scene requires; Cézanne had been able to study a similar painting by Louis Le Nain in the Aix Museum. The second version (p. 160) moves closer to the subject, and includes three card-players and one man looking on.

Then there is a second group consisting of only two men seen in profile, one on either side of the table (p. 161). Now all the details necessary in a genre painting have been eliminated in favour of greater expressive impact, an impact which Roger Fry compared with the dignity and solemnity of an ancient monument. The two card-players make an alert, indeed almost reverent impression. The world all about them seems of little consequence. The setting is adumbrated only loosely, a delusory realm in which only the two men's activity has meaning and clarity. The focus is totally on them; busy everyday life is vanquished in this moment of peaceful solemnity. The tranquillity of the subject is reinforced by the stable, almost symmetrical composition. The main axis, somewhat off-centre, runs where the bottle stands; the balance and counter-pointing of axes and angles give the composition a sovereign calm but also a frisson of tension. And, having established his space with this fine instinct for balance, Cézanne has also differentiated between the two players in psychological terms. The pipe-smoker on the left makes a cool, calculating impression, while his vis-à-vis with his hat-brim turned up looks warm and open, and more involved in the game. The colour scheme is well suited to the contrasts: using the basic polarity of violet and yellow Cézanne runs an entire gamut of subtle shades, through to neutral grey, all of it heightened by warm browns and reds.

When a painter repeats a motif so often and with growing concentration, we are naturally tempted to wonder what it meant to him. Badt's interpretation is the most interesting, albeit rather far-fetched. He believes the *Card-Players* has a psychological weight related to an 1859 sketch known as the Ugolino drawing, which also has two figures opposite each other at a table. Badt sees the early drawing as an expression of Cézanne's hatred of his authoritarian father and his dream of making a living from painting. By

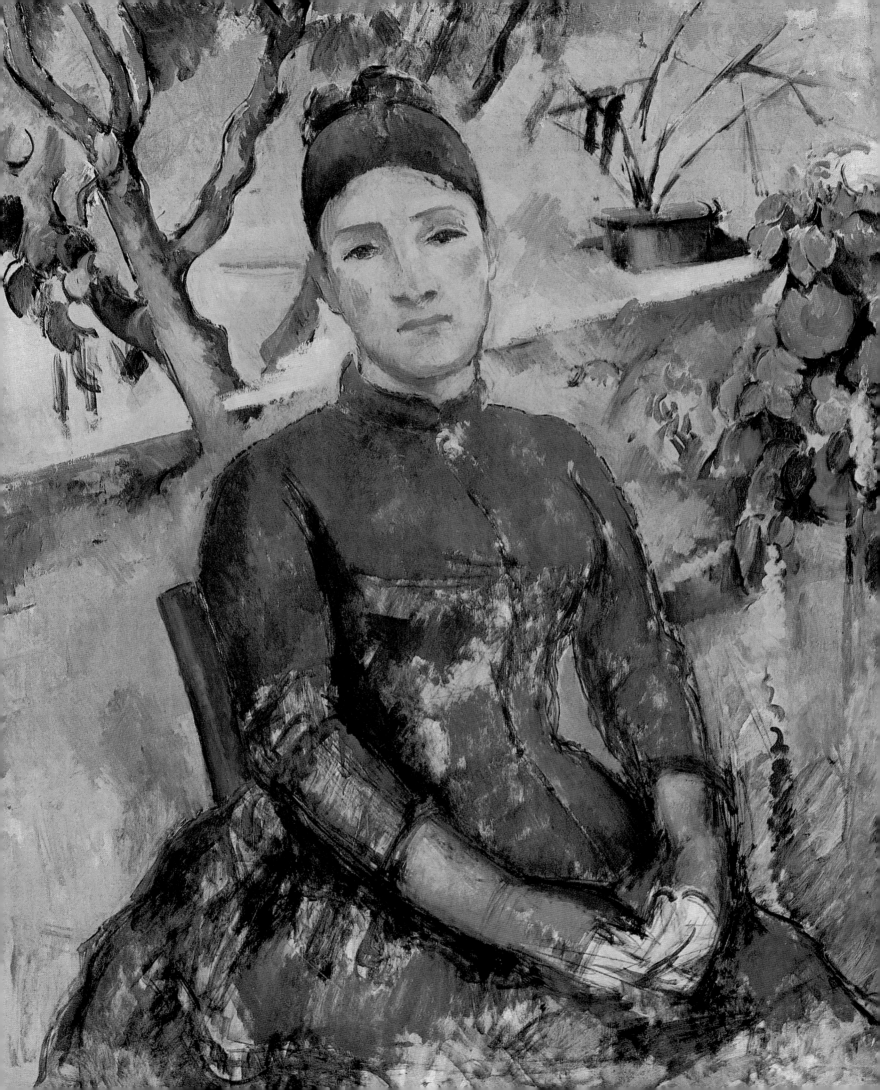

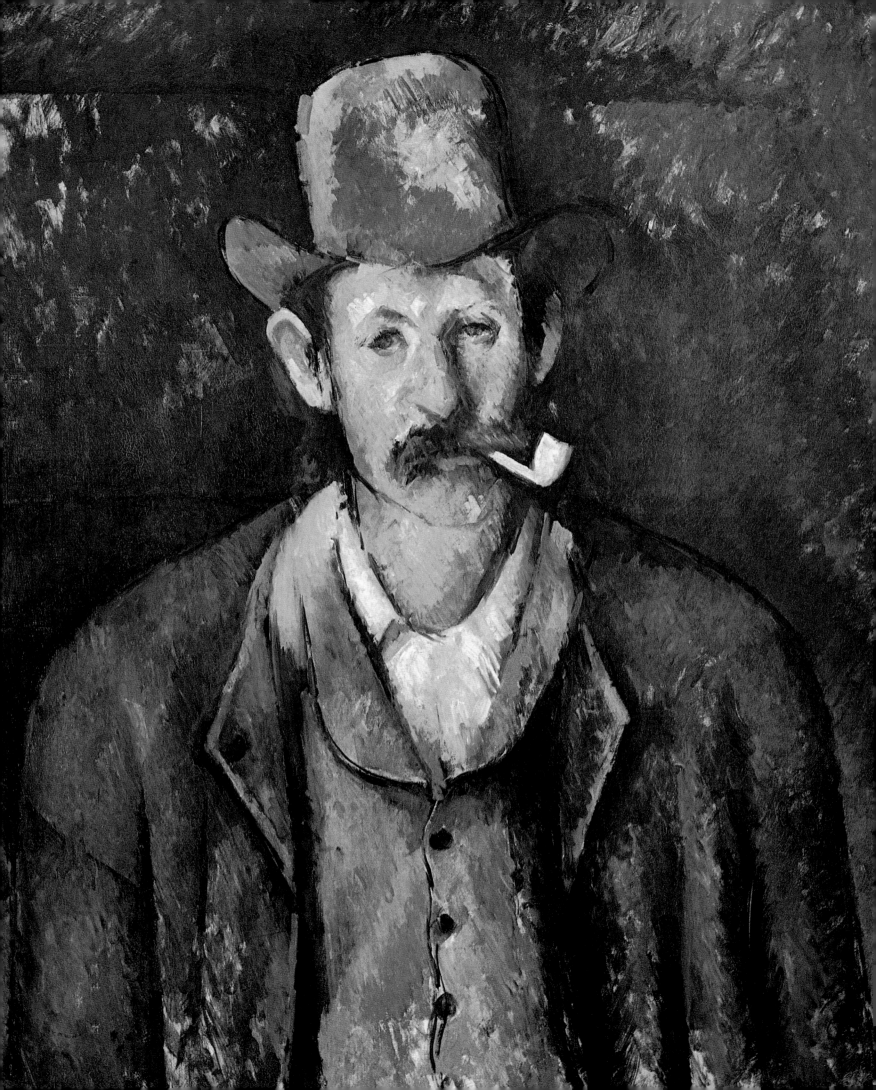

analogy, the compositionally similar painting of the card-players demonstrates the artist's independence and confidence as a painter — in its technical assurance and nicely nuanced colouring. Card-playing can also be taken as an equivalent of modern painting; many Impressionist works were compared with playing cards on account of their bright and shiny surfaces. Badt's psychological interpretation is based on the breach with Zola. Cézanne (he proposes) wanted this painting to show Zola that his one-time dependence on the parental home was a thing of the past.

It is an attractive interpretation. Perhaps it is not altogether convincing, though. For one thing, Cézanne was still far from attaining self-confidence as a painter or as a man, as various episodes in his later years suggest. To the very end, Cézanne's recorded comments show him doubting his success as an artist. Then, the 1886 breach with Zola following publication of *L'Oeuvre* was final. When talk turned to the friends of their youth, both would make only dismissive remarks. Why would Cézanne paint so important a picture for so unpleasant and disloyal a friend? The early drawing may well have had something to do with his hatred of his father; but meanwhile that hatred had been superseded by a new understanding and even love after Cézanne came into his inheritance and was relieved of financial cares. And finally, the preliminary studies show that Cézanne prepared his subject meticulously; a hasty and forgotten sketch done in his youth could scarcely have contributed anything to his approach.

What remains is the monumental solemnity of the painting, which goes far beyond genre work and must be seen together with Cézanne's other portraits. In the *Card-Players*, as in his other late portraits, Cézanne succeeded in harmonizing Man and his environment. All Cézanne's art was motivated by the quest for reconciliation between Man and Nature, between men and their fellow-men.

The portraits of the 1890s achieved that solemnity, that harmony of Man and environment. It is the quality that distinguishes even an unprepossessing subject such as the *Woman with a Coffee Pot* (p. 164). Cézanne's housekeeper looks rigid and aloof, curiously remote from Life; and yet Life itself seems almost defined in her. The austerity of the composition is heightened by the vertical spoon in the cup and the cylindrical coffee pot. The door is a grid of rectangles. Cézanne was simplifying and arranging the world of real objects in order to lend his compositions a monumental severity. We might compare the sternly symmetrical structure of early Italian painters such as Giotto.

In portraits such as this, Cézanne transcended everyday reality, giving it a profound symbolic meaning. There was nothing Impressionist about this, though Cézanne's approach *did* overlap interestingly with that of the Symbolists as described by Aurier in *On Symbolism in Painting* (1891): "The ultimate, true goal of painting

Card-Player, 1890–1892
Pencil and water-colour, 48.5 x 36.3 cm
Museum of Art, Providence (R.I.)

Man with a Pipe, 1890–1892
L'homme à la pipe
Oil on canvas, 73 x 60 cm
Venturi 564
Courtauld Institute Galleries, London

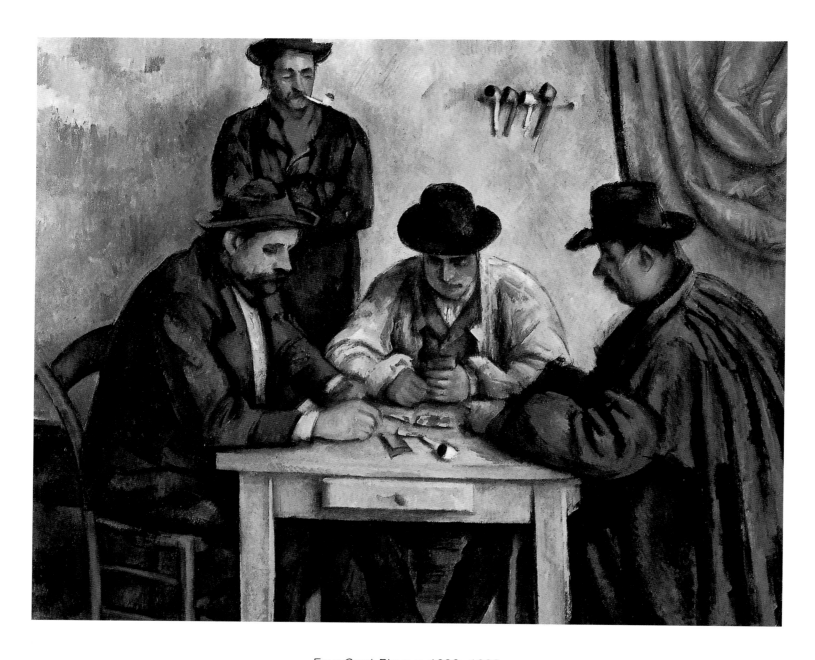

Four Card-Players, 1890–1892
Les joueurs de cartes
Oil on canvas, 65 x 81 cm
Venturi 559
The Metropolitan Museum of Art, New
York

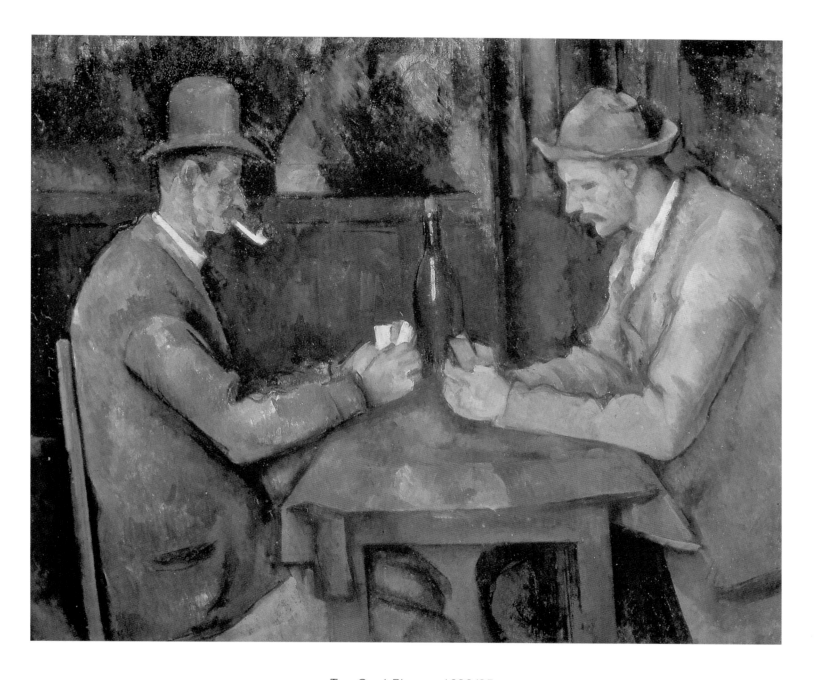

Two Card-Players, 1890/95
Les joueurs de cartes
Oil on canvas, 47.5 x 57 cm
Venturi 558
Musée d'Orsay, Paris

cannot be the accurate reproduction of objects. Its highest aim is to express ideas by translating them into a special language. To the eye of the artist who wants to express the Absolute, objects are valueless per se. He can merely avail himself of them as signs. They are letters in a vast alphabet which can be deciphered by genius alone. To set down his thoughts and poesy using those signs, without forgetting that signs in themselves, necessary though they may be, are nothing and the idea is everything – that is the task of the artist whose eye has grasped the essence of palpable objects."

In another series of four paintings showing a *Boy in a Red Waistcoat* (p. 152) Cézanne painted a model called Michelangelo Di Rosa. Compared with other portraits done in the same period, these four different poses make a real and spontaneous impression. Yet they too are the product of thorough compositional calculation which uses observation of the subject for deeper, symbolic ends. The picture in the Mellon Collection shows the boy standing, his right hand on his hip, the other at his side. The relaxation of the pose is emphasized by the heavy hanging drapes. At left they fall straight and at right in angled swathes, thus stressing the position of the model. Another version in the Museum of Modern Art shows the boy in profile, beautifully highlighted by the dark drapes that frame his face. His tranquil, contemplative pose is well captured in sonorous colours that spread from the colourful centre, the red waistcoat. The Zurich picture reproduced in this book is more melancholy still. The pose leaning on one elbow with the head inclined to one side appears in Cézanne's early work (cf. *The Temptation of St. Anthony*, p. 33) and now re-appears in the late work as a sign of meditativeness but also as a memento mori. *Old Woman with a Rosary* (p. 163) rounds out this group of pictures which express Cézanne's religious feeling, fear of death, and endeavours to attain his artistic goal.

It was a period of doubt and humiliation for Cézanne. He quarrelled with almost everyone who visited Aix or Jas. Renoir took flight. There was a terrific row with Fernand Oller, an old fellow-student from the days of the Académie Suisse. For reasons which often remained obscure, Cézanne would break off relations to people he had always valued. Anyone who dared venture into his presence sensed the turmoil in him. His fear of contact stemmed from his fear of being dominated. He preferred solitude. The sole exceptions to this rule were his occasional visits to Monet's residence at Giverny, where Monet had recently begun his series of paintings of water-lilies.

Cézanne, Geoffroy, Mirbeau, Auguste Rodin and Georges Clemenceau celebrated Monet's 54th birthday at an excellent dinner that was characteristic of Monet's hospitality. Cézanne was unusually affable on that occasion, though Mirbeau ("the foremost writer of the time"), Rodin ("the wonderful stonemason") and the

Old Woman with a Rosary,
1900–1904
La vieille au chapelet
Oil on canvas, 81 x 65.5 cm
Venturi 702
The National Gallery, London

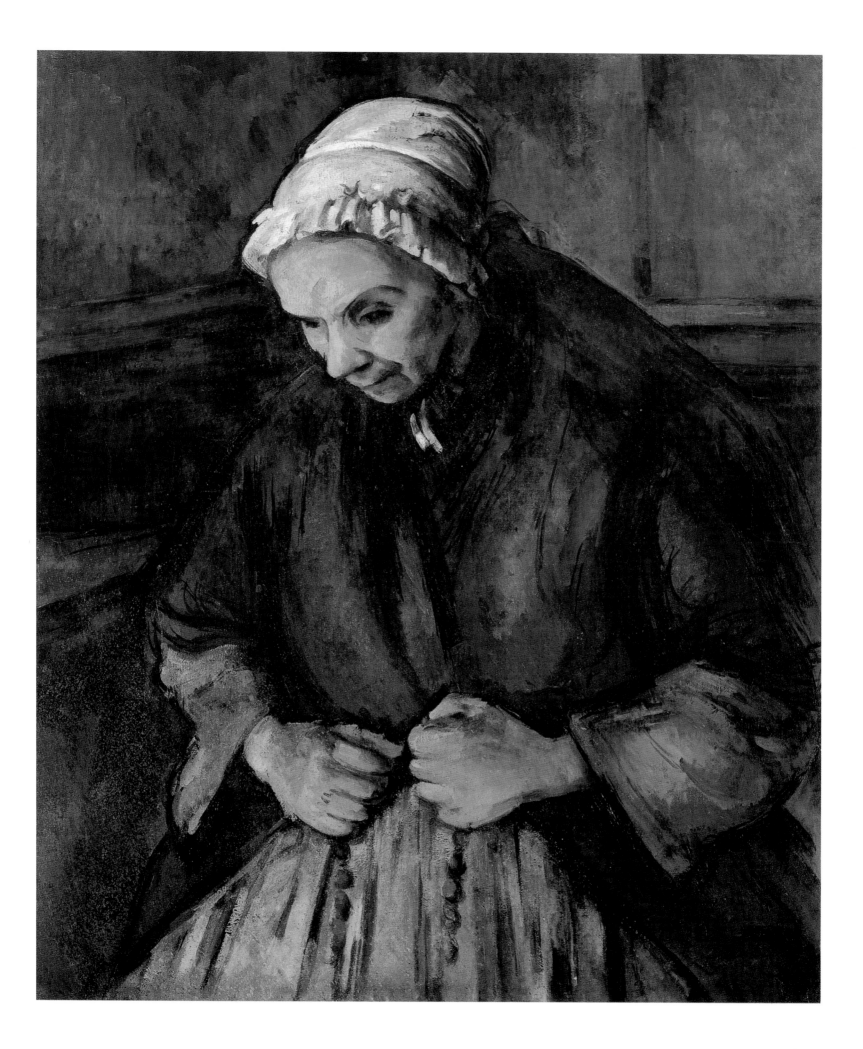

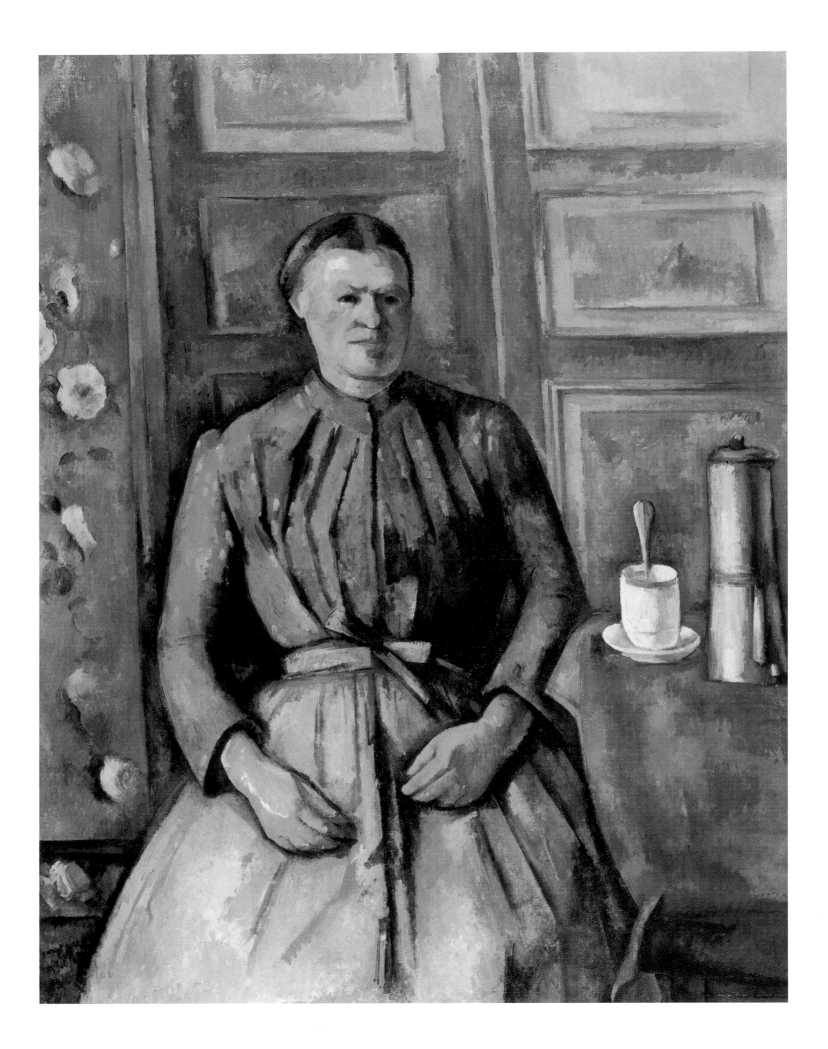

liberal free-thinker Clemenceau left him tense. He laughed uproariously at Clemenceau's jokes, though his private views did not coincide with Clemenceau's. "M. Rodin is not at all proud, an excellent fellow!" he told Mirbeau and Geoffroy merrily. Only when talk turned to Gauguin's departure for Tahiti did Cézanne become abusive. This Gauguin! This globetrotter who supposed he could get ahead with Cézanne's "little insight"! But what did he produce? "Little Chinese pictures!" Heated and indignant, Cézanne snapped: "I never intended that lack of spatial modelling." How absurd it was to frame colour zones with lines, trapping the forms like that! He himself aimed to unite colour and form into an indestructible unity.

Soon after, Monet invited him over again. Renoir, Sisley and other painters of the early revolutionary days were also invited to this banquet among friends. Monet gave a speech praising Cézanne's art. At the very first words, Cézanne turned sombre. And when Monet had finished he gave him a distraught look: "You too, Monet? Are you poking fun at me too?" Cézanne fled Giverny in a hurry, leaving a number of unfinished paintings behind. As his moods grew wilder and more unpredictable, the misunderstood genius became a sore trial for his fellow-beings.

In April 1895 Cézanne painted his portrait of Gustave Geoffroy. We see the writer (who had praised the painter's art so highly) sitting at his table in a comfortable chair, his library behind him. On the table are manuscripts, an open book, a small plaster figure by Rodin, and a flower in a vase. The sittings were interminable. Cézanne had to use a paper rose; the real flowers had long since withered. Still, he made good progress. He went to Belleville (where the writer lived) almost daily, worked on the portrait, and lunched with the writer and his mother. When talk turned to contemporary art, Cézanne would grow fractious. The latest theories concerning Impressionist art or atomistic hypotheses only made him laugh. Clemenceau? Yes, he had temperament, but his free-thinking disturbed Cézanne deeply. "I am too weak. And Clemenceau could never afford me protection. Only the church can protect me." After several weeks' work, Cézanne abruptly abandoned the portrait. Geoffroy implored him in vain to give it another week. With eighty sittings behind him, Cézanne left the near-completed picture as it was and fled Paris for the solitude of Provence. He wrote to Monet: "I have had to give up the study Geoffroy commissioned for the time being. He was so obliging and flexible that I am rather ashamed at my paltry results, after so many sittings and alternating moods of enthusiasm and discouragement. So now I am back in the south, and perhaps I should never have left to pursue the chimaera of Art." (6 July 1895.)

Cézanne had aged prematurely. His hair was snow-white, he was diabetic, and he was at loggerheads with the whole world. What remained of his plans at the age of fifty-six? He was mis-

Woman with a Coffee Pot, 1890/95
Femme à la cafétière
Oil on canvas, 130.5 x 96.5 cm
Venturi 574
Musée d'Orsay, Paris

understood even by his closest friends and family. Marie had moved out of Jas de Bouffan because she could no longer stand the rows with her mother. Cézanne went on painting, driven to it: landscapes, still-lifes, portraits. Ordinary people in the neighbourhood served as his models, farmers who sat leadenly at the table, head in hand, in that contemplative, melancholy pose Cézanne so often used in his portraits (cf. p. 25).

In one of these portraits, *Farmer in a Blue Shirt* (Private collection, New York), another picture showing a woman with a parasol is quoted behind the farmer's head. The detail comes from a screen Cézanne and Zola painted together in their youth; it appears in various still-lifes in the 1890s. The juxtaposition of the rococo elegance and grace of that woman and the stolid, serious expression of the farmer implies symbolic associations of a kind that match Cézanne's new religious mood and his meditations on Life and Death as parts of the cycle of being.

His new emphasis on the spiritual is especially apparent in the portraits of the Nineties. His attitude was determined not only by personal fears and doubts but also by a general shift in French culture at the time. Time and again in that period Cézanne contemplated the nothingness of Life; the skulls that appeared in some of his works were evidently symbols of that nothingness, but so too was the melancholy visible in the poses his sitters were shown in.

Cézanne was swimming against the current. In the last years of his life he was impelled increasingly by unease, by a fear of not reaching his ambitious goal. In spite of the firm definition of his compositional strategy and colouring, that unease and fear can be detected in his portraits too. The gesture of crossing or folding the arms, recurrent in late portraits, indicates both self-confidence and defensiveness. Both resigned and domineering, it is a gesture that can be traced back to earlier days when Cézanne often painted his Uncle Dominique in this pose (cf. the portrait as a monk, p. 44). The gesture also reminds us of the old masters Cézanne valued: pictures of saints by Eustache Le Sueur and Pierre Restout in the Aix Museum, where the pose indicates both melancholy and renunciation of this world. The gesture is clearly related to that of the head propped on a hand, as is the pose with crossed legs and clasped hands which we see in the last portraits of Vallier, the gardener (cf. p. 169).

Vallier was Cézanne's final model. He hired him to look after the garden of his studio in the Chemin des Lauves, which he took in 1902. Cézanne had long been attracted to the ordinary people of his home parts. They were not only models he could easily handle but also congenial characters. He sensed an affinity to them, and saw in them a bygone view of Time and Life, a traditional attitude to the business of living which modern times were eradicating. "In today's reality, everything is changing. But not for me. I am living in the town where I spent my childhood, under the eyes of people my

Lady in Blue, 1898/99
Dame en bleu
Oil on canvas, 88.5 x 72 cm
Venturi 705
Hermitage, St. Petersburg

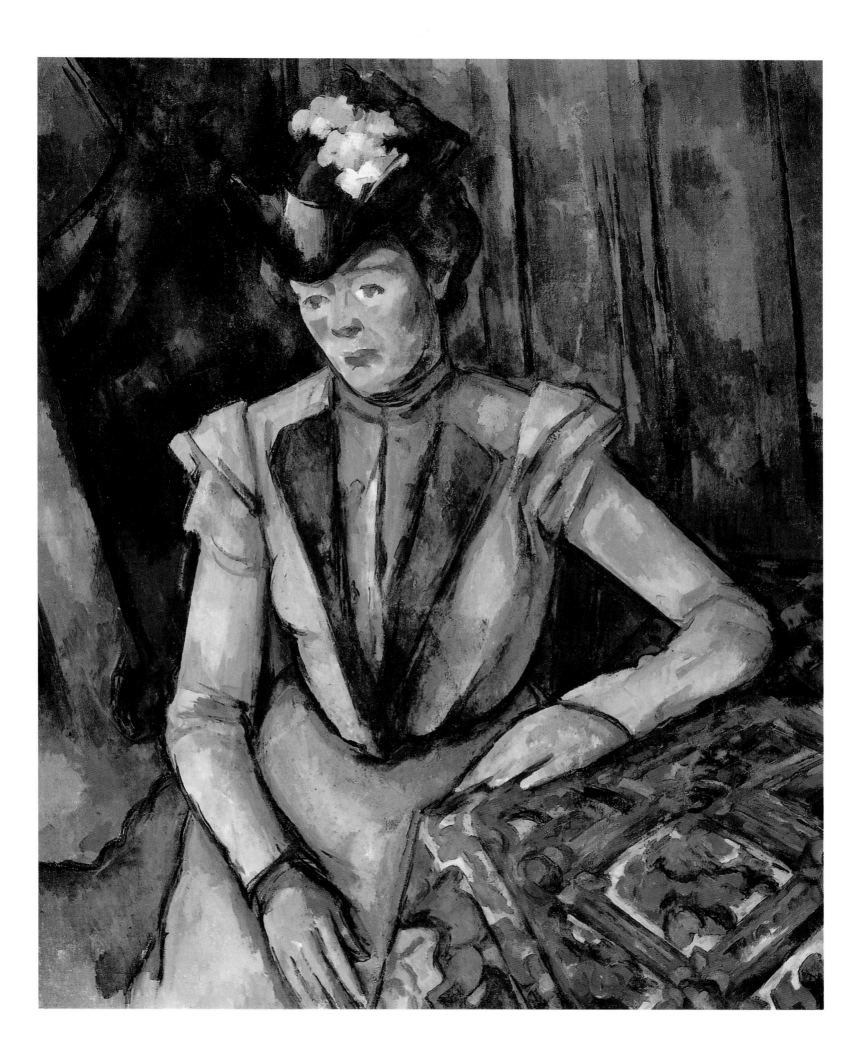

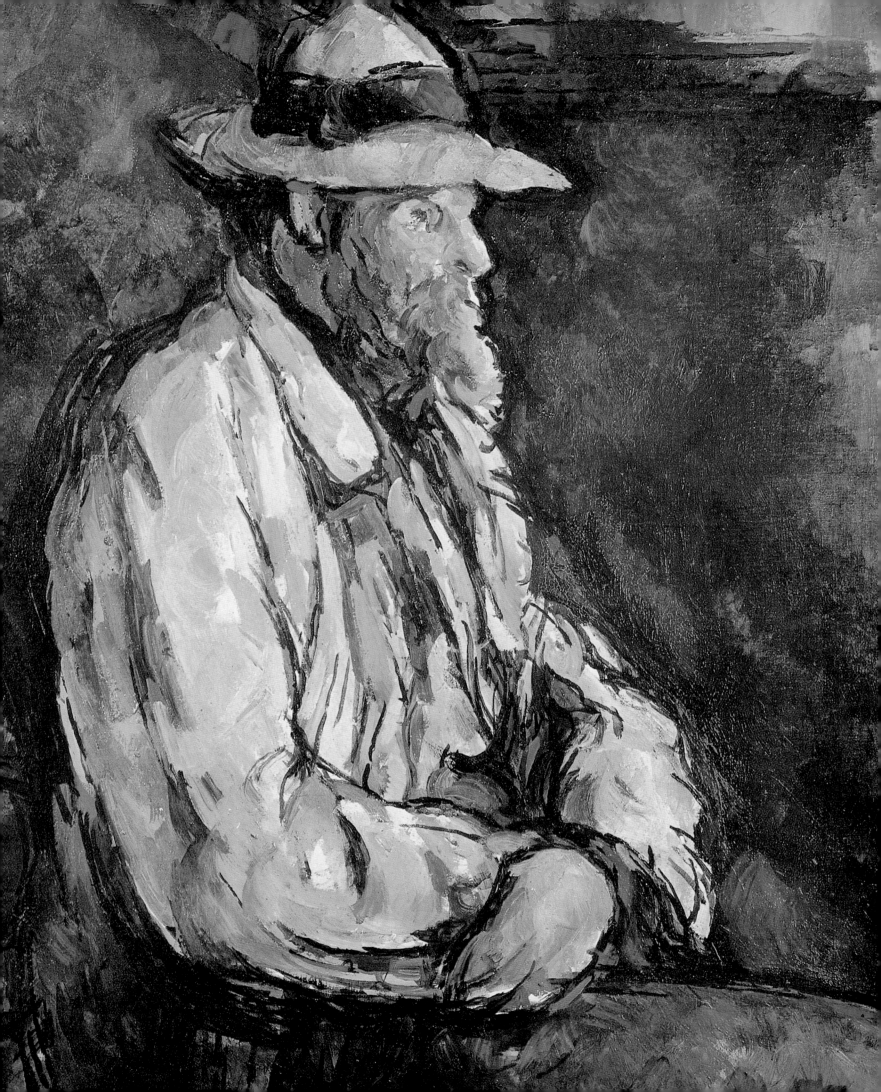

own age, in whom I see my own past. I love above all things the way people look when they have grown old without violating tradition by embracing the laws of the present. I hate the effects those laws have." (Letter to Jules Borély, 1902.)

The great final portrait of the gardener (p. 168) presents Vallier in an attitude of harmony, profoundly at peace with himself and Nature. The profile is unusual in 19th century portraiture and recalls the early Italian masters Cézanne admired and studied. Indeed, it may be that the monumental seriousness of his art derives from its affinity to earlier, "primitive" art in quite general terms. Cézanne once told Gasquet: "I am the primitive of a new art." The position of the figure indicates that it is a deliberate interpretation rather than a study after Nature. Cézanne's painterly technique has been deployed strategically to heighten his expressive effects. The line of the beard corresponds to that of the shoulder and arm; the arms and sleeves underline the sense of composure conveyed by the overall pose. On the other hand, the facial features are only cursorily sketched. The essential nature of the man is presented primarily through his pose, and the approach to form. Cézanne put the entire colour range of his late work into this portrait. The bright figure is set off against a rich fabric of deep colour that bonds the man into the natural setting (as in the paintings of bathers). The lyrical freedom of colour and the utterly unimpeded brush-strokes endow this portrait with a unique emotional warmth and human presence.

Far more than in the bathing scenes, in fact, Cézanne achieved the harmony of Man and Nature which he longed for in these late portraits. Vallier the gardener was the last figure Cézanne identified with. In him, he finally seemed to have attained peace within himself and with the world, a peace he expressed in a great artistic achievement that established Cézanne's art far beyond the flux of evanescent fashions, as the perfect emblem of Creation in a state of profound tranquillity.

Vallier the Gardener, 1902–1906
Pencil and water-colour, 48 x 21 cm
Private collection, Paris

Vallier in a Straw Hat, 1906
Portrait de Vallier
Oil on canvas, 66 x 54 cm
Venturi 718
Private collection, Switzerland

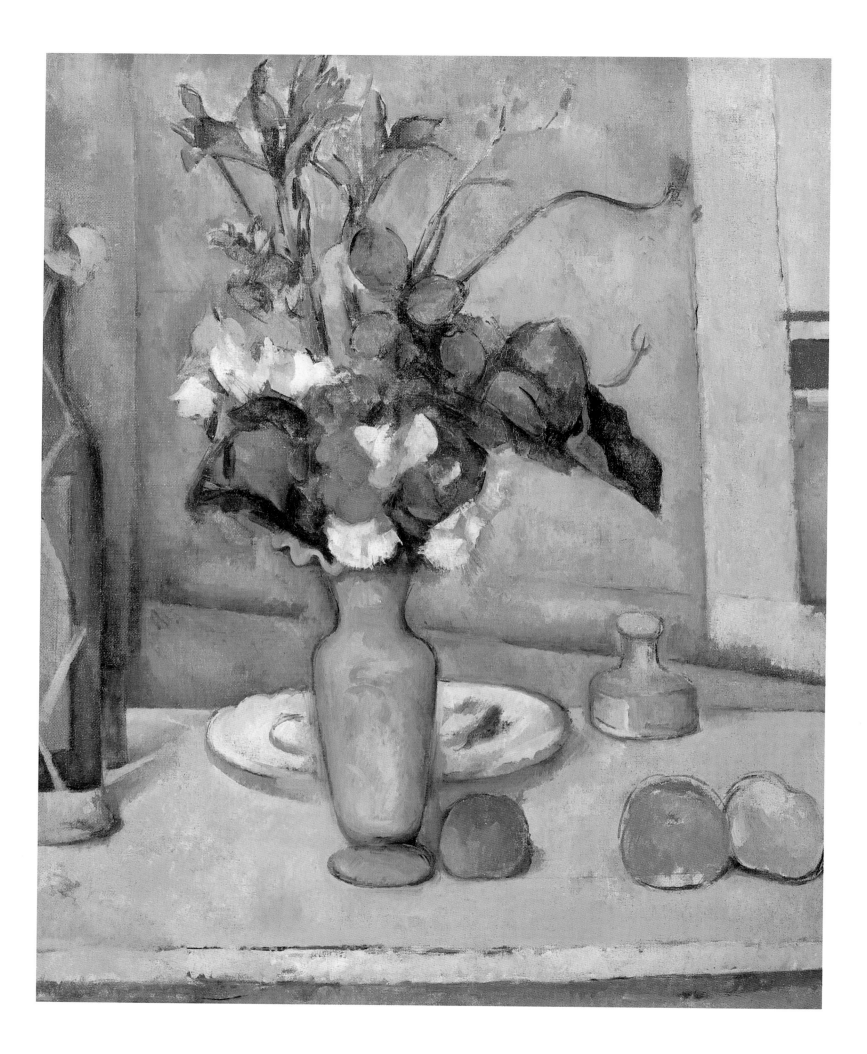

"I should like to astonish Paris with an apple": The Still-Lifes

The still-life was welcomed as heralding a new realism in painting, alongside the landscape revival. It was not until the 17th century, in response to the diversity of Dutch art, that the still-life came to be taken seriously. Still-lifes in the 17th and 18th centuries not only foregrounded the painter's technical virtuosity but also mirrored society's increasing prosperity, curiosity for the exotic, and pietist symbolism.

Various influences were at work in Cézanne's early still-lifes: Courbet's and Manet's, but also those of Spanish and Dutch art of the Baroque era. Cézanne engaged more thoroughly with the still-life than any other *fin de siècle* painter. A few ordinary household objects, and a few fruits he repeatedly turned to, sufficed as the subject of a delightful work of art. Still-lifes and landscapes gave the artist his first practice in disciplining his "temperament" and in improving and controlling his technique and composition. And it was in his still-lifes that Cézanne's outstanding qualities as a painter were first recognised. His landscapes and figural works could strike even well-disposed critics as too distorted and "primitive", but his still-lifes prompted acknowledgement from almost every connoisseur of art.

Even the Symbolist Huysmans, a familiar of Zola's Médan circle and perfectly inclined to accuse Cézanne of defective vision, wrote of the still-lifes: "There, in full light, in china fruit-bowls or on white table-cloths, are his pears and apples, set down quickly in crude strokes and smudged with a thumb: seen from close to, they are a wild mess of bright red and yellow, green and blue. Seen from the correct distance they are choice, juicy fruits that set the mouth watering. And suddenly one becomes aware of altogether new truths, truths one had never paid attention to before: unfamiliar yet real shades, patches of colour with a character all their own, shadows falling from the far side of fruits across a white cloth, with a hint of blue that makes them quite magical if one compares with ordinary still-lifes done in senseless asphalt colours."

This opinion was shared by the young painters who revered Cézanne, Gauguin foremost among them. He had bought a number of Cézannes at Tanguy's shop, including *Fruit-Bowl, Cloth, Glass and Apples* (p. 175). Gauguin so admired the painting that he included it in a painting of his own which showed him on the

"There is neither line nor modelling, there is only contrast. Once the colours are at their richest, the form will be at its fullest."
PAUL CEZANNE

Blue Vase, 1885/87
Le vase bleu
Oil on canvas, 61 x 50 cm
Venturi 512
Musée d'Orsay, Paris

171

way to a synthetist style (*Marie Henri*, 1890, The Art Institute of Chicago, Chicago).

The painting is composed with marvellous simplicity, and yet in its formal and colour qualities it is complex. In classical fashion a knife lying on the table guides our vision into the picture, pointing to the centre where four apples lie in a pyramid on a white cloth. Off-centre to the left is a fruit-bowl with more apples and grapes; to the right of it is a half-empty wine glass, delicately painted and blending into the background, its elegant form nicely counterpointing the leafage pictured on the wallpaper behind. Individual shapes seem slightly distorted, adapted to the purposes of the overall composition. The rim of the fruit-bowl, for instance, looks decidedly odd: flat towards the front but curving upwards at the back. This appears to be necessitated by the proportional requirements of the painting. The curves and straight lines of the bowl match the shapes of the apples and grapes, the background leafage, and the chest too.

The colouring is extremely evocative, and provides the composition with additional unity. The various contrasts of reddish-orange and green recur in paired formations throughout the canvas, setting up echoes and correspondences. The slow transition from light to shadow means that in every colour there is a wonderful range of deep, velvety nuances. The shades range from the delicately transparent to patches of thick pigment, ever-changing yet nonetheless contributing to a consistent overall texture. Cézanne disregards the surface appearances of things, and instead re-creates them in paint: the transparent and the opaque, the smooth and the rough, the atmospheric spatiality of things and the flat painterly dimension of the wallpaper pattern. Individual forms are clearly marked off in this tautly woven structure of parallel brushstrokes by fine black lines around the objects. Cézanne's imitators seized upon this species of cloisonnism and emphasized the technique; Cézanne, for his part, used it less in later work, substituting gradual shading in darker tones.

In the evolution of Cézanne's still-life technique, *Vessels, Fruit and Cloth in Front of a Chest* occupies a special position. The objects are clear and firm, treated in terms of light and dark that hark back to early work. We see various objects on a table, from an angle somewhat above it: three earthenware vessels of different sizes at left and centre, a white table-cloth, and on the cloth, roughly in the centre, a bowl of apples. (Cézanne steeped his cloths in plaster, to give soft materials the desired hardness and form.) At the back there is a chest cropped by the right edge of the picture and reaching slightly further left than the table. Further left there is a painted screen which was in the house at Jas de Bouffan and repeatedly appears in Cézanne's paintings.

This picture clearly illustrates Cézanne's aim for firmness, compactness and density. Formally speaking, we should note the triangular conceptualization, the base of the triangle resting on the

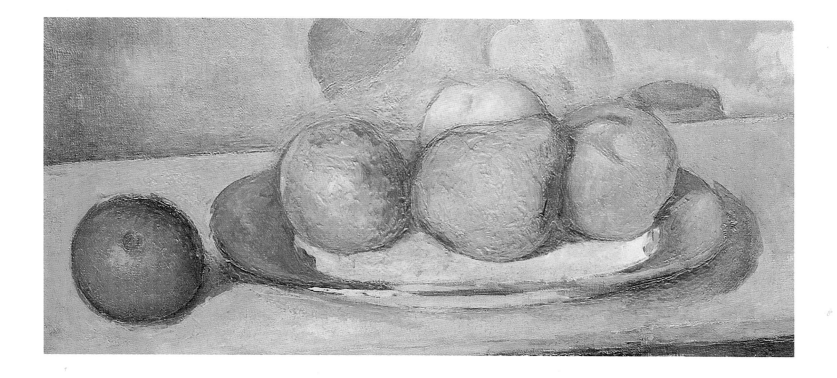

foremost edge of the table, the triangle itself then established by two of the vessels (the sugar bowl and ginger jar) and returning on the right down the folds of the cloth. This introduces a lively note into the rather placid arrangement. At left, sightlines draw our gaze elsewhere, beyond the big vase to the ornamental scroll patterning of the screen (a kind of counterpoint to the cloth). The chest, table edges, screen, and standing vessels act out a balanced interplay of verticals and horizontals. Taking our point of departure as the centre of the canvas we can also follow visual echoes of round and elliptical forms, in the fruits, the mouths of the vessels, the key-holes and the knobs on the chest. The openings of the vessels do not seem subject to one single perspectival viewpoint. Cézanne is departing from strictly linear perspective in order to make corres-pondences within the picture all the clearer. Furthermore, there is a tension between spatial depth and surface flatness in the painting. The still-life in the foreground has a three-dimensional look to it, but the background seems two-dimensionally flat, and the two impressions are interestingly at odds. The patterning on the screen, and the structure and grain of the chest, mean that the background presents no unified image, no backdrop such as still-lifes were placed against in earlier times, for purposes of peaceful contrast. In Cézanne's work the still-life is in competition with the background; there is a tension in the painting which is only partially counteracted by the manifold colour correspondences linking foreground and background.

At first we think the most signal colour values are located in the apples. But then we notice that the painting's basic colours – green, red, yellow and blue – interact throughout the canvas. The yellows and reds so gloriously present in the apples are there in the

Plate of Fruit, 1879–1882
Nature morte
Oil on canvas, 19 x 39 cm
Venturi 348
Národni Gallery, Prague

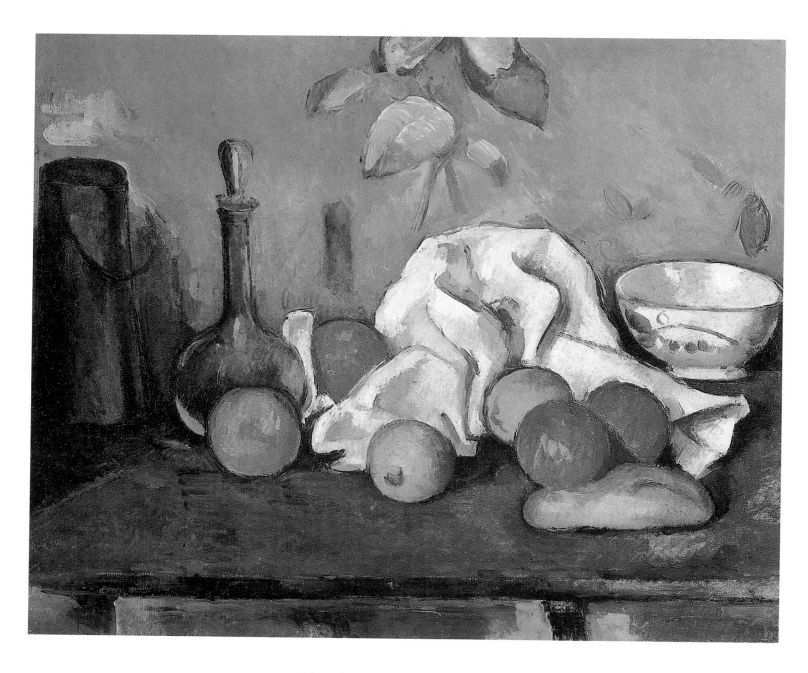

Vessels, Fruit and Cloth, 1879/80
Nature morte aux fruits
Oil on canvas, 45 x 54 cm
Venturi 337
Hermitage, St. Petersburg

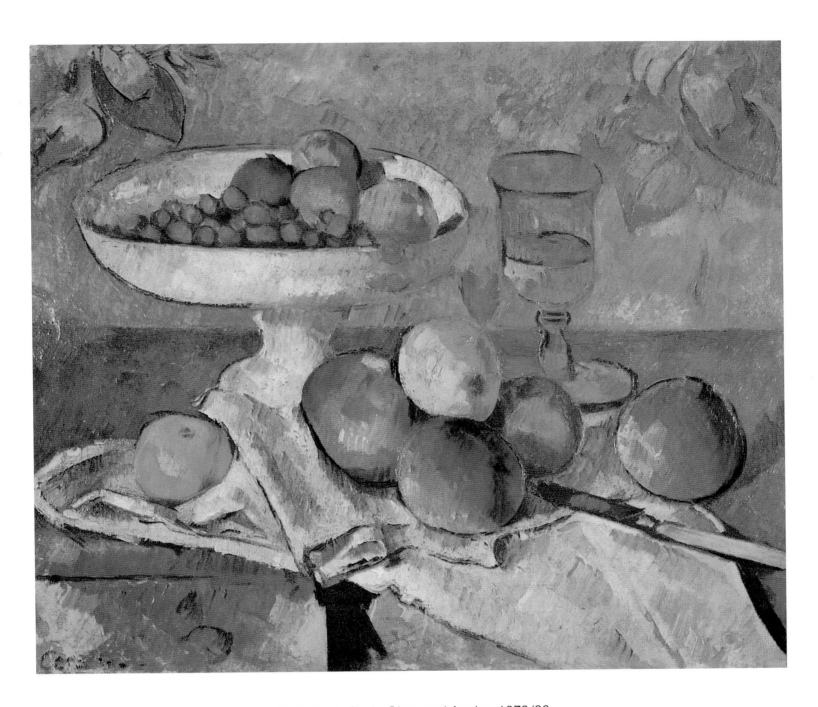

Fruit-Bowl, Cloth, Glass and Apples, 1879/80
Nature morte: Compotier, verre et pommes
Oil on canvas, 46 x 55 cm
Venturi 341
Private collection, Paris

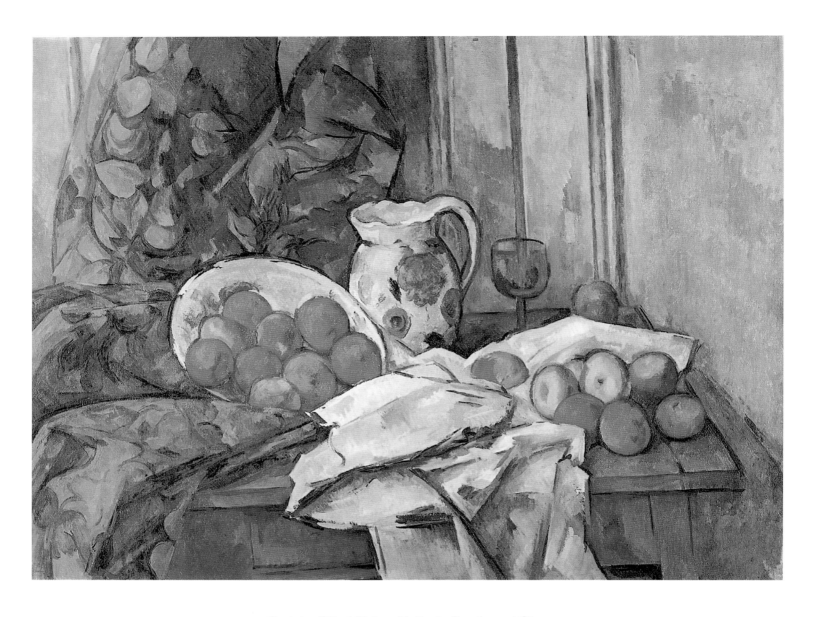

Curtain, Tilted Plate with Fruit, Carafe and Glass,
1900–1905
Nature morte au pot de faïence
Oil on canvas, 73 x 100.5 cm
Venturi 742
Oskar Reinhart Collection, Winterthur

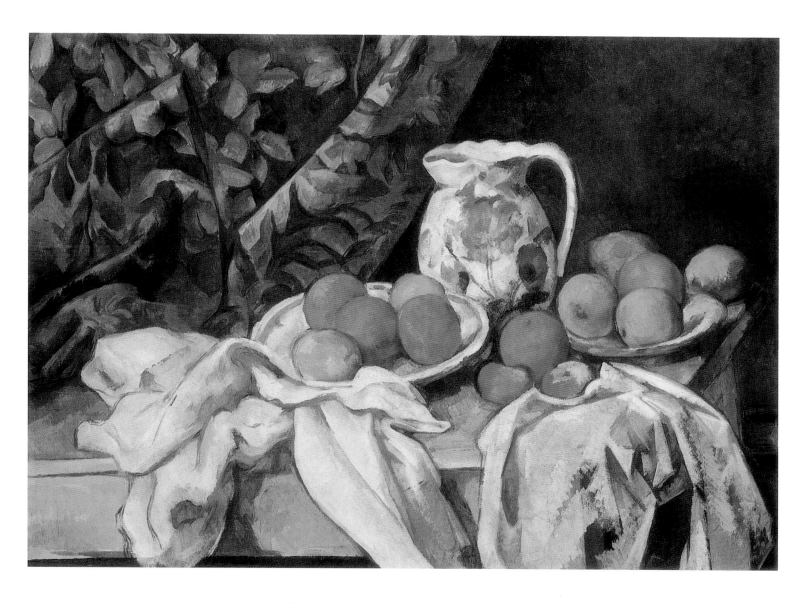

Curtain, Carafe and Plates with Fruit,
1898/99
Nature morte au rideau
Oil on canvas, 54.7 x 74 cm
Venturi 731
Hermitage, St. Petersburg

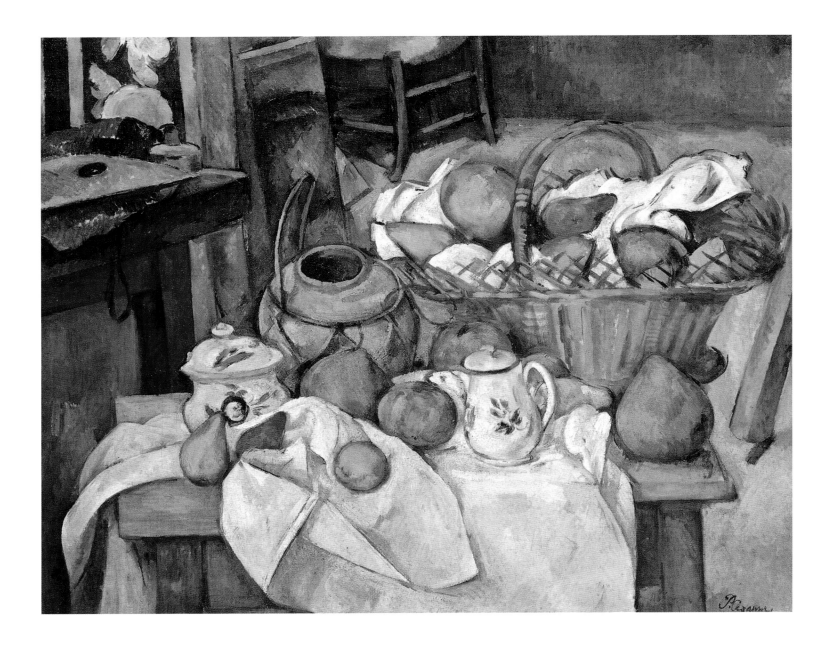

*Vessels, Basket and Fruit
(The Kitchen Table),* 1888–1890
Nature morte au panier des fruits
(La table de cuisine)
Oil on canvas, 65 x 81 cm
Venturi 594
Musée d'Orsay, Paris

chest too, and in the table, and also (paler) in the pattern on the screen. There are no direct contrasts, though the yellow and orange of the apples are certainly opposed by the sheeny, grey-blue white of the cloth, ginger jar and sugar bowl. It is only in the pungent green of the vase, somewhat further off, that we find an emphatic colour highlight; and that, in turn, is echoed in the greenish-blue marbled base of the screen and (at the other side of the canvas) in the greenish shadowing of the cloth.

Thus colours and forms together give this picture its incomparable harmony and equilibrium, and also its mysterious tension. In the verticals of the objects against the horizontals of the chest, in the crumpled heap of the cloth, and in the convoluted ornamentation on the screen, elemental life forces of a kind Cézanne usually confined to his figure scenes and landscapes become visible.

A number of statements by the artist himself show that he attached some importance to his still-lifes and did not see them

merely as routine composition practice: "You see, what I have not yet managed to achieve, what I shall never manage in a portrait (I sense it), I have perhaps approached here ... in these still-lifes. I have conscientiously kept to the object... I copied... Look at this. Months of work have gone into it. Laughter and tears, gnashing of teeth. We were talking about portraits. People imagine a sugar bowl has no face, no soul. But it changes every day. You have to know how to get hold of these fellows... These glasses, these plates, they talk to each other, they're constantly telling confidences." (To Gasquet.)

Was the infinite variety of the late still-lifes a kind of protective wall, built against those regular conflicts which appeared in old age as a sorely aggravated fear of contact? (Cézanne himself often spoke of his inhibitions with female models, which prevented him from achieving his aims in that respect.) This would imply that the still-lifes express more than merely a sense of equilibrium in inanimate objects. In the still-lifes, things can enjoy contact, the harmony of colours, and (deputizing, as it were) situations which were too much for Cézanne in life. What love and feeling he brought to the painting of these simple things! What inimitable sensuousness there is in these fruits! Always the same fruits... Perhaps no previous painter, with the possible exception of Cézanne's much-admired Jean Baptiste Siméon Chardin, had performed these labours with such intensity: "Objects influence each other through and through ... They spread their influence imperceptibly about, by means of their auras, as we do by means of looks and words; Chardin was the first to sense this, he caught the atmospheres of objects in gradations of colour... There was nothing he ignored. He got that contact of the minute particles that are around things, the life-particles that surround things." (To Gasquet.)

Cézanne too wanted to reproduce the atmospheres of things, their auras and correspondences, the colourful and living interconnections of all things – a rich fabric of relationships that was more to him than games of form. The starting point and central motif of the still-lifes are fruits. They imbue all other objects with an atmosphere of tenderness. Cézanne's fruit has a paradisiac quality: "I decided against flowers. They wither on the instant. Fruits are more loyal. It is as if they were begging forgiveness for losing their colour. The Idea is exuded from them together with their fragrance. They come to you laden with scents, tell you of the fields they have left behind, the rain that nourished them, the dawns they have seen. When you translate the skin of a beautiful peach in opulent strokes, or the melancholy of an old apple, you sense their mutual reflections, the same mild shadows of relinquishment, the same loving sun, the same recollections of dew..." (To Gasquet.)

Vessels, Basket and Fruit (The Kitchen Table) (p. 178) is one of

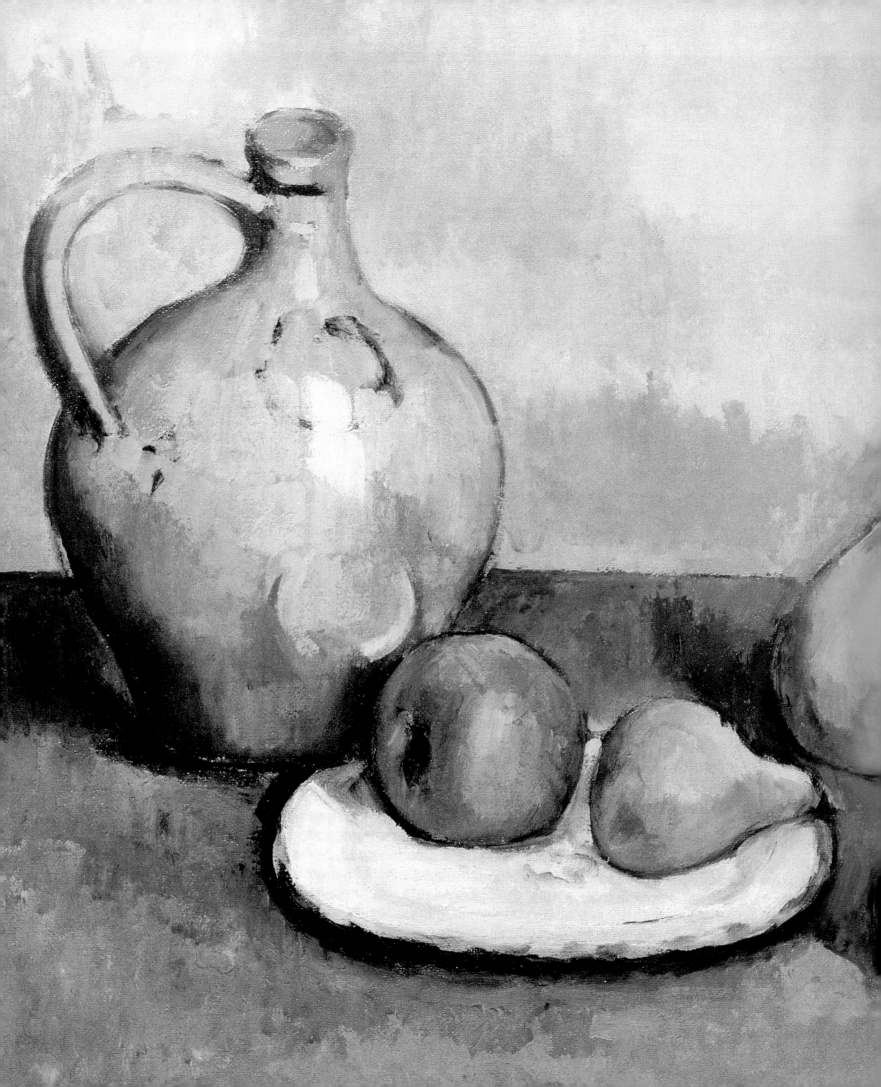

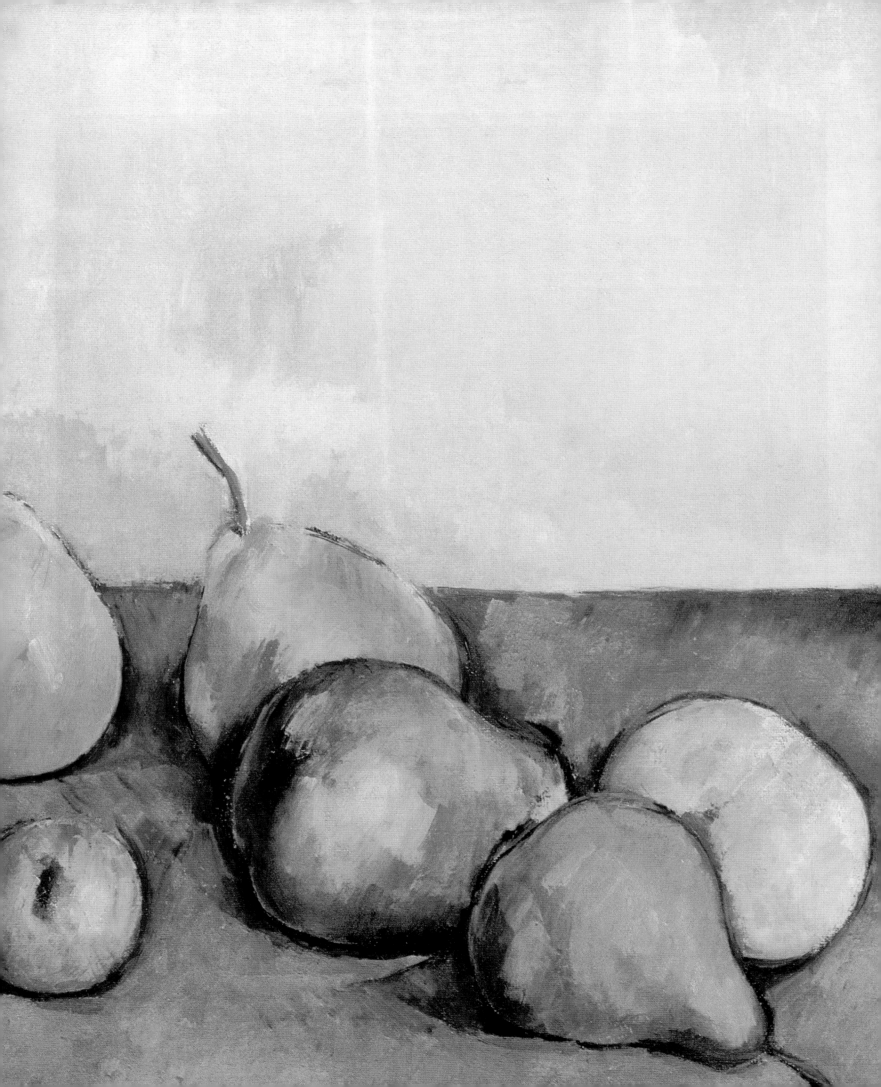

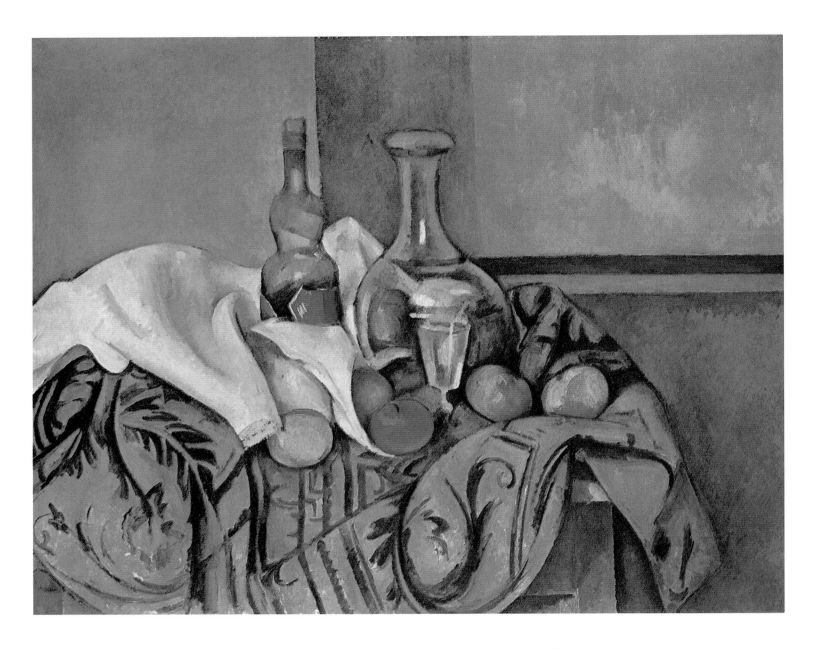

Vessels, Fruit and Cover (The Peppermint Bottle),
1893–1895
Nature morte: la bouteille de peppermint
Oil on canvas, 65.9 x 82.1 cm
Venturi 625
National Gallery of Art, Washington, D.C.

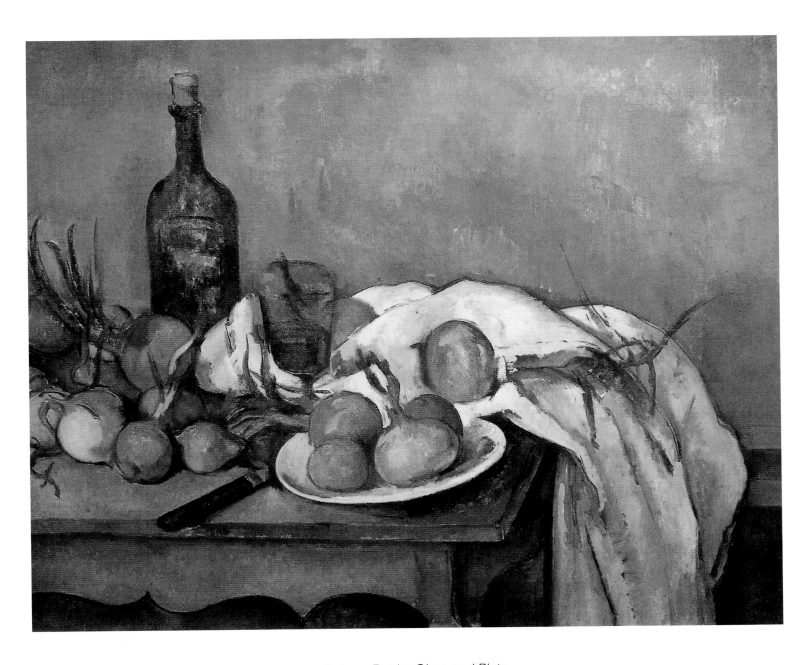

Onions, Bottle, Glass and Plate,
ca. 1895/1900
Nature morte aux oignons
Oil on canvas, 66 x 82 cm
Venturi 730
Musée d'Orsay, Paris

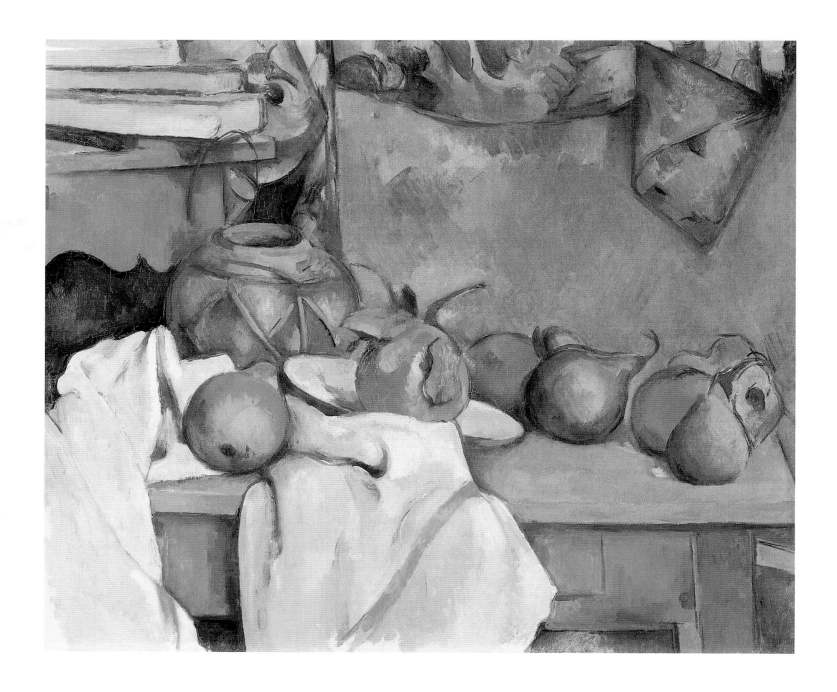

Books, Straw-Cased Jar and Fruit, 1890–1893
Nature morte au pot gingembre
Oil on canvas, 46 x 55 cm
Venturi 733
Phillips Collection, Washington, D.C.

Cézanne's finest, richest still-lifes. In distinction to *Vessels, Fruit and Cloth in Front of a Chest* and other earlier still-lifes, the space seems crowded out with objects. On a small table there are a basket of fruit, a white cloth with vessels on it (including a sugar bowl and ginger jar), and more pears and apples. The space is precisely defined by the chest at left, the chair at the rear wall, and the chair leg at the right edge of the picture. Nonetheless there is an unsettling discontinuity of natural and pictorial space; and the distorted perspective of some of the objects, and the inconsistent treatment of straight edges, add to our unease. The near side of the basket, the china bowl at left, and the pot at right, are all seen from about the same elevation; but the ginger jar, the left end of the table-top, and the fruit in the basket, all seem viewed from rather higher. There are also lateral distortions: the front of the basket is

seen slightly from the left, the handle from further right. The bowl and pot tend to the left but the ginger jar is tipped forward. These compositional devices were often used by Cézanne around that period to heighten the spatial dynamics. We are also struck by the inconsistent handling of the table edge, which seems to be balancing the objects at either side as on a pair of scales. On the right, like a weight, there is an outsize pear which appears to be anchoring the overall structure together with the table leg.

The poet Rainer Maria Rilke found very apt words for the qualities of balance Cézanne achieved: "He would devote his attention patiently to landscapes and still-lifes, but when he appropriated them he would do so by taking complicated, circuitous routes. Starting with the darkest hues, he would add a layer that went somewhat further, and so forth, till by moving outward from shade to shade he arrived in due course at another, contrasting component in his picture, whereupon he would begin again in similar manner, from a new centre. I imagine that the two processes of contemplative appropriation and putting what was appropriated to a personal use were opposed in him, perhaps in consequence of long deliberation, so that they instantly began to talk, as it were, constantly interrupting each other, continually at variance. And the old man put up with their disharmony." (Rilke, *Letters on Cézanne*.)

Careful assembly of motifs was only Cézanne's starting point in the business of perception. Next the space itself needed defining. Cézanne's visual space was subject to laws quite different from those that govern usual perception. He would violate perspective and use multiple points of view to establish a subjective space ruled by the principle of harmonious equilibrium. The simultaneity in this approach anticipated Cubism as well as contemporary additions to the range of perception (dioramic shows, panoramas and, later, films). The still-lifes also show that Cézanne by no means neglected linear spatial construction; he simply attuned it to his colour values. It was the interplay of linear construction, colour schemes, outlining, and a hatching style of brushwork, that gave his objects their own subjective space.

Aside from the formal aspects of this experiential zone, Cézanne's objects, seeking contact and touch, are metaphorically revealing of his own conflicts with people, conflicts he tried to put behind him in the still-lifes. Every fruit, every bottle, every fold in a cloth, takes on a broader life as an actor in the conflict between spatial flatness and spatial depth. This was Cézanne's account of that spatial *angst* that was to become a fundamental experience of Man in the 20th century and which many artists were to try to express. Cézanne uses his objects to point symbolically beyond a mere heap of things to the Real, the existential foundation of human life. The still-life is arguably the level-headed, objective art form *par excellence* but the choice and arrangement of things is

always indicative of the artist's emotional state: "The things chosen for still-lifes [. . .] come from areas with specific connotations: the private or family sphere, the realm of pleasure and conviviality, the artistic sphere, work and recreation, the decorative and splendid, and (less frequently) the range of objects with a negative charge, things that can focus meditation on the vanity of transient, earthly existence and on death." (Meyer Schapiro.)

Ease of handling, of arrangement, and of "appropriation" and artistic use, does not fully explain Cézanne's curious preference for certain motifs. There is no hint of social gourmandise in his fruits and vessels, as there is (for example) in Manet. His apples and pears hold no promise of a sumptuous banquet. They belong entirely to the world of painting, and only in that world do they have any meaning. The centrality of still-lifes in Cézanne's oeuvre implies a subjective, personal motivation in his choice of the form in general and the objects in particular.

Cézanne's concentration on a few things is particularly striking in the case of apples. Let us take his *Still-Life with Apples and Oranges* (p. 187) as an example. The deep, vivid purples, yellows, reds and greens in the oriental carpet and in the apples contrast effectively with the white cloth, with its countless shimmering nuances. The intense colours in this work are comparable with Cézanne's colour schemes in the late portraits; they give the picture a distinctive balance. In all, Cézanne painted six versions of the same objects, variously arranged.

Apples naturally occurred in the still-lifes of Courbet, Fantin-Latour, and other contemporaries of Cézanne. But there they are subordinate components in an overall scheme, rather than the centre of attention. In Cézanne's early literary attempts, still-life subject matter that suggests emotional conflict with his parents is often included – in his poem 'Hannibal's Dream', for instance. Cézanne reputedly told Geoffroy in 1895 that he wanted to astonish Paris with an apple. Paris, in this case, means the capital of the 19th century art world; every artist had to conquer Paris if he was to have the success Cézanne missed. But possibly Cézanne was thinking of Zola's *L'Oeuvre*, in which Claude Lantier remarks that a revolution can be started with a well-painted carrot.

In his lost painting *The Judgement of Paris* (a subject Cézanne had tackled early in his career) we find a third possibility. In Cézanne's version of the familiar mythological story, Paris is handing a basket of apples to a diminutive woman who lacks the charms of the three beauties. Apples are traditional symbols of Love. Equally traditional is the comparison of apples and women's breasts. Could it be that Cézanne chose apples because they permitted him to study the voluptuous forms and colours which his shyness prevented him from studying in female nudes? He is said to have told Renoir: "I paint still-lifes. Female models scare me. Women are forever waiting for a chance to dupe you." Even for *Les*

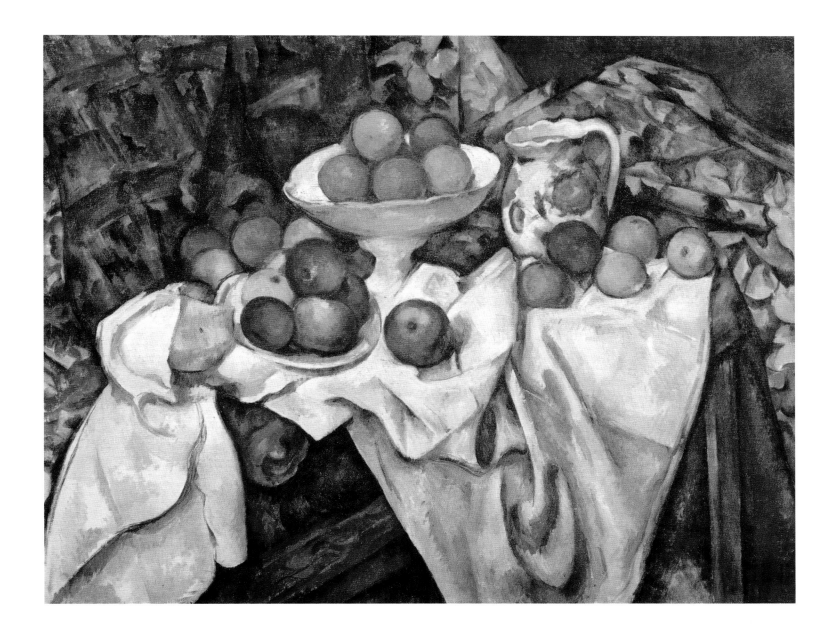

Grandes Baigneuses he was obliged to use early nude drawings since his inhibitions made the use of nude female models impossible.

In his careful arrangements of available, sensuous things, Cézanne could express the entire range of human conditions and relations: loneliness and togetherness, harmony and conflict, merriness and melancholy, luxury and asceticism. Cézanne's expressive approach to the still-life was striking even in his early work, before apples and other fruits took up their central position. His observation that he would like to astonish Paris with an apple suggests how much the fruit meant to him. In addition to hopes of success in the city that had spurned him for so long, the remark's conflation of the ordinary and the mythological apple expresses a personal dimension relating not only to the fulfilment of erotic dreams but also, in general terms, to the societal difficulties of human beings. Beginning with what could be seen, Cézanne

Still-Life with Apples and Oranges,
1895–1900
Nature morte aux pommes et oranges
Oil on canvas, 74 x 93 cm
Venturi 732
Musée d'Orsay, Paris

projected all his emotions into the patient scrutiny of the object. The creative act took on symbolic meaning that went beyond the merely visible. "The eye must grasp, bring things together. The brain will give it all shape," he said to Gasquet.

The act of shaping the visible was to make apparent what Cézanne wished to express in unspoken terms: "the same mild shadows of relinquishment, the same loving sun, the same recollection of dew, a freshness." The whole emotional range of Man is in Cézanne's still-lifes, expressed with subtle sensitivity. Cézanne was not as successful in achieving this copiousness of Life in his great figure compositions showing bathers; when he did succeed, it was at the cost of considerable generalization. The still-lifes were his domain. The ever-new arrangements of a few simple things point to the creative secret that peaked in his late work: conflation, intense colour, and harmonious yet tense inter-correspondence and equilibrium of all things, all with a like dimension of Life's sheer fullness.

The breathtakingly beautiful still-lifes of the 1890s (oils and water-colours) show this nicely. *Vessels, Fruit and Cover (The Peppermint Bottle)* (p. 182) is a simple, exquisite example. The few objects stand out with intense individuality against the grey-green background. There are a liqueur bottle (its red label providing an assertive note of colour), a carafe and glass, and a number of apples, all on a white table-cloth and a cover painted in glorious muted blues. For all the economy of its means, the picture is a veritable symphony of colour.

Onions, Bottle, Glass and Plate (p. 183) differs in tonal mood, in the emotive character of the colours. On a kitchen table (left of centre and cropped) we see a number of onions (some on a white plate). The plate links up to the cloth hanging over the table edge. A knife guides the sightlines into the painting. Verticals are supplied by a wine bottle and half-empty glass. The marvellous iridescence of the reds is counterbalanced at the rear by a superbly nuanced play on the basic contrast of red and green.

The still-lifes with plaster Cupids (pp. 190 and 191) are among the most intriguing of the late phase. A plaster figure (after Puget's *Amor*) occupies most of the space in the second picture. It is on a table amidst onions and apples; four of the apples are heaped pyramid-style on a plate. The onions have shot, and the shoot of an onion on the left points towards an earlier still-life (with the peppermint bottle, p. 184) stood against the studio wall. A second picture has an effect of framing the Cupid. And at the back is the *Anatomy*, copied from another plaster figure used for student exercises. This interesting juxtaposition of things from Nature and Art highlights the symbolism in Cézanne's work once more. Presenting apples, Cupid, and the anatomical study of a scourged man together in this way says a great deal about Cézanne's imagination. This is no mere game of formal relations. Cézanne's love of Baroque art and

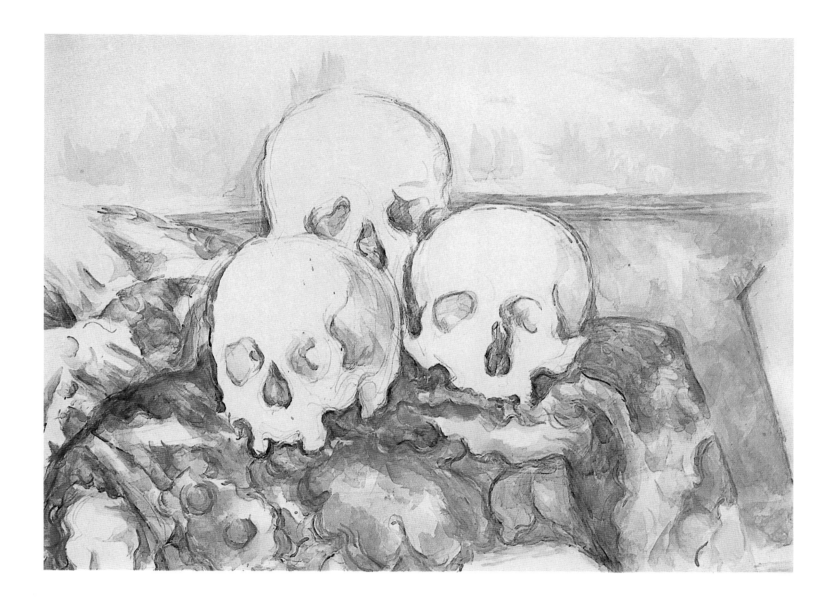

his copies after Puget are familiar. In Puget's figure he sensed "the blowing of the mistral" — in other words, its associations were focussed strongly on his home parts and thus memories of his happy youth. At the same time, the juxtaposition of Cupid and apples obviously has erotic significance. The tormented *écorché* of the anatomical study represents the painter, forgoing the satisfaction of his (erotic) dreams. This eloquent and complex still-life also reminds us of Cézanne's repeated insistence that a painter must study both Nature and the Old Masters. The synthesis of those twin studies is superbly expressed in this painting. Finally we come to Cézanne's memento mori still-lifes. Along with sensuous fruits and voluptuous drapes, the last still-lifes include a familiar, ages-old symbol of the vanity of Life: the skull. If symbols of this kind appeared in his early work too, there Cézanne placed them in Romantic contexts, with a candle and open book: the young Cézanne was perhaps attitudinizing, but in advanced age he was meditating deeply and earnestly. His late skulls, gleaming on dark backgrounds, are direct and almost brutally unambiguous. They

Three Skulls, 1904
Nature morte avec trois crânes
Pencil and water-colour,
47.6 x 62.9 cm
Venturi 1131
The Art Institute of Chicago, Chicago

189

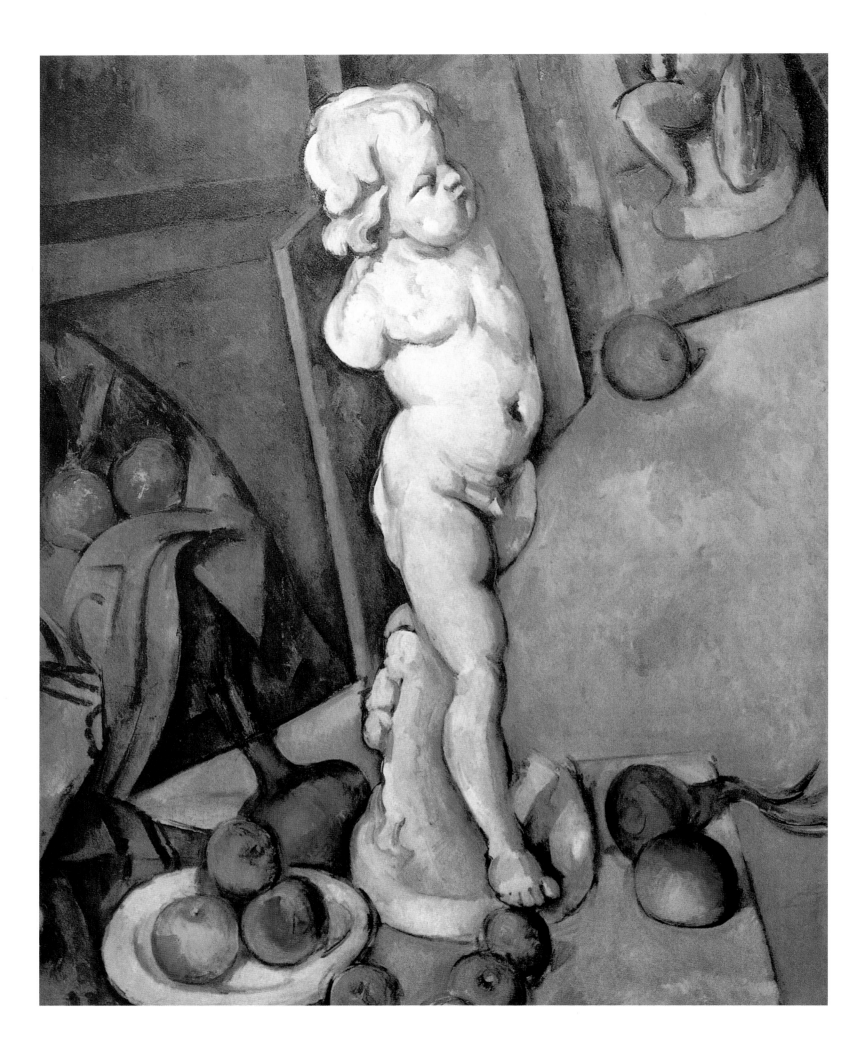

betray strong emotion, fear of death, and a contemplative frame of mind, and bring to mind the ascetic hermit Cézanne identified with in old age.

In some water-colours of skulls (cf. p. 189), Cézanne took the liberty of bathing his negative props in spectral light. "A skull is a wonderful thing to paint," he told Vollard in 1905 as they considered his painting *Three Skulls on Oriental Covering* (private collection). The twin poles between which Cézanne lived the final years of his life and which determined his spiritual conception of art were expressed in the very choice of motifs in that work: the morbid together with the sensuous, constituting a symbolic unity. The one was unthinkable without the other. It was only in using deep, serious colour values could Cézanne make his approach to the artistic goal he envisioned: "Art is a religion. Its aim is the elevation of the spirit." (To Léo Larguier, 1901/02.)

The objects in Cézanne's still-lifes stand metaphorically for a profounder reality he apprehended, where conscious and unconscious needs and social experiences meet. Masterfully structured, they indicate a profundity of understanding that is rare in the genre. The poetic, imaginative power of these works places them alongside the portraits and landscapes of Cézanne's late period. "But from the moment we become painters we are swimming in vast waters, in the fullness of colour, the fullness of reality. Our tussle with things is a hard, direct one. Things sustain us. A sugar bowl can teach us as much about ourselves and our art as a Chardin or a Monticelli. Our pictures are quite literally *nature morte*." (To Gasquet.)

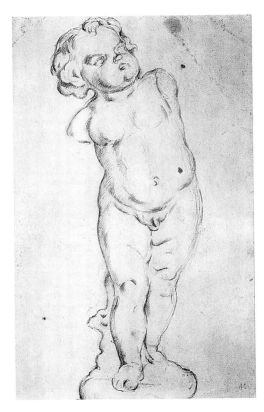

Study of a Plaster Cupid, 1886–1889
Chalk and pencil, 48.2 x 31 cm
Museum Boymans-van Beuningen, Rotterdam

Plaster Cupid and the 'Anatomy', ca. 1895
Nature morte avec l'amour en plâtre
Oil on paper on wood, 70 x 57 cm
Venturi 706
Courtauld Institute Galleries, London

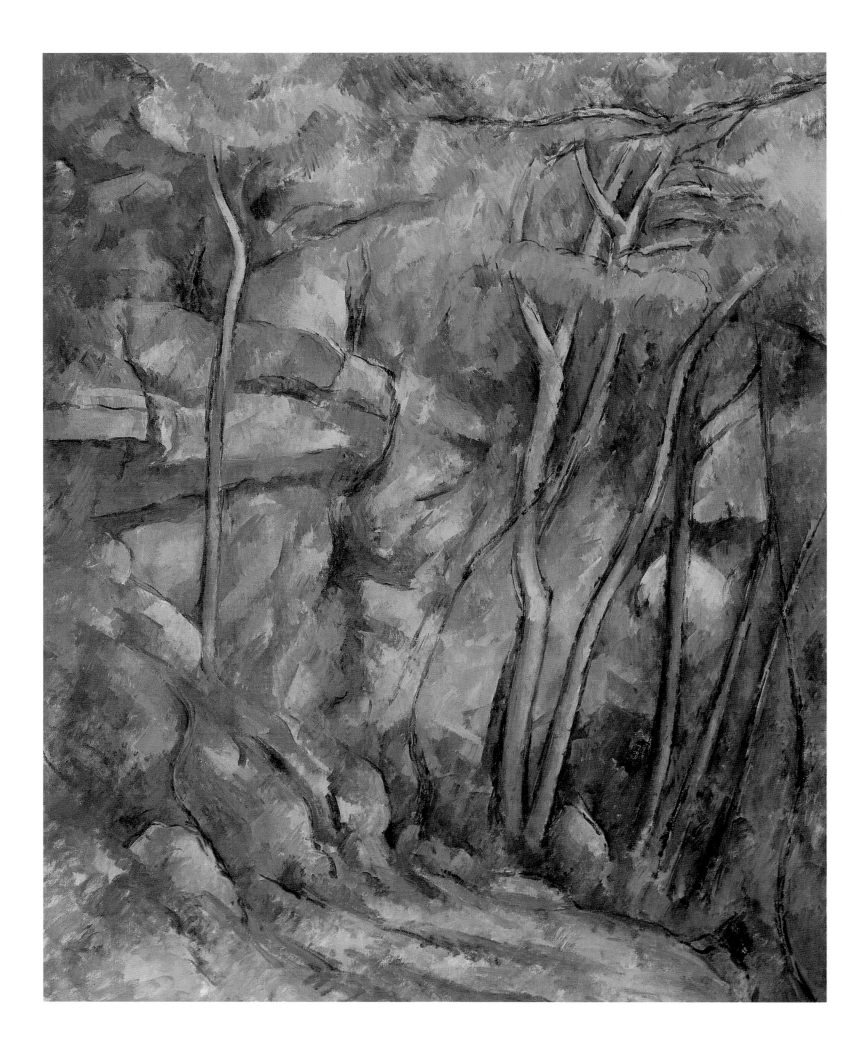

The Painter and his Mountain: Late Landscapes and Theories

The stir the Caillebotte Gift had caused in academic circles meant that Cézanne's name too was once again on everybody's lips. One of his bathing scenes gave particular offence to the guardians of artistic propriety; and (as we have seen) only two of Caillebotte's Cézannes (half the holdings) were accepted.

Ambroise Vollard, the young art dealer, was now taking an interest in Cézanne. At the prompting of Pissarro, Renoir, Monet and Guillaumin he organized Cézanne's first solo exhibition at his gallery in the Rue Laffitte. The pictures were shown unframed, and owing to space problems which prevented Vollard from showing all of them simultaneously the exhibition was changed midway. Vollard put three paintings in his window: the bathers scene from the Caillebotte Gift, *Leda and the Swan* (Barnes Foundation, Merion) and a further nude. The response of the critics and public was unanimous. The *Journal des Artistes* typically demanded to know whether "the sight of these depressing monstrosities, which go beyond all legally permissible obscenity" would not make the sensitive throw up. Some well-disposed critics conceded Cézanne's influence on the younger generation of artists; but the most trenchant and unfeeling opposition originated in Zola's circles, where Cézanne had supposed he had allies who understood him. In an article in *Le Temps* (9 March 1895) François Thiébault-Sisson recapitulated all the prejudices and wrongheadedness that Zola and his character Lantier had put into circulation: "That was how he was when in 1857 [!] he came to Paris from Aix-en-Provence in quest of an artistic formula, as his friend Emile Zola had sought a literary formula. And thus he still is today, reclusive, shy: he not only avoids public appearances, he also prefers not to exhibit his pictures, for the simple reason that now as then he is incapable of assessing himself, incapable of making as much as he might of what remains a truly new concept (he has left that to others more skilful) – in a word, too inchoate an artist to realise the things he was the first to envision, to show the full extent of his talent in authoritative works …"

Fellow-painters who thought highly of their own (academic) ability and mocked Cézanne's "unfinished" pictures judged no less harshly. The only ones to be enthusiastic were his old comrades-in-arms: "Vollard's Cézanne exhibition is truly magnificent.

Trees and a Roof, 1883–1885
Pencil, 32.6 x 34.5 cm
Museum Boymans-van Beuningen, Rotterdam

Château Noir Park, ca. 1900
Dans le parc de Château Noir
Oil on canvas, 92 x 73 cm
Venturi 779
Musée de l'Orangerie, Jean Walter and Paul Guillaume Collection, Paris

There are still-lifes, utterly wonderful landscapes, and distinctly unusual, extraordinarily simple and carefully done bathing scenes. One has the impression that everything is based on two tones. The whole exhibition is most impressive." The enthusiasm of Pissarro – who had exchanged a drawing of his own for two [!] paintings of Cézanne's – was shared by Renoir, Degas and Monet, all of whom also bought pictures by Cézanne.

Yet the recognition of the Impressionist artists could not console Cézanne in the face of this new wave of hostility and abuse: "I curse the Geoffroys and the other smart-alecks who write articles for fifty francs a shot and attract attention to my person. My whole life long I have worked to earn my own living. But till now I believed that one could be a good painter without drawing attention to one's private life. Of course an artist wants to achieve as much – intellectually – as he possibly can; but the man himself must remain in the dark." (To Gasquet, 30 April 1896.)

Two years later, Cézanne's mother died at the age of 83. For Cézanne it was one of the blackest days in his life. He was so distraught, indeed, that he could not even attend the funeral. Thereafter he withdrew totally into his painting. There were new exhibitions at Vollard's, at the autumn Salon, and with Les XX in Brussels, and the admiration the younger painters had for him was growing steadily; but none of this could dispel his renewed suspicion and profoundly disheartened mood. He would set up his easel in places more and more remote and inhospitable, and calm his agitated feelings by working on his pictures.

From 1895 to 1899 Cézanne painted a number of pictures at the disused Bibémus quarry. They capture the chaos of bizarre, tumbled rocks, partly overgrown, in expressive and nicely unified visual terms (p. 197). Still, there remains a sense of misanthropy and defensiveness, which Cézanne projected upon the place. The rocks, heaped together at one pictorial level, obstruct our gaze almost antagonistically. The strip of sky visible at the top is almost blocked out by the massive rocks. The intense orange colouring emphasizes the fantastic quality of the scene, and contrasts sharply with the green of the vegetation and the blue of the sky.

One of Cézanne's most dramatic works of this period was *Mont Sainte-Victoire seen from Bibémus* (p. 211). Beyond the quarry in the middle distance, the crown of the mountain rears abruptly, seeming menacingly close; it takes up most of the upper third of the painting. The economical brush-strokes follow a very few structural lines which plot the distribution of the rich, intense colours. The richest colours are in the quarry, where the green of the trees and the beige-grey of the mountain meet. In the mountain itself the various colours are subtly modulated, becoming less intense once again in the blue of the sky above. This symphonic use of colour overlays the rugged formal idiom and becalms the conflicts implied in contrasting hues. The rocks and greenery, sky

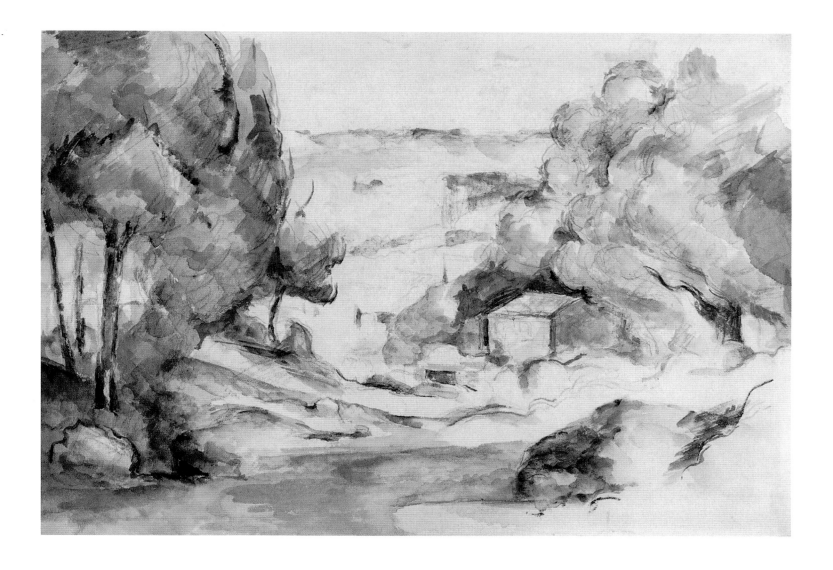

and earth become one fundamental unity, that unity towards which all Cézanne's artistic endeavours tended. It is as if he identified with his landscapes, projecting his fears and wishes, dreams and ideas onto them. Even deserted landscapes appear alive with some mysterious being of their own, an existence that owes its origins not to Man but to an inner source of natural energy.

Other pictures illustrate Nature's variance with Man, even a destructive hostility, more clearly. *Ruined House* shows a deserted house on a steep slope, with dark, gaping windows and a split down its walls to the foundations. *The Deserted House* (1892-1894, private collection, USA), with its gleaming white walls and closed shutters, also establishes that unreal atmosphere, characteristic of Cézanne's late landscapes. These are "*sujets* with an aura" (André Breton), expressing a good deal of their creator's inner state – as his early landscapes had done. Those landscapes were scenes of violence and passion, though; the late landscapes have been purged of instinctual energies and are subject to laws of their own, an inner excitement achieved solely by dedicated artistic scrutiny, which Cézanne communicates through the vibrancy of his colours. And thus the artist's imaginative powers, spurred by

Landscape in Provence, ca. 1880
Paysage en Provence
Pencil, water-colour
and gouache, 34.6 x 49.9 cm
Kunsthaus Zürich, Zurich

the visual phenomena of Nature, vision forth the secret locus of metamorphosis, where all things are purged and purified. In an 1878 letter to Zola, Cézanne had already put this experience of Nature into words: "Furthermore I have observed [. . .] that places are saturated in the manner of their presentation and the passion they excite in people, and thus attain a greater unity with the actors in events and are less isolated from other things. They seem to give life to themselves, as it were, and thus share in the sufferings of humankind."

Nature becomes the focus of sensations, motions of the spirit that consort with an artistic frame of mind. Another "*sujet* with an aura" was the Château Noir, a house hidden amidst trees (the Parc du Château Noir) near the quarry. The place had attracted legends. It was also known as the Château du Diable (Devil's Castle), and a one-time owner was said to have dabbled in alchemical experiments and black magic. Its high neo-Gothic windows and imperfect proportions, which added to its ruined charm, must have made it optically irresistible to Cézanne.

Cézanne painted the spooky building in the style of Poe's House of Usher in the short story: in one painting it is a ghostly silhouette beyond black tree-tops; in another (p. 204) it is covered in a net of branches, framed by criss-cross lines with a red door bright at the centre; or again (p. 202) it is barely visible beyond thick woods that seem intent on concealing it. But the house is always shown in the natural setting which decay has made it a part of. And the woods afforded Cézanne an additional motif: impenetrable areas which few walkers would try to enter and which could hardly be called picturesque (cf. p. 201). Cézanne was able to immerse himself in that wilderness; the scattered rocks, luxuriant greenery and profound solitude were much to his taste for melancholy.

There were also grottoes and rocky overhangs in that isolated region, where in pre-historic times Man had sought shelter and also held primitive initiation rituals. In his painstaking renderings of these historic parts, in drawings, water-colours and oils, Cézanne transformed the hard rock, giving it gentler, curving contours and linking the layers into rhythmic, sensuous wholes. It takes little imagination to detect female forms in some of these pictures, determined as they are by Cézanne's anthropomorphic view of Nature (cf. p. 192).

The doctrine of the spirit of things applied to both the organic and the inorganic: crags, houses, mountains, the sky, and above all trees. Cézanne's paintings of trees, particularly of the pines that grow in his home parts, are among the most poetic products of his pantheist sense of Nature. *The Great Pine* (p. 117) is a fine example. The lone, lofty tree is stretching out its branches like arms, in air that we can *feel* to be bracingly fresh. The movement does not seem to originate in the breezes of the mistral but rather in the inner dynamics Cézanne apprehended in all things: "It shook me

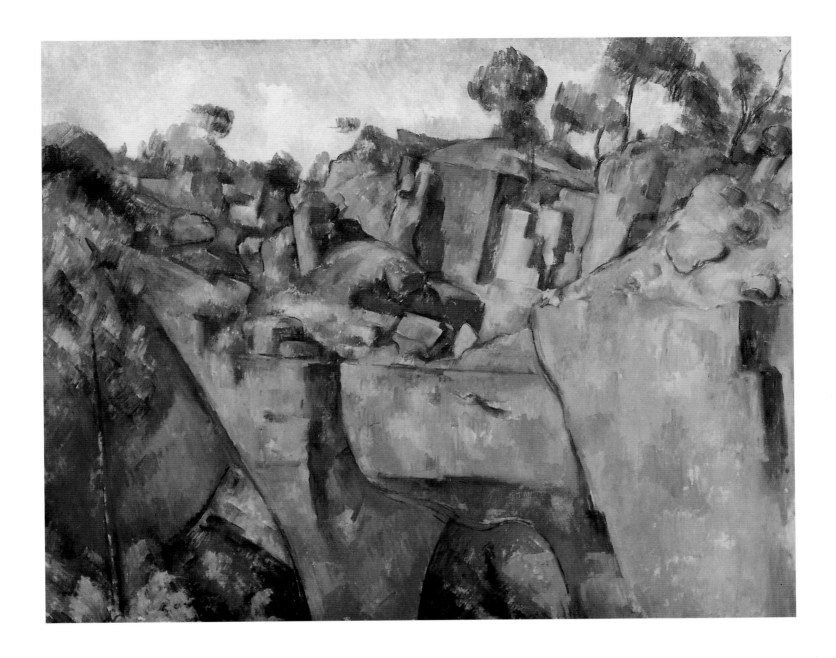

up properly with a sense of dread. If I can use the secret of my colours to communicate that dread to others, will they not have a sense of the universe? An oppressive sense, perhaps, but all the more fruitful and exquisite? [...] Trees as sensitive creatures? What do we have in common with trees? What is the link between a pine as I see it and the pine as it truly is in itself? Ah, if I were to paint that ... It would make that part of Nature we view when we look at a picture real, would it not? Trees as sensitive creatures." (To Gasquet, around 1900.)

In his seclusion, Cézanne spoke to only one man in these terms: Joachim Gasquet, a young poet, the son of a friend of Cézanne's youth, Henri Gasquet, a baker. Joachim Gasquet would accompany Cézanne on his daily expeditions to paint "sur le motif". The young poet was extremely enthusiastic about Cézanne and his art. Initially Cézanne was put off by this enthusiasm, but the young man's patent sincerity led him to accept it. Gasquet had especially

Quarry at Bibémus, 1898–1900
Carrière de Bibémus
Oil on canvas, 65 x 81 cm
Venturi 767
Folkwang Museum, Essen

Landscape near Médan, 1879/80
Pencil, 26.4 x 30 cm
Kupferstichkabinett,
Öffentliche Kunstsammlung, Basle

admired a landscape showing Mont Sainte-Victoire which had been shown at the *Amis des Arts* exhibition (and had been mocked by the self-appointed "Friends of Art"). Cézanne, touched by the poet's genuine admiration, made him a gift of *The Great Pine* (p. 118) shortly after. On their joint wanderings through the dearly-loved countryside of Provence, Cézanne began to confide in his new friend; though the age gap was considerable, they shared their love of Provence, with Mont Sainte-Victoire at its heart.

"Look at Sainte-Victoire," said Cézanne to Gasquet. "What a sweep! What a commanding thirst for sunshine! And what melancholy in the evening when all that heaviness settles upon it. Those blocks were fire. The fire is still in them. The shadow, the day, seems to recoil from them in awe, to be afraid of them. Plato's cave is up there; when great clouds pass over you will notice that their shadows tremble on the crags as if scorched, as if they were being quaffed by a fiery mouth at the same time."

The massif of Sainte-Victoire lies north-easterly on the plain of the Arc; at over a thousand metres, it dominates the surrounding country. For Cézanne and the people of Aix, the mountain was far more than a geophysical feature, though. The changing fortunes of Provence had been linked to the mountain throughout history. The mountain's name (which only established itself in common use in the 19th century) went back to bloody battles fought between Roman legions under their general, Marius, and the tribe of the Cimbri. Whether the name is interpreted as referring to a "sacred victory" or the "victory of the saint", it certainly points back to pre-historic cultic rituals that were celebrated in the caves on the mountain and in the vicinity. Provence is one of the most ancient inhabited parts of the world. The mountain, residence of a saint dating back to antiquity, was appropriated by Christianity in the 5th century, when hermits settled there. The grotto of the hermit St. Ser, which had a Romanesque church built over it, was still used for pilgrimages in Cézanne's time, by girls in quest of husbands and mothers whose children were sick. In the 17th century a Camaldolite monastery was built there, and wanderers were welcome to rest there awhile.

Undoubtedly Cézanne and the friends of his youth would have lit bonfires at night on the mountain on the Feast of St. John: the midsummer celebrations were a traditional climax in Provençal festivities. Again and again the young friends went on trips to Mont Sainte-Victoire. They could easily shelter in deserted monastic buildings or huts, or (more comfortably) with the Jesuits at the *Colline des Pauvres* on the Bibémus plateau. Thus in choosing his motif, Cézanne was establishing a thematic link with the history of his homeland and was also recalling purely personal experiences and memories.

Cézanne did 30 oils and 45 water-colours of Mont Sainte-Victoire. He approached his mountain from ever-new angles. It was a

sun that shone for him, "the Austerlitz of painting" (letter to Aurenche, 25 September 1903). In *The Cutting* (pp. 60/61), as long ago as 1870, the vast mountain appeared in the background as a monumental reminder of the threat the industrial age posed to Nature. That picture marked Cézanne's breakthrough, the change from his earlier, sombre work to steady observation of Nature under the tuition of Pissarro. In the 1880s, the mountain appeared more and more often. The broad, panoramic view across the Arc valley to the mountain, framed by a pine, introduced a newly poetic note not only into Cézanne's work but indeed into Provençal landscape painting as a whole (where the mountain had been a traditional feature in the background). Cézanne admired the Provençal painter Granet, whose watercolours had achieved a particularly light and fluent manner. But in Granet's pictures of Mont Sainte-Victoire too, the mountain typically appears merely as a picturesque anchor in the distance. It was Cézanne who for the first time placed the mountain in bright, clear sunlight in the middle of his compositions as the central motif. The other elements in his paintings – pine branches, or the Arc valley – are only there to lead our gaze to the mountain, majestic in the centre.

Now, in his late work, a new series of Sainte-Victoire paintings evolve in a crescendo, peaking in Cézanne's great accomplishment, from the heights of which we can see far into the future development of European art. At first the mountain is seen with some detachment, from the south-west (p. 213) or from the Rue de Tholonet. But the power of its attraction increases till it becomes the absolutely dominant motif in a picture. In 1902 Cézanne quit his cramped town flat in the Rue Boulegon (where he had moved following the sale of Jas de Bouffan in 1897) and set up in a studio house of his own on the Chemin des Lauves. From above the studio he had a wonderful, unrestricted view of Mont Sainte-Victoire, and from there he painted his final series.

"In these paintings, Mont Sainte-Victoire is radiant and untouchable, standing forth in a timeless light as on the first morning in Creation. The blue, green and orange tones have all the freshness of rediscovered clarity. Everything is new, everything is beautiful. The azure of the heavens turns crystal. Foliage and meadows are transformed into translucent emeralds. The rocks shine like gold topaz." If Henri Perruchot waxes lyrical in his study of Cézanne when he comes to describe these paintings, in view of their colourful splendour it is hardly surprising. For instance: in the Philadelphia picture (p. 213) the wedge profile of the mountain rests on an array of sparkling colour contrasts (orange, green and ochre) which give way to heavy, dark bluish violet shades at the bottom of the canvas, shades which themselves echo the colours which appear in lighter hues in the mountain. The interplay of colour correspondences transforms the motif into a brightly-coloured fabric, a free play of colours which goes beyond the objective

"I wanted to copy Nature. And I failed. But I was content when I realised that (for example) the sun cannot simply be reproduced but must rather be expressed by some other means … by colour."
PAUL CEZANNE

reality of the scene depicted. The comparison with glittering crystals can be readily understood, too, if we consider the use of individual brush-strokes and alternation of colours to create strong contrasts and a pattern of light and dark. Water-colours of the period (p. 208) demonstrate the new colour principle even better. The paper has been covered in very thin layers of related colour tones, slightly overlapping, establishing a colour scale. This produces a patchwork structure of incessant layering and linking; in the first instance, all we can distinguish are values of light and dark. The longer we look, the better we see that these "skins" of colour in fact have a perfectly recognisable thing at the centre – Mont Sainte-Victoire. In these water-colours, paint becomes a substance without material presence, yet firm at the same time and transparent, or crystalline, as it were.

Cézanne termed this procedure "modulation", perhaps on the musical analogy of modulation from one key to another, though the word is etymologically related to a module or unit, too. Bernard, the

Lake Annecy, 1896
Le lac d'Annecy
Oil on canvas, 64 x 81.3 cm
Venturi 762
Courtauld Institute Galleries, London

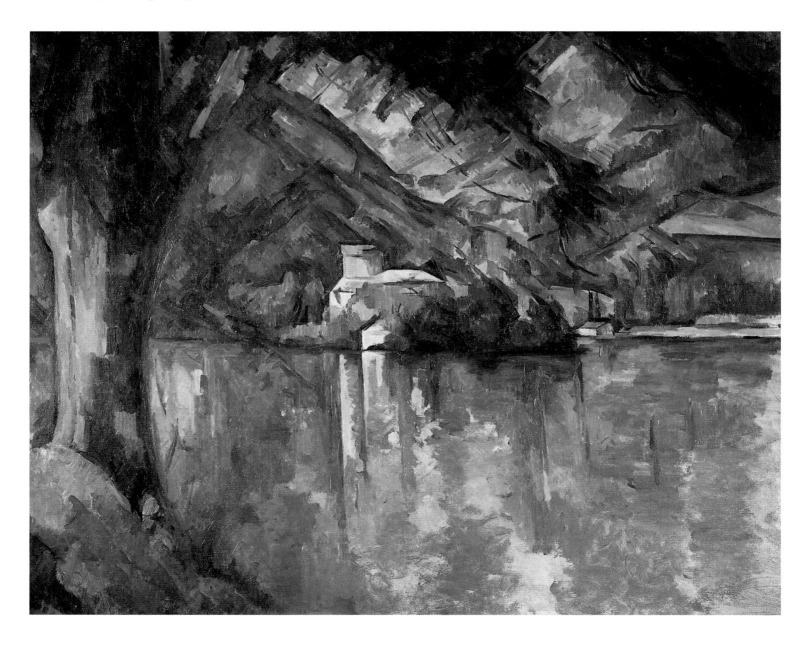

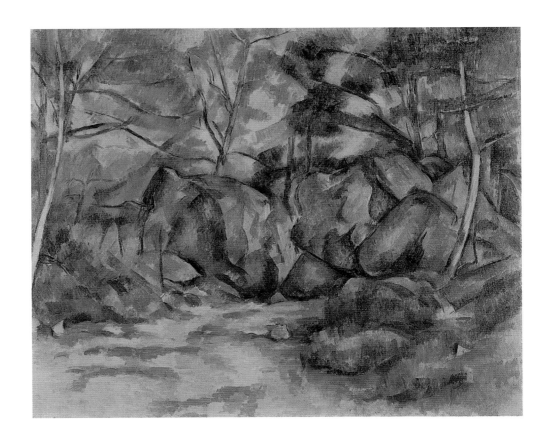

young painter, who visited Cézanne in 1904, was allowed to watch the master at work and left us a description of his painting technique: "He had an idiosyncratic way of working, quite unlike what is usual and immensely complicated. He began with the areas of shadow, and with one dab to which he would add a second, bigger dab, then a third, till all the tones, covering each other, modelled the object in question through their colours. Then I grasped that his labours were guided by a law of harmony and that all these modulations followed a course that was fixed in his mind in advance." (Bernard, *Conversations with Cézanne.*)

This painting technique gave Cézanne the means to incorporate the data of perception into a firm structure, to create his composition (with recognizable shapes and all the elements in the picture harmonizing) on a basis of colour. Talking to Gasquet, and availing himself of an eloquent gesture of interlocked fingers, Cézanne described the arduous process of "realisation", of harmonizing perception of Nature and compositional principles, in these words: "Not a single stitch must be loose. There mustn't be a single gap for the tension, the light, the truth to escape by. I have all the parts of a canvas under my guidance simultaneously. With like pressure and like belief, I connect whatever is tending to split asunder. Nature is constant, but none of Nature's visible phenomena endure. Our art must present the destruction of permanence, with the constituents and appearances of all its changes. In our imaginations, Art must make permanence eternal." But any intervention on the part of the intellect would wreck the "process of translation"

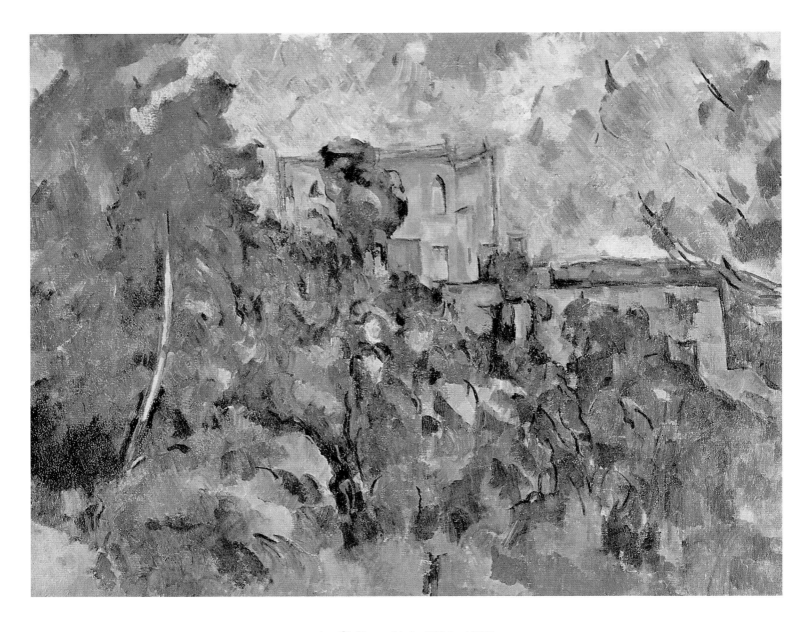

Le Château Noir, 1904–1906
Oil on canvas, 73.6 x 93.2 cm
Venturi 794
The Museum of Modern Art, New York

(as Cézanne called the conversion of observed data into pictorial terms).

"Art is a harmony parallel to Nature," said Cézanne. The artist's task is not simply to copy Nature. He has to interpret it (though without dispensing with observation). For Cézanne, the artist was like a light-sensitive plate, to be steeped in the visual perceptions of Nature. The technical process followed next: selecting the components, translating, interpreting. Cézanne spoke of two parallel processes, two texts that must coincide: "One has a grasp of one's language, after all, the text that has to be deciphered, the two parallel texts, Nature seen and Nature felt, out there and in here [tapping his forehead], they must interpenetrate each other if they are to last, and live, the life of Art ... the life of God. Landscape is mirrored in me, takes on human form in me, and thinks in me. I make it objective, transfer it, and fix it on my canvas." (To Gasquet.)

The many pictures, both oils and water-colours, with unfinished areas suggest how difficult Cézanne found that process of assessing and making. The blank areas nonetheless can stand in their own right beside the coloured areas: the brightest zones in the landscape, full of light. Taken together with areas of colour, blank areas have a structural significance, too. They provide transitions within scales of colour, and represent light and atmosphere; this becomes especially apparent in the water-colours.

Cézanne's "theories" were of course always filtered and interpreted and perhaps misrepresented by those friends and painters to whom he put his views. Nevertheless, at the heart of these statements there appears a kind of concept, that "formula" Cézanne often referred to, which includes the conjoining of "optics and logic" (as Bernard tells us). A good deal of what is recorded as Cézanne's can be traced back to painting handbooks of the time (by Thomas Couture or Antony Régnier, for instance) or to writers such as Stendhal, Balzac or Baudelaire. Even his oft-quoted statement that Nature should be treated as spheres, cones and cylinders proves on closer inspection to be an echo of the Platonic theory of geometric forms which was part and parcel of every aesthetic system in the 19th century (such as Charles Blanc's) — and of the curriculum at an academy such as the Aix art school.

Cézanne goes on to speak of the essential "depth in painting", which he aims to convey by colour alone: "Nature should be treated as cylinders, spheres and cones. It should all be aligned in correct perspective, so that every side of an object or surface tends towards a central point. Lines running parallel to the horizon establish the lateral extent — that is to say, the scene cut out of Nature, or, if you prefer, the spectacle our *Pater omnipotens aeterne deus* unfolds before our eyes. The lines that run at right angles vertical to the horizon establish the depth. Now, for humankind Nature is more an affair of depth than of lateral surface, and that is why it is

"My method, my law-book, is realism. But a realism full of unconscious grandeur. The heroism of the real."
PAUL CEZANNE

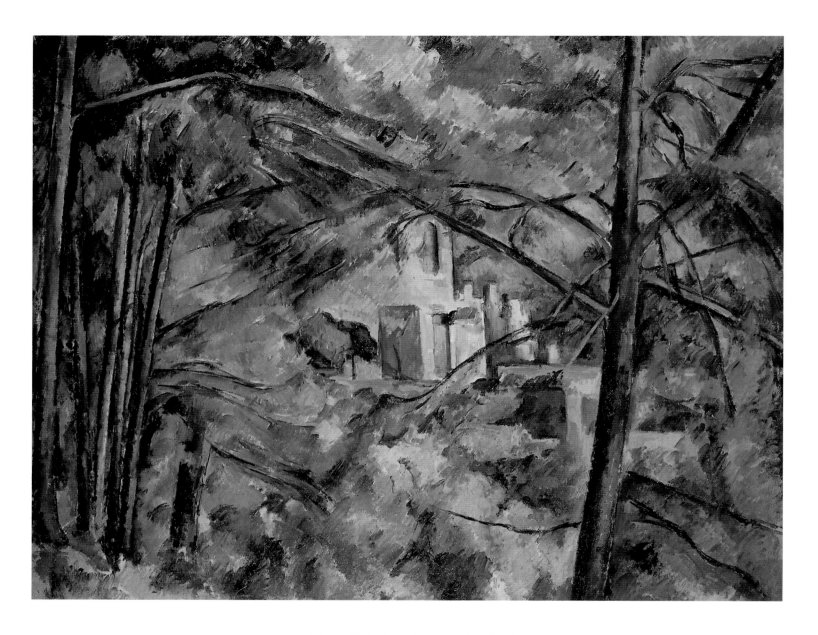

View of Château Noir, ca. 1894/95
Vue du Château Noir
Oil on canvas, 73.5 x 92.5 cm
Venturi 667
Oskar Reinhart Collection, Winterthur

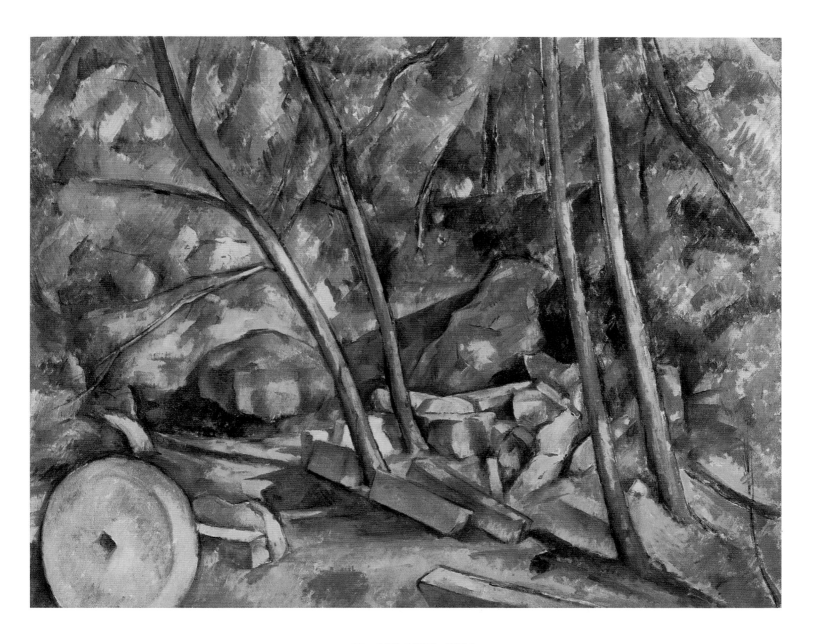

The Mill, 1892–1894
La meule
Oil on canvas, 73.5 x 92 cm
Venturi 768
Philadelphia Museum of Art, Philadelphia,
Mr. and Mrs. Carroll S. Tyson Collection

essential to add sufficient blue to the reds and yellows we use to convey the vibrancy of the light, in order that the air become palpable." (To Gasquet.)

For Cézanne, geometry was "the yardstick of the Earth"; he observed regular structures and recurring rhythmic patterns in Nature. On the other hand, his rule of thumb was: "Bodies in space are all convex." All forms of perception aim at convexity, which means in practice that they have a focal point where Cézanne places an emphasis in his colour scales, even if the objects concerned are flat (walls or tables). What was truly new in Cézanne's painting technique (after 1885) was his modulation of colour, which made it possible to take radical liberties or to remain faithful to the object. The representation values and inherent values of colour and light, space and surface, are completely meshed and interactive in his colour scales.

Mont Sainte-Victoire must have seemed the perfect subject for this technique. It was tranquil and permanent. It was readily visible from a distance, and could be walked around and thus presented in a number of varied ways without any need to alter the technical approach. For Cézanne in his isolation, doubting himself and the universe, Mont Sainte-Victoire was a final refuge. "I am stubbornly going on with my work. I can see the Promised Land ahead. Will my fate be like that of the great leader of the Hebrews, or will I be permitted to enter it? [...] I have made a certain amount of progress. Why so late, and so arduously? Art may really be a priesthood that demands men of purity who will belong to it utterly." (To Vollard, 9 January 1903.)

Cézanne's religious leanings towards the end of his life (his "mediaeval phase") were prompted less by fear of death in itself than by fear of not being able to see his great artistic aims achieved. Cézanne placed himself totally in the service of his art; and in the final paintings of Mont Sainte-Victoire, seen from Chemin des Lauves, he brought his whole talent to bear on what was to be a crowning accomplishment of modern painting and his legacy to his art. He seemed more under the spell of the mountain than ever; his personal idiom and his method of applying the paint grew more and more expressive. What did Mont Sainte-Victoire really mean to Cézanne in those final years?

In the Zurich painting the mountain is far off across the flatland. The picture is loosely structured and there are blank areas of canvas. But then comes the Basle picture (p. 212), a marvellous achievement that signals the end of one era and the birth of a new one. Compositionally it resembles others in the series, with the plain far below and the profile of the mountain soaring above the horizon. At the left edge, though, there is a dark area (perhaps representing the foliage of a tree) of monumental presence. This dark area stretches across the horizon and merges with the green in the sky (which Cézanne used to signify dark clouds and changes

The Red Rock, ca. 1900
Le rocher rouge
Oil on canvas, 92 x 68 cm
Venturi 776
Musée de l'Orangerie, Paris

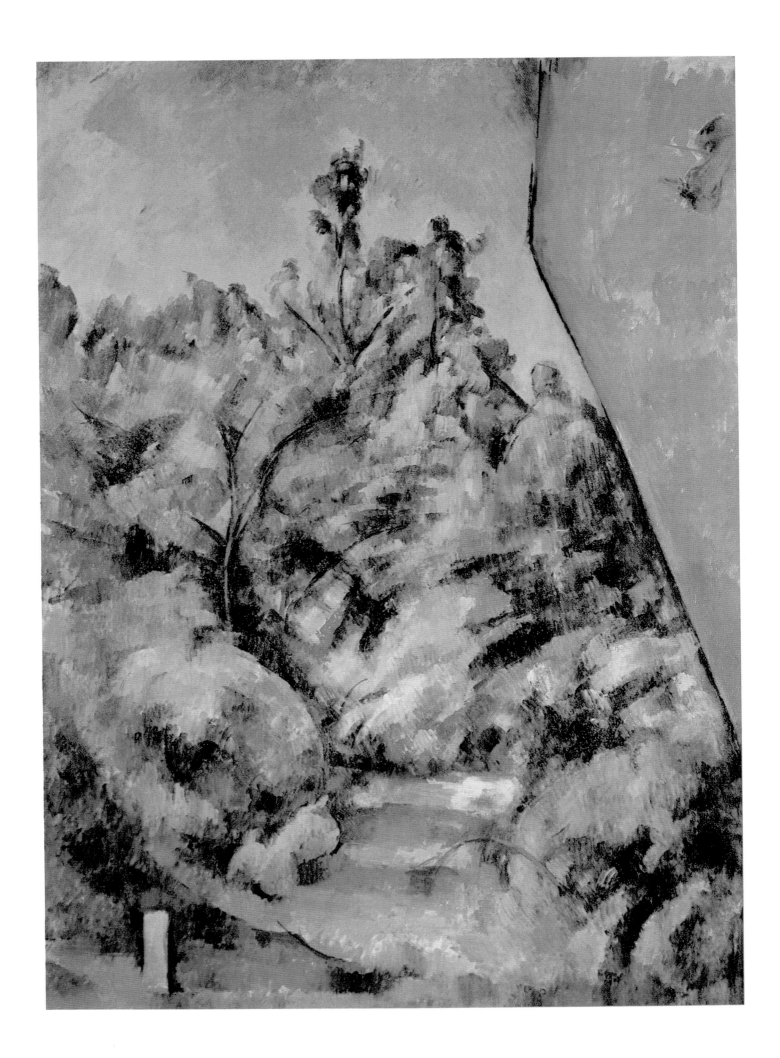

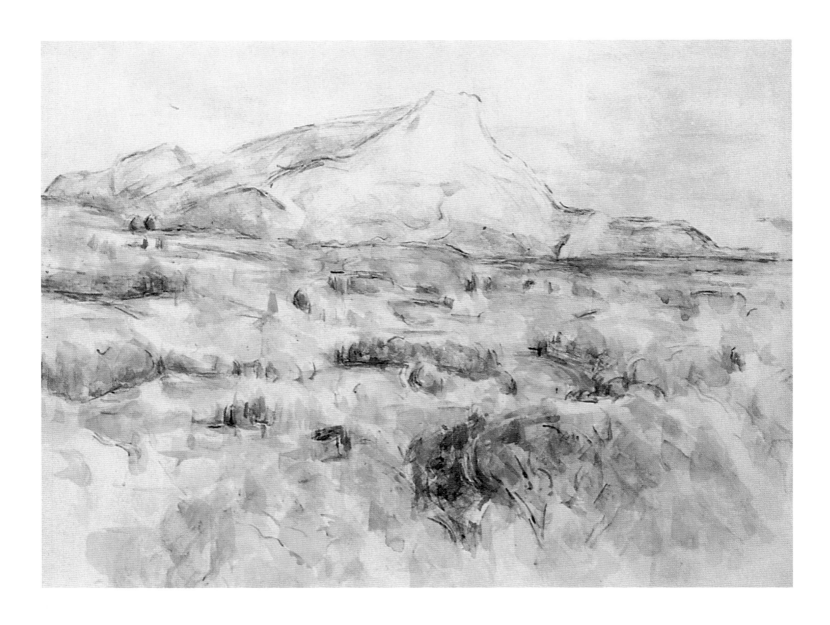

Mont Sainte-Victoire, 1902–1906
La montagne Sainte-Victoire
Pencil and water-colour, 42.5 x 54.2 cm
The Museum of Modern Art, New York

in the light). The shadowy zone also extends laterally, giving the entire composition a dramatic quality, that sinister atmosphere which we often sense in the late landscapes (such as the Château Noir pictures). There are strongly contrastive flecks of bright colours in that dark area: red, orange, ochre and blue. These flecks, appearing in that sequence, lead up to the mountain, where they blend with the blue colouring of Sainte-Victoire. The sky echoes the colours of both flatland and mountain, modulating them subtly.

The bright colour structure is like a crystal formation in a rock druse, with the gleaming scales of colour leading upwards. But the painting makes a twofold impression, both crystalline and fluent: there is also a torrential flow in Cézanne's colours here which is beyond rational analysis. Gauguin had already referred to the "roaring of a great organ" in speaking of Cézanne's works. And it was no accident that Cézanne chose the word "modulation", with all its musical associations of changes in key. Cézanne was well aware of both alternatives, the constructivist/crystalline and the fluid/musical: "There are days when the universe appears to me

as a vast flood, a torrent of reflections in the air, reflections that dance all about the ideas of Man. [...] The colour prism represents our first approach to God, our seven forms of bliss, the divine geography of the great and eternal White, the diamond zones of God." (To Gasquet.)

At the close of the 19th century, Cézanne was not the only one to think in terms of analogies between colour and music. The Symbolists included that correspondence in their tenets of faith, and for them its apotheosis was to be found in the abstract art which was just making its appearance. Abstract art saw freedom of colour (in analogy to music), whether of a constructive or rhythmic character, as an important new liberty in the process of artistic creation. Mallarmé broke the rules of poetry by dissolving his punctuation and using different typographical effects and words employed for rhythmic reasons; his work entered the human consciousness at a deep level, like music, and remained not altogether accessible to the rational faculty. We do not know whether Cézanne had close contact with the Symbolist poets. He might have met Mallarmé and Huysmans at Monet's home in Giverny. But at all events Cézanne and literary Symbolism are manifestly cognate, and the affinity can be detected in Cézanne's art.

Cézanne's concept of Nature was fundamentally different from that of the Impressionists. Their pictures struck him as being too much "like cotton-wool", lacking firm structures, drawing on the magic of momentary perception alone. Monet was the only one Cézanne was later prepared to see as a "great painter", on the grounds that he had "painted the iris shimmer of the world". In his late paintings of water-lilies, Monet was aiming at a metaphoric dimension in Nature, beyond Impressionism. The four elements of Earth, Air, Fire and Water meet evocatively; and the objects which are the subject of the paintings, the water-lilies, dissolve in a stream of brightly-coloured flecks. In Cézanne's concept of Nature, the solid and the fluid, stasis and flux, were in equilibrium. He introduced stable structure into the world of Impressionist colour. His modulations developed like the geological strata of the earth, which Cézanne had studied carefully with Marion, the friend of his youth. In the *Carnets de Jeunesse* there are whole pages of geological terms, with drawings illustrating the origin and structure of mountains, in Marion's hand.

"To paint a landscape properly," Cézanne told Gasquet, "I first have to know the geological strata... One fine morning, next day, the geological fundaments are gradually revealed to me, the layers of strata, the great plan of my canvas, and in my mind's eye I trace the skeleton of stone. [...] I start to acquire some detachment from the landscape, to see it. This first sketch, these geological lines — they are what releases me from it. Geometry, the yardstick of the Earth." First Cézanne would lay down the geological lines of his motif in a preliminary sketch. Then the modulations of colour would

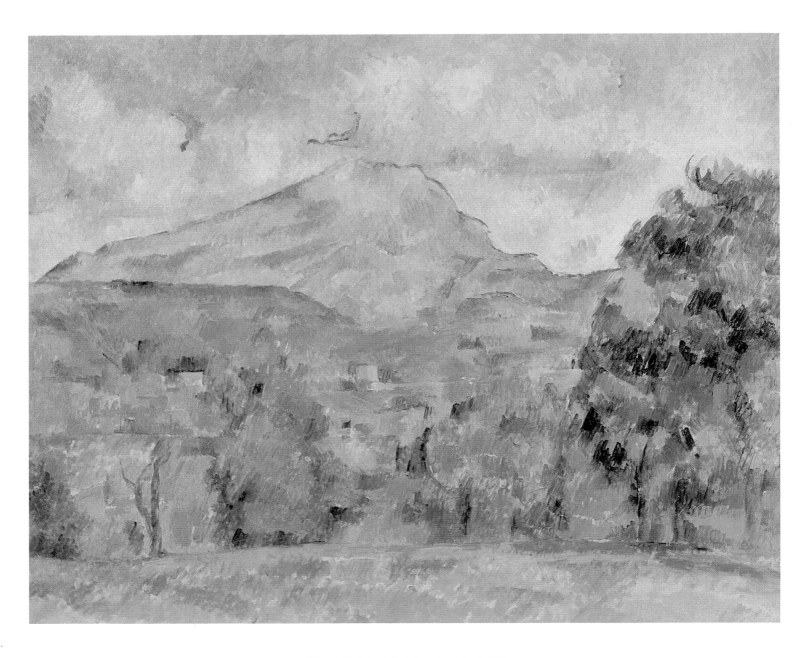

Mont Sainte-Victoire, 1888–1890
La montagne Sainte-Victoire
Oil on canvas, 65 x 81 cm
Venturi 662
Berggruen Collection, Paris

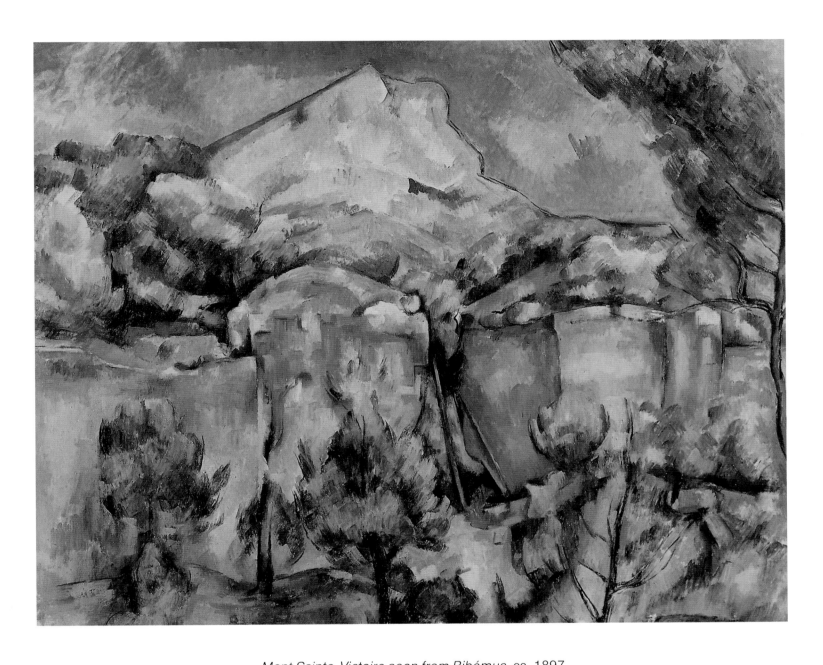

Mont Sainte-Victoire seen from Bibémus, ca. 1897
La montagne Sainte-Victoire, vue de Bibémus
Oil on canvas, 65 x 80 cm
Venturi 766
Baltimore Museum of Art, Baltimore,
The Cone Collection, Dr. Claribel Cone and Mrs. Etta Cone, Baltimore

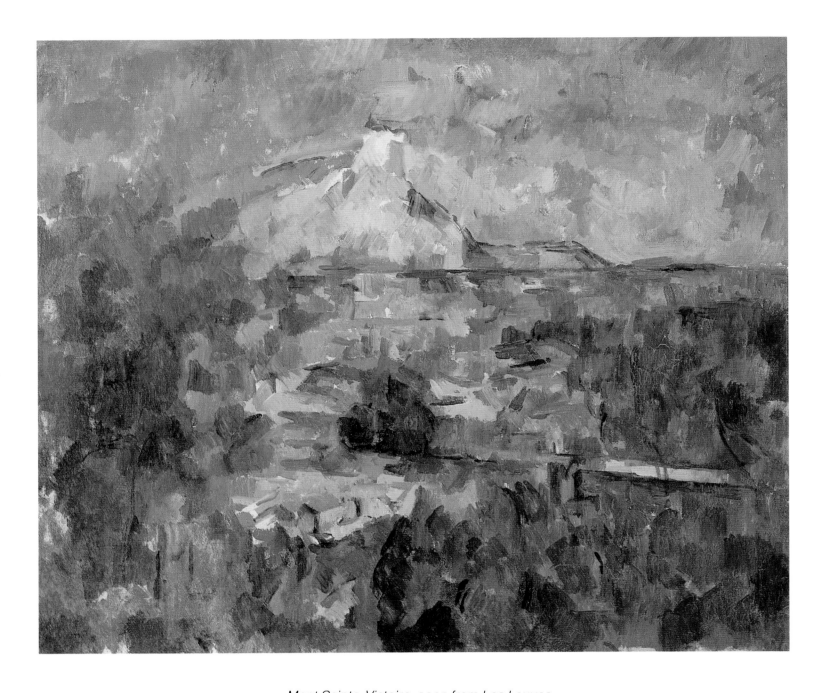

Mont Sainte-Victoire, seen from Les Lauves,
1904 – 1906
La montagne Sainte-Victoire, vue des Lauves
Oil on canvas, 60 x 72 cm
Venturi 1529
Kunstmuseum Basel, Basle

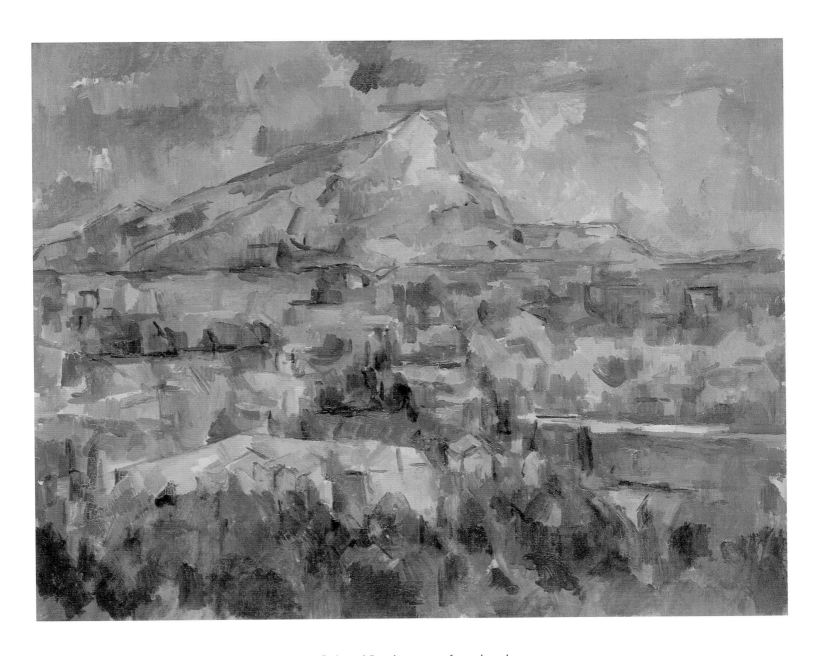

Mont Sainte-Victoire, seen from Les Lauves,
1902–1904
La montagne Sainte-Victoire, vue des Lauves
Oil on canvas, 69.8 x 89.5 cm
Venturi 798
Philadelphia Museum of Art, Philadelphia,
George W. Elkins Collection

follow, a constructive superstructure based on his sketched (and felt) outline stratification of Nature. Out on his walks in Provence, Cézanne must have noticed the so-called *bories*, pre-historic shelters made of stacked rocks and stones, which shepherds used for shelter in Cézanne's time. Those *bories* provided him with an illustration of geological layering, before his very eyes.

Thus accusations to the effect that Cézanne divorced colour and draughtsmanship simply will not do. "One is a painter and draughtsman to the same degree," he said; and, "Once colour is at its richest, form is at its fullest." These statements, which may be difficult to understand at first glance, refer to the modulation method, the patient placing and sequential organization of dabs of paint to create a coherent structure in which form, colour, space, volume and light are all established by a single means: paint. In his colours, Cézanne's image of Nature achieved a condition of simultaneous stability and flux, a balance of Creation in a state of becoming and change and the underlying, unchanging geological design. "At times I conceive of colours as vast, noumenal entities, ideas with a physical presence, creatures of pure reason, with whom we can enter into relations. Nature is not an affair of the surface; it is in depth. Colours express that depth on the surface. They arise from the roots of the world. They are its life, the life of ideas." (To Gasquet.)

Cézanne's "Nature" was not only the landscape of Provence but the universal, visible reality of the world. He wanted to make an inner, deeper order apparent in his subjects, with a meaning that went far beyond our modern notions of the laws of Nature. Cézanne was pursuing a pre-modern idea of Nature; his Nature, with its harmonious correspondences, was indicative of a spiritual omnipotence which was the foundation of all laws. Colours expressed that spiritual, all-comprehending reality: "Colours are the visible flesh of ideas and of God, the manifestation of the Mystery, the bright play of laws." (To Gasquet.) Cézanne's principles of order – modulations – reflect the higher Order of Nature; they crystallize the permanent forms of the world and transform his still-lifes, portraits and landscapes into visions of new harmony and beauty. This process of crystallization by no means precludes natural processes of evolution and change. Indeed, it was in his late works, the synthesis of Cézanne's creative endeavours, that the solid presence of colour entered a state of flux once more. His compositions are marked by a wonderful balance of construction and flux, fundamental permanence and dazzling fabrics of colour.

Cézanne always started from perception of his subject; but he adapted what he saw to his own view of Nature. "I wanted to copy Nature, but I couldn't. Still, I was satisfied when I realised that although one cannot present the sun one can convey it by other means [...] by colour." (Maurice Denis, *Cézanne*, 1907.) In such statements, and of course in his paintings, we clearly see Cézan-

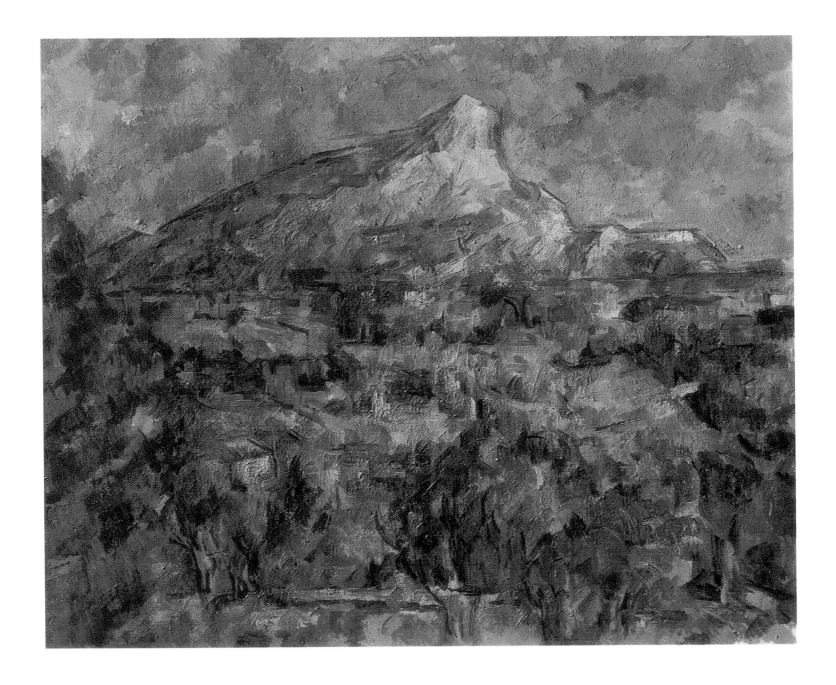

ne's affinity to literary Symbolism, an affinity which his contemporaries were not slow to identify. Denis, for example, with Cézanne in mind, defined Symbolism as "a relation between an outer form and a subjective condition." Every work of art, he claimed, was "a translation [. . .] of a sensation or, in more general terms, of a psychological fact." (Denis, *Cézanne*.)

Cézanne's oeuvre evolved from an oppressive psychological background and defiant rebellion against all kinds of tradition into an intense and humble view of Nature which put an end to his root conflicts. In the portraits, still-lifes and landscapes of his late phase, that view developed further into a Symbolism of Nature, where Nature is an all-embracing, harmoniously balanced state of being. "The task of the genius is to arrest that upsurge into the immovable in one moment of equilibrium without forfeiting the sense of that dynamic motion." (To Gasquet.) Only in the balance

Mont Sainte-Victoire, seen from Les Lauves, 1905
La Montagne Sainte-Victoire, vue des Lauves
Oil on canvas, 60 x 73 cm
Venturi 803
Pushkin Museum, Moscow

of forces could the depth of Nature and its underlying meaning be apprehended.

In Cézanne's view of Nature, the things of the human world, of domestic life, Man's natural environment, and indeed Man himself, are all inseparably interrelated, made of the same essential, existential substance. This system of relations points to the idea of divine harmony, a higher Order of everlasting Laws which guarantee the continuation of existence. "The task of the genius is to reveal the amity of all these things in the infinite air, alike in their upsurge and ambition." (To Gasquet.) Cézanne's pantheist view of Nature is not of a religious character. His pictures present a higher, meta-religious energy, awareness of the spiritual in the present, and perception of the relation of Man to the world. Cézanne did not choose Mont Sainte-Victoire because of its traditional associations but because it reminded him of happy days of his youth and focussed the history of his homeland. The hard, crystalline structure of the mountain matched Cézanne's desire to create something firm and enduring, and to see the heart of Nature as strata. In the last analysis, that is what distinguishes his spiritual Symbolism of Nature from the vegetative myth in Monet's waterlilies. Monet immersed himself in the flux and organic rhythms of Nature, and so in the symbolism of the unconscious; but Cézanne was out to capture the higher Order of Nature, framed in the dichotomy of surface change and deep permanence. The very paint makes his aim apparent: it is crystalline and firm, but also fluent and transparent. In the last painting of Mont Sainte-Victoire (p. 215) the colour composition again constitutes a solid unity. The artist's brush-strokes declare his fundamental attitude to Nature as an interwoven fabric within a greater order. The pure, crystalline hardness of the mountain, luminously done in colours of unreal beauty, does full justice to Cézanne's concept of existential permanence as the fundament of being.

"Paul Cézanne has his place as the mystic amongst the great painters. The message of his art is this: he does not see things as they are but in relation to painting, which is to say, in terms of concrete expression of their beauty. Contemplative in character, aesthetic rather than objective in his way of seeing, he expresses himself in terms of his sensibility, through an instinctive and emotional apprehension of correspondences and accordances. Because this moves his art close to music, it bears repeating that he is a mystic, since music is the sublimest, most divine of forms. Any art that approaches the condition of music is on its way to absolute perfection. In language that means poesy, in painting beauty." (Bernard, *Paul Cézanne*, 1904.)

Landscape in Blue, 1904–1906
Paysage bleu
Oil on canvas, 102 x 83 cm
Venturi 793
Hermitage, St. Petersburg

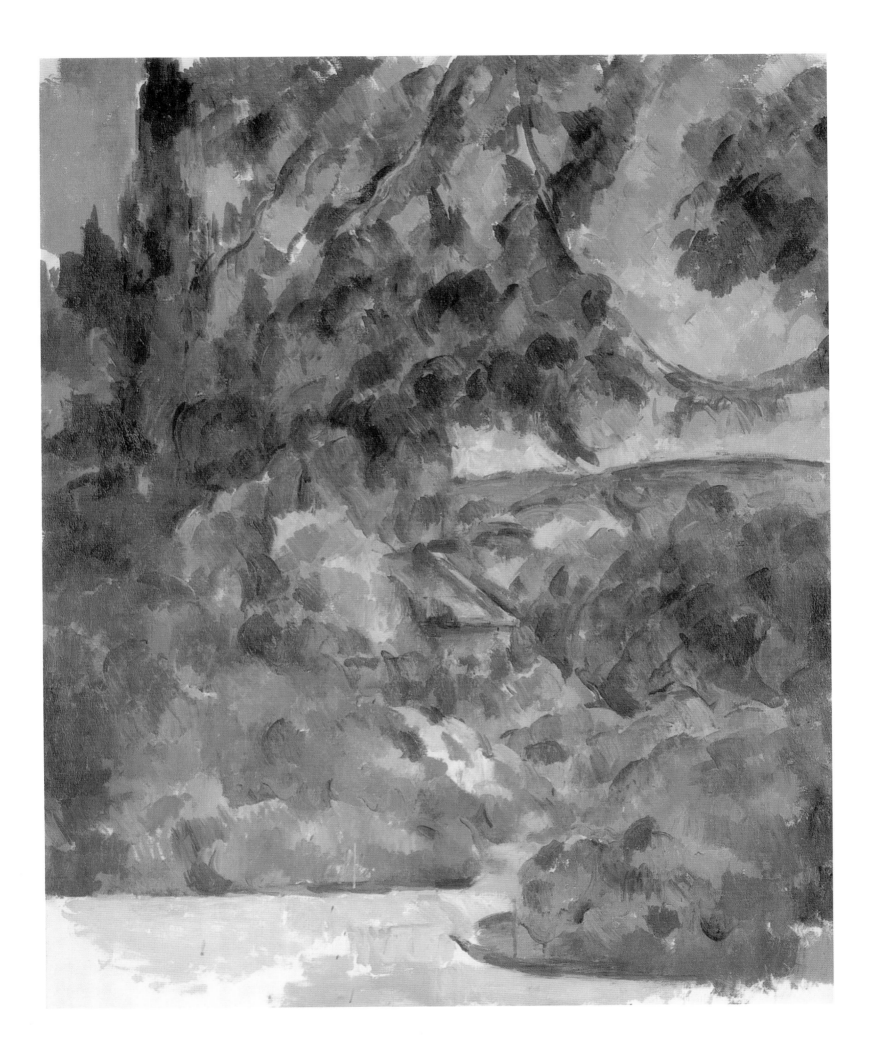

Paul Cézanne 1839–1906: A Chronology

1839 Paul Cézanne is born on 19 January in the Rue de l'Opéra in Aix-en-Provence. His father, Louis-Auguste Cézanne (1798–1886), is a hatter. His mother, Anne-Elisabeth-Honorine Aubert (1814–1897), is the daughter of a Marseille wood-turner. Paul's parents are not yet married.

1841 Birth of sister Marie on 4 July. She and Paul remain close throughout his life.

1844 His parents marry on 29 January.

1844–1849 Primary school in Rue des Epinaux, Aix.

1848 On 1 June his father establishes the Bank Cézanne & Cabassol with Cabassol, formerly cashier with the bankrupt Bank Bargès. The new enterprise is the only bank serving Aix and district, and prospers.

1849 Paul goes to Abbé Savournin's Ecole Saint-Joseph as a day pupil. Fellow-pupils include the future sculptor Philippe Solari and Henri Gasquet, whose son Joachim became a poet (cf. p. 128).

1852–1858 Boarding pupil (after 1858 day boy) at Collège Bourbon in Aix (now the Lycée Mignet). Friendship with Emile Zola, whose father is engineering a dam at Aix, and with Baptistin Baille, later professor at the Ecole Polytechnique in Paris.

1854 Sister Rose born on 30 June.

1858 12 November: passes school-leaving exams after failing in July. Takes art courses given by painter Joseph Gibert in the Musée Granet in Aix (till August 1859). There he meets Achille Emperaire (p. 48). Interested in music, especially Wagner's operas, and plays in an orchestra with Zola. Zola goes to Paris.

1859 At his father's wish he studies law at Aix University, though he wants to be a painter. Father buys Jas de Bouffan (p. 90) near Aix, once the property of a courtier of

Cézanne, about 1861

Louis XIV. Cézanne takes the art school's second prize for an oil study. Exempted from military service (his father pays for a substitute).

1860 Paints allegorical mural *The Four Seasons* (Musée du Petit Palais, Paris) for the big salon at Jas de Bouffan. Takes courses at Aix art school. With his mother's and sister's support he obtains his father's permission to study art in Paris. Studies works of the school of Caravaggio in Aix Museum.

1861 Abandons law studies and goes to Paris (April to autumn), where Zola awaits

him. Meets Armand Guillaumin and Camille Pissarro at Académie Suisse, where he does nude studies without a teacher. Fails École des Beaux-Arts entrance examination (probably for the first time) and doubts his talent. Returns to Aix in September to work in his father's bank. Art school in Aix (till August 1862). Still fascinated by art, he enters a couplet in the bank ledger: "Alarmed and dismayed, old Banker Cézanne / Finds his place taken by a painter man."

1862 Quits bank in January. Devotes himself to art and sets up a studio at Jas de Bouffan. Friendship with Numa Coste. Father makes him a monthly allowance of 150 francs; he returns to Paris in November. At Café Guerbois meets the painters Frédéric Bazille, Claude Monet, Alfred Sisley, Pierre-Auguste Renoir, and others.

1862–1864 Regularly at Académie Suisse. Turned down by the École des Beaux-Arts: "Cézanne has the temperament of a colourist but he exaggerates."

1863 Living at 7, Rue des Feuillantines. With Edouard Manet, Pissarro, Johan Bartold Jongkind, James Abbot McNeill Whistler, Henri Fantin-Latour and others rejected by the official Salon, he exhibits at the Salon des Réfusés. Paints turbulent, expressive pictures. Admires Eugène Delacroix and Gustave Courbet – and Manet, whose scandalous paintings *Le Déjeuner sur l'Herbe* and *Olympia* he later adapts (pp. 39, 78/79). Copies works in the Louvre.

1864 Till 1869 resident alternately in Paris and Aix. August in L'Estaque near Marseille. The Salon jury regularly turn him down. Meets Antoine-Fortuné Marion, a young geologist and amateur painter, in Aix, and admires his paintings.

1864–1870 Painting demonic, erotic scenes that express personal traumatic experiences: *The Abduction* (p. 32), *The*

Cézanne's sister Marie. About 1861

Jas du Bouffan, the estate Cézanne's father Louis-Auguste bought in 1859

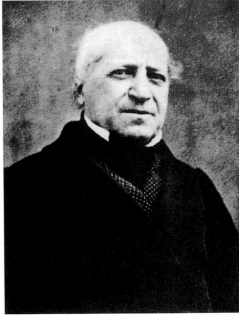

Cézanne's father Louis-Auguste

Temptation of St. Anthony (p. 33), *A Murder* (p. 36), *The Orgy*, *Autopsy* (p. 42).

1865 Living at 22, Rue Beautreillis with Francisco Oller. Autumn in Aix. Friendship with Antony Valabrègue (p. 45) and the German musician Heinrich Morstatt. Paints *Jug, Bread, Eggs and Glass* (p. 54) and portraits of Uncle Dominique (cf. p. 35).

1866 In spite of Charles Daubigny's support the Salon rejects him. Protests to director of fine art. First attempts at *plein air* painting at Bennecourt on the Seine.

Discusses the future of art with Zola. Meets Manet, who praises his still-lifes. August to December in Aix. Paints portrait of his father reading the paper (p. 15).

1867 January to June and autumn in Aix; summer in Paris. *Rum Punch* rejected by Salon. Paints *The Abduction* (p. 32), one of his few works to bear a date, and *The Negro Scipio* (p. 26).

1868 Frequent copying in the Louvre. May to December in Aix; works at Jas de Bouffan.

1869 Meets Hortense Fiquet (born 1850), a bookbinder who works part-time as a painter's model. Reads Stendhal's *Histoire de la Peinture en Italie*. Paints *The Black Clock* (p. 56) and *Tannhäuser Overture* (p. 43).

1870 Stock's cartoon of Cézanne appears in a Paris magazine. Living at 53, Rue Notre-Dame-des-Champs. After the outbreak of the Franco-Prussian War on 18 July he and Hortense move to L'Estaque; he avoids being called up. His father closes the bank and retires, and is elected onto the town council. Landscapes: *The Cutting* (pp. 60/61), *Snow Thaw in L'Estaque* (p. 59).

1871 From L'Estaque to Aix, then in autumn to Paris, where he lives at 5, Rue de Chevreuse and subsequently 45, Rue de Jussieu.

Cézanne in 1871

Paul Cézanne: *Paul Cézanne, the Artist's Son*, about 1878. Pencil, 10.8 x 6.5 cm. Private collection, Paris

Cézanne about 1875

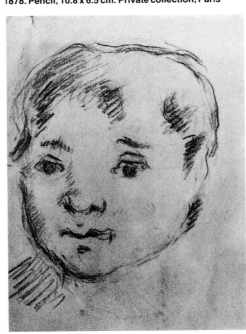

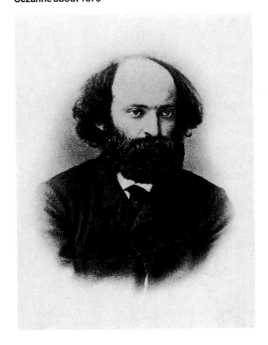

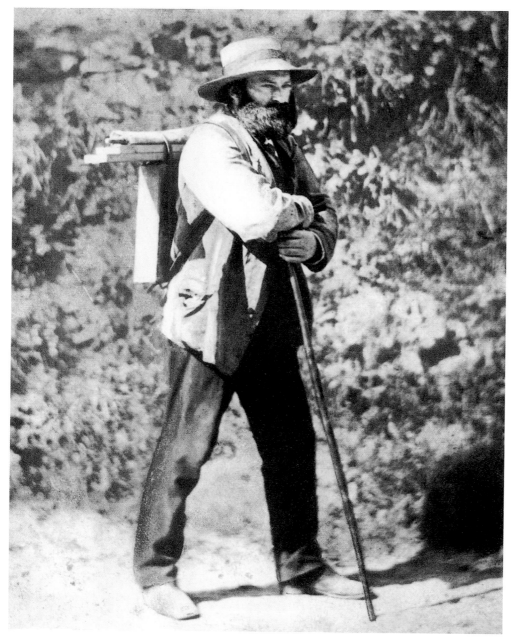

Cézanne in 1874, aged 34, setting out to paint near Auvers

Impressionist exhibition in April. (Cézanne does not exhibit at subsequent shows.) Only Renoir's friend Georges Rivière has a good word to say for his work. Works with Pissarro at Pontoise and later alone at Issy near Paris. Bronchitis. Sees that his own aims are not those of the Impressionists.

1878 Works all year at Aix and L'Estaque; Hortense and Paul live in Marseille. Cézanne's father "discovers" them and reduces his son's allowance. Zola, who has bought a house at Médan (p. 100), comes to his financial assistance. Serious bronchitis in September.

1879 From April till spring 1880 with Hortense and Paul in Melun. Visits Zola at Médan in the autumn. There is distance between the two old friends. Zola sees Cézanne as a failure; Cézanne sees Zola as "a bourgeois upstart".

1880 January to March in Melun; then at 32, Rue de l'Ouest, Paris. In August visits Zola at Médan and meets Joris-Karl Huysmans. Renoir paints his portrait (p. 1). His younger sister Rose buys a plot of land for 16,500 francs. Paints portraits of Hortense and son Paul, and self-portraits.

1881 Rose Cézanne marries Maxime Conil, a lawyer in Aix, on 26 February. May to October with Pissarro in Pontoise, where he meets Paul Gauguin. November in Aix.

1882 Winter at L'Estaque; Renoir visits him there, contracts pneumonia, and is nursed back to health by Cézanne and his mother at Jas de Bouffan. March to October in Paris. Exhibits a (?self-)portrait at the

Stock's cartoon of Cézanne in a Paris newspaper, showing the two paintings the 1870 Salon jury rejected (cf. p. 48)

1872 4 January: birth of son Paul. With Hortense and Paul he moves to Saint-Ouen-l'Aumône on the Oise, near Pontoise. There he paints with Pissarro and adopts his light, Impressionist palette: The House of the Hanged Man at Auvers (p. 70). Dr, Paul Gachet is interested in his art and buys some paintings. End of the year to Auvers-sur-Oise, where he remains till spring 1874.

1873 Paints at Gachet's house in Auvers. Working with Pissarro. Meets Paris paint dealer Julien Tanguy, who barters paint and canvas for paintings. Meets Vincent van Gogh.

1874 First Impressionist exhibition at Nadar's studio in the Boulevard des Capucines. Cézanne exhibits The House of the Hanged Man at Auvers (p. 70) and A

Modern Olympia (pp. 78/79); the critics and public respond with outraged ridicule. From September in Paris at 120, Rue de Vaugirard. Pissarro paints his portrait (p. 83).

1875 Through Renoir he meets Victor Choquet, a customs officer and art collector, whose portrait he later paints (p. 84); Choquet shares Cézanne's admiration of Delacroix. Moves to 15, Quai d'Anjou, next to Guillaumin.

1876 Introduces Manet to Choquet. April to July in Aix and L'Estaque; back to Paris in August. Conceals the existence of Hortense and Paul from his family.

1877 Living at 67, Rue de l'Ouest. Shows 16 paintings at the third

Salon. Five weeks in the autumn at Zola's in Médan. Works with Pissarro in Pontoise. October in Aix.

1883 May to December in Aix and L'Estaque. Visits Monet and Renoir; paints at La Roche-Guyon with the latter. Gauguin buys two Cézannes at Tanguy's.

1884 Final, unsuccessful submission to the Salon. Works mainly in Aix and environs. Paul Signac buys a Cézanne landscape from Tanguy.

1885 Spring at L'Estaque and Aix. Neuralgia in March. June and July: with Hortense and Paul chez Renoir at La Roche-Guyon, regaining his composure after a mysterious affair with an Aix woman. After sojourns at Villennes (near Pontoise) and Vernon (near Givenchy) he visits Choquet at Hattenville (Normandy). Sees Zola at Médan. August to December in Aix and Gardanne.

1886 28 April: under pressure from his mother and sister he marries Hortense. The change of status has no effect on their mutual estrangement. True affection is shared with his son Paul alone. 23 October: his father dies at the age of 88, leaving a fortune of 1.6 million francs to his widow and children. Cézanne's quarter-share releases him from financial worry for the rest of his life. His sister Rose buys a house, possibly Bellevue (pp. 107, 108), for 38,000 francs. Publication (in March) of Zola's novel *L'Oeuvre* leads to a final breach with Zola: Cézanne identifies with its hero, Claude Lantier, a painter of genius who is at

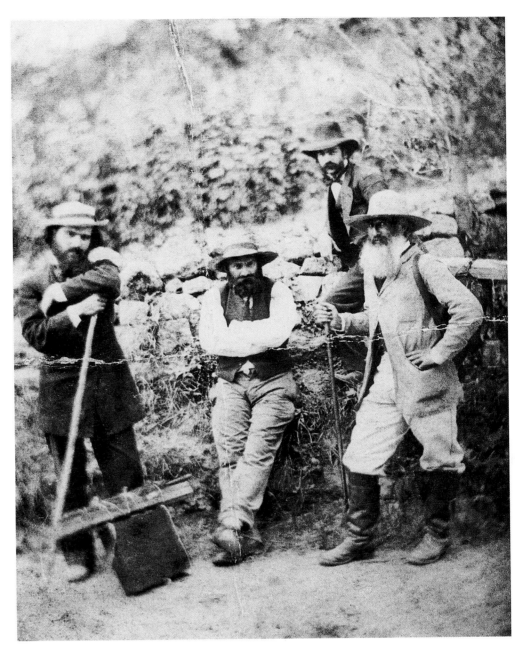

Cézanne (centre) with his friend Camille Pissarro (right). About 1874

Cézanne (seated) in 1877, aged 38, with Camille Pissarro (right) in Pissarro's garden at Pontoise. Pissarro's son Lucien is sitting on the backrest of the bench

odds with the whole world and himself and finally commits suicide. Spends most of the year at Gardanne with his wife and son; summer in Paris and Choquet's house in Hattenville.

1887 Mainly in Aix, painting in the open at Château Noir or the Bibémus quarry. Exhibits in Brussels at the invitation of Les XX. Paints Jas de Bouffan (p. 20) and *The Great Pine* (pp. 117, 118).

1888 Renoir visits him at Aix in January. Takes new Paris lodgings at 15, Quai d'Anjou and rents a studio in the Rue du Van-de-Grâce, where he paints *Mardi Gras.* Five months of work in Hôtel de la Cour in Paris, in Alfort, Créteil and Eragny (with Pissarro). Meets van Gogh and Gauguin anew; does not like their paintings.

1889 Choquet has *The House of the Hanged Man at Auvers* (p. 70) exhibited at the World Fair in Paris. June: visits Choquet at Hattenville. In summer Renoir visits him at Aix, and they paint together at Montbriand till they quarrel.

1890 January: with van Gogh and others he exhibits at the Brussels "Les XX" show (three pictures). First symptoms of diabetes, which later plagued him. Moves to Avenue d'Orléans. Five months in the summer in Switzerland with his wife and son (this trip may have been in 1891). Autumn at Aix, painting at Jas de Bouffan.

1891 Begins the year in Aix, later in Paris and Fontainebleau. His friend Choquet dies in April. Makes Hortense and Paul move to Aix for good.

Cézanne, about 1889/90

Cézanne's friend Emile Zola. About 1886

Cézanne in his Paris studio, 1894

1892 In Aix and at 2, Rue des Lions-Saint-Paul, Paris. Painting in the forest of Fontainebleau near Alfort and Samois. Buys a house in the village of Marlotte, Ambroise Vollard, a young art dealer, sees his paintings at Tanguy's. Paints his *Card-Players* (pp. 162, 163) and *Woman with a Coffee Pot* (p. 165).

1893 Living in Aix and Paris. Paints in the forest of Fontainebleau. Tanguy dies.

1894 Living in Aix and Paris. When Théodore Duret's collection is auctioned off in March, three Cézannes fetch good prices. Monet buys one of them. Painting at Avon, Barbizon and Mennecy. Autumn at Monet's in Giverny. 14 November: at Monet's 54th birthday celebrations he meets Georges Clemenceau, Auguste Rodin, Mary Cassat and Gustave Geoffroy,

who later writes on Cézanne and is painted by him (p. 168). At the auction of Tanguy's estate, Vollard buys Cézannes for prices ranging from 45 to 215 francs.

1895 January to June in the Rue Bonaparte, Paris. June to June 1896 in Aix. Goes to the Bibémus quarry and Mont Sainte-Victoire. In November he rents a shack at the quarry to store pictures. December: first solo exhibition at Vollard's Paris gallery (in the Rue Laffitte) including some fifty pictures selected by his son. Monet, Renoir, Pissarro and Edgar Deges express their esteem, but the public is unresponsive.

1896 Paints at the Bibémus quarry till June. Meets Gasquet the poet in April; Gasquet is subsequently important as a friend to talk to. Vollard visits him in Aix.

June: taking a cure at Vichy. July and august: in Talloires by Lake Annecy (*Lake Annecy,* p. 203). Autumn and winter in Paris, in the Rue des Dames (Montmartre). In an essay, Zola describes Cézanne as "a genius who never matured".

1897 January: influenza. Moves to 73, Rue Saint-Lazare. May in Mennecy. Vollard buys all the pictures he has in his studio. In Aix from June, painting at the quarry and Le Tholonet. 25 October: his mother dies at Jas de Bouffan at the age of 82. His sister Marie takes over the running of the household. Quarrels over the inheritance begin.

1898 Spends half the year at Aix, then moves to 15, Rue Hégésippe-Moreau, Paris. Paints at Montgeroult and Marines near Pontoise, at Marlotte near

Self-Portrait in a Hat, 1879-1882. Oil on canvas, 66 x 51 cm. Kunstmuseum Bern, Berne

Place des Prêcheurs in Aix-en-Provence. About 1900

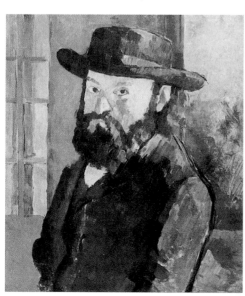

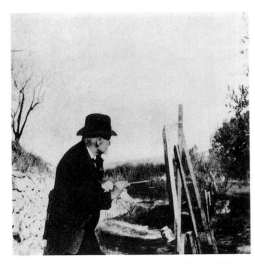

At work *sur le motif* in Aix-en-Provence. About 1906

Talking to the painter Gaston Bernheim de Villers

Fontainebleau, and at nearby Montigny-sur-Loing. Death of Emperaire (p. 46). May and June: second solo exhibition at Vollard's, with a catalogue.

1899 In Paris and environs till autumn. The Italian collector Egisto Fabbri, who possesses 16 Cézannes already, visits him in May. Paints the portrait of Vollard (p. 122) in his studio in the Rue Hégésippe-Moreau. In autumn he moves to Aix and remains there continuously for five years (till autumn 1904) except for a trip in autumn 1902. To clear up inheritance problems, Jas de Bouffan ist sold on 25 November for 75,000

francs, to Cézanne's regret. Exhibits three paintings at the Salon des Indépendants. Moves into a small town apartment at 23, Rue Boulegon, Aix. Madame Brémond is his housekeeper. Hortense and Paul spend most of their time in Paris. December: further solo show at Vollard's. When Choquet's collection is sold, the Cézanne's go for an average price of 1,700 francs. Monet has already paid 6,750 francs for *Snow Thaw in L'Estaque* (p. 61). Vollard visits Gauguin on Tahiti and tells him he has bought all the paintings in Cézanne's studio. Cézanne becomes more and more eccentric.

1900 At Roger Marx's prompting, three Cézannes are included in the Century Exhibition of French art (from Jacques-Louis David to Cézanne) at the Paris World Fair. One of them is *Fruit Bowl, Cloth, Glass and Apples* (p. 179), previously in Gauguin's possession. Another is *Pool and Trough at Jas de Bouffan* (p. 17), Cézanne's fame is growing. Paul Cassirer arranges Cézanne's first German exhibition, in Berlin. Diabetes is acute.

1901 Maurice Denis exhibits *Hommage à Cézanne* at the Salon. Cézanne exhibits two paintings at the Salon des

At Les Lauves near Aix, 1905.
Photograph: Emile Bernard

Cézanne seated in front of *Les Grandes Baigneuses* in his studio in Aix in 1904. Photograph: Emile Bernard

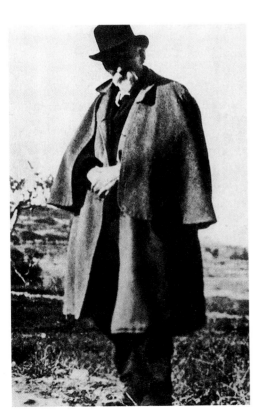

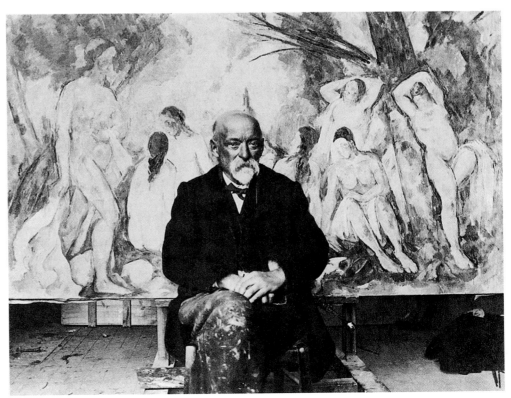

Mont Sainte-Victoire, Cézanne's favourite subject, seen from the road to Le Tholonet about 1900

Coats and still-life props in Cézanne's Aix studio. About 1930

Cézanne's last studio at Aix. About 1930

Indépendants. November: buys a plot of land at the Chemin des Lauves, a hill north of Aix, where he builds a studio. Frequent meetings with poet Léo Larguier and painter Charles Camoin, who are doing military service in Aix.

1902 January: Vollards visits. Cézanne works in Aix and Le Tholonet till his studio is complete. Visits Gasquet at Eguilles near Aix. Denis urges him to exhibit three pictures at the Salon des Indépendants. Shows two paintings in Aix at an exhibition of the *Société des Amis des Arts*, of which he is a member. September: begins using the new studio. Visits Larguier in the Cevennes in autumn. 26 September: makes his will, leaving everything to his son Paul and only the legal portion to Hortense. 29 September: death of Zola. Paints his last pictures of Mont Sainte-Victoire (pp. 213, 219, 221).

The studio by the Chemin des Lauves at Aix-en-Provence. About 1904

1903 At the sale of Zola's collection of paintings the ten Cézannes go for an average of 1,500 francs. Exhibits seven pictures at the Vienna Secession, including *Mardi Gras* (p. 157) and *Trinitarian Monastery at Pontoise (The Retreat)* (p. 66).

1904 Emile Bernard visits him at Aix, watches him at work, and photographs him. Last trip to Paris. Paints in Fontainebleau. Works on *Les Grandes Baigneuses*. Exhibits nine paintings at La Libre Esthétique in Brussels. At the autumn Salon he has a room of his own containing 33 paintings. Cassirer organizes second solo exhibition in Berlin. Leo and Gertrude Stein buy their first Cézanne. Gasquet, Larguier, Camion and Gaston Bernheim-Jeune visit him in Aix. Cézanne becomes more difficult with people; his health is poor.

1905 Vollard exhibits Cézanne watercolours. Shows at autumn Salon and the Salon des Indépendants. Finishes *Les Grandes Baigneuses* (pp. 145–147). March: Bernard and Denis visit him in Aix. In the summer he takes a short trip to Fontainebleau. Monet describes him as "one of the masters of our times". Paul Durand-Ruel shows ten Cézannes at the Grafton Gallery in London.

1906 March: Vollard exhibits twelve Cézannes. The German collector Karl Ernst Osthaus visits Cézanne in April and buys two canvases for the Folkwang Museum

(pp. 108, 200). August: bronchitic attack. Exhibits ten paintings at the autumn Salon. 15 October: a storm catches him unawares while he is working "sur le motif" in Aix; looking for shelter, he collapses. He is found and taken to Aix on a cart. Next day he forces himself to work on his last picture, the portrait of Vallier the gardener (p. 170). 22 October: dies of pneumonia at his flat in Aix. Hortense and Paul, who are in Paris and have been informed of his condition, are too late to see him alive again.

1907 Major retrospective in memory of Cézanne at the autumn Salon (56 paintings). His fame and stature have been consolidated through to our own times.

Table with an ornate lower edge, with props Cézanne used in still-lifes. In the Aix studio. About 1935